# The People's Spiral of US History

## From Jigonsaseh to Solartopia

By Harvey "Sluggo" Wasserman

*Original Organic Edition*

Published & Copyright© 2022 by Farmers Green Power, LLC

Sources / e-books / audiobooks / posters
corrections / critiques / crank letters / kudos
@ www.solartopia.org

12439 Magnolia #18; Valley Village, CA 91607

ISBN: 978-1-64606-050-4

"Harvey Wasserman constantly provokes us and educates us, sometimes outrages us, often inspires us… He is always delightfully readable."

—Howard Zinn, A People's History of the US

"You can't put it down… flows like a thrilling novel…best history book I've ever read."

—Lila Garrett, Connect the Dots, KPFK-Pacifica

"Genius!…a magnificent piece…I'm blown away."

—Eric Roberts, "King of the Gypsies"

"Harvey shows history as a living organism…The graphics alone, showing Indigenous and Puritan contributions to American DNA, are a better education than I ever got at school…".

—Mimi Kennedy, Actor/Activist Progressive Democrats of America

"…lively, engaging, original, zany, psychedelic, feisty, opinionated… "

—Eric Foner, Pulitzer Prize Winner, Gateway to Freedom

"The best history book I ever read."

—Joel Segal, Progressive Democrats of America

"Hey, Sluggo—well, now, you've finally gotten off your solar ass—and yep, here's a true Yippie history of the dang USA."

—Paul Krassner, Yippie Godfather

"Brazen! Outrageous! Shocking! And all too unbelievably true. Hilarious and mournful, here's the perfect history of the U.S. for the 2020s.

—Prof. H. Bruce Franklin, Crash Course: From the Good War to Forever War

A must read. An accessible, conceptually easy way to make a shift in one's understanding of US history."

—Tatanka (Kit Bricca), "Minding Tatanka"

"Sluggo's midnight ride thru American history… rockets through time"

—Bobby Rinaldo

"…an easy but deep read by one of the greatest historians of our generation…a great story… poetic… optimistic."

—Ken Wachsberger, Voices from the Underground

Harvey's stories are brilliant, and his worldview expands us all…

—Thom Hartmann, Syndicated Radio Host, Author

"Harvey Wasserman is truly an original…"

—Studs Terkel

Sluggo Wasserman ~ 1970
photo credit: C.E. Green

# *Mitakuye Oyasin*

*"This is the Eighth Sign.  You will see many youth, who wear their hair long like my people, come and join the tribal nations, to learn their ways and wisdom....*

—Frank Waters, Book of the Hopi

### *Our Mother is Indigenous*...our Father a Puritan.
We Americans are born of fierce genetic contradictions.

Our double-helix has raged through six historic cycles, becoming a spiral. Now we squeeze again through a narrow (re)birth canal toward a sustainable age.

*On this tortured delivery, the fate of the Earth depends.*

**This telling was born in 1970**, amidst a terrible war (aren't they all!) and a transformative counter-cultural upheaval.

*(Its many sources and influences are at www.solartopia.org)*

It's shaped by William A. Williams's *Contours of American History*.

It's rooted in Howard Zinn's *People's History of the United States*.

It bursts from 50 years of joyous Yippie uproar for peace, civil/voting rights, social justice, psychedelics, and an organic green-powered Earth.

**At empire's end, at the brink of eco-extinction,** we face an all-out fascist assault on our democracy...an autocratic *blitzkreig* fueled by terrible injustice, extreme economic division, advanced cultural dementia.

To survive at all, our feminist Indigenous core desperately seeks a sustainable synthesis with our corporate macho technocracy.

It's an evolutionary leap demanded by a burning planet.

**But we're out of time and space.**
So let's ride this spiral helix and see how we can save ourselves ....

# THE BIG PICTURE

# *CONCEPTION*

*Every culture passes through the age-phases of the individual...*

*Each has its childhood, youth, [adult]hood and old age...its determined phases, which invariably occur.*

– Oswald Spengler, *Decline of the West*

# Our Indigenous DNA
## *Mother Earth's Matriarchs Nurture Our Nation*

*Our Mother is an Indigenous matriarch*
*In her womb our nation was conceived.*
*Her beloved daughter Jigonsaseh was our first matriarch...the true mother*
*of American democracy.*
*Everything American is rooted amongst those first diverse societies...*
*Now a revived matriarchy is poised for rebirth.*
*And not a moment too soon!*

Women ran much of native North America. They raised the kids, chose the chiefs, shaped our Indigenous DNA. Said the Hopi...

*...the family, the dwelling house and the field are inseparable, because the woman is the heart of these, and they rest with her. Among us the family traces its kin from the mother, hence all its possessions are hers.*

*...The man builds the house but the woman is the owner, because she repairs and preserves it; the man cultivates the field, but he renders its harvest into the woman's keeping, because upon her it rests to prepare the food and the surplus of stores for barter depends upon her thrift.*

The *Iroquois Confederacy* was the cradle of our civilization. Its matriarchy created our Indigenous Originalism, born as early as 1140AD.

*Deganawidah*, the *Haudenosaunee* Peacemaker, joined the great *Onandaga* orator *Ayawentha* to work for peace.

*Ayawentha's* wife and three daughters just died in war, which was rare.

Much Indigenous combat stopped with first blood. Victorious tribes often adopted captured women and children. Reports of indigenous rape are virtually nonexistent. Captured whites often chose to "go native."

For eons, *People of the Long House*--- Mohawk, Oneida, Onandaga, Cayuga, Seneca--were forever at war. They shot from behind trees, struck as the spirit moved them, slipped away to regroup and return with guerrilla tactics that changed the world.

Stretched across what's now upstate NY, they improvised in tune with Mother Nature. Had they been immune to the European diseases that killed 90% of them, the whites would STILL be fighting their way west.

And had those Europeans opened their minds and hearts---had they cooperated instead of conquered (*studied instead of slaughtered*)---we humans today might not be at the brink of burning ourselves off this planet.

As Renaissance Europe emerged from the Dark Ages in constant turmoil, the *Hodenosaunee's* eco-social harmony far transcended the era's white nation-states.

*The Peacemaker* was a stutterer. *Ayawentha* spoke his heart. But as they united the tribes, it was the powerful, beloved matriarch *Jigonsaseh* who at last combed the snakes from the tortured head of *Tadodaho*, the fierce, fearsome Onandaga war chief who'd made peace seem impossible.

With epic patience and diplomacy, the three Peacemakers made *Tadodaho* the new leader of a sophisticated alliance, joining Five Nations in peace. They convened America's first Congress, then laid the foundation for an advanced consensual democracy that would keep their own internal peace for centuries.

The newcomer French called the *Haudenosaunee* "Iroquois"...a serpentine slur. Mainstream historians and politicians shun their governmental genius.

But the *Haudenosaunee* formed humankind's purest democracy. While the emerging states of Europe suffered through warring tyrannies of absolute, inbred, often idiotic monarchs, the Iroquois Union thrived in harmony.

The Five Nations sent fifty chiefs to a central council. Representation was based on local head counts. The various tribes kept their traditional structures.

But in their shared Great Law of Peace, individual liberties were sacred, carefully spelled out in the 117 codicils that preceded our own first Ten Amendments.

While the men hunted, fished and pontificated, the tribal matriarchs prepared the food, kept the fires, raised the kids. Charles C. Mann doubts they ran the show...

*...It is the general consensus of anthropologists and archaeologists that there are no known examples of societies where women had more political and social power than men.*

There were certainly North American tribes run by men. But among (at least) the Iroquois, Cherokee and Hopi, such doubters might get a memorable feminist earful. In the tradition of *Jigonsaseh*, the women chose the chiefs....and could remove them...as they did to Donald Trump in 2020.

Letting the men blab away "makes them feel important," smiled Audrey Shenandoah, a modern Haudenosaunee matriarch. "It gives them something to do."

Ben Franklin said the whole thing ran "better than the British Parliament." Maybe 15 million Indigenous inhabited North America before Columbus. Maybe 100 million peopled the western hemisphere, maybe more.

In what's now the US, a thousand diverse bands, tribes, clans, nations, confederacies spoke more than 500 languages. Each bore its own culture, traditions, belief systems, world-view.

Extended Indigenous families shared feast and famine in unison. In all of North America, only the town of Cahokia---near today's St. Louis---may have exceeded a population of 20,000. The mysterious mounds that surround it speak to ancient civilizations long since vanished for reasons we may never know.

Many tribal names mean "the people." Until the whites came, the Indigenous sensed no separate identity beyond the differences between their tribes and nations.

Many had legends of a migration from Asia. Some ancestors certainly crossed a "Land Bridge" from Siberia. But most also contend their home has always been here,

that at least some of the human species originated in the western hemisphere. (*On the science of that belief, time will tell*).

There were chiefs and shamans, warriors and captives…but no Original Sin or Hellish afterlife. Death and Life are forever inseparable.

The Indigenous still favor burial amidst the bones of their ancestors, whose spirits they still embrace in both life and passing. Every rock, plant, river, cloud, forest, insect, animal (including the human) walks with a universal consciousness named *Orenda*, *Wakan*, *Manitou*, *Huaca*, and more.

Indigenous oral histories reflect ceaseless cycles of natural seasons, reproductive rhythms, rhymes of generations, free from fear of a hateful God or terminal Apocalypse.

A woman's reign over her reproductive choices was guaranteed with roots and herbs and centuries of knowing just how to use them. Diverse sexual orientations were mostly embraced as just another strand in the web of life.

The Indigenous naturally sustained a level of physical health long lost to urban Europe. Pristine lakes, streams and ocean beaches embraced their everyday immersions, accompanied by ritual sweat baths and the rigorous exercise of an outdoor existence. They made their clothes and homes, implements and artifacts, from what the Earth provided.

For the Indigenous core, land was a living organism, everywhere revered…and often shaped to meet their needs. Charles C. Mann's *1491* says most tribes regularly scorched the forest understory into fertile char. They nurtured chosen trees for fruits, nuts, medicine, syrup, vines, building materials, weapons, firewood.

With exceptional survival skills, evolved over the eons, they shaped the "forest primeval" into a virtuosic parkland, burnt free of underbrush, nurtured with char, filled with productive trees, carefully balanced for a reliable supply of wild animal protein.

In shaping their surroundings, the tribes looked to the long term, making their decisions with a mind toward future progeny. For a modern corporate-capitalist society that gears its planning toward the next quarterly report, the idea of paying things forward as far as seven generations is virtually incomprehensible. But living on land that sustained them for countless millennia, this was their Ingidenous core.

In tandem came advanced techniques to breed and rotate the crops that fed them. The tribes could claim certain technological advances, like the syringe. But their Earthly genius was sustainability, in field and forest, lake and stream.

In places like the Ohio Valley, fertile topsoil nine feet deep nurtured the balanced protein-rich trinity of corn, beans and squash. Tomatoes and basil thrived in harmony. Nuts, roots, herbs, berries, fungi, and a cornucopia of fruits and vegetables forever fed a thriving civilization. Some villages ran six square miles and more of maize alone.

Rather than domesticating animals (*a constant source of European disease*) the Indigenous managed waters, field and forest for a constant "crop" of fish and game. They treated illness with herbs, potions, poultices, teas.

"Above all," writes Roxanne Dunbar-Ortiz in *An Indigenous Peoples' History of the United States*…

*...the majority of the Indigenous peoples of the Americas had healthy, mostly vegetarian diets based on the staple of corn and supplemented by wild fish, fowl, and four-legged animals.*

*People lived long and well with abundant ceremonial and recreational periods.*

Trade flourished among the societies "with a complex system of roads and paths which became the roadways adopted by the early settlers." In the Haudenosaunee Sacred Law, says Onondaga Faithkeeper Oren Lyons...

*The first principle is peace.*
*The second principle, equity...justice for the people.*
*And third, the power of the good minds, of the collective powers to be of one mind: unity.*
*And health...*
*And the process of discussion, putting aside warfare as a method of reaching decisions, now using intellect.*

Through all Indigenous societies ran the sense of a "natural paradise," a holistic ecology in synch with the Earth.

Among Newcomers who could SEE it, Indigenous America inspired a transcendent ideal that irresistibly resurfaces again and again throughout the spiral of our history. It flows from the vibrant aquifer of our creative core, the nature-based strand of our blended DNA. "Man is born free," wrote the romantic French visionary Jean-Jacques Rousseau, "but everywhere lives in chains."

The free were Indigenous. Europe was bound and gagged.

At birth, Euro-American revolutionaries used Indigenous guerrilla tactics to stun Britain's Redcoats. The transcendent "Indian loving" genius Ben Franklin helped blend the Great Law into a federal Congress and Bill of Rights. Wrote the legendary Swiss psychiatrist Carl Jung...

*...North Americans have maintained the European level with the strictest possible puritanism, yet they could not prevent the souls of their Indian enemies from becoming theirs.*

Our residual Calvinist/evangelical elite is still terrified by the tribal mystique. As individuals, the Indigenous have been as flawed and full of contradiction as the rest of us. It's at least as critical to avoid romanticizing the Indigenous experience as it is to avoid denying its influence. America's First Peoples are still people.

But their sustainable societies succeeded on this land for centuries.

They created complex, productive civilizations as advanced as any, anywhere, with eco-matriarchal ways still rooted deep in our soil...and souls.

9

With often savage vehemence, mainstream historians still deny the Indigenous influence on America's imperfect embrace of democracy.

*(And there is no shortage of Indigenous who want no "credit" for or connection to birthing the imperial Republic that has done them such harm).*

Yet newcomers here a half-millennium or less cannot so cavalierly dismiss the embedded impact of those who've been here ten, twenty or more.

In 1988, while our then-matriarch Nancy Reagan ran the White House, a Concurrent Resolution of Congress confirmed the obvious…

*…the original framers of the Constitution, including most notably, George Washington and Benjamin Franklin, are known to have greatly admired the concepts, principles and government practices of the Six Nations of the Iroquois Confederacy…*

*…the Confederation of the original thirteen colonies into one Republic was explicitly modeled upon the Iroquois Confederacy as were many of the democratic principles which were incorporated into the Constitution itself.*

Respect for Earth, consensus-based equity, and continued resistance to eco-suicide mean America's First Peoples still hold the code to genetic survival.

For "Indigenous Originalists" the Great Law's natural hoop remains the ultimate American authority. From the native wellspring of our historic spiral comes the cyclical Awakening of our Indigenous DNA…our enduring, continually reborn humanist spirit…an evolving embrace of irrepressible diversity, reverence for life, consensual democracy, veneration for women, love of justice, eternal laughter.

"We like being called Indians," an Indigenous attorney once told me. "It reminds us that Columbus was lost."

"Freedom," says Oren Lyons, "that's what the whites found here."

# Our Puritan DNA
## *The Cult of God the Father & His "City on the Hill"*

*Countless immigrants have come here to find freedom. All have spliced their diverse customs and cultures into our DNA.*
*But the absurdly uptight English Puritans would tolerate none of it.*

In the 1630s, 30,000 black-robed, doom-preaching "Visible Saints" anointed Boston their "City on the Hill." Their "exceptional" corporate macho-imperial Judeo-Christian White Supremacy tests us forever with Orwellian "Iron Heel" instincts most brutally imposed during the pandemic terrors of Woodrow Wilson and Donald Trump.

These English Calvinists brought passions for literacy, limited democracy, and advanced technology. They saw themselves as racially and spiritually superior, destined to dominate all non-Puritans...and Nature Herself. Their obsessive paranoia, dour intolerance, hubris, misogyny and greed *still* drive our global empire.

Above all, said H.L. Mencken, these insufferable fanatics were driven mad by "the haunting fear that someone, somewhere, may be happy."

Hating diverse opinion and social democracy, these New England patriarchs burned witches and dissidents, hippies and humanists. Boston's Cotton Mather...

*...was once emptying the Cistern of Nature, and making Water at the Wall. At the same Time, there came a Dog, who did so too, before me. Thought I; "What mean, and vile Things are the Children of Men, in this mortal State! How much do our natural Necessities abase us, and place us in some regard, on the same Level with the very Dogs!"*

To the Puritans of yesterday, today and tomorrow, Mother Earth's "heathen savages" and "agents of Satan" infested a "hideous wilderness," a hellish purgatory, a "Valley of the Shadow of Death," of "Briars and Thorns, of Trouble and Sorrows."

Throughout Europe, "civilization" was defined by sprawling, hideous cities... filthy, disease-ridden, unjust, violent. With an air of divine superiority, these narcissistic newcomers brought all that here...including the "custom" of buying human scalps, as did Cromwell's Puritan Roundheads when they ravaged Ireland and Scotland.

America was now an "exceptional" mission, a Manifest Destiny. Boston was the New Jerusalem, God's own beacon. Its corporate union of church and state was an autocratic theocracy. Elected *only* by the proven faithful, Puritan magistrate-priests ruled through a divinely ordained theocracy with an utter lack of humility or humor.

They called themselves "Christians." But Calvin's elite scorned the empathy and compassion of the *Sermon on the Mount.* The non-white, dissident and non-wealthy were "unfitt" except to labor in the fields, toil in the factories, die in battle. Had Jesus dared preach on a Boston street corner, he'd've been hanged on the spot.

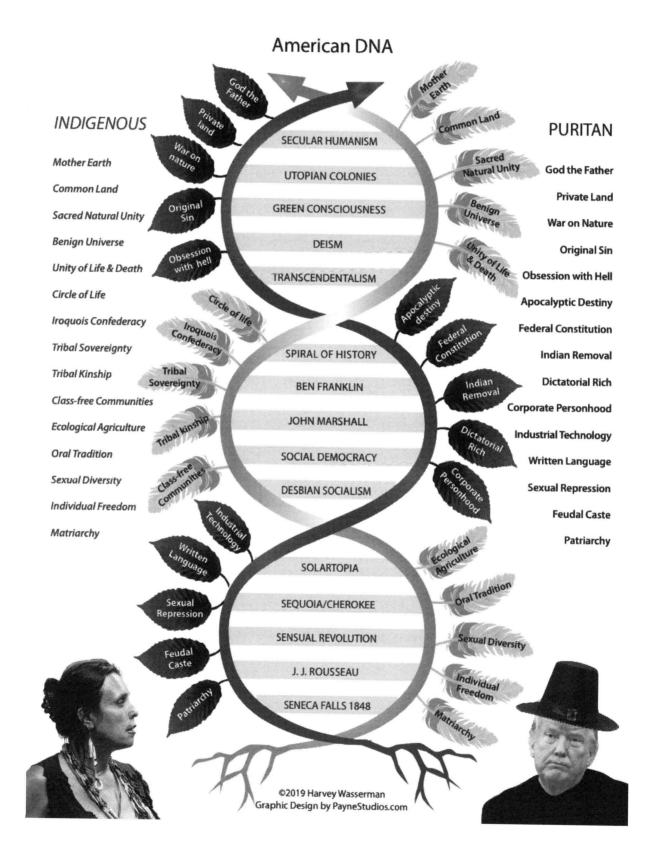

# American DNA

**INDIGENOUS**

**PURITAN**

*Mother Earth*

*Common Land*

*Sacred Natural Unity*

*Benign Universe*

*Unity of Life & Death*

*Circle of Life*

*Iroquois Confederacy*

*Tribal Sovereignty*

*Tribal Kinship*

*Class-free Communities*

*Ecological Agriculture*

*Oral Tradition*

*Sexual Diversity*

*Individual Freedom*

*Matriarchy*

God the Father

Private Land

War on Nature

Original Sin

Obsession with Hell

Apocalyptic Destiny

Federal Constitution

Indian Removal

Dictatorial Rich

Corporate Personhood

Industrial Technology

Written Language

Sexual Repression

Feudal Caste

Patriarchy

SECULAR HUMANISM

UTOPIAN COLONIES

GREEN CONSCIOUSNESS

DEISM

TRANSCENDENTALISM

SPIRAL OF HISTORY

BEN FRANKLIN

JOHN MARSHALL

SOCIAL DEMOCRACY

DESBIAN SOCIALISM

SOLARTOPIA

SEQUOIA/CHEROKEE

SENSUAL REVOLUTION

J. J. ROUSSEAU

SENECA FALLS 1848

©2019 Harvey Wasserman
Graphic Design by PayneStudios.com

12

The Calvinist Elect came here to conquer, multiply, and impose the wrath of an angry God, in whose hands all humans were lowly sinners, born guilty, inherently doomed.  Even the most apparently righteous went to Hell upon His slightest whim.

To escape this curse, every Puritan male had to read the Bible. Harvard was founded to teach them how.

Women *(of course)* were scorned. But the Calvinist fathers worried they might have souls. So they let them read.  But not vote.  Those who dared speak out, like Anne Hutchinson and her Quaker sisters, were banned or hanged.

A Puritan could eat, but not enjoy it. Drink alcohol, but only as a sacrament.  Have sex, but only within marriage, and NOT for fun.

The eternal "conservative" obsession with other peoples' sex lives extended for centuries to such Visible Saints as Jimmy Swaggart, Jim Bakker, Carl Enyert, Anthony Perkins (both of them), Pat Robertson, Jerry Falwell, the Westboro Baptist Church.  Any variance from the missionary position was deemed criminal, even in wedlock. Self-anointed sex police spied through windows to make sure nobody was having too much fun.  No warrant was required, then or now.

Visible lust was a mortal sin. Being gay was beyond discussion. Hymnals were for church.  Dancing was for the Devil.

So, apparently, was bathing.  Many Indigenous began their days with a dip in a nearby lake or stream.  Europeans immersed themselves rarely, kept to the same clothes, and "stank to High Heaven" even before they got there.

Sabbath "entertainment" was an endless Biblical horror show.  Black-robed priests raged on for hours.  You came or else.  Forget about leaving early *(unless you were George Washington, who walked out whenever he felt like it).*

Getting filthy rich meant you *might* be headed for Heaven.  But nothing was guaranteed.  That sick uncertainty metastasized into a crazed obsession for which no sum of money is ever enough, no matter the cost to person or planet.

The Calvinist ethic was the spirit of capitalism.  Its rage for riches was "God's Anointed Way."  Technology was His Lordly tool to conquer and consume a hellish Earth and its damnable sinners.

Soon the Bay Colony ripped nearly all the fish from Cape Cod Bay, raped forests, poisoned streams, extincted game…all in desperate pursuit of sacred legal tender.

Calvin's corporate-imperial elite was God's Elect, an army of self-anointed saints, duty-bound for Christian empire and holy cash.

But these haughty narcissists suffered a psychotic twist:  predestination.  No matter how obsessively even the purest disciple worked and suffered, tithed and toiled, God's plan was immutable…and inscrutable.

Human free will had no meaning.  The hardest-working True Believer could still be scorched at death.

This "horrible decree" infected our "Visible Saints" with terminal paranoia and totalitarian intolerance. Doubt itself was Calvin's ultimate terror.  A bad dream, a weak moment, an errant thought, a glimpse of lust, a breath of joy…these were Satan's calling cards.  The Puritan psyche could bear neither personal uncertainty nor public dissent.  Said Nathaniel Ward…

*He that is willing to tolerate any Religion ... besides his own either doubts his own ... or is not sincere in it.*

The Puritan Trinity was God, gold, Glory. History's somber path led to absolute Imperial Dominion... or ultimate damnation. There could be no middle ground for religious tolerance or social democracy, women's rights or racial equality.

Calvinism, wrote Tawney, was like a "coiled spring that shatters every obstacle by its rebound"...including any sort of stable, sustainable, sane human society.

In six stages, from 1688 to 1992, that Puritan fury spun the placid cycles of Indigenous harmony up an evolutionary axis, a techno-imperial spiral.

Like the seasons of the year, alternating pulses of evolving consciousness flashed from materialistic winter... to thaws and cracks...to a springtime awakening...a hot summer of war... an autumn reaction...another winter's decay and freeze...and then...yet again...to those *divine* thaws and cracks, *where the light gets in.*

Whirling like a sea spout, these shortening seasons have twirled our dizzied American organism toward the end-of-empire Trumpocalypse from which we still stagger and emerge, barely alive....

Those coils of history have driven our species to unimaginable imperial wealth and technological mastery...metastasized with greed, intolerance, injustice, racism, misogyny, ecological suicide and a dark, depressing view of life itself.

Yet our soul always springs back *(our Spirits are always moved)* with those Awakened, Indigenous, outrageous outbursts for grassroots democracy, peace, social justice, ecological sanity, raucous humor and spiritual transcendence *(not to mention sex, drugs, rock & roll).*

Now human survival demands we *somehow* fuse this back/forth, life/death feud between our sustainable Mother Earth and our imperious God the Father.

That dynamic synthesis is our ultimate imperative, our evolutionary key...the vital gateway to a livable future.

*So let's go find it...*

# The People's Spiral of US History

## Our Six Shortening Cycles, 1688-1992

*"History doesn't repeat itself, but it does rhyme."*
*—-Mark Twain*

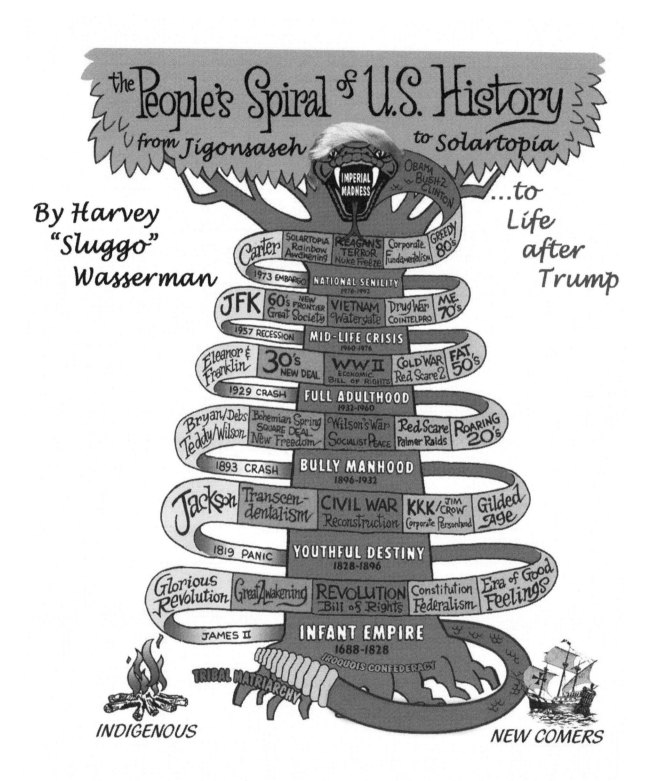

# The People's Spiral of U.S. History

**Our Desperate Race to Solartopia**
*Millennials/Zoomers*

**Clinton, Bush 2, Obama, Trump**

*(middle vertical band: Counter-Culture)*
*(right vertical text: Farmers Green Power — www.solartopia.org)*

| CYCLES> | BURST OF ENERGY | AWAKENING | WAR | REACTION | AFTERMATH |
|---|---|---|---|---|---|
| **6** Imperial Senility 1976 - 1992 | **Carter** | *Solartopia* / *Rainbow Awakening* | **ATOMIC TERROR** / *Nuke Freeze* | Corporate Fundamentalism | Greedy '80s |
| **5** Midlife Crisis 1960 - 1976 | **JFK** | *The '60s* / *New Frontier* / *Great Society* | **VIET NAM** / *Watergate* | Drug War Cointelpro | Me '70s |
| | | **The Baby Boom is Born** 1946 - 1964 | | | |
| **4** Full Adulthood 1932 - 1960 | **Eleanor & Franklin** | *The '30s* / *New Deal* | **WORLD WAR II** / *Economic Bill of Rights* | Cold War Red Scare 2 | Fat '50s |
| **3** "Bully Manhood" 1896 - 1932 | *Bryan / Debs* **Teddy / Wilson** | *Bohemian Spring* / *Square Deal / New Freedom* | **WILSON'S WAR** / *Socialist Peace* | Red Scare Palmer Raids | Roaring '20s |
| **2** Youthful Destiny 1828 - 1896 | **Jackson** | *Transcendentalists* | **CIVIL WAR** / *Reconstruction* | KKK / Jim Crow Corporate Personhood | Gilded Age |
| **1** "Infant Empire" 1688 - 1828 | **Glorious Revolution** | *Great Awakening* | **REVOLUTION** / *Bill of Rights* | Constitution Federalism | Era of Good Feelings |

*Indigenous Matriarchy Haudenosaunee Confederacy* — **Roots: Indigenous & Newcomers** — PURITAN PATRIARCHY TECHNO-DOMINION

# Cycle One: "Infant Empire"

| Glorious Revolution | Great Awakening | REVOLUTION Bill of Rights | Constitution Federalism | Era of Good Feelings |
|---|---|---|---|---|

# A BURST OF ENERGY
## *The Glorious Revolution*

*European seed impregnated our Indigenous mother.*
*It was an epic, violent rape.*
*We took embryonic shape in 1688.*
*At birth (1776) we turned the world upside down.*

First came the Vikings. Their sleek schooners crossed oceans, sailed up our rivers, penetrated Greenland and Canada (as they had Britain and the continent).

Then *(maybe!)* came the Chinese. Gavin Mendes says two giant junks reached our west coast in 1421. It's an intriguing assertion in search of hard evidence.

In 1492, Columbus brought greed, torture and religious totalitarianism. Spain raped Florida for her youth and treasure, then pillaged the Great Southwest long before the Pilgrims did it to Plymouth. Spanish horses transformed the prairie.

Crazed Conquistadors gutted the great Aztec, Mayan, and Incan civilizations. They torched "Godless" libraries equal to any in Europe, an unconscionable loss of priceless human wisdom. They further assaulted the "heathen blasphemy" of America's nature-based spirituality with a "Pharmocratic Inquisition" that's yet to end. Says Michael Pollan in *How to Change Your Mind*:

> *…The Spanish sought to crush the mushroom cults, viewing them, rightly,*
> *as a mortal threat to the authority of the church…The Nahuatl word for the*
> *mushrooms—-flesh of the gods—-must have sounded to Spanish ears*
> *like a direct challenge to the Christian Sacrament.*

In Spain's Catholic footsteps, Boston's Puritan-corporate elite waged all-out war *(yet to end)* on the *peyote* and other hallucinogens used for centuries by the Indigenous to penetrate the mysteries of the pagan cosmos. Of late, America's Wars on Drugs have meant to erase the "woke" counter-culture and civil/voting rights awakenings of the 1960s and beyond.

The attack does not seem to have worked.

In 1588, Spain's Catholic Philip2 tried to bury Elizabeth1, his uppity Anglican kin. For his "Holy" Armada, Phil gouged Iberia's forests and drank the blood of the countless innocents he slaughtered in the mines and foundries, fields and forests… all to build his anointed fleet… which God's own "Protestant Wind" sank in early July. Some 15,000 soldiers and sailors died. Philip *(thankfully)* never recovered.

But Good Queen Bess did, opening England to a glorious Enlightenment that included William Shakespeare… and the American colony at Roanoke, which sank from sight around the same time as the Armada.

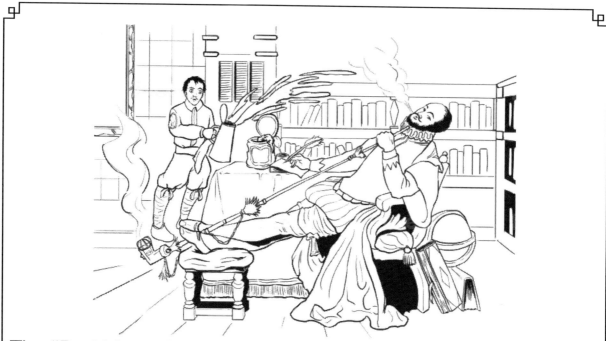

## The "Red Man's Curse"

Tobacco is still considered sacred (in small quantities) by many Indigenous. But the English pirate Sir Walter Raleigh (shown toking above) saw money in it. Elizabeth I (who may have choked on her first puff) chartered Roanoke, which mysteriously disappeared 1585-8. In 1607, Jamestown birthed a global drug trade.

Tobacco's early promoters called it a miracle drug. The Puritans hated the pleasure it gave and (rightfully) branded it the Devil's Weed. King James's "Counterblaste to Tobacco" cited health dangers apparently as an excuse to raise taxes on it.

Labor-intensive tobacco became the portal through which chattel slavery came to America. In 1688 Virginia shipped out some 18 million pounds.

But prices varied and it was hard to grow. Jamestown Governor William Berkeley branded tobacco a "vicious ruinous plant." George Washington and Thomas Jefferson agreed, favoring instead their sturdier, more useful hemp crop (though neither wrote of smoking it).

Deceptively denied by cynical corporations, tobacco's profitable poisons have killed countless millions worldwide. Nicotine, its primary addictive hook, today powers the pesticides destroying the global bee population.

As for the above illustration, legend has it that when Sir Walter first toked up, a frightened servant doused him with water, thus becoming the first anti-smoking activist.

What did NOT disappear was a new-found addiction to tobacco, pursued after 1607 by an unholy cadre of rich white Cavaliers.

Their Jamestown *entrepot* was in a hellish swamp, poisoned by pestilence, war and America's newborn racism.  The Virginia Corporation poured in a steady stream of human filler, meant to grow the hugely profitable Evil Weed.  Half died yearly, until the white population stabilized.  The Indigenous have yet to recover.

By the law of primogeniture, the Cavaliers' paternal estates in southern England went to the first-born boys.  So their younger brothers came here to cash in on "the Curse of the Red Man."

These young Lords afflicted our national DNA with the medieval brutality of their cushy childhoods.  They spawned chattel slavery, American racism, the "three-fifths bonus," the Confederacy, KKK, Jim Crow, "southern strategy," Drug War, Trump's MAGA and an affinity for autocracy that curses us still.

In 1619, Africans deepened our DNA.  The first score were cruelly traded for supplies at Port Comfort, Virginia.  Millions more were soon stripped from ancient civilizations as rich, wise and diverse as any on Earth.  Yet the white *massas* fiercely denied Africa's humanity and ignored its wisdom *(except in early Boston, where the slave Onesimus introduced Cotton Mather to inoculation against smallpox).*

Chained to ship bottoms and whipping posts, these tragic innocents died by the millions.  As the Spaniards torched the Mayan libraries, and the English scorned the gifts of America's Indigenous, New World slave-masters shredded African genius into menial labor.  They stunted our growth and impoverished our souls with cruel contempt for a universe of knowledge in agriculture, medicine, science, law, the arts.

Many Africans dragged to earliest Virginia served out their indenture and gained their freedom.  Some built their own plantations.  Blacks and whites freely associated, worked side-by-side, intermarried, raised rainbow children.

But in 1676, Nathaniel Bacon, a ruthless Cavalier, led black and white workers in a violent uprising aimed at taking Indigenous land.  A thousand multiracial rebels drove royal Governor William Berkeley from Jamestown, then razed it.  They slaughtered peaceful tribes and took their ancestral homes.

Berkeley and Bacon soon died.  So did the rebellion.  But for Virginia's white planters, mixed-race insurrection became the ultimate nightmare.

So they turned the colonial working class against itself.  The terrible tool was chattel slavery.  The legacy was malignant racism.

Economic historians still debate whether the "peculiar institution" was financially superior to indentured servitude.

*But slaveowners had more vicious use for it---to divide and conquer.*

From the late 1600s onward, white *massas* cruelly crushed their black chattel into an "untouchable" sub-human caste. They raped, tortured, beat and sold them at will, branding even their own offspring legally, spiritually, genetically inferior.

The point was to make poor whites---no matter how destitute---think themselves better than any black.  Said Lyndon Johnson three centuries later…

# Early American DNA

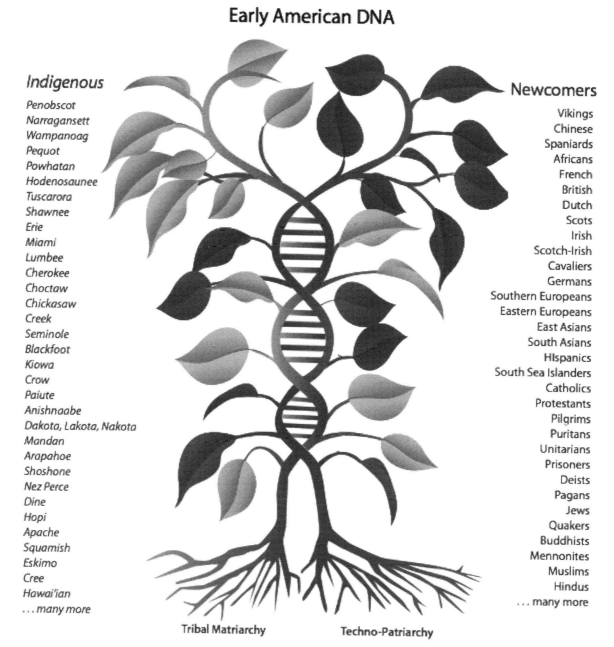

**Indigenous**

Penobscot
Narragansett
Wampanoag
Pequot
Powhatan
Hodenosaunee
Tuscarora
Shawnee
Erie
Miami
Lumbee
Cherokee
Choctaw
Chickasaw
Creek
Seminole
Blackfoot
Kiowa
Crow
Paiute
Anishnaabe
Dakota, Lakota, Nakota
Mandan
Arapahoe
Shoshone
Nez Perce
Dine
Hopi
Apache
Squamish
Eskimo
Cree
Hawai'ian
. . . many more

**Newcomers**

Vikings
Chinese
Spaniards
Africans
French
British
Dutch
Scots
Irish
Scotch-Irish
Cavaliers
Germans
Southern Europeans
Eastern Europeans
East Asians
South Asians
Hispanics
South Sea Islanders
Catholics
Protestants
Pilgrims
Puritans
Unitarians
Prisoners
Deists
Pagans
Jews
Quakers
Buddhists
Mennonites
Muslims
Hindus
. . . many more

**Tribal Matriarchy**    **Techno-Patriarchy**

## Columbian Exchange

Companion planting, crop rotation, controlled burn, sustainable food . . .
Agave, amaranth, avocado, beans, bell pepper, black raspberry, blueberry,
cashew, chicle, chili peppers, cocoa, cotton, cranberries, guava, Jerusalem
artichoke, maize, manioc, papaya, peanut, pecan, pineapple, potato,
pumpkin, quinoa, rubber, squash, strawberry, sweet potato, sunflower,
tomato, wild rice, turkeys, tobacco . . .

Clear cutting, cash farming, monoculture, agribusiness . . .
Wheat, rice, barley, sugar, coffee, dandelions . . .
Cattle, horses, goats, sheep, pigs, donkeys, mules,
honeybees, black rats, cockroaches . . .
Smallpox, typhus, scarlet fever, yellow fever, diphtheria,
influenza, measles, typhoid fever, plague (Black Death) . . .

*...If you can convince the lowest white man he's better than the best colored man, he won't notice you're picking his pocket. Hell, give him somebody to look down on, and he'll empty his pockets for you.*

This hideous strategy shattered the American soul. Chattel slavery's "race bribe" became a deadly obsession, the divide-and-conquer weapon of mass distraction used by corporate elites to rule American politics... right up to the 2016 race-hate campaign that put Donald Trump in the White House...and the one in 2020 that moved him out.

From Cavalier Virginia to Nixon's Drug War, from Bacon's Rebellion to Trump Tower, America's race card has been reliably deployed to divide the working/middle class and poison the body politic. As a weapon of caste warfare, an excuse for conquest, a method of mass manipulation...the illusion of White Supremacy has been America's ultimate birth defect, its most lethal core cancer.

A year after the first Africans arrived in Virginia, the *Mayflower* set sail from Plymouth with 102 whites. They were headed for contract labor in the Virginia Company's tobacco fields. Some were religious refugees. Others were impoverished "strangers" desperate for a new life.

But a "Pilgrim Wind" blew them to Cape Cod. Anchored offshore, 41 men *(no women were allowed to sign)* drew up the *Mayflower Compact*. It was our first *Declaration of Independence*, claiming freedom from corporate overlords.

On the beach, Squanto greeted the Pilgrims in the Queen's English *(he'd been shanghai'd by traders three years earlier and put on display in London).*

The newcomers moved into the homes of Squanto's relations just dead from diseases brought by trappers and traders. Their first "Thanksgiving," celebrated in 1621, was certified as a national holiday by Abe Lincoln just after Gettysburg.

In the 1630s, some 30,000 Visible Saints came to make Boston the dystopian paradise of a hateful God. But they never quite achieved Divine perfection.

Like Satan himself *(and his Awakened kin through all our historic cycles)* Boston's outliers were relentless rebels. Thomas Morton danced around a Maypole with local Indigenous, who were "most full of humanity." Samuel Maverick joyously mocked God's Elect, who locked him up, again and again, to no avail.

Roger Williams preached love and compassion. In 1636---the year they formed Harvard College---the Elect put him out to freeze in the winter woods. But local Narragansetts took the saintly priest to Providence, where Roger built a haven for runaway slaves and endangered Indigenous...not to mention Quakers, Jews, rebellious youth and uppity women. That included Anne Hutchinson, our pioneer white feminist. A highly literate rebel Puritan, her freewheeling salons infuriated the Boston elite.

They expelled her for claiming direct communion with God *(and for knowing Scripture better than they did)*. For the next hundred years, Bay Colony Puritans ran a totalitarian tyranny, hanging witches, deporting dissidents, desperately seeking the "pure" totalitarianism that *(thankfully)* STILL escapes them...but which their MAGA/Bannonite progeny hope to achieve in 2022 and 2024.

23

Down the coast, Manhattan was a rich hunting ground, shared by regional tribes for countless centuries.

In 1624, Dutch traders gifted the locals sixty guilders in junk jewelry. The tribes took it as a gesture of appreciation for letting the newcomers hunt there. But the burghers assumed they'd "bought" the place, which made zero sense to people with no concept of private land. Divided and fenced, the game moved on.

Soon a bustling hub of trade and commerce, the Duke of York---later James2---claimed New Amsterdam in 1664 without firing a shot. Unlike Boston, New York had no dress code or sex police. A free-wheeling haven for sailors and merchants, printers and populists, dissidents and democrats, it became *(and still is!)* the ultimate port town. Three centuries later, Mohawk skywalkers danced atop its tallest towers.

To the southwest, the Scotch-Irish poured into the Alleghenies. Many fled England's awful Puritan dictator Oliver Cromwell, who conquered Scotland and Ireland by provoking a ghastly civil war that ended only when an army of great women, with Bill Clinton in tow, charmed them down.

These tough, resourceful "hillbilly" highlanders married into the Cherokee nation, loved their freedom, hated the British. Their frontier farms formed the mountainous backbone of our yeoman culture and a fiery mass of our upcoming Revolution.

At the colonies' heart was the City of Brotherly Love. Its Quaker founders preached equality and justice, civility and peace. Their Society of Friends was born in defiance of Cromwell's Puritans, who jailed them without mercy.

The Quakers' charismatic godfather, George Fox, preached peaceful---but relentless--- resistance. His "Inner Light" embraced all humans, black and white, male and female, rich and poor, prince and pauper. The American Friends planted Europe's early social-democrat roots, which flowed into our DNA through Thomas Paine *(a Quaker's son)* and his mentor, Ben Franklin, our transcendent genius.

Unique in all the world, Philadelphia was a haven for dissidents and dreamers, rebels and utopians. The Quakers were austere and prosperous, open and loving. They sat silent in their meeting houses until "the spirit moved them." They lived simply, worked hard, made honest money, honored the Indigenous and resisted slavery, racism, greed, misogyny, excess. They embedded in our DNA an indelible love for harmony, social justice, and human dignity drawn straight from the *Sermon on the Mount*. Their pushy pacifism *still* questions the limits of our American soul.

Quaker New Jersey gave women (until 1808) their first right to vote. Maryland bounced between the Churches of Rome and England, but at last embraced toleration.

Georgia was born as a Utopian colony, embracing some 60,000 prisoners. Instead, the evil weed of chattel slavery took root there...as it did in Virginia, Maryland, Delaware, the Carolinas and wherever else cotton and tobacco were grown.

The Florida/Carolina coast also hosted a pirate culture whose 1650-1718 "Golden Age" extended throughout the Caribbean. Some 10,000 pirate/privateers---likely a third of them black---raided imperial shipping from renegade boats often run as democracies. For decades they ran Nassau like a rogue egalitarian republic.

Legendary buccaneers like Sam "Robin Hood" Bellamy saw themselves as class warriors. They liberated countless Africans from hellish slave ships, often integrating them as equals into their own crews. Though rife with much the same racism, misogyny and greed as the "civilized" empires they pillaged, the pirate culture made legends of the likes of Anne Bonny and "Black Cesar" long prior to America's abolitionist/feminist movements.

Into this astounding mosaic of Infant America's countless clans and confederacies, tribes and nations, poured a new tsunami of transcendent diversity, first from Europe and Africa, then Asia, Latin America, the islands of the Caribbean and South Seas.

From moderate Plymouth and the rock-ribbed New England hill country, to totalitarian Boston, benign Providence, raucous New York, the remote Scotch-Irish hill country, peace-loving Quaker Philadelphia, moderate New Jersey, diverse Maryland, the slave-owning south...British North America in the 1600s was a human hodgepodge unlike any other.

It was anything but unified. Near century's end, five pesky Quakers invaded Boston (hippie-style) to protest its Puritan pathology. Marching through town stark naked on the Sabbath, they lit up a collective freak-out... and were quickly hanged.

News of their death was not well received. But the colonies had little to do with each other beyond trade and gossip. Overall, the new Americans saw themselves as loyal Brits living in distinct, diverse communities under imperial rule.

For Cromwell and the Kings, America's only purpose was to enrich England, whose Trumpist colonial governors were mostly vile, violent, corrupt and stupid.

In 1688, James2 repeated Philip2's fatal error of exactly a century before...he tried to make England Catholic again.

Elizabeth's Anglican progeny would have none of it. Scottish rebels swarmed down from the Highlands for James's daughter Mary and her liberal lover, William of Orange. These "Hill Billies" helped win a nonviolent Glorious Revolution that came with a Bill of Rights, a Toleration Act, an empowered Parliament.

In America we colonists happily dumped James's lackeys. Boston locked up Edmund Andros, its insufferable royal governor.

But disguised as a woman, Andros escaped. He thus birthed an epic chorus of celebrity crossdressers, including Confederate President Jefferson Davis, FBI Director J. Edgar Hoover, New York Mayor Rudy Giuliani.

From Maine to Georgia, the uprising's diverse frontier fire engulfed our Indigenous, Puritans, Pilgrims, Quakers, Anglicans, Catholics, Jews, Deists, Unitarians, English, Dutch, Scots, Irish, Africans, Cavaliers, Hispanics, Asians, prisoners, agnostics, atheists, hillbillies, wealthy widows, urban merchants, yeoman farmers, city workers, Jack Tar sailors, pillaging pirates, poor whites, drifters, grifters, levelers, dissidents, diggers and other unruly human upstarts who surged into the glorious gumbo soon to become the United States of America.

In 1689, Good King Billy ordered Puritan Boston to stop hanging Quakers, even those who Questioned Authority.

Our electric embryo danced at the edge of Indigenous freedom. Our Awakened DNA was primed to twirl an unsuspecting world upside down.

25

# SPRINGTIME
## The First Great Awakening

*Something drove Salem mad.  Maybe it was ergot, a brain-bending fungus.*

*Ergot* grows on damp, badly stored grain.  Some say it shattered the Puritan mystique.  Maybe---like later *cannabis*, *psilocybin* and LSD--- it *woke* the new American mind to democracy and freedom.

The Glorious Revolution had already destabilized colonial authority.  In reaction there came a violent evangelical greed we would see again…and again…and yet again.

In 1692-3, a gaggle of Salem's adolescents went hysterical.  The "witches" they accused were often women of means.  The sheriff gladly grabbed their property.  *Somehow* the "afflicted" girls' families wound up with much of the accurseds' land.

A score of innocents were duly hanged.  Cheering crowds embraced the ritual slaughter like a medieval Super Bowl.  They crushed to death a defiant Giles Corey, whose last "f-you" demand was for "more weight."

In angry outrage, secular colonials slashed the Puritan death grip.  Church/state separation, the right to a lawyer, no self-incrimination, credible evidence…all flowed through Salem's madness into America's ultimate legacy…our sacred Bill of Rights .

In the 1730s and '40s, a more benign spirituality exploded across the land.  Jonathan Edwards lit the fuse.

He didn't mean to.

Edwards was a youthful spellbinder in the western Massachusetts river town of Northampton (which much later became a citadel of women's rights).  He somehow mashed up Calvinist hellfire-and-damnation with a frontier love of nature.  The contradictions were impossible.  They shattered his parish and shook our first cycle of spiritual transcendence to its Indigenous roots.

Young Jonathan began by terrorizing his flock.  They were all, he warned, "sinners in the hands of an Angry God…

> *…The God that holds you over the Pit of Hell, much as one holds a Spider, or some loathsome Insect, over the Fire, abhors you, and is dreadfully provoked; his Wrath towards you burns like Fire; he looks upon you as worthy of nothing else, but to be cast into the Fire; he is of purer Eyes than to bear to have you in his Sight; you are ten thousand Times so abominable in his Eyes as the most hateful venomous Serpent is in ours. You have offended him infinitely more than ever a stubborn Rebel did his Prince: and yet 'tis nothing but his Hand that holds you from falling into the Fire every Moment.*

Aflame with such rants, terrified congregants begged for salvation.  Edwards tortured them for hours, dragging them through Hell, demanding obedience while they writhed in agony.

26

But Jonathan was young and passionate. In a heartbeat he could whiplash his terrified sheep from their hellish purgatory to ecstatic transcendence.

They once were lost, but now were found...

*...And now you have an extraordinary Opportunity, a Day wherein Christ has flung the Door of Mercy wide open, and stands in the Door calling and crying with a loud Voice to poor Sinners; a Day wherein many are flocking to him, and pressing into the Kingdom of God; many are daily coming from the East, West, North and South; many that were very lately in the same miserable Condition that you are in, are in now an happy State, with their Hearts filled with Love to Him that has loved them and washed them for their Sins in his own Blood.*

From there Edwards somehow leapt into the glorious bosom of a loving Mother. Born to a Puritan cult that saw the Earth as Satan's playground, he soared to a "new birth" like a stoned tree-hugging hippie, tripping his brains out on Indigenous rapture...

*...I walked abroad alone, in a solitary place in my father's pasture, for contemplation...And as I was walking there, and looking up on the sky and the clouds, there came into my mind so sweet a sense of the glorious majesty and grace of God that I know not how to express. I seemed to see them both in a sweet conjunction: majesty and meekness joined together; it was a sweet, and gentle, and holy majesty... God's excellency, his wisdom, his purity and love, seemed to appear in every thing; in the sun, moon and stars; in the clouds and blue sky; in the grass, flowers, trees; in the water, and all nature.*

With his right brain in Hell and his left in paradise *(like some psychedelic prophet on scriptural fungi)* young Jonathan flipped his flock to white America's second wave of stoned-out madness...this time ecstatic.

Via *ergot* or otherwise, astonished Northampton in 1735-36 danced into a primeval group hug, a nine-month "Summer of Love." Feuds were settled, debts forgiven, insults forgotten, laughter indulged, carnal knowledge shockingly embraced.

Tales of raucous music, group euphoria, and sexual daring filled the air. The pews filled with the "conversion of many souls."

Then they emptied. Souls on fire flocked to outdoor revivals to find the Rapture with head-busting Holy Rollers a universe beyond those boring Old Line Calvinists. In the shadow of these frontier Woodstocks, the entrenched Elect quaked with horror.

Blacks and women freely preached, as did radicals like James Davenport and Karl Tennant. African rhythms transformed quiet hymnals into spiritual uproars that eventually evolved into gospel, jazz, swing, bebop, R&B, rock & roll, disco(!), rap, hip hop, grunge.

Ben Franklin's pal George Whitefield, a cross-eyed English spellbinder, boomed out a voice audible to 10,000 seekers long before the age of electric amps.

# *A Newspaper (and a Great Woman) Change Everything*

*The New-York Weekly Journal was published by John Peter Zenger, a German immigrant who barely spoke English. In the summer of 1735 (as the Great Awakening raged) Zenger ran an anonymous screed ridiculing royal Governor William Cosby, who threw him in jail.*

*Cosby expected to fill the jury box with his cronies. But Zenger's wife Anna kept the paper going, and summoned a mob. The judge allowed their actual peers to decide the case.*

*Sensing history, the young printer Ben Franklin rushed up from Philadelphia with the legendary lawyer Andrew Hamilton (no relation to Alex). Accepting Truth as protected speech, the grassroots jury immediately acquitted Zenger and spliced press freedom into our DNA.*

*Later British courts did not agree. But the Zenger verdict became the birth certificate of our "fourth branch of government"… and of the ability of a powerful woman to change history.*

Numb. XLVII.

THE

New - York Weekly JOURNAL.

*Containing the freſheſt Advices, Foreign, and Domeſtick.*

MUNDAT September 23d, 1734.

Phyllis Wheatley, our first published black poet *(and an Awakened power in her own right)* wrote this of Whitefield and his transcendent rants ...

*Thy sermons in unequall'd accents flow'd,*
*And ev'ry bosom with devotion glow'd;*
*Thou didst in strains of eloquence refin'd*
*Inflame the heart, and captivate the mind.*

Evangelizing Methodists and Baptists, Presbyterians and pagans conjured up a cycle of passion that would fiercely pulsate through the spiral of our history.

The Great Awakening's grassroots spirituality pulverized the Puritans' rump rigidity. It blew open the arteries of social democracy. Its joyous release smashed the stale death grip of Puritan "exceptionalism."

Again...again...and yet again this liberational song would explode *(with ascending force)* up the axis of our history, powering a spiral, landing in the early 21st century amidst a youthful Millenial/Zoomer half of the nation, desperate for liberation.

Freedom of the press was at its apex. As the Great Awakening shredded Northampton, New York's awful royal governor William Cosby jailed John Peter Zenger *(a German immigrant)* for printing pamphlets Cosby hated.

But Zenger's wife Anna kept them coming. An aroused mob surrounded the courthouse. On August 5, 1735 *(after just ten minutes' deliberation)* Zenger's peers set him free, enshrining Truth as protected speech. Freedom of the press was embedded in our national DNA...along with a woman's power to win a social movement.

In each cycle of our ensuing history, an Awakened spring shattered a stale winter of Puritan paralysis. New England's Transcendentalists (1830s-50s), farm-labor Populist-Socialist-Bohemian radicals (1870s-1910s), grassroots / New Deal social democrats (1930s), New Left black power / feminist / LGBTQ / antiwar / yippie / green activists (1960s), Solartopian ecologists (1970s), #MeToo / #BlackLivesMatter / Bernie-AOC / Green New Deal activists...all built on the best of the cycles before.

Social justice, racial equality, feminist ascendance, sexual freedom, psychedelic exploration, populist passion, digital utopianism, artistic liberation...new art, thought, writing, speech, song, dance, sex...all fed the lifeblood of our Indigenous spirituality, our relentless, pulsating demand for egalitarian justice and holistic transcendence... powering the leaps of our human evolution.

Meantime...in the 1770s...sparked by the Calvinist rantings of an accidental instigator---sustained by the power of a feminist media maven---this first Great Awakening aimed us like a flaming arrow at our imperial overlords.

29

# SUMMER
## *Revolution*

*In 1776, it became our exceptional fate to show humankind that the universal curse of Empire (including our own) must eventually decompose.*

At birth we were a perfect storm.

Indigenous freedom and Puritan ferocity were both embedded in our national embryo. We were literate, armed, organized, obstinate, and gloriously endowed with a visceral vision of inalienable rights.

Our grassroots muscle---using Indigenous guerrilla tactics---came from a fierce farm community rooted in the generous soil of an unspoiled continent. It fought in league with an urban working class done with being robbed by pompous imperial jerks.

We came with four "Visible Saints" bearing much of our genius and many of our contradictions: Ben Franklin, Tom Paine, George Washington, Thomas Jefferson.

Their brilliant inner orbit was lit by the likes of Abigail, John and Samuel Adams, Alexander Hamilton, James Madison, Patrick Henry, Ethan Allen. They rode a grassroots wave of angry artisans and agrarians willing to fight and die for land, freedom, democracy, independence....REVOLUTION!

Indigenous harmony, abolition of slavery, women's rights, universal suffrage, social democracy, economic justice, cultural tolerance, ecological sanity...all these would take more time *(more tearful peeling of the onion of our oppressions)*.

But in 1776, we took an epic leap...away from monarchy and titled aristocracy... to the promise of freedom recently discovered amongst the Indigenous.

Amidst our birthing process, the *Mahatma* of the moment was Ben Franklin--- master of the middle path---utterly unique in all of human history.

The Great Sorcerer and his peerless apprentice *(Tom Paine)* were our transcendent secular humanists. In an Age of Reason their enlightened minds and compassionate souls helped turn the world upside down.

Born in Boston, 1706, Ben was the 16th of his Puritan father's 17 children. As an ambitious teenager, Ben sought out Boston's leading Puritan---Cotton Mather---who told him to "stoop" with humility. With virtually no formal education, this transcendent enigma became our greatest civic and scientific genius.

The endlessly curious Franklin discovered, codified, quantified, organized, and made useful our initial understanding of electricity. The term "battery" is his. So is the lightning rod which he refused to patent. He had all the money he needed, he said, and gifted this essential utility as a free service to humankind.

Having lost a young son to smallpox, Ben advocated for the early science of inoculation. He invented bifocals, swim fins, wind surfing, an odometer, and *(thank God!)* a flexible urinary catheter. He created the glass armonica, for which both Mozart and Beethoven composed original music.

Ben did NOT patent his eco-green Franklin Stove, which moved centuries of wasteful flames from open fireplaces into efficient metal boxes, conserving countless

forests while saving homes and lungs from cancerous ash.  Like today's photovoltaic cells and LED lighting (see our *Solartopian* finale) Ben's hot boxes fused untamed fire into sustainable technology.

Sailing home from London in 1774, Ben became the first to chart the Atlantic Gulf Stream.  His oceanographic readings still benchmark our climate crisis.

In 1777, Congress sent our #1 celebrity off to seduce France.  When the coonskin cap he wore became a (*zut alors!*) fashion statement, he ordered a shipload, scoring yet another small fortune.

Ben's rock star visage graced dinnerware all over the continent.

He also pioneered the lending library, fire department, and public sanitation service, which cleansed Philadelphia's toxic streets.  The mail service he ran – a precursor to the internet – linked up the new nation.

The new arts of political cartooning and media syndication helped make him rich.  At 42, Ben devoted himself to public service, maintaining (*unlike Jefferson*) a lifetime of level-headed solvency.

Franklin revered Indigenous wisdom.  When he convened a 1754 conference in Albany to plan a colonial union, he chose a *Haudenosaunee* chief to preside.  He embedded the *Great Law's* structural template into our federal Constitution.

Above all, the Elder Savant of this newborn nation endowed our core DNA with a love of reason, moderation, humor, humility...*and women!*

Like virtually all our principle Founders, Ben was very explicitly NOT a Christian.  His Deism embraced a divine Creator who fired up the universe, gave humankind the power of reason...then left.  No angry God judged our lives.  No eternal Hell threatened our sanity.  Neither Jesus nor the eucharist appear in our federal Constitution.  None of our most influential Founders deemed this a "Christian nation."

Like most whites at the time, the young Franklin first believed that people of color were inherently inferior.  He owned two slaves.

But at a multi-racial (*probably Quaker*) school, he SAW the black kids learning just as well as the whites.  He freed his own slaves and became an ardent abolitionist.  His last essay---in 1790---mocked our nation's Covenant with Hell.

Ben's "adopted son," Thomas Paine, was the 18th Century's best-selling author.  Born to a British Quaker, Tom's riveting *Common Sense* demanded independence, social justice, an end to monarchy.  It was read, sung, heard and praised by virtually all Americans.  It lit our Revolutionary fuse.  No other agitator's screed has ever had a bigger impact.

Paine and Franklin were early social democrats.  They hated chattel slavery... and what comes when greedy elites hold more property than they need.

Paine mocked the death penalty and war as immoral tools of a callous ruling caste.  He demanded the vote for all regardless of race, gender or class.  He urged on free public education, a guaranteed minimum income, support for our elders (*like the Social Security System won by a later Franklin*).

Such radicalism (*born of English Diggers and Levellers as well as the Indigenous*) inspired relentless, evolving pulsations of Awakened Americans demanding freedom,

justice, bread, land. They hated the King's obscene wealth, his smug imperial over-lords, his corrupt East India Tea Company, his greedy Tory landowners.

George2 was a madman who ran naked through the streets of London breaking windows. George3 barely spoke til age 11.

In 1763, the Brits beat the French in America and India. Until Gandhi turned out the lights, the sun didn't set on their global empire for nearly two centuries.

But the King didn't want his imperial troops back in London. And he was too cheap to build barracks for them here. So he demanded we feed and house them while they took our jobs and hit on our daughters. We kicked in the womb.

In Boston, March, 1770, we broke water by flinging ice balls at the remnant Redcoats. They shot five of us dead. Crispus Attucks *(a black man)* died first.

In 1773, our Supreme Agitator used that Massacre to rouse the rabble for an anti-corporate assault. Dressed as Mohawks, Sam Adams and his Sons of Liberty pitched the East India Company's tea into Boston Harbor....

*...Rally Mohawks, and bring your axes*
*And tell King George we'll pay no taxes...*

Nobody got hurt. Quaker-style, the rebels replaced a busted captain's lock the next day. But the King's tea drowned without pay.

The colonists had pricked a global beast far more powerful than the Crown. The East India Company towered over civil government. Pre-cursor to the trans-nationals soon to dominate *(and decimate)* the Earth, its Calvinist corporate personhood meant to crush anything that resembled democracy, all the way to *Citizen's United* and beyond. Said Baron Thurlow in the late 1700s...

*...Corporations have neither bodies to be punished, nor souls to be condemned*
*They therefore do as they like.*

Then the Brits made Franklin a revolutionary.

Ben was in London on business. He supported the King and had nothing to do with the Tea Party. But in January 1774, some pompous Lords, the scum of England's idle rich, summoned him for public abuse.

Through two hours of rich guy trash talk at a Parliamentary "hearing," Franklin stood perfectly silent. Then he sailed home *(charting the Gulf Stream along the way)* and hurled his exceptional genius into an Earth-shattering overthrow.

In April 1775, seven hundred Redcoats marched to Concord, meaning to hang Sam Adams and John Hancock, our best agitator and richest smuggler. Instead they killed eight farmers. It was the Imperial thing to do.

But these were the "shots heard 'round the world." And the Brits still had to get back to Boston.

From dozens of nearby farms, we swarmed through the forests, Indigenous-style. We picked them off from behind rocks and trees *(slipped away)* then did it again...and yet again.

Some 250 Redcoats fell.  It was white America's first anti-Imperial guerrilla bloodbath.  Its spontaneous genius fed a mighty stream that led straight to Vietnam, whose stealth fighters decimated our own imperial army two centuries later.

Soon after Concord, George Washington took charge.  He was a lousy field tactician.  During the French-Indian War, the Indigenous repeatedly shot him up.  But somehow he survived…and then turned their tactics on the British.

The Iroquois called Washington—like his great-grandfather---*Conotocarious*, Destroyer of Towns.  "When that name is heard," said the Seneca, "our women look behind them and turn pale, and our children cling close to the neck of their mothers."

In 1779, an expedition under his command destroyed 40 villages, burning homes and crops so the Iroquois would starve in winter.  Troops sliced dead Indigenous flesh into leggings.

But Washington later complained that breaking treaties with the tribes—as we did at least 400 times---would sully our nation's "honor."

A youthful fever may have rendered the Father of Our Country biologically sterile. It pocked his face and inspired him to quarantine and vaccinate our army, which may have saved the Revolution. He had lousy teeth but great hair, and never wore a wig.

America's leading beer brewer named his dogs *Tipsy* and *Drunkard*. Master of the barnyard curse, George famously left Sunday services early *(as only he could've done)*.  His Bible came with a flask.

The man who "could not tell a lie" dizzied the Brits with fake intelligence and every untruth he could conjure. Having survived smallpox, he inoculated our troops, mostly protecting them while the un-vaxxed Redcoats died in droves.  His guerrilla attack on Trenton changed everything.

To train our ragtag army, Washington recruited the Prussian Baron von Steuben, who was about as openly gay as one could be back then.  At Valley Forge, George's *aide-de-camp*, Alexander Hamilton, may have lived in intimate bliss with John Laurens *(that one's still in hot dispute)*.  George later assured a Rhode Island Jewish community that its place was secure in a new republic that had no official religion.

When his "winter soldiers" were in despair, our richest slaveowner had our most radical scribe *(Paine)* evoke the "times that try men's souls."

About a fifth of them may have been African-American.  Britain's Lord Dunsmore offered colonial slaves their freedom in exchange for military service.

Like Lincoln in the Civil War, Washington quickly realized he could not win without black soldiers.  They stayed in uniform longer than whites, and may have contributed a quarter of the Revolutionary army's overall service time.  An all-black regiment arose from Rhode Island.

Amidst the chaos, as many as 50,000 slaves went free, as did twenty of Washington's *(including Hercules, his very large personal body guard)*.  Pending Martha's death, his final will freed the rest…but only one may have actually gone free. Earlier on he needlessly kept tabs on the runaway Oney Judge in New Hampshire.

He loved to drink but hated to be touched.  He split with Paine, but kept Tom's belief that…

# TOM JEFFERSON'S MORTAL JESUS

At the peak of his genius, Thomas Jefferson produced a radical New Testament that ran across the pages in Greek, Latin, English and French.

Like millions of ensuing Americans, Tom admired the historic Jesus as a transcendent humanist, peace activist and social justice crusader...but NOT as the Son of any God, real or imagined.

In his 1820 Life and Morals of Jesus of Nazareth, Tom lauded Yeshua's courage, compassion and commitment, denouncing the empire that so cruelly crucified him. But Jefferson excised references to the Jewish martyr as Divine, dismissing Original Sin, the Virgin Birth, the Trinity and Resurrection, while characterizing the Book of Revelations as the rantings of a madman.

Like Washington, Franklin, Paine and their fellow Founders, Jefferson made it clear the United States was NOT a Christian nation. The absence of an established religion was enshrined by his pal Madison in the very first phrase of the First Amendment, and in Tom's own "separation of church and state."

But throughout the spiral of our history, social activists have drawn on the Sermon on the Mount to join with other non-violent teachings in promoting universal values of peace, justice, empathy, compassion and loving sacrifice for the greater good.

Quaker, Catholic Worker, Protestant Pacifist, Jews and Buddhists, Muslims and Hindus, pagans and protestors... religious and secular activists alike have joined Jesus's teachings with other pleas for spiritual harmony in their communal, egalitarian crusades.

Social democrats like Ralph Emerson, Gene Debs, Alice Paul, Dorothy Day, Martin Luther King, the Berrigan Brothers and Code Pink have powerfully preached the "love thy neighbor" paradigm of the greater good.

Their "Social Gospel" has been geared to resist the Baronial money-changers' "Gospel of Wealth." Self-proclaimed "Christian Socialists" like Debs and Norman Thomas (an ordained Presbyterian minister) have fought to anoint America's mass labor movements. The Civil Rights movement has been deeply rooted in the black church. Pope John23 helped inspire the anti-war / human rights campaigns of the 1960s and beyond. Francis joined the crusades to save the planet.

Overall the Jeffersonian view of Jesus' preaching has lent a "Christian" confirmation of American social activism for nigh on two centuries.

In the new millennium, Trumpist "Christian Identity" televangelism became a very different being.

34

**REWARD**

FOR INFORMATION LEADING TO THE APPREHENSION OF —

## JESUS CHRIST

WANTED — FOR SEDITION, CRIMINAL ANARCHY-VAGRANCY, AND CONSPIRING TO OVERTHROW THE ESTABLISHED GOVERNMENT

DRESSES POORLY. SAID TO BE A CARPENTER BY TRADE, ILL-NOURISHED, HAS VISIONARY IDEAS, ASSOCIATES WITH COMMON WORKING PEOPLE THE UNEMPLOYED AND BUMS. ALIEN — BELEIVED TO BE A JEW ALIAS: 'PRINCE OF PEACE, SON OF MAN'–'LIGHT OF THE WORLD' &c &c PROFESSIONAL AGITATOR RED BEARD, MARKS ON HANDS AND FEET THE RESULT OF INJURIES INFLICTED BY AN ANGRY MOB LED BY RESPECTABLE CITIZENS AND LEGAL AUTHORITIES.

*Art Young's 1917 radical rendition of the "Rebel of Nazareth" ran in The Masses at the peak of our Bohemian Spring. Forever embraced as a non-violent comrade in the transcendent struggle for peace and justice, Yeshua/Jesus is somehow evoked by mass movements awash in violence, bigotry and greed.*

*We await his return for a fuller explanation.*

*...The great mass of our Citizens require only to understand matters right-ly, to form right decisions.*

While Washington led our infant army, America's actual birth certificate was drafted by our most infuriating Visible Saint.

Tom Jefferson proclaimed "all men are created equal." But as for "ladies," their "tender breasts...were not formed for political convulsion."

Tom's first draft of the Declaration featured a rant against slavery, which Congress deleted. But he still bought and sold slaves throughout his life. In all, he freed just a tiny handful. Two were his biological children.

Jefferson sang of "life, liberty and the pursuit of happiness." He praised the Common Man. He lauded ceaseless Revolution. But he scorned the natural rights of women, blacks and the Indigenous. He feared urban "mobs and masses."

And he ran our first imperial presidency.

Tom had the male lead in our defining drama of gender, race and servitude.

It starts with a stolen African woman (probably named *Parthena*) who was raped by John Hemings, captain of the slave ship that brought her to Virginia. Their daughter, Betty Hemings, was bought by John Wayles, who sired her six mixed-race children.

The last, named "Sally Hemings," was born in 1773, just after her father's white daughter Martha married Thomas Jefferson, a neighboring slave owner. Those white Jeffersons had two girls and a boy. But Martha died in 1782.

Soon thereafter, the forty-something Tom became our second Ambassador to France, relieving Ben Franklin. Sally served there as his teenaged house slave.

After her return (*pregnant*) to Monticello, Sally and Tom likely shared a room near his study. Conflicting reports of a firstborn son sent to live on a nearby plantation are unsupported by later DNA tests...which *do* confirm the lineage of three other sons and a daughter.

Tom and Sally's imperfect union lasted until he passed on July 4, 1826. He never brought her to DC. Nor did he admit to their bond. But no other First Couple has birthed three children while in office.

At the request of Dolley, later our fourth First Lady, Sally named one of her sons for James Madison, Tom's closest friend. In 1918, a Jefferson-Hemings descendent, Frederick Madison Roberts (*a Los Angeles Republican*) became the first African-American elected to the California Assembly, where he befriended Earl Warren, later Chief Justice of the US Supreme Court.

Tom and Martha's white daughters, Patsy and Polly, birthed thirteen children between them. For two tense centuries, their progeny denied any kinship to Sally's. But DNA tests later inspired a tearful embrace on *(of course!)* the Oprah Winfrey Show.

*Sally's descendants now want her **rightfully** recognized as our third First Lady.*

In Paris, where Tom and Sally's sexual union first formed, Ben Franklin had al-ready seduced King Louis XVI. The French hated the British. Our slyest fox turned that rivalry into the troops and ships that helped get us free.

Only Franklin could've convinced an absolute monarch to help arm a revolutionary mob that hated absolute monarchs. It cost Louis a trip to the guillotine.

But before the beheading, the French King gave Ben a bejeweled snuff box. Congress---which refused to pay Ben's expenses---banned such gifts with an "emoluments clause" meant to keep our government from being bought by foreign powers. It worked pretty well until the coming of Donald Trump.

In 1781, the French fleet Franklin finagled turned the tide at Yorktown. Ignoring the local tribes, the Brits ceded us the continent all the way to the Mississippi. When he inked the deal, Ben donned the same suit he'd worn when those pompous lords made him a Revolutionary back in 1774. He hoped that the truce between the new nation and the old…

> …*will be lasting, and that Mankind will at length, as they call themselves reasonable Creatures, have Reason and Sense enough to settle their Differences without cutting Throats; for, in my opinion, there was never a good War, or a bad Peace.*

Meanwhile, Washington gave up power.

He'd kept our ragtag regulars and agrarian guerrillas fighting the Brits for seven impossible years. Twice he might have made himself dictator. Instead, he quit the army in 1783, then the presidency in 1797. Until January 6, 2021, no outgoing US president challenged the peaceful transition of American executive power.

George loved to farm, especially his beloved hemp. Unlike so many other revolutionary leaders who became awful dictators, Washington plowed under the idea that our newborn nation needed *(or would stand for)* an absolute ruler.

Today we deify the Indigenous-killing, slave-owning, gay-friendly, biologically barren "Father of our Country" for his martial stamina…and for his religious tolerance, tactical daring, and monumental walks away from power.

He denounced monarchy, hated a titled aristocracy and urged respect for treaties signed with the indigenous.

But he deemed the new nation an "Empire for Liberty" that would engulf the planet and lay waste to countless native peoples.

We love Tom Jefferson's magic pen that sang of all men being "created equal." But we cringe over the women he dissed, the slaves he didn't free, the Indigenous he would ethnic cleanse, the global empire he helped deliver.

Ben Franklin, our greatest genius, owned slaves …then freed them, and became our most influential early abolitionist….

…And so it goes. Our Revolution and its wholly human heroes enshrine our evolution even as they embody our epic contradictions.

*So let's just stop erecting monuments to mere mortals (filling the spaces instead with works of great art) while stamping the ones we keep "Nobody's Perfect" or "Judge Not Lest Ye Be Judged".*

Using Indigenous tactics, we beat Earth's most powerful empire. Rooted in Athens, Rome, England and the *Great Law,* our Articles of Confederation (1783-89) al-

lowed no official religion, no king, no titled aristocrats, no president, no taxes, no spies, no unified currency, no standing army...and no practical means to amend.

Neither the name *Jesus* nor the word *Christian* appears in the Declaration or Constitution (also missing is *corporation*, our dominant institution).

Franklin, Paine, the Adamses, Jefferson, Madison, Monroe, Ethan Allen and the Revolutionary urban/frontier working/middle class were mostly Deists, Unitarians, atheists and agnostics. Their Earth-shattering Revolution birthed a democratic republic with no official religion...but failed to transcend slavery, racism, injustice, intolerance, greed...contempt for women, gays and nature...or an "exceptional" addiction to conquest and empire.

In fact, the rich white men who wrote the Constitution made big money on it. Dedicated to "the general welfare," its magnificent Bill of Rights---which came later---is too often ignored. We were, warned Franklin, "a Republic, if you can keep it."

As that republic became history's #1 empire, says Roxanne Dunbar-Ortiz...

*...the United States has been at war every day since its founding, often covertly and often in several parts of the world at once.*

So we're still that imperfect onion. Our epic unpeeling makes us laugh and cry even as we dance our way up the evolutionary fire pole.

Back then, our Revolution was young, our spirit proud, and our spiral just uncoiling. Our Founders assumed we had a universe of time and space to work through our contradictions and find our destiny, which seemed manifest.

*HAH!!*

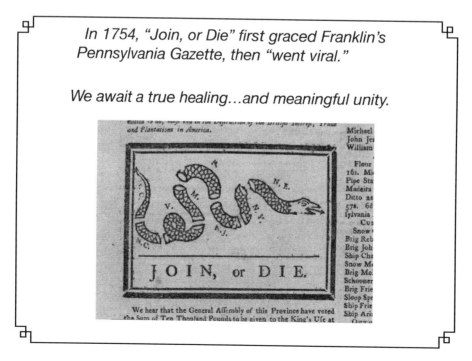

*In 1754, "Join, or Die" first graced Franklin's Pennsylvania Gazette, then "went viral."*

*We await a true healing...and meaningful unity.*

# FALL
## *The Constitution/Federalism*

*Summer passions do spend themselves.*
*Our first Revolution was born of hope and promise.*
*But the brilliant summer of our newborn ideals quickly fell to an autumn chill.*

The grassroots farmers and urban workers who beat the British demanded freedom…and social democracy.  They took rich Tories' land for the communal good. They dumped Earth's most powerful king.  They wanted no return to tyranny, even at the hands of fellow Americans.

Our Articles of Confederation were deliberately weak. The states ran the show. The towns and counties kept their militias.  The farmers kept their distance.

But amending the Articles required a unanimous vote of all the states.  The structure was too rigid to adapt to changing times.

On the home front, vulture bankers and thieving tax collectors swooped down on our winter soldiers.  As in all wars, our fighters were heroes as they fought and died. With victory, they got their parades and accolades.

And then they were patronized and pitied, abused and abandoned.

Many Revolutionary heroes were never paid.  Their wounds *(physical, financial, mental, spiritual)* were ignored. Frontier Minutemen and their Continental cohorts lost their farms.  "Plough Jogger" spoke through the ages …

*…I have been greatly abused, have been obliged to do more than my part*
*in the war, been loaded with class rates, town rates, province rates, Conti-*
*nental rates and all rates … been pulled and hauled by sheriffs, constables*
*and collectors, and had my cattle sold for less than they were worth …*
*The great men are going to get all we have and I think it is time for us to*
*rise and put a stop to it, and have no more courts, nor sheriffs, nor collec-*
*tors nor lawyers.*

In January, 1787, Daniel Shays, a former Continental Captain, rallied a yeoman brigade.  With twigs of hemlock stuck in their hats, some 1500 armed "regulators" *(like their 1930s Great Plains counterparts)* swarmed through the hills, fields and forests of western Massachusetts.  As would John Brown 72 years later, they marched on an armory (this one at Springfield) to get guns.

Sam Adams – once our supreme agitator, now a corrupt servant of urban money – screamed for blood.  Under General Benjamin Lincoln, Boston's armed rich *(including a swarm of Harvard students)* fired into the farmers' ranks.  Four died.  A score were wounded.  The rebels regrouped but were too weak.  Shays fled to Vermont, which was still a Democratic Republic.

The new American elite took Shays's Rebellion as a wake-up call. They demanded a strong central government, an un-civil fortress against the grassroots grunts who'd actually won the Revolution.

From May 25 to September 17, 1787, up to fifty-five bankers, lawyers, merchants, plantation owners, military men, legislators, business Barons *(and one genius media maven)* convened in Philadelphia. Their spacious high-ceilinged chamber had large windows. At the doors were armed guards. Where they once approved the Declaration of Independence, now they devised a reactionary ruling structure.

Invited were no Indigenous, no yeoman farmers, no women, no people of color *(except, perhaps, Hamilton),* no sailors, no rank-and-file soldiers, no urban workers, no artisans, no unpropertied private citizens.

There was no official transcript. Festooned in full uniform, Washington presided in the chieftain's chair for four months and said...*nothing.*

Then 39 wealthy white men signed the document that chilled the hot passions of anti-authoritarian revolution into the cold realities of an oligarchic central government with a manifest imperial destiny.

The new Constitution rid our soil of royal families and titled aristocracy. That much was a major evolutionary leap beyond our European DNA.

But as the great Howard Zinn later emphasized, the Declaration's guarantee of "life, liberty and the pursuit of happiness" had morphed to "life, liberty and property."

The new US Constitution was now thrice-removed from our original code of laws. Indigenous North America had sustained a transcendent web of tribal societies over many millennia, maintained through a highly evolved oral tradition.

The British (plus Spain and France) then imposed their imperial codes. In turn the Revolution embraced the Articles of Confederation.

Now the *coup* of 1787-9 implanted the US Constitution atop the *Hodenosaunee/* British Imperial/Articles layers of our diverse soul.

*Thankfully!* our implacable urban/rural revolutionaries demanded a Bill of Rights.

At first the Founders genuflected to Athenian democracy and Imperial Rome. Both were built on slavery and suppression of women. But the core spirit of Revolution and democracy that filtered into the new nation flowed from the Iroquois *Great Law* and sibling social contracts that blended order, freedom and democracy. Their *Indigenous Originalism* still permeates our DNA.

By 1789, the new Constitution was the continent's dominant structural force, meant to contain the grassroots democracy that had just won the Revolution. Woodrow Wilson *(who later trashed that very Constitution)* confirmed that the new government had been established....

> ...*upon the initiative and primarily in the interest of the mercantile and wealthy classes...urged to adoption by a minority, under the concerted and aggressive leadership of able men representing the ruling class [and] the conscious solidarity of material interest.*

Like the *Haudenosaunee* Confederacy, the new United States centered on sovereign states sending representatives to a general council. The new US Congress had, like Rome, a "lower" House and an "upper" Senate. These were balanced with an elected executive and an appointed judiciary. There was not a hint of matriarchy.

The new Federal elite got a national army, taxation, tariffs, courts, currency, and stable commerce amongst the states. Property qualifications for voting lingered until the 1860s. Free blacks could vote in five states. Women could vote only in Quaker-influenced New Jersey, and there only until 1808.

An Electoral College balanced the small states against the big ones. It let slave-owners count each of their chattel for three-fifths of a vote for president, and in apportioning the US House. The slavers used that "bonus" to dominate the White House and Lower House until 1861. After the Civil War, Jim Crow racism kept a death grip on both the former Confederacy and the national Congress.

Madison later branded the Electoral College as a shoddy piece of work, disliked by Founders who were exhausted by the time they accepted it. It STILL allows a minority of voters to crown the likes of election-losers Rutherford B. Hayes, Benjamin Harrison, George W. Bush, Donald Trump.

Grassroots farmers and urban workers mostly hated the new Constitution. In a fair national tally, it would almost certainly have been rejected.

To seal the *coup d'état,* the new American elite arbitrarily announced the need for nine of twelve states to approve. *(Vermont stayed independent until 1793).*

Historian Staughton Lynd says New York anti-Federalists won a majority of delegates. But enough at the state conventions flipped their votes to seal the deal. Some emerged *(of course)* with unexplained new wealth.

The new Constitution could be amended with two-thirds of Congress, a presidential signature, and then three-quarters of the states. Tough, but doable. The new national organism could change and grow. But first it served the rich.

In reaction, our Revolutionary populists demanded a Bill of Rights to resemble the *Haudenosaunee* codicils. Virginia's was drafted by Madison and Jefferson, who joined Franklin and Washington in studying Indigenous law.

Still seething over post-war taxation and the killing of Shays's rebels, an angry populace threatened a new Revolution. Madison initially dismissed the idea. Then he grudgingly compiled the Bill of Rights, for which he later declared great pride.

Sweeping pronouncements like the *Declaration of Independence* (1776), *Declaration of the Rights of Man* (1789), *Economic Bill of Rights* (1944), and *Universal Declaration of Human Rights* (1948) enshrine our highest principles.

But our Bill of Rights is the *LAW*.

Our First Amendment became history's most essential sentence, fit to be carved high on the walls of every public building, especially schools and courthouses....

*Congress shall make no law respecting an establishment of religion, or prohibiting the free exercise thereof, or abridging the freedom of speech, or of the press, or the right of the people peaceably to assemble, and to petition the government for a redress of grievances.*

This magnificent line *guarantees* our most basic freedoms – religion, speech, media, assembly, petition. Other amendments outline due process and ban self-incrimination, double-jeopardy, spying, unwarranted search and seizure, arbitrary imprisonment, excessive bail and torture (*remember* that!!).

Ever since ratification on December 15, 1791, our cycles of history have pitted human rights against official tyranny. Our worth as a nation has ALWAYS rhymed with the extent of our commitment to those ten sacred codicils.

In 1791-4, Washington and his Treasury Secretary (Hamilton) imposed a hated whiskey tax. Angry agrarians, many of them hardscrabble vets, grabbed the guns they'd used to beat the British and marched toward Philadelphia.

But George now had a federal army. His ambitious Jamaica-born aide gladly crushed the rebels who'd won the Revolution, but now lost the peace.

In 1797, Washington again went home to farm, declining a third term. In the new nation, neither generals nor presidents should rule for life. It was his most formative moment. *(Sadly, his lesson does not yet apply to Supreme Court Justices).*

The eternally grouchy John Adams took over. His sensible feminist wife Abigail *(who'd've made a much better president)* helped stabilize a post-war equilibrium.

The Adamses also hosted a hero of the Haitian Revolution as the first free black man to dine with a US president. It'd be a long time before that happened again.

In 1800, John ran for re-election against his charming, devious Vice President.

The Founders actually believed that in their gentlemanly new republic, he who'd just lost the presidency would happily serve the winner as a faithful vice president. So Jefferson became VP after losing to Adams in 1796. It did not go well.

Four years later, John had no idea his "good friend" Tom had secretly hired the scandal-monger James Callender to smear him. Enraged by Callender's scurrilous trash, the absurdly thin-skinned Adams assaulted the First Amendment with the dictatorial Sedition Act, still used to threaten government critics.

For daring to doubt a president, John fined and jailed Callender and other investigative journalists, including the illegitimate son of Franklin's illegitimate son, who had also become a printer. Abigail *(who should've known better)* went along.

When the Electoral College gave Jefferson the slave-built White House in 1800, Adams stomped home to Quincy. Years later, he learned Tom had hired the guy who'd smeared him, and (according to legend) broke his hand punching something really hard. Skinflint that he was, Jefferson stiffed Callender, who retaliated by breaking the first public stories about Sally Hemings and her many Monticello children.

A lover of all things French, our third president was linked by frightened Federalists to the Revolution that beheaded Franklin's "friend" Louis XVI. A Red Scare/Great Fear spread amongst America's authoritarian elite. Somehow this shy, shifty, mob-fearing slaveowner became a virtual anti-Christ.

His haters came on like witch hunting Salemites. Yale's Puritan President Timothy Dwight, a grandson of Jonathan Edwards, demanded new lynchings. Rev. Jedidiah Morse howled out a crazy "illuminati" conspiracy somehow involving the composer Beethoven.

Like so many other tyrannical fanatics throughout our history, Morse promised to name Satan's insidious agents, but never did. To these early McCarthyites, Godless rape, pillage, terror and madness were on the march.

Above all, they screamed that the incoming president was a satanic revolutionary.

In fact, he was an imperial moderate, an early Eisenhower.

In the chilly fall of our first organic cycle *(while he sired Sally's final three children)* our third president plunged the new nation into an industrial winter of material excess… and the early birth pangs of the global empire that would prove our ultimate downfall.

*In the 1800 campaign, at the secret behest of Vice President Jefferson, journalist James Callender smeared President Adams (who threw him in prison).*

*When Jefferson failed to pay Callender, he introduced America to Sally Hemings (our third First Lady) Tom's intimate "servant" for some 40 years, mother of at least four of his children.*

# Indigenous Revenge?
# Tecumseh's Curse

Around the time Francis Scott Key stuck us with the Star Spangled Banner, a "cyclical curse" began tracking the death and maiming of seven presidents.

The great Shawnee war chief was its namesake. The charismatic genius was born under a shooting star in what's now southern Ohio. He spoke five languages and wanted the whites OUT of his homeland.

During the War of 1812, Tecumseh bitterly renounced his British allies for their brutality and torture. His vision was of an all-Indigenous union living in harmony on their ancestral lands.

Reviving the role of Deganawidah, Tecumseh travelled throughout the Indigenous East, trying to unite the tribes.

To start, Tecumseh established a base at Tippecanoe (in today's Indiana). He left his brother Tenskwatiwah ("the Prophet") to maintain peace while he went off to recruit the southern nations for a unified council of resistance. As The Peacemaker had visited the Mohawk, Oneida, Onandaga, Cayuga and Seneca, Tecumseh now sought out the Cherokee, Chickasaw, Creek, Choctaw and others.

But in his brother's absence, Tenskwatiwah foolishly attacked US forces commanded by General William Henry Harrison, a Virginia slaveowner. Harrison jumped at the opportunity to wipe out the encampment, leaving the returning Tecumseh without a base. Isolated and over-extended, the resistance faltered.

In 1813, at Thames River, Harrison may have killed Tecumseh. But he never got the great chief's body.

In 1840, Harrison was elected president as our next-to-last Whig. As he made clear in his Inaugural speech, he demanded control of Indigenous lands. But during his VERY long rant (some say it lasted three hours) Harrison caught pneumonia. When he died a month later, many credited "Tecumseh's Curse."

The next six presidents elected on a "zero year" —-Lincoln (1860), Garfield (1880), McKinley (1900), Harding (1920), FDR (1940), JFK (1960)— all died in office.

Reagan (1980) was shot, but lived…sortof.

The unelected George W. Bush has survived since 2000, as has Al Gore, who won the popular vote that year, but did not become president.

Donald Trump says he won in 2020. Maybe he should check with Tecumseh.

# WINTER
## *The Era of Good Feelings*

*Amidst a fierce reactionary furor, John Adams rightfully won popular re-election. Without the 3/5 bonus, Adams could claim 65 Electoral votes, Jefferson just 62.*

*But like the Constitution's ratification, the 1800 election was rigged...as were many more to come.*

The Founders who wrote the Constitution were no fans of the universal ballot. Voting rights were left largely to the states, where stringent property requirements severely limited the franchise.

The Indigenous were denied the federal ballot until 1924.

Women could vote only in Quaker New Jersey, and only until 1808. In a land once ruled by matriarchs, no American woman could vote again until 1869 (in Populist Wyoming) and not nationwide until 1920.

State-by-state, property requirements gradually dissolved through 1860. Wealthy black men could vote in some northeastern states right from the start. But even after the 15th Amendment allegedly guaranteed the right to vote "regardless of race," countless Jim Crow tactics excluded black voters right through the election of 2020, which nearly made Donald Trump Dictator for Life.

Slavery was the original tool of racist disenfranchisement, pitching people of color into a caste that deemed them subhuman. The Electoral College added injury to insult by letting slaveowners count their chattel for 3/5ths of a vote. Without that racist "bonus," John Adams would have beat Tom Jefferson in 1800. Electoral losers have since taken the presidency in 1824, 1876, 1888, 2000 and 2016. It damn near happened again in 2020. Because rural states control a disproportionate number of Electoral votes, the College still leans right.

The 3/5ths bonus also counted slaves toward Congressional districts, giving plantation owners an outsized grip on the US House until the Civil War. The rural-dominated US Senate still favors rule by conservative, rural states despite the overwhelming numerical advantage of under-represented urban centers.

Then came the art and science of *Gerrymandering,* rendered infamous by Massachusetts Governor Elbridge Gerry in 1812. A Democrat-Republican, Gerry crammed all the Federalists he could into isolated blocs, leaving him the rest of the state. Somebody said the reptilian districts resembled salamanders.

In 2010, the GOP used computerized "Red Map" gerrymandering to take the US House and many critical swing state legislatures. It gave them control of the country despite losing the overall popular vote by substantial margins.

Throughout our history, election theft has come with pitching ballots in rivers, burning polling stations, buying election officials, intimidating voters of youth and color, stripping registration rolls, flipping vote counts and much more. In the early 2000s, electronic voting machines turned election theft into an easy internet-based exercise in elementary computer hacking.

But in 2018 and 2020, with a spike in the use of paper ballots, decades of grassroots organizing for civil rights and election protection ignited our history's biggest turnout of voters of youth and color. In 2018 they flipped the House to the left. In 2020 they ousted Donald Trump, whose failed 2021 coup attempt took domestic anti-democratic violence to a whole new level.

The Democrats then proposed sweeping federal legislation meant to spread the franchise and its guarantees. Grassroots demands for non-partisan districting---as in Iowa, California and Michigan---meant to bury both Gerry and Trump's legacies.

In the spirit of Hamilton's Federalists, the GOP struck back to limit the franchise, forever gerrymander the swing states, and enshrine corporate money, the Electoral College, a reactionary Supreme Court. Twenty-two decades after Tom Jefferson took power, the American public must finally decide how much democracy it really wants.

But in March, 1801, Jefferson entered a White House built by slaves being bought and sold nearby, in a District *still* denied statehood 220 years later.

A pouting John Adams left town before the ceremony.

Adams's Federalist allies saw the soft-spoken Virginian as a raging radical. Similar reactionaries in future cycles would inflame the KKK South, the Evangelical 1920s, Red Scare '50s, Cointelpro '60s & '70s, Reagan '80s and Trump's Age of Covid, forever raging against that diverse, woke "Army of Devils."

With Jefferson, they screamed, blood would be boiled, children raped, heads posted on spikes, buildings burned, order destroyed, the country bankrupted.

But the terminally shy Tom, who rarely spoke in public, preferred consensus. "We are all Republicans, we are all Federalists," he wrote. Then he ushered in a chill winter's blizzard of industrial consolidation and imperial expansion.

The new capital's seeds were sown at a 1790 dinner party. Jefferson and Madison dined with Hamilton, whom they both disliked *(the feeling was mutual)*.

But they had issues to settle. The slaveowners hated coming to the Congress in Philadelphia. While the *massas* were off doing the country's business, those pesky Quakers kept talking their slaves into running north to freedom.

Hamilton was an abolitionist. His alleged military lover, John Laurens, was dead. Married into a wealthy New York family, Alex fathered eight children.

He also fathered the corporate state. He wanted America run by a modern industrial oligarchy, not by either a medieval slaveocracy or the general public. Alex liked hard money and a clean balance sheet. The Feds, he said, should pay off the states' war debts, then help fund a commercial-industrial empire.

The Virginia agrarians were not inclined. But lubricated by Tom's fine wines *(which he could not afford)*, the trio cut a deal.

Jefferson and Madison would let Congress bail out the states.

In exchange, Hamilton let the slaveowners move the nation's capital to a dismal southern swamp, far away from those annoying Quakers.

Ten years later, the slave-built White House briefly hosted John and Abigail, Then, for 24 years, came the Virginia slaveowners---Jefferson, Madison, and Monroe.

46

With them came Hamilton's dream of a corporate empire. In his seminal 1791 *Report on Manufactures* and other writings, Alex demanded that taxpayers fund our commercial/industrial jumpstart. The rich would use public money---including that levy on Pennsylvania whiskey---for a national bank and manufacturing infrastructure.

The new industrial elite preached the "free market." Their Bible, Adam Smith's 1776 *Wealth of Nations,* exalted the "invisible hand" of open competition.

But Adam Smith was a humanist. He feared unregulated monopolies would clog the markets and game the system. Without public vigilance, the iron fist of oligarchy would drive us without pity to radical inequality and imperial overreach.

John Adams helped it happen. He knew Jefferson hated the staid jurist John Marshall. So, Adams made him Chief Justice. From 1801 to 1835, Marshall (Tom's cousin) made the Supreme Court a mighty fortress for a rising corporate empire.

Marshall's timing was perfect. Exhausted by war and reaction, we were hot to get rich. Jefferson lit an imperial fire that, by 1991, would engulf the world.

In 1801, Tom sent American ships to what's now Libya *(the shores of Tripoli)* to crush Barbary pirates who were messing with our trade. As in the Obama-Clinton return assault 208 years later, countless thousands died needlessly.

Meanwhile Tom borrowed $15 million from a British businessman to buy Louisiana, west of the Mississippi. The Purchase doubled our size, trampled the Indigenous…and violated Jefferson's alleged belief in limited government.

But it was the portal to Manifest Destiny. Tom wanted a place to send the eastern tribes…and he knew a steal when he saw one.

Ironically, the Purchase was made possible by Haiti's slave revolution, which terrified Tom and his fellow plantation owners.

The French dictator Napoleon was using New Orleans to squeeze our commerce. War seemed inevitable. So he sent troops to tighten his grip.

But France's sugar-growing colony of Hispaniola was on the way. Toussaint L'Ouverture---the "Black Washington"----was leading 500,000 self-proclaimed *Haitians* in a war for freedom and independence. "I was born a slave," said Toussaint, "but nature gave me the soul of a free man."

Bonaparte sent his white troops to crush the "inferior" black rebels in Hispaniola…and to then come beat us in Louisiana.

But Haiti became Napoleon's Vietnam; his troops never saw New Orleans.

Toussaint's revolution struck terror in the hearts of all slaveowners. Ten US presidents refused to recognize the new nation or to send an ambassador *(Lincoln did both in 1863).* The white world has never forgiven black Haiti for beating a European army…or for an anti-colonial revolution tinged with social democracy.

After our 1783 truce with Britain, America's "Infant Empire" took shape.

Jefferson adopted Federalism's commercial-manufacturing vision. Abandoning their agrarian dreams, the end-of-ideology Virginians did the Hamiltonian thing of using the federal government to fund the infrastructure for a rising corporate state.

In 1812, imperial War Hawks captured Congress. With the infantile fantasy of conquering Canada, our little army torched York (later Toronto). The Brits then burned

the White House. Had they caught Madison, then-VP Elbridge Gerry would've become our fifth president.

At the ensuing battle of Fort McHenry, a slave-owning lawyer stuck martial, racist lyrics on an old drinking song. The un-singable mess morphed into a "Star-Spangled Banner" played best *(wordlessly)* by Jimi Hendrix at Woodstock '69. It has been most accurately honored by sports heroes refusing to stand for it.

The Era of Good Feelings embraced the three consecutive two-term presidencies of Jefferson, Madison and Monroe. The trifecta was unmatched until the Clinton-Bush2-Obama Boomer Triangulation two centuries later.

Meanwhile, this first winter of our material content demanded normalcy, not turmoil. Like the Gilded 1890s, Roaring 1920s, Fat '50s, "Me" '70s and Greedy '80s to come, there was money to be made and land to be conquered. Few Americans bothered to read or vote. Wrote Ralph Waldo Emerson of Massachusetts...

*...From 1790 to 1820, there was not a book, a speech, a conversation, or a thought in the state.*

Retired with Sally and their many children at Monticello, Jefferson soured on the new empire whose birth certificate he drafted. He'd coopted Hamilton's Federalism to fund infrastructure for a manufacturing juggernaut. In 1816, in his timeless, self-contradictory rhetoric, Tom railed against exactly what he'd helped create...

*... I hope we shall... crush in its birth the aristocracy of our moneyed corporations, which dare already to challenge our government to a trial of strength and bid defiance to the laws of our country.*

In 1819 there came *(as always)* the crack where the light got in. An irrationally exuberant stock market panicked and crashed. Monroe's second term plunged into chaos. Depression raged. Landlords went broke. Factories sold for pennies. Angry labor organizers birthed the first industrial unions.

In 1824, J.Q. Adams---as Secretary of State---issued the Monroe Doctrine, which humbly claimed sovereignty over the entire western hemisphere, warning Europe to forget about any involvement on "our side of the ocean."

It was pure imperial *chutzpah*, totally at odds with our anti-imperial birth. We were now Latin America's *massa*. The consequences have been devastating.

In 1824, Andy Jackson trounced Adams2 in the popular vote. But JQ gamed the Electoral College to steal the White House. The bad *karma* was instant: Quincy's presidency *(like his dad's)* was an unruly mess.

By 1828, America's first cycle of conception, birth, Awakening, war, reaction, and early material growth was done. Our Infant Empire was twice its birth size, forever at war, crushing Indigenous peoples everywhere. The nascent commercial-industrial Infant Empire had slept comfortably numb through its first winter's fat, smug snooze.

But then it jerked awake to the startling tantrums of a Tennessee wild man.

# TRAILS—-AND PIPELINES—OF TEARS

"There will come a time in the remote future," wrote Helen Hunt Jackson in her 1881 Century of Dishonor, "when to the student of American history [the Cherokee removal] will seem well nigh incredible."

That time clearly has not yet arrived. Andrew Jackson personally profited from ethnic cleansings like the brutal 1838 removal of 13,000 Cherokee from their ancestral lands. Nearly two centuries later, Jackson's Trumpian progeny did the same.

The ghastly calculus is familiar. Some three dozen North American towns and counties still bear the name of Jeffery Amherst, who gave (as a "gesture of peace") smallpox-infested blankets to Ohio Valley tribes, killing them in droves. US troops who slaughtered 300 Lakota at Wounded Knee got Congressional Medals. In 1961 John Kennedy overrode Seneca treaty rights to approve the eco-destructive Kinzua Dam. In league with big corporations, federal, state and local governments still assault treaty rights and tribal sovereignty wherever money can be made poisoning our land, air and water.

At least since the 1960s, a continual flow of diverse, committed activists has joined with the Indigenous to fight back.

The relationships have been demanding and complex. But in the 2010s mas-sive multi-racial uprisings fought the Keystone Pipeline, meant to slash through the Heartland, devastating Indigenous lands and waters. Pushed to the brink, President Obama finally stopped it.

Under Trump (and Canada's Justin Trudeau) the Dakota and and other pipeline fights have proceeded with traditional ferocity.

But in 2021, Joe Biden made an Indigenous woman (Deb Haaland) his Interior Secretary. It seemed to signal a new awareness of the Earth and her Rainbow children. We shall see.

# CYCLE 2: MANIFEST ADOLESCENCE

| Jackson | Transcendentalists | CIVIL WAR Reconstruction | KKK \| Jim Crow Corporate Personhood | Gilded Age |
|---------|--------------------|--------------------------|-------------------------------------|------------|

# A Burst of Energy
## *Andrew Jackson*

*At the 1824 dawn of our second cycle, amidst the hard freeze of a winter's de-pression, four men ran for president as Democrat-Republicans.*

*Andrew Jackson beat them all, trouncing John Quincy 153,544 to 108,740.*

*But Adams2 hijacked the White House. He disliked slavery. But he cut backroom deals with slaveowners Henry Clay of Kentucky and South Carolina's John Calhoun. The outcome was a one-term presidency as tortured as his father's.*

Andy Jackson was not a gracious loser. He'd fought at least fourteen duels. A bullet sat about an inch from his heart.

To crush Adams2 in 1828, Jackson formed the Democratic Party, a long-standing pillar of slavery, racism, and imperial assault. State-by-state abolition of property requirements for voting sent the overall national vote count soaring from around 350,000 in 1824 to more than a million four years later.

And Old Hickory would not be denied.

Driven from the White House, John Quincy served 17 years in Congress, becoming a fierce abolitionist...and our greatest ex-president.

But for a generation of farmers and workers born after the Revolution, Andrew Jackson was the Common Man's messiah. A wild mob made a drunken brawl of his inauguration. With hair as good as Washington's *(and much better teeth)* he never wore the wig of the old plantation elite.

Andy was the orphaned son of impoverished Irish immigrants. The rising industrial working/middle class, much of it Irish, gave him a white urban base that stayed Democrat right through the New Deal and New Frontier.

But for Old Hickory, money both talked and swore. An alleged "labor man," he crushed a union revolt on the Chesapeake & Ohio Canal. He hated Hamilton's National Bank, but slipped hard cash to cronies at the "pet banks" he set up to replace it.

Jackson's violent contempt for women, blacks, Hispanics, the Indigenous, ethical business practices and the law itself defined our macho frontier individualism, and set a low moral bar for the later coming of Donald Trump.

Jacksonian adolescence came with a "Manifest Destiny" to conquer the continent. "Free" western land meant any hard-working white male elected by God *(or Ayn Rand)* could get rich running slaves, killing natives, gouging the Earth, and bending the rules whenever money was to be made.

Much started with Jefferson. In 1806, Tom promised sanctuary to the Delaware if they would adopt white ways and give up common ownership of tribal lands. But he'd already bought Louisiana and aimed to ethnic cleanse them out there.

In 1814, Jackson slaughtered some 800 Red Stick Creek men, women and children at Horseshoe Bend. He sliced their corpses to make reins for his horses. *(Some 200 escaped to join the Seminoles in Florida's Everglades, where they were never defeated).*

Many Cherokee became successful farmers, merchants, bankers, and business managers. They devised a written language, wrote a constitution, published a newspaper, built a state capital at Echota, ran seven lumber mills. Their mixed-race chief, the blue-eyed John Ross, ran a slave plantation near Chattanooga.

Andy didn't care that they'd fought for him. His cronies robbed, raped, murdered and pillaged whatever gold, timber and land they wanted. When the Cherokee asked for federal protection, Jackson replied with the 1830 Indian Removal Act, demanding they be forced across the Mississippi into Jefferson's Louisiana.

So the Cherokee petitioned for statehood. Chief Justice Marshall denied that, ruling no new state could be created out of an existing one *(which Lincoln would do anyway for West Virginia in 1863)*.

But Marshall also ruled the Removal Act unConstitutional. He confirmed the tribe's sovereignty. By law, they could now enforce their own mandates, not be forced west, and eventually build their own casinos.

Jackson told the Court and the Cherokee to drop dead. He would expel his former allies at gunpoint, and to hell with the Constitution. *(He also made a personal fortune on native land he stole for himself and his cronies).*

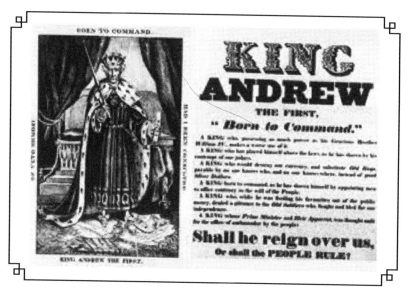

In May, 1838, Jackson's successor, Martin Van Buren, ripped children from their families and drove 14,000 Cherokee out of their homes, concentrating them in an open field. Without shelter, food or recourse, about a thousand ran into the hills, where there's still a town called "Cherokee".

In the fall, federal troops forced the tribe onto the "Trail of Tears," an 800-mile death march to Oklahoma. A quarter died. The gash still festers in our nation's soul.

Some 10,000 did make it. They built a capital at New Echota, a school system, a reborn society. Today, more than 730,000 strong, many Cherokee still avoid Jackson's face on the $20 bill *(hopefully soon to be replaced with Harriet Tubman's)*.

In the Everglades, the renegade Seminole embraced runaway slaves and ran rings around the regular army in a ten-year guerrilla war. Masters of the dismal swamp, they remain a formidable power in Florida politics.

In 1821, the revolutionary Republic of Mexico abolished slavery, then invited Tennessee frontiersmen to settle Texas, where they re-introduced it.

In 1836, the "Texicans" rebelled. They lost the Alamo, but soon won their independence and demanded statehood. For nine years, Mexico's threat of war---and fierce abolitionist opposition to a new slave state--- kept Texas out of the Union.

Then came Jackson's truest disciple, James K. Polk. Elected in 1844, "Young Hickory" spent his years in the White House buying and selling teenaged slaves, separating many of them from their families. He personally profited from land confiscated from the Choctaw, who were forced to Oklahoma.

He also set out to conquer the continent. He offered the Mexicans cash for their lands north of the Rio Grande. They refused.

So Polk used a murky skirmish near the Nueces River to howl for war. With loud Congressional approval, the Tennessee Democrat sent US troops pouring into Mexico City's "Halls of Montezuma."

Abolitionists denounced this "barbaric" attack as an imperial ruse to spread slavery. Transcendentalist Henry Thoreau refused to pay his taxes. Ralph Emerson preached nonviolence. First-Term US Representative Abraham Lincoln of Illinois spoke passionately for peace, then declined to run again.

So did Polk. In his single term (1845-49), James K. grabbed the rest of what's now Texas, plus New Mexico, Arizona, California, Nevada, Utah, Colorado and parts of Oklahoma and Wyoming. He got Oregon and Washington from the Brits. He laid claim to Cuba.

After all that acquisition, the exhausted conquistador left the presidency in March, 1849. He dropped dead (at 53) in June.

In their outbursts of imperial energy, Jackson and Polk obliterated our post-Revolutionary winter slumber. They retired the Founders to the realm of passed gods. Their Manifest individualism sent a violent deluge of armed settler-colonists pouring into the frontier.

In that era of uproar, from the 1820s to the '60s, we were a hyper-energized adolescent, full of radical ideas and greedy aggression, racially bipolar, hellbent for war, Civil and Imperial.

But in literature, spirit, the arts…in *feminism, abolitionism, communalism*…. a gorgeous creative spring…a second Great Awakening…burned a transcendent mind shaft deep into our hot young soul.

*That's where the light got in.*

# SPRINGTIME
## The Transcendentalists

*As our youthful nation robbed the continent from its Indigenous offspring, there also came a springtime thrill of humanist passion. The reborn Transcendent spirits that had aroused the American embryo in our first Great Awakening now soared through the arts to the better angels of our soul.*

*In the 1830s, they roared to life ...pouring from the souls of black folk and the feminists and abolitionists, writers and poets, workers and activists, seekers and utopians, musicians and artisans, instigators and organizers.*

*Throughout the cycles of our history, these ever-present upstarts awaken again and again, with ascending force...in the humanist well-springs of our left/green dreams...for social democracy and an organic whole.*

*These days of magic were about miracle and wonder...bucolic beauty and great new art, racial/feminist liberation...and the rise of an angry industrial working class.*

As always in America, it began with race.

From the start, the south spewed a surreal *Gone with the Wind* mythology of happy black folk swooning in awe of their slave-owning *Massas*.

But the *Massas* themselves knew better. They lived in constant terror of violent revolt. To own sentient humans demanded keeping both feet on their necks. In the south's "agrarian paradise," fear-based Slave Codes said blacks could not marry, own property, travel freely, meet together, talk back to whites, learn to read.

The ceaseless torture and rape, murder and outrage imposed on chained human chattel testified that the southern elite knew full well its enslaved work force was a seething volcano set to explode.

Brilliant black writers and activists like Harriet Tubman, David Walker, Sojourner Truth, Robert Smalls, Mary Ann Shad Cary, Solomon Northup, Maria W. Stewart, Frederick Douglass and so many more never stopped resisting.

Douglass's autobiography, Northup's *Twelve Years a Slave*, Walker's *Appeal* made it clear that slavery's ultimate payback would be utterly apocalyptic.

In the Civil War, more than 200,000 blacks staged their own war of liberation. At least 40,000 died fighting for freedom in Union blues.

They had powerful white allies. Tom Paine demanded abolition. Ben Franklin petitioned Congress for it. Much of Latin America embraced it in the 1820s. So did England in 1833, Russia in 1861.

But here, white middle-class American women who worked for abolition---many of them Quakers---were blindsided by an ugly sexist ambush.

During the Revolution, Abigail Adams's 1776 letter to husband John demanded he "remember the ladies" when it came to equal rights. His snarky response set the tone for a pathetic strain of misogynist denial that led straight to Donald Trump.

Abigail and other war wives ran the farms, fields, and families. A half-century later, when their "uppity" daughters dared to speak in public against slavery, insecure men with small hands showered them with verbal abuse....and flying vegetables.

In 1840, Elizabeth Cady Stanton and Lucretia Mott sailed to London for a global Abolitionist gathering. But the "movement" men---including Elizabeth's husband, whom she quickly left---treated them with contempt. With righteous fury, a new generation of feminists convened a women's rights convention, and proclaimed...

*...We hold these truths to be self-evident, that all men and women are created equal.*

Composed in the heart of *Hodenosaunee* country, the 1848 Seneca Falls *Declaration of Sentiments* demanded equal rights. Paulina Wright Davis's *Una* was our first feminist magazine. Lucy Stone kept her name after marriage, birthing a new generation of "Lucy Stoners." Amelia Bloomer started wearing pants.

Amidst an ecstatic spring of artistic genius, these uppity creatives planted the seeds of a reborn matriarchy.

Louisa May Alcott, Herman Melville, Emily Dickinson, Edgar Allen Poe, Harriet Beecher Stowe, Nathaniel Hawthorne, Sojourner Truth, Henry Longfellow, Margaret Fuller and a holy host of rebel writers and thinkers, poets and songwriters, artists and activists, made our frontier culture a gorgeous garden of exceptional genius.

Walt Whitman *(our first gay laureate)* "sang the Body Electric" in *Leaves of Grass*, rising with our first gay president, James Buchanan. I know, wrote Whitman...

*...that all men ever born are also my brothers...and the women my sisters and lovers.*

*Moby Dick, Little Women, The Scarlet Letter, Summer on the Lakes, Fall of the House of Usher, Song of Hiawatha* headlined the era's creative treasures.

Sang the divine Emily Dickinson...

*Trade all you have or might have been for one small breath of ecstasy.*

Vibrant nature-based visuals by Albert Bierstadt, Frederic Church, Asher Durand birthed the Hudson River School. Thomas Cole's huge five-phased paintings powerfully portray the cycles of civilization *(readily visible at the Museum of the City of New York)*.

Transcendentalist fire burned in dozens of utopian communities *(which sailed the slipstream to the hippie 1960s and beyond)*. The Shakers, a Quaker offshoot formed by Mother Ann Lee, worked off their sexual energies with elaborate dances *(and really great furniture)*. While proclaiming the Indigenous to be a "Lost Tribe of Israel," the Mormon Church of the Latter Day Saints embraced polygamy and fled to a quirky, straight-laced life in Utah.

The Oneida Community favored "complex marriage" over "exclusive affections." Their polyamorous mating rituals were elaborate and entertaining. Founder John Noyes kept a written log of Oneidan sexual adventures *(what was he thinking?!?)* then fled to Vermont to avoid prosecution for the adultery he'd so dutifully documented.

Radical dreams of pre-industrial socialism and communal farming erupted everywhere. West of Boston, Brook Farm was home to an *"awakened literati."*

The Owenites ran big, modern factories based on a communal feminism that opposed "false notions" of male dominance. At Utopia, Ohio, and Modern Times, New York, communities founded by Joseph Warren were open and anarchistic.

In Concord, Ralph Waldo Emerson's amiable Unitarianism transcended the Puritans' Hellish obsessions. His gentle spirituality embraced a natural kinship with Hindu and Buddhist laws of empathy and karma. Cut loose, Ralph could sound like a latter-day Jonathan Edwards…or an early Yippie on LSD….

*…Standing on the bare ground, —-my head bathed by the blithe air, and uplifted into infinite space, —-all mean egotism vanishes. I become a transparent eye-ball. I am nothing. I see all. The currents of the Universal Being circulate through me; I am part or particle of God.*

Henry David Thoreau dove even deeper into the spiritual thicket. Ralph said his bearded hippie neighbor was like "a bird or a fox," an Indigenous soul in a white man's body. Henry spent endless hours watching ant colonies and bird's nests. His tripped-out musings on Mother Nature are genial, loving, luminescent.

Thoreau and Emerson shared mixed feelings about industrial technology. They embraced its wonders but feared its power, warning against the curse of "improved means" without "improved ends."

They also hated Polk's attack on Mexico. Henry went to jail rather than pay taxes for it *(his aunt bailed him out in the morning)*.

Then he wrote the era's transcendent masterpiece on peaceful resistance. *Civil Disobedience* asks simply that people of conscience resist evil…but without violence. That their rebellion be firm but civil. That they throw themselves into the cogs of a life-crushing machine and peaceably defy evil until it somehow surrenders.

Thoreau condensed a pacifist core of Quaker principles into a sleek, secular monument to social change. Humankind must overcome armed injustice with the mystical force of moral suasion…and evolve through the steady civility of standing firmly but peaceably for amity, compassion, ecological harmony, social justice.

The ethereal, inexplicable, pulsating force of that transcendent ideal makes us human…and bends our historic arc inevitably toward justice.

*Civil Disobedience* was joined in 1848 by a less pacific pamphlet that also shook the world. Writing in England, Karl Marx and Friedrich Engels' *Communist Manifesto* gave voice to a newborn labor movement's collective rage against a modern factory machine gone absolutely mad with brutality and greed.

The Industrial Revolution consumed human lives like chunks of coal.

Early Marxism fused impoverished workers into organized resistance which demanded better wages and working conditions, social justice, democratic rights, an end to imperial wars that forever devoured them for the private profit of the idle rich.

Workers versus owners, unions versus corporations, labor versus capital, immigrants versus the established, developing countries against the rich ones, humans with empathy and compassion versus those without...they all squared off in an epic class struggle whose final outcome remains in doubt.

"Labor is prior to and independent of capital," wrote Abraham Lincoln, who admired Marx's writings, and wrote him personally. "Capital is only the fruit of labor, and could never have existed if labor had not first existed. Labor is the superior of capital, and deserves much the higher consideration."

But Marx's call was marred by a tragic phrase only a Stalin or a Mao could love: "dictatorship of the proletariat." It would prove a horrendous curse for decades to come.

In 1861, the price came due on a primal curse of our own---chattel slavery. Our rising industrial machine...with its imperial march into the Indigenous west, and its absolute demand for free passage through New Orleans....turned our sweet Transcendental Spring into the deathly inferno of an apocalyptic summer from Hell.

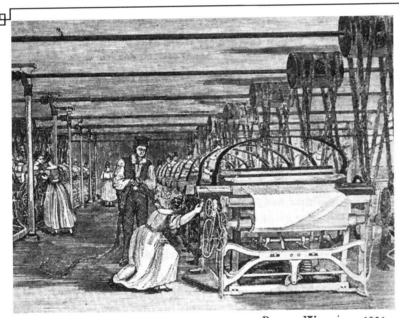

Power Weaving  1836

*Despite long hours and lousy pay, many women (like the later Rosie the Riveter) found the early textile mills liberating.*

*Making their own money, living in dormitories with other females, free to take classes and shape their own lives, their early experiences fed the era's Transcendentalism.*

*But Thoreau, Emerson and others worried about industrialism's dark sides.*

*Their worst fears were soon exceeded.*

# SUMMER
## *Civil War*

*Rare among slaveowners, George Washington and Thomas Jefferson were astute, passionate agrarians.*

*They embraced the art of crop rotation and the science of contour plowing.*

*They also heaped glowing praise on their favorite plant: cannabis.*

*There's no evidence they smoked it, which anyway would've given them a headache. But they would never have believed it would be made illegal (WHY???).*

*Hemp made rope, sails, clothing, paper, food, building materials. George bought special seeds from India. He separated the male plants from the female.*

*It was SO much easier to raise than that demon weed, tobacco.*

*Hemp was America's #2 cash cow. Had it been the South's core crop, chattel slavery could never have taken root.*

*But King Cotton was a terrible tyrant. It addicted its debt-ridden growers to constant injections of cash. They grew it (like tobacco) on the same land year after year. They lacked fertilizer, a willing labor force, an understanding of crop rotation. They wore out the soil, then moved west.*

*It could not last.*

Starting with Jamestown, 1619, European slavers ripped anguished humans from a hugely diverse continent. The priceless agricultural skills that sustained Africa's deep, rich civilizations for countless millennia came with them.

But the White Supremacist slaveowners scorned their ancient wisdom. The medieval south was a seething Hell, ruled by smug totalitarians, besieged by endless resistance. Historian Edward Baptist wrote that especially in King Cotton's 1800-1861 ginned-up boom time, "white people inflicted torture far more often than in almost any human society that ever existed."

Racism was the drug of choice. It meant to justify African enslavement and Indigenous genocide. White "Christians" anointed themselves as superior to fellow humans of color. Biblical passages were duly found to deify the unholy delusion.

Free white Europeans immigrating across the Atlantic shunned the slave south. So by 1860, the north counted some 21 million residents, versus 9.5 million southerners, nearly half of them black. Even with the three-fifths bonus, the slaveowners could not keep up in Congress or the Electoral College.

But still they wanted Kansas and Nebraska, where our second cycle's hot summer burst into flame.

After a murderous 1859 rampage through "Bleeding Kansas," the abolitionist John Brown attacked a federal armory at Harper's Ferry, Virginia, seeking guns for a slave rebellion. Brown was hanged by General Robert E. Lee, who made a name for himself in the Mexican War, then turned traitor…but was never himself hanged.

In 1860, the Democratic Party split. Angry southerners demanded the mouth of the Mississippi and the west. Four million slaves were their prime capital asset.

But northern bankers, factory owners, workers and farmers would never let a hostile power control New Orleans…or the Great Plains. Enraged Abolitionists, black and white, south and north, feminist and otherwise, wanted slavery sent to oblivion. Abraham Lincoln became their instrument of intent.

Home-schooled and dirt-poor, Lincoln became our quintessential Common Man. His hardscrabble father kept him in a form of frontier servitude. But unlike so many other Jacksonians, Abe was never consumed by the quest for riches.

A backwoods individualist, a rail-splitting wrestler, a self-taught attorney, he indulged in race jokes, thought to send blacks to Africa, renounced slavery even as he spoke of preserving both the Union and its "peculiar institution."

Having clawed his way to Congress, Lincoln denounced Polk's Mexican War, knowing it might cost him his career. His bipolar "melancholia" darkened with a tough marriage horribly cursed by the loss of three young sons.

Like FDR's polio and JFK's war wounds, Abe's personal demons forced him onto what historian William Appleman Williams called "a quest for immortality and transcendence."

Raised in nature, Lincoln willed parts of Yosemite to the new state of California for our first public land preserve. And in the era's greatest single sentence, he forever enshrined our slavers' *karma*. The slaughter of Civil War would rage, he mourned at his Second Inaugural…

> *…until all the wealth piled by the bond-man's two hundred and fifty years of unrequited toil shall be sunk, and until every drop of blood drawn with the lash, shall be paid by another drawn by the sword.*

The slaveocracy's race-based caste system played poor whites against black slaves. Its feudal Confederacy was the bastard spawn of a medieval elite. But within the larger federal Union, it faced a demographic reality it could not overcome.

The North was now an emerging industrial super-power. Its incoming waves of European millions confronted the South with a free laboring mass even the Electoral College couldn't withstand. Fort Sumter in 1861---like Trump's 2021 attack on the Capitol---signaled a demographic struggle the medieval Old Guard could not win.

An early techno-geek, Abe was our first "wired" president, the only one to hold a patent (for a flotation device). In 1863 he established the National Academy of Sciences. He pushed hard for the trans-continental railway he dreamed of riding to California. With striking green foresight, he predicted that "as yet the wind is an untamed, unharnessed force, and quite possibly one of the greatest discoveries hereafter to be made will be the taming and harnessing of it."

Lincoln telegraphed in real time directly to battlefields like Gettysburg, personally deploying observation balloons, ships, trains, arms, troops. He investigated a prototype machine gun that *(thankfully!)* was not yet ready for mass slaughter.

As our Civil War erupted, Russia's modernizing Tsar Alexander2 freed more than 20,000,000 serfs. In 1861 they got full rights as citizens, including the ability to marry and run a business. Many kept the houses they lived in and at least some of the land

they'd worked for unpaid centuries. The Russian aristocracy hated it. But this towering transition came largely without violence.

We had no such luck.

Northerners were of multiple mindsets. Transcendental Abolitionists raged against the machine. White workers wanted western farms. The rising Robber Barons wanted control of Congress and the Mississippi, with corporate license to utterly loot the natural resources of the south and west.

When bloodshed erupted, the urban working class mostly wanted nothing to do with this "rich man's war." Irish street gangs torched Manhattan in 1863, lynching blacks who competed with them for jobs and status. It was a bloody chasm fed by the baronial rich. Democrat machines *(like Tammany Hall, named for an Indigenous chief)* ran the Celtic barrios like the Jim Crow south.

Lincoln *(like Washington during the first Revolution)* hesitated to arm African-American soldiers. But he knew the Union couldn't win without them.

The black abolitionist Frederick Douglass criticized Abe's slow pace. But he agreed that…

*…Though Mr. Lincoln shared the prejudices of his white fellow-country-men against the Negro, it is hardly necessary to say that in his heart of hearts he loathed and hated slavery….*

Abe's 1863 *Emancipation Proclamation* fulfilled John Brown's mission. Black liberators now had guns. Said Douglass…

*…Once let the black man get upon his person the brass letter, U.S., let him get an eagle on his button, and a musket on his shoulder and bullets in his pocket, there is no power on Earth that can deny that he has earned the right to citizenship.*

That year Harriet Tubman *(the "Black Moses")* led a raid into Maryland with some 300 armed African-Americans. They helped free at least 700 slaves.

Just one of every twenty white Confederate families owned a hundred-plus slaves. They were the pompous descendants of the original Cavaliers…entitled, arrogant, obsolete.

Eight of ten white southerners owned no slaves at all. Soon these "po' white" *Johnny Rebs* deserted in droves. In Mississippi, the belly of the Confederacy, they made the "Free State of Jones" into a zone of multi-racial liberation.

To knuckle down the ranks, Lee's desperate officers hanged 22 deserters in a single day, meaning to terrify their unhappy grey grunts. It didn't work.

Nor did the slaughter of the Indigenous. Amidst a war to abolish slavery, white Minnesotans meant to hang 303 Mandan who dared to demand supplies owed them under the usual broken treaty. Lincoln cut the kill list and paid Minnesota $2 million, far more than the tribes were owed.

But on December 26, 1862, thirty-eight Indigenous died in US history's biggest mass execution. Their families were ethnic cleansed further west.

Absent the slaveowners, Congress that year passed a Homestead Act, granting western tribal lands to white settlers. In 1863, Lincoln finally recognized the Haitian Revolution, 60 years after Toussaint's black rebels beat the astonished French.

On January 31, 1865, by just two votes, Lincoln got the Thirteenth Amendment through a divided House. To do it, he prolonged the war---and the killing. Had he not, the Civil War might've ended with the peculiar institution still in tact.

But the 13th Amendment's fatal flaws let Jim Crow racists impose "involuntary servitude" through a hideous prison system. Lincoln still thought to compensate slaveowners for their "loss of property" while sending freed blacks—nearly all of them born here—"back" to Africa. Wrote W.E.B. DuBois…

*…Lincoln was impressed by the loss of capital invested in slaves, but curiously never seemed seriously to consider the correlative loss of wage and opportunity of slave workers, the tangible results of whose exploitation had gone into the planters' pockets for two centuries.*

In the perennial ritual of evaluating Abraham, we enter the dusk. How do we deal with his repeated shreddings of the Constitution? Was his "Great Civil War" one of human liberation…or a "war of northern aggression" perpetrated for a rising corporate empire? Do we blame him for hanging those 38 Mandan…or thank him for saving the other 265 from murderous Minnesotans? Did he slaughter 620,000 to preserve the Union….or was that the price we all had to pay to abolish slavery?

Lincoln had about him a preternatural intelligence and haunting depth. His melancholia came with no pharma miracles…but a demand for greatness.

Gene Debs's leap came in a Woodstock jail. Helen Keller overcame deaf/blindness. FDR's personal Hell was polio, Eleanor's her abusive parents. For Malcolm and Martin, it was the lifelong scourge of racism. JFK's inborn, privileged genius was driven ever-deeper by his war wounds and Addison's disease.

*…So what miraculous inner resource will we now find to save our place on the planet we ourselves are destroying?*

Some profiles are hauntingly incomplete because assassins cut them off so young. Kennedy's unanswered question is Vietnam. Lincoln's is southern land.

Marching through Georgia, William Tecumseh Sherman (*named for the great chief, he was nonetheless a horrific Indigenous-killer*) promised thousands of ex-slaves 40 acres and a mule. Enhancing what our first revolutionaries had done to Tory land, General Oliver Howard (later co-founder of Howard University) distributed abandoned coastal plantations to freed ex-slaves who'd worked them under the lash. Said the Radical Republican Thaddeus Stevens…

*…We especially insist that the property of the chief rebels should be seized and [used for] the payment of the national debt, caused by the unjust and wicked war they instigated…*

*...The whole fabric of southern society must be changed and never can it be done if this opportunity is lost.*

Russia's freed serfs got land and houses. In classic Jeffersonian tones, Stevens said our new black citizens deserved no less...

*...Nothing will so multiply the production of the South as to divide it into small farms. Nothing will make [citizens] so industrious and moral as to let them feel that they are above want and are the owners of the soil which they till....*

*...No people will ever be republican in spirit and practice where a few own immense manors and the masses are landless. Small and independent landholders are the support and guardians of republican liberty...*

*...If we refuse to this downtrodden and oppressed race the rights which Heaven decreed them, and the renumeration which they have earned through long years of hopeless oppression, how can we hope to escape still further punishment if God is just?...*

Lincoln supported reparations for slaveowners while he apparently opposed giving their plantations to those who'd worked them. But he owed the ex-slaves the Union victory, and knew the brutality of a landed elite. Says Eric Foner...

*...Lincoln was certainly not in favor of redistributing southern property but he liked to allow different projects to go forward and see what happened. At Davis Bend, Grant divided the land among the slaves. Sherman did something similar. Lincoln said nothing pro or con....*

*...Congress in the Freedmen's Bureau Act envisioned blacks renting and then buying land.*

*The idea was in the air but [Andrew] Johnson killed it.*

Like the Founders and our other early icons, Lincoln remains a haunting enigma, a mystifying mix of warmth and wit, depth and complexity...wrought with contradiction... capable of incomparable genius and profound growth... killed way too soon for a full evaluation.

A savvy, seasoned attorney, Lincoln would never have fallen prey to the Baronial manipulations that ignited an 1869 crash that ruined millions.

But we can't be sure that he'd've tried to reconstruct the South 1865-1869 the way Grant did from 1869 to 1877. And we don't know what he might've done about southern justice, racial reparations, western land, Indigenous rights, industrial democracy, a rising Baronial class.

What we do know *(what really matters)* is what *did* happen.

To win re-election in 1864, Lincoln made Andrew Johnson *(a Tennessee Jacksonian)* his VP. As with a later Johnson, we still pay a fearsome price.

Andrew came drunk to Abe's second inaugural in 1865 (He then skipped Grant's inaugural in 1869, pre-cursing Donald Trump's no-show in 2021). An unreconstructed racist, he killed the idea of redistributing plantations….and a whole lot more.

But in the hot summer of our "Second American Revolution," after 620,000 had died, the 13th Amendment abolished chattel slavery *(except in the prison system).* The 14th meant to guarantee southern blacks their basic human rights *(soon hijacked by the corporations).* The 15th pledged the right to vote "regardless of race" *(a promise still unkept).* A Civil Rights Act promised racial justice which was paid for in blood, but lynched by the Supreme Court.

In 1869, the iron-fisted U.S. Grant sent troops to guarantee the right to vote and Reconstruct the south. Poor whites and blacks shared public offices. Their kids shared schoolrooms. Much of the south sang of multi-racial harmony. There indeed had dawned a new birth of freedom.

But then came, yet again, the Autumn Freeze.

Racist terror raged through the Jim Crow south.

Dressed like beds, torching crosses, raping innocents, hating Jews, lynching their own mixed-blood cousins…the KKK turned to death all it touched…including the dream of a diverse peace.

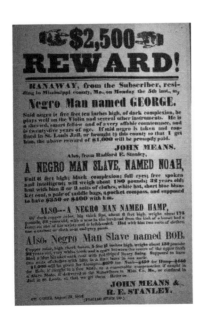
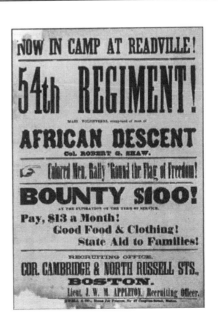

*THE DIFFERENCE A* REVOLUTION *MAKES: The 1850 Fugitive Slave Act let slavers pursue and offer rewards for their escaped "property," even in the North; but after Ft. Sumter, those ex-slaves were paid to hunt down their former "owners." Massachusetts' 54th Regiment informs the cinematic masterpiece* Glory!

# FALL
## *Jim Crow Democrats & their KKK Terror*

*At Appomattox (April 9, 1865) Lincoln's victorious Union responded to four years of ghastly carnage with a landmark gesture.*

Astride his horse Traveller, Robert E. Lee rode in to surrender. Icon of the Lost Cause, he wore his finest Cavalier grays.

U.S. Grant came late. His shabby private's uniform was a muddy mess. But he was the victor.

For a surreal moment they chatted amiably about the Mexican War, where they'd briefly met. Then it was down to business. Quanah Parker, a Comanche war chief, kept the official record.

Lee was a traitor. Lincoln had offered him command of the Union Army. Instead, he led a carnal crusade for history's most vicious form of human bondage. Many of the 620,000 dead now rotted under Lee's Virginia plantation, which became Arlington National Cemetery.

By law, the Union could have hanged him, as Lee had done to John Brown six years prior. Instead, Grant offered 25,000 rations for the starving southerners. He let Lee keep his sword. The rebels kept their sidearms and horses for spring planting. The victor in one of history's bloodiest wars took no prisoners, issued no indictments, staged just one execution (of a foreign-born prison camp commander).

It was an exceptional moment. It recalled Washington walking away from his Revolutionary Army, and then again from the presidency. It signaled a time to clear wreckage, heal wounds, embrace an America free at last of chattel slavery.

It was also a strategic necessity. Lincoln and Grant well knew what it might mean to fight an outlier army of angry grey guerrillas fanning into the hills and hollers, fields and forests. It was a lesson we learned in our own Revolution…then forgot in the Everglades, Great Plains, Philippines, Korea, Vietnam, central America, Iraq, Afghanistan…wherever our imperial Calvinist legions have hit local resistance.

Two days after peace, Lincoln and his son Tad walked Richmond's streets. They brought no military escort. They were mobbed by grateful freed blacks and curious poor whites. Abe asked a band to play "Dixie," then conversed with a free black man, horrifying the former slaveocracy.

On April 14, a deranged actor, working with at least six co-conspirators, put a bullet in the back of Abe's head. It was a ghastly plunge into eternal psychosis that haunts us still.

Soon after Appomattox, as Abraham moldered in his grave, Robert E. Lee became president of Washington College (later Washington and Lee). He lived until 1870 and oversaw the first US college courses in business and journalism. "We have but one rule here," Lee wrote, "and it is that every student be a gentleman."

The KKK had no such concerns amidst the Jim Crow rampage for caste, power and property that still tears our nation apart.

Yet countless Klansmen are themselves descended from raped slaves.

Consider again the progeny of Tom Jefferson and Sally Hemings. Their great-grandmother came from Africa. Their grandmother and mother were considered black. But two of Sally's offspring easily passed for white, as did scores of her descendants.

So let's ask the obvious: How many "white" men and women in the American south today are of at least partial African descent?

*How many "White Supremacist" KKK fanatics and latter-day bigots are themselves part black?*

Over the course of the centuries, how many of these racial purists and forever haters are themselves of mixed race, out raping and lynching, jailing and disenfranchising so-called "n*****s" who are often their own blood cousins.

As of late 1865, more than 4 million American slaves were technically freed.

African-Americans then comprised a third or more of many deep south states. If they voted with liberal white Republicans *(there were a few)* they could take power.

The Party of Jackson responded with a century-plus of murder. From the 1860s to the 1980s, KKK terrorists assassinated at least 4,000 of their black kin.

Some killings were random. But most were the targeted, intensely political purges of black women and men who dared to organize their communities. Klan lynch mobs insured Democrat control of the south (plus Congress and the courts).

The Thirteenth Amendment also allowed for "involuntary servitude" in response to even minor---often non-existent--- "crimes." So in service to White Supremacy, millions of blacks---north and south---have been brutally imprisoned, stripped of their rights, plunged into post-bellum slavery on chain gangs and worse.

*The same agenda drove the 1971-2021 Drug War.*

Andrew Johnson pardoned the slaveocrats en masse. He was impeached by the Republican House. But shy just one vote, the Senate failed to remove him.

*In light of future presidents' illegal wars and attempted coups, it would've been healthy for Congress to oust at least one out-of-control chief executive.*

In September, 1868, in Opelousas, Louisiana, white supremacists murdered some 200 black children, women and men, torching a duly elected black/white government. Similar mass assassinations poisoned the post-war south.

In 1869, Grant took the White House. He hated the Klan, and sent Reconstruction forces to guarantee rights for both freed slaves and poor whites.

The center held for eight path-breaking years. Under federal protection, African-Americans voted alongside whites. Together they elected some 2,000 mayors and governors, Reps and Senators, sheriffs and dog catchers. In the Carolinas, Mississippi, Louisiana the races worked in harmony *(for the first time since Bacon's Rebellion)* to improve education, business, government, sports, music, life.

And then it crashed. In 1876, with Grant not running for a third term, New York's Tammany Democrat Samuel Tilden beat Ohio's Rutherford B. Hayes by 250,000 ballots. But the Republicans stole enough Electoral College votes to perpetrate a tie.

For five months the nation stood at the brink of a new Civil War. Then came the deal: the Dems offered Hayes the White House if he'd end Reconstruction.

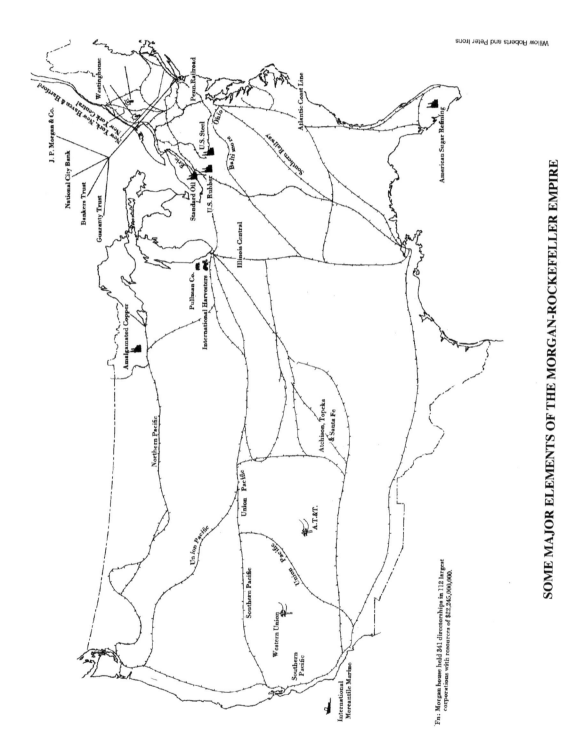

Willow Roberts and Peter Irons

**SOME MAJOR ELEMENTS OF THE MORGAN-ROCKEFELLER EMPIRE**

Fn: Morgan house held 341 directorships in 112 largest corporations with resources of $22,245,000,000.

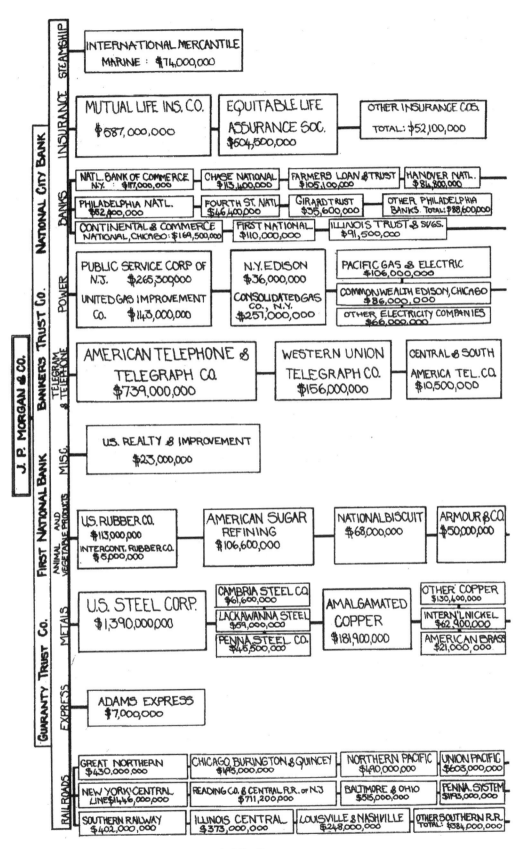

J.P. Morgan holdings: a partial listing

He did, killing any immediate hope for southern justice. The Klan ran wild. Democrat terror retook Dixie with disenfranchisement, mass incarceration, targeted murder, lynchings, beatings, rape, cross burning, more.

Facing literacy tests, the poll tax, the whites-only primary, a rigged legal system and a brutal prison gulag, the black community was all but re-enslaved. After a contested election in Colfax, Louisiana, 1872, the KKK slaughtered up to 150 citizens of color. From 96% in 1876, the southern black voter turnout dropped to 61% in 1880, 11% in 1898, 2% in 1912. In Florida, de facto felony disenfranchisement laws are still in force.

In March 1881, Tsar Alexander2 was killed by youthful idiots claiming to be revolutionaries. "Russia's Lincoln" had a repressive side. But he was the last reform-minded Tsar until the rise of Gorbachev a century later.

On July 2, an unhinged office seeker shot our own newly elected President James A. Garfield, a gentle genius who could write simultaneously in Greek and Latin.

The beloved Ohioan might well have led the nation on a great leap. His friend Alexander Graham Bell invented a device to find the bullet. But the bumbling Dr. Willard Bliss prevented its proper use, fed him a terrible diet, and turned Garfield into Tecumseh's third presidential victim.

As the new century dawned, Jim Crow ran the industrializing "New South" with an iron fist that carried deep into Congress and the courts. Even after the horrors of Civil War, racial segregation kept blacks and whites locked in their unequal castes.

Supreme Court dicta like *Plessy v. Ferguson* (1896) and *Williams v. Mississippi* (1898) enshrined the new American *apartheid.* Blacks and whites were banned from playing sports, checkers, cards, or music together. The Jim Crow elite fearfully segregated public schools, transportation, hotels, restaurants…lest blacks and whites again get to know, like, organize and rise up together.

Justice John Marshall Harlan, in his iconic *Plessy* dissent, *saw* the impact…

*…What can more certainly arouse race hate, what more certainly create and perpetuate a feeling of distrust between these races, than state enactments which, in fact, proceed on the ground that colored citizens are so inferior and degraded that they cannot be allowed to sit in public coaches occupied by white citizens.*

In 1898, a white supremacist mob crushed Wilmington, North Carolina's duly elected mixed-race government. At least 60 people were slaughtered. More than 2,000 fled. It was Reconstruction's fatal freeze.

Southern slavery was legally gone. But its freed victims were destitute, disenfranchised, degraded. A KKK "cotton curtain" separated the races. Andrew Jackson's Jim Crow Democrats ruled the former Confederacy with a burning cross.

And in the north….

# WINTER
## *The Gilded Age*

*The Civil War made a few businessmen very rich.*

In 1861, $300 got you out of the Union Army; just owning 50 slaves exempted you from the Confederates'.

Among northerners who bought their way free were J. Pierpont Morgan, John D. Rockefeller, Andrew Carnegie, James Mellon, Philip Armour, Jay Gould. Mellon's father wrote him that "a man may be a patriot without risking his own life or sacrificing his health. There are plenty of lives less valuable."

The "more valuable" made fortunes selling guns, ammo, uniforms, food, boats, rail and telegraph services, medical supplies, and more to both sides.

War was *(as always)* a racket.

The bone spur Barons spawned a modern corporate beast with just one genetic imperative—to make money. Void of moral constraint, corporations still claim human rights while scorning human accountability. Transcending that "conservative" Robber Baron mindset may be our ultimate survival test.

In 1776, says Richard Grossman, there were six chartered American corporations. Their dark magic was the privilege of going bankrupt without personal consequence. The costs of incompetence, fraud, theft and greed STILL trickle down from the perpetrators onto the public.

America's early corporations were chartered by the states. They were limited in what they could do and where they could do it. Adam Smith's 1776 *Wealth of Nations* warned that big monopolies would shred markets and trash the general welfare. The Gilded Age proved him a prophet.

Through the post-bellum era, states like New Jersey and Delaware issued corporate charters that let new industrial behemoths do any kind of business anywhere they wanted. For the alleged free market, it was a death sentence.

The tombstone was chiseled with the Supreme Court's 1886 *Santa Clara* case. Court clerk Bancroft Davis, a former railroad president, dubiously claimed that the Justices deemed corporations to be "persons" under the Fourteenth Amendment.

The Supremes may have said no such thing. But the corporate personhood virus festered for decades…all the way through *Buckley* (1976) and *Bellotti* (1978), *Citizens United* (2010) and *McCutcheon* (2012). Over time the corporation became our *de facto* Supreme Being, with inalienable rights to buy any election, commit any crime, destroy any eco-system in "libertarian" pursuit of profit, power and privilege.

They rose with the big textile factories. In Lawrence and Lowell, countless bobbins spun slave-raised cotton into global gold. The women who ran them came mostly from farms, lived in dormitories and *(like Rosie the Riveter)* loved their freedom.

69

But after Appomattox, America's industrial revolution hit critical mass. Shop floors morphed into hell-holes. Owners became monsters---and mobsters---feasting on the cheap labor tsunami (1848-1921) that poured in from Ireland and Germany ... then from Greece and Italy, Poland and Russia and, until 1882 and 1907, from China and Japan. Andrew Carnegie crowed that based on 1860 auction prices, the incoming wage slaves who fueled our bully industrial youth were worth untold billions.

Millions of them died in factories, stockyards, slaughterhouses, mines, ships, trains. Their filthy tenements beggared those of India and China. Newcomers restocked the production lines as the maimed and dead were carted away.

Likewise the Indigenous. Raised in Ohio, William Tecumseh Sherman's parents had known the great chief. On the Great Plains, he disgraced his middle name...

*...We must act with vindictive earnestness against the Sioux, even to their extermination, men, women and children.*

As in Australia, New Zealand and Canada, Indigenous children were torn from their parents. In hellish jails and brutal boarding schools they suffered physical, cultural and sexual abuse beyond imagining.

At Little Bighorn (1876) Lakota war chiefs Sitting Bull and Crazy Horse fought back, wiping out 268 US cavalrymen. But during a sacred 1890 Ghost Dance at Wounded Knee, US troops machine-gunned some 300 starving Lakota. Twenty soldiers got the Congressional Medal of Honor for what their Commander, Nelson A. Miles, called "a horrible massacre of women and children."

As the frontier died, the prairie swarmed with settler-colonists and their trains, towns, trade, taxes, corporate tyrants. They virtually exterminated the buffalo, stripped the sod, sowed the seeds of a Dust Bowl eco-catastrophe. Their yard-fattened livestock launched cholesterol's terminal attack on America's cardio-vascular core.

Corrupt pols handed huge swaths of Indigenous land to Barons whose cheap, rickety rails tore up the prairie like infectious lashes on a slave's ravaged back.

In 1869, at Promontory Summit, Utah, Irishmen working west from Missouri met Chinese laborers coming east from California to link the oceans. But Baron Leland Stanford couldn't lift the hammer to drive in the ceremonial gold spike.

So a worker got it done...and a flunky rushed in to retrieve the spike.

Conservative historians still swoon over Big Shots like Stanford who "built" America's industrial machine. What they really did was grift Trumpian scams to get themselves Hamiltonian tariffs, outrageous graft, obscene land grants.

It was the farmers and workers *(their names don't make the history books)* who plowed the fields, cut the forests, swung the hammers, suffered long, died early. Their blood, sweat and tears still define our ability to evolve and survive...

# A Mound of Eco-Death

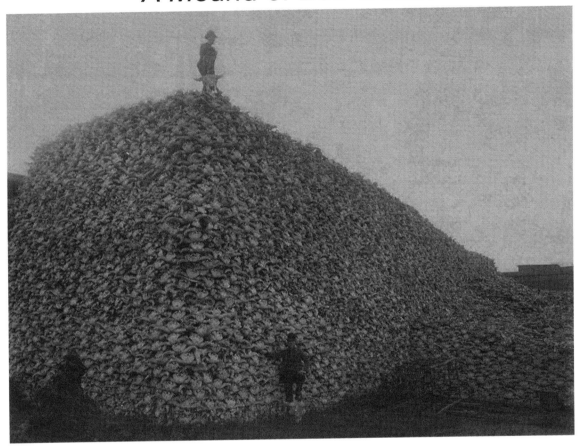

This hideous mountain of bison skulls was formed (circa 1870) by "sportsmen" shooting from moving trains.

The carcasses rotted as the herds fell from tens of millions to near extinction, depriving the Great Plains Indigenous of their primary sustenance.

*It is WE who plowed the prairies*
*built the cities where they trade*
*Dug the mines and built the workshops*
*endless miles of railroad laid…*
*They have taken untold millions*
*that they never toiled to earn*
*But without our brain and muscle*
*not a single wheel can turn.*

From rolling passenger rail windows, "sportsmen" shot countless buffalo, driving these precious animals---and the tribes they supported---to the brink of extinction.

Wall Street sharks did the same to small investors…and the president.  In 1869, Jay Gould crashed the stock market to make a killing in gold.

Tough-guy Grant was out of his league.  The Ohio horse-whisperer… honest but naive…was no match for the frenzy-feeding Barons who gorged on his presidency.

The ensuing "Gilded Age" *(Mark Twain's term)* was run by 400 families, based mostly in Manhattan.  They groped our assets, trumped our government, towered above the law. Working families starved and died while the corporate elite lit cigars with $100 bills, staged banquets for pet dogs, put diamonds in their teeth, gouged out gargantuan estates, lived as if the arc of history had no bend…or end.

At the dawn of the "American Century," the Barons became both the Elect of God and the Select of Nature.  Puritan theocracy and Charles Darwin's *Origin of Species* fused into a "Social Darwinist" psychosis.

Darwin himself hated slavery and admired John Brown.  But riches now signified both Puritan divinity AND genetic superiority.   As in the libertine eyes of the later Ayn Rand, no act of thievery was ever too low, no pile of cash was ever too high.

Helping the poor became a sin against God…and a crime against nature.  To worry about "the general welfare" as mandated in the Constitution was to defile the Divine order and weaken the "supreme" white race.

As the machine-gunned Lakota froze at Wounded Knee, Commanding Officer Nelson Miles framed the trifecta of our Manifest adolescence:  he slaughtered the Indigenous in our final continental conquest; he gunned down union workers at Eugene V. Debs's 1895 national rail strike; then he opened the overseas genocide at the Empire's new outposts in Puerto Rico and the Philippines.

In its Gilded winter, at the end of our second cycle, the Barons' "Gay Nineties" became a "Great Depression" for the rest of us.

As they crushed our First Peoples and suppressed farmers and workers, the new mega-corporations colonized Latin America and the Caribbean, took Hawaii and the Philippines, and busted through China's "Open Door" to share an imperial gang bang with England, France, Italy, Germany, Russia and Japan.

Our "Bully Manhood" would bring not a third American Revolution…but, instead, a First World War.

# CYCLE 3: *"BULLY MANHOOD"*

| *Bryan/Debs*<br>**Teddy / Wilson** | **Bohemian Spring**<br>Square Deal/New Freedom | **WILSON'S WAR**<br>*Socialist Peace* | Red Scare<br>Palmer Raids | Roaring<br>'20s |
|---|---|---|---|---|

# A Burst of Energy
## Bryan, Debs, Teddy, Wilson

*On a continent bursting with natural resources, riding a tsunami of cheap human labor, we entered our young adulthood as the world's #1 industrial power. Theodore Roosevelt called it our "Bully Manhood."*

A techno-revolution set the stage for the American Century.

Conceived by Thomas Edison and Nikola Tesla, utility power lines flashed electrons from coal-burning power plants that heated our Earth and blackened our air, land, water and lungs. Charles Brush developed the first wind-powered electricity, as well as the pole lamps that lit the streets of Cleveland.

The phonograph, wireless radio, motion picture, automobile, and airplane all arrived between 1877 and 1905. So did Sigmund Freud's new psychology, Friedrich Nietzsche's "Superman," and Albert Einstein's four epic breakthroughs *(including E=MC2)* that in 1905 changed everything.

Our body politic shattered into four social classes: the Robber Barons, family farmers, factory workers, and an educated middle/upper class that managed the new industrial machine.

At the countercultural vanguard were *Bohemians*, the latest incarnation of the forever free thinkers riding history's magic bus from Awakened Northampton and Thoreau's Transcendentalism to 1930s radicalism, the '60s hippie farms...and then deep into the diverse Solartopian eco-activism of the 1970s and beyond.

In rebellious joy, before Woodrow's War, they lit up our third Great Awakening.

At the era's core was a cataclysmic struggle for control of the industrial machine. Each contender had its own Messiah.

For southern and western farmers, things went downhill right after Appomattox. Jefferson's ideal of a yeoman utopia, self-sufficient on the land, growing its own food, fell into the death maw of an industrial cash economy.

As homesteading families poured into the prairie, they stripped away the sod for grain and cattle. Their ultimate crops were fiscal failure, ecological ruin and heart-stopping cholesterol.

Forever strapped for cash, the new pioneers fell prey to the rising Baronial monopolies. The seed, machinery, rail fees, homes, loans, transportation and tax payments the farmers needed in the dawning age of corporate agribusiness were all controlled by green-shaded bean counters in faraway cubbies whose pencils sketched their doom. In the south, destitute po' whites and black ex-slaves alike were crushed between the old plantations and "New South" factory farms, backed by Barons who turned urban centers like Atlanta and Birmingham into industrial machines.

It was more than even those rugged Jacksonian "self-made" macho men could handle alone.

In 1867, the Patrons of Husbandry championed good farming, civic virtue, and mutual aid. Their Grange meeting halls were safe havens for desperate agrarians under corporate attack.

After 1876, the Greenbacker Party demanded freely coined silver and more paper money. Inflation would water down farm mortgages and raise crop prices.

The Hearst family based their fortune on that silver. Their mines financed the "yellow journalism" hate sheets that howled for imperial war and corporate greed.

In the late 1880s, Grangers and Greenbackers formed Farmers Alliances to dodge the monopolies. They birthed co-op market exchanges, credit unions, community banks, and a grassroots infrastructure.

It all fed the People's Party.

Against epic odds, these dirt-poor "Populists" forged a transcendent coalition of southern and western, black and white, ex-Democrat and ex-Republican, former Yank and Johnny Reb farmers. They revived the Leveller spirit of Tom Paine's *Agrarian Democracy* and Ben Franklin's civic virtue. They rebirthed the Minutemen who took Tory land for the greater good. They *SAW* an economy where human need trumped corporate greed. Said Pop firebrand "Sockless" Jerry Simpson...

*...It is a struggle between the robbers and the robbed!*

In Omaha they leapt toward social democracy. Their 1892 People's Party platform demanded votes for women, direct election of US Senators, the initiative, referendum and recall, a reformed judiciary, a strengthened Bill of Rights, a currency based on crops, popular control of the banks and electric utilities, railroads, steamships, telecommunications networks, and an end to war and empire (though some wanted both for overseas markets).

For president they chose the former Iowa Greenbacker and Union General James B. Weaver. Virginia's former General Benjamin Fields would be his VP.

So with blue/grey brass topping the ticket, the Pops meant to unite mostly white Republican Union veterans in the west with mostly white ex-Confederate Democrats in the south...and black ex-slaves who warily left the party of Lincoln.

It was a fragile coalition. But Populist candidates counted more than a million votes in 1892. They seemed poised at the brink of the unthinkable: uniting white westerners with black/white southerners in a brave new multi-racial Reconstruction.

When the economy crashed in 1893, the People's Party was set to repeat history. A young GOP took the presidency in 1860. Why not the Populists in 1896?

But history threw them a screwball. His name was William Jennings Bryan.

At their 1896 convention, grassroots Democrats blamed incumbent President Grover Cleveland and his conservative "Gold Bugs" for the raging Great Depression.

Amidst the chaos, a young (35) Nebraska Congressman took the nomination. Raised evangelical, Bryan preached holy spellbinders for hope and change...

*...Food and clothes for the thousands of hungry and ill-clad women and children...the reopening of closed factories, the relighting of fires in dark-ened furnaces...hope instead of despair; comfort in place of suffering; life instead of death.*

But Bryan's actual policies were fake. His one hard demand was for free silver. His contempt for grassroots populism was tangible. His Democrat running mate was a Maine banker. When it came to hard core social change, the Great Orator was a fitting model for the cowardly lion in Frank Baum's 1900 Populist satire, *The Wizard of Oz.*

GOP kingmaker Mark Hanna *(the Karl Rove of the day)* said that if Bryan won, they'd just shoot him. Nobody thought he was kidding.

The Populists were trapped. The westerners joyfully endorsed Bryan. But the southerners were divided and confused.

Opposing Byan would invite blame for electing McKinley. But supporting him meant joining the Democrats. For a black or white Populist in Jim Crow Dixie, that was virtual suicide.

Thus was born the corporate two-party system's signature "lesser of two evils" death trap, forever shattering grassroots movements and sabotaging real social change.

If they stuck to their principles, and supported their own party, the Pops would help elect a Republican. But if they supported the Democrat, their movement would implode. Bryan would betray their grassroots campaign. And then he'd lose anyway.

*It was the modern duopoly's electoral quagmire, the schizoid death trap perfectly set to kill any effective bottom-up challenge to the money power. Time and again since 1896, the corporate Democrats have convened the circular firing squad to dispose of America's grassroots left. The impacts have been catastrophic.*

Thus Billy Bryan dug the American farmer's political grave.

The western Populists had little problem leaving the Baronial GOP to support a Nebraskan. Out on the prairie, Bryan's being a Democrat was tough…but bearable.

But for southerners *(black or white)* to back *any* Democrat was political poison. Many swallowed. But most *(rightly)* feared the worst.

To snare the Populist nomination, Bryan promised to honor their radical demands for real social change.

Of course, he lied.

About a third of the Populists supported Eugene V. Debs, the charismatic founder of the American Railway Union. Debs became a labor icon in 1894-5 when President Cleveland *(yet another Democrat happy to crush the unions that supported him)* jailed Gene for leading a national rail strike.

Tall, thin, amiable, incorruptible…a transcendent writer and speaker…the "American Saint" preached the Social Gospel of Jefferson's Jesus, a *Sermon-on-the-Mount* communal creed of universal justice. Caring and charismatic, Debs was HUGELY loved by our working/middle class masses.

Their world erupted at the 1877 Great Railway Strike.

Tom Scott of the Pennsylvania Railroad lit the fuse. Without warning, he slashed workers' wages---but not his own---by ten percent. Furious trainmen grabbed engines, torched rail yards, shot supervisors, shut the system from St. Louis east. Dozens were killed by troops sent to crush them.

The 45-day strike spanned four states. It paralleled the Populist uprising just then spreading through the farms and fields of the west and south.

But Scott and his young aide, Andrew Carnegie, were rich guy masters of divide and conquer. America's immigrant working class was atomized by language, race, gender, ethnicity, religion, geography, trade. When strikes *(like Bacon's Rebellion)* threatened to succeed, the Barons puked up strike-breaking scabs and had their "elected" mayors and governors send in troops for tax-funded slaughter.

Straight as an arrow, Debs opposed the 1877 Great Railway Strike. He worked the rails, then rose through the union ranks. Trusted everywhere for his honesty and devotion, Gene organized the American Railway Union, meant to unify all train workers into one big organized industrial family….the true key to a democratic future.

Busted and imprisoned by Grover Cleveland, whom he'd supported in 1892, Debs became Labor's new Honest Abe. Populists and unionists *saw* Gene leading a farm-labor/rural-urban alliance to crush the Barons and take national power.

They hoped in 1896 that he'd run with Tom Watson, a firebrand Georgia lawyer who embraced a southern multi-racial alliance. In coalition, the west / south / black / white / urban / rural / immigrant / Indigenous / farm / labor / feminist / Bohemian coalition would transcend the two-party system. The new American Century would dawn as a social democracy, not a corporate empire.

But at that crucial moment, Debs was behind bars in Woodstock, Illinois…jailed by the feds for "conspiring" to shut down the national rail system.

Cautious by nature, Gene stuck with Bryan. Without Debs, the Populists were left to meekly beg the young Nebraskan to carry their banner and to accept Watson as his VP. Despite his promises, he did neither.

Thus the farm-labor ships passed in the night. The critical alliance that might have fused agrarian radicals with urban unionists did not happen. In our annals of *"what ifs,"* this remains among America's most profound.

Had the St. Louis Convention ignored Bryan and nominated Debs---likely running him with Tom Watson---could they have won in 1896 *(or 1900)* as did the Republicans in 1860? Could their farm-labor alliance have birthed a social democracy powerful enough to subdue the Barons' corporate empire?

We'll never know.

*We DO know that once he got the Populists' nomination, Bryan snubbed their grassroots candidates, including Watson. Except for free silver, he backed virtually nothing from the People's Party platform. Thus he set the corporate Democrat play-book for twelve decades of triangulation and deceit, dividing and co-opting grassroots movements while delivering electoral defeat and political ruin.*

Like the later Bill Clinton, Billy Bryan DID have charisma. He ran an epic whis-tle-stop campaign, criss-crossing the country in the era's first political/evangelical crusade.

From the back of his train, the new agrarian messiah delivered up to 36 spellbinders a day to some 5 million fans. Passionate crowds hung on his every word.

A set of triplets was named William, Jennings, and Bryan. To the frenzied masses, he seemed sure to win. With a fair vote count, maybe he did.

The corporations ran Ohio's Republican Sen. William McKinley, as dull as a doctored vote count. Cleveland steel Baron Mark Hanna raised him a staggering $15 million in corporate cash. He deployed scores of dirty tricksters, dispatched hundreds of speakers, planted thousands of newspaper articles, spewed out millions of pamphlets, stuffed countless ballot boxes…did just what he needed to win.

It was the primal Baronial blitzkrieg, the birth of modern mass election theft.

Along the way, Hanna bragged that he could hire half the working class to shoot the other half (including Bryan, if he'd won).

But there was no need.

The official vote count gave McKinley a six million margin. With perfectly straight faces, Hanna's henchmen explained that farm animals ate all those Bryan ballots. Or they were washed away by floods and hurricanes. Or they were lost (then found) having miraculously morphed into votes for McKinley.

Bryan's defeat shattered the fragile Populist coalition. Westerners blamed southerners. Southern whites, including Tom Watson, blamed their black allies. Jim Crow retook Dixie. Lynch mobs ran wild. Democrat bigots (often calling themselves "populists") rode the KKK back to absolute power.

Except in the upper Midwest, agrarian radicals lost their voice. Once America's backbone, the family farm was disenfranchised, decapitated, doomed to disintegrate. Jefferson's yeoman and Jackson's frontiersmen fell into a spiral abyss that ate our small-town democracies and bared the land to corporate rape.

Now the face of the Democratic Party, Bryan launched a lifelong career as a vacuous windbag. He loudly opposed our imperial plunge…but helped conquer Cuba. He quit as Secretary of State to protest Wilson's senseless leap into World War I…but got nothing of substance for our dying agrarian community.

Since the 1896 fiasco, countless fake "populists" have betrayed the promise of the People's Party…trashing the public trust to serve the Baronial elite…playing the part of grassroots messiah while steering the course of corporate conservatism.

Such is the substance of modern corporate "moderation": divide and confuse, using race, misogyny and militarism to bury the substance of social democracy.

Our imperial death spiral has been the tragic consequence.

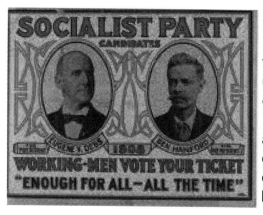

But still we had Gene Debs.

The 1877 Great Railway Strike lit his fuse. The Knights of Labor---our first national union---accepted women, blacks, the unskilled. It demanded social change. But it would not strike.

The Barons (right up to Jeff Bezos) wanted all unions dead. The workers who made them obscenely rich were their useful idiots. Union organizers and peaceful demonstrators were fired, beaten, jailed, shot.

78

But step by bloody step, they gained a foothold...

*Now we stand outcast and starving*
*mid the wonders we have made*
*But the Union makes us strong.*

*We can break their haughty power*
*gain our freedom when we learn*
*That the Union makes us strong.*

From this great grassroots rebellion arose the "American Saint."

Gene Debs's American Railway Union was a radical sanctuary, open to all. Born in Terre Haute to French immigrants, he married (at 30) the Victorian Kate Metzel, who built him a "House Divided." When Gene came out as a Socialist, she fainted. While he travelled ceaselessly, they stayed married---and childless---with differing opinions anchored to a deeper bond.

In 1894, in solidarity with a small contingent of Pullman workers, Gene's ARU launched the second Great Railway Strike and shut down the national system. In response, Cleveland's federal troops killed at least thirty strikers.

Hearst and the pre-FOXist corporate media called Debs a "dictator...an enemy of America." The feds jailed him for "conspiracy." From his Woodstock cell, he supported Bryan.

But a steady flow of radical writers and organizers turned his head. With time to read and think, he denounced capitalism. Puritan greed could never sustain a just or sane society...

*...I am for Socialism because I am for humanity.*
*We have been cursed with the reign of gold long enough.*
*Money constitutes no proper basis of civilization.*

Gene's epic leap to a whole new way of thinking thrilled our toiling masses, who made him our rock star labor leader. At last American workers could *SEE* an economy answering to human need, not corporate greed or Calvinist empire. Said Debs...

*...Every robber or oppressor in history has wrapped himself in a cloak of*
*patriotism or religion, or both.*

Like the Quakers and Owenites, Oneidans and Abolitionists, American Socialists sang of utopian justice. They embraced our common humanity and demanded food, clothing, housing, education, medical care, dignity...a fair share for all.

The means of production would be owned by the public, run by the workers. Gene rejected Marx's call for a "dictatorship of the proletariat." Throughout his career, the American Socialist Party stood by the freedoms of speech and press while the Democrats and Republicans trashed and abused them at will.

Debs embodied Abigail Adams's feminism, Tom Paine's *Agrarian Democracy*, Franklin's civic virtue, Madison's *Bill of Rights*, Thoreau's civil resistance, Emerson's

hatred of war, Douglass's abolitionism, Tubman's dogged persistence, Lincoln's lyric genius, Mark Twain's hatred of empire.

In the eyes of the American Socialist Party, racism, sexism, class, conquest, and war were our Original Sins. Real democracy meant sharing the wealth. It was a *human right* to be fed, housed, clothed, educated, employed, medically secure.

Fueled by tens of millions of immigrants, the socialist movement's natural divisions ran even deeper than the Populists'. Its ethnic diversity was staggering, its language barriers impossible, its personal and ideological rivalries insane. The eternal infighting of its fragile coalitions drove even the toughest organizers mad.

But as the new century dawned, humanist ideas and ideals melded into our mainstream. Millions assumed *(as long as Gene was around)* that the Socialist working/middle class would soon take national power.

Debs ran for president in 1900, 1904, and 1908. Huge, frenzied crowds cheered his relentless attacks on the Baronial rich. The "Honest Abe of the Working Class" drew a million official votes *(likely a vast undercount)* in 1912's epic four-way race. Despite dubious electoral conditions, Socialists won seats all over the US. Throughout the Heartland, Democrats and Republicans openly fused to beat them.

In 1916, Gene ran for Congress from Terre Haute. Surrounded by devoted family, lifelong friends and impassioned neighbors, his "official" ballot tally was *zero*.

While Debs's Socialists struggled for a fair vote count, Progressive technocrats seized the new century's burst of energy. Their Visible Saint was Teddy Roosevelt, the Bull Moose.

TR hailed from old Long Island Dutch aristocracy. Endowed with patrician wealth, astounding intellect, and volcanic energy, he was a true Force of Nature. He rose as New York City police commissioner, then mayor, then governor of the Empire State. Meanwhile he led the imperial assault on Cuba and gloated...

*...I killed a Spaniard with my own hands.*
*Look at those damned Spanish dead!*

Theodore scorned "uppity" blacks and suffragette women, radical farmers and organized labor. But he also swore to bust the decadent Baronial monopolies. His Progressive phalanx was a new technocratic class. They were middle managers, corporate lawyers, financial experts, professors, researchers, government regulators, factory supervisors, industrial farmers, military strategists, teachers, politicians, librarians, skilled workers...the literate managerial shock troops of the American Century's reformist bureaucracy.

Proudly puritanical, almost exclusively white, the new techno-scientific Elect would rule the planet and remake the race.

TR was their Oliver Cromwell and Andy Jackson. Asthmatic as a kid, he ranged the western wilds with the passionate persistence of a Biblical fanatic. His manic energy seemed to border on the superhuman. He read as many as four books a day and wrote countless screeds, including a history of the frontier whose natural beauty he loved, but whose Indigenous he scorned.

TR's contempt for immigrant and union rights was legend. The "health of the race" demanded that white females bear as many children as possible. He met with the African-American leader Booker T. Washington, but made clear his belief that humans of color were inferior. As for his love of battle…

*…No triumph of peace is quite so great as the supreme triumphs of war.*

Armed struggle, he said, thinned the masses, selected the superior, boiled the blood, forged a master race.

Comfortably rich, he had zero tolerance for cloakroom crooks. The Republican machine wanted him out of New York. In 1900, they conspired to bury him in the Vice Presidency. Mark Hanna frantically warned them it was a bad gamble.

Sure enough (*to the horror of the hacks*) Tecumseh's Curse struck McKinley dead. His accidental successor quickly set out to bust the trusts, bury the unions, conquer a global empire.

At home, TR preached a half-way covenant. Corporate capitalism would rule the roost. But it would bend to government intervention.

So his "national socialism" would combine a "Square Deal" with Progressive regulation. Already on the books were the Interstate Commerce Act (1887), Sherman Anti-Trust Act (1890), and other federal impositions meant to curb the Barons while leaving their private fiefdoms essentially untouched.

Proclaiming himself a "Trust Buster," Teddy became a popular hero by suing to break up U.S. Steel, Standard Oil, and their sibling monopolies. But his tangible impact was marginal. Wall Street lawyers captured the regulatory commissions. Multi-colored stock certificates hid the "busted" trusts behind interlocked directories.

In 1907, Roosevelt did support a federal child labor law. The Tillman Act banned direct corporate campaign contributions.

But he also seeded a Federal Reserve slush fund to bail out Trumpist Barons who forever overreached. In the century to come (*in our own unique form of "lemon socialism" or "socialism for the rich"*) the Fed would slip trillions in public cash to bankers who were "too big to fail" even for an alleged trustbuster like TR.

Most memorably for the public good, Teddy followed Lincoln and Grant in working to preserve our natural resources. The priceless network of national parks he helped establish is among the greatest legacies of any president…until the Reagans, Bushes and Trump began to rip it apart.

In 1908, Teddy handpicked William Howard Taft to run the government for him while he and his son set off for Africa, where they killed more than 500 large animals.

Taft weighed 350 pounds and got famously stuck in the White House bathtub. He also stuck the public with a bevy of regulatory agencies that laundered corporate greed while doing little to check its epic abuses.

In 1912, Teddy demanded that the GOP give him back the White House. But at a rigged convention, Taft dared to deny him the nomination. So TR ran as a "Bull Moose" and split the party.

In Milwaukee, an angry barkeep shot him. With the bullet lodged *(like Andy Jackson's)* near his heart, Teddy spoke for another 75 minutes. It did stop his campaign. But his Bully mix of war and empire, regulation and privilege, conservation and exploitation, racism and misogyny lived on.

The four-way 1912 presidential election was *(like 1824 and 1860)* a sure sign of national crisis. Taken together, TR, Taft, and Debs far outpolled (59-41%) Gov. Woodrow Wilson. But the New Jersey Democrat won the awful Electoral College.

Woodrow was the ultimate technocrat. The former President of Princeton held the first Ph.d. in political science. He won tariff and market reforms along with regulatory agencies essentially run by the corporations they were meant to control. Pompous, dour, an outspoken White Supremacist, Wilson later jailed peace advocates for quoting from his own books, including *(without irony) The New Freedom.*

Teddy, Taft and Wilson were the Progressive scene-setters for history's ultimate corporate-imperial crusade. Amidst a mind-bending explosion of industrial wealth, technological transformation, desperate mass poverty and social upheaval, the nation shook like a human volcano.

The American Century's monopoly-capitalist Puritan Elect was now primed to conquer, exploit and remake all of humankind in the name of God, progress, the free market and *faux* democracy.

Henry Adams---the grouchy great-grandson of our grouchy second president---shrieked of a widely shared terror....

*The outline of the city became frantic in its effort to explain something that defied meaning....*

*...Power seemed to have outgrown its servitude and to have asserted its freedom. The cylinder had exploded and thrown great masses of stone and steam against the sky....*

*...The city had the air and movement of hysteria, and the citizens were crying, in every accent of anger and alarm, that the new force must at any cost be brought under control....*

*...Prosperity never before imagined, power not yet wielded by man, speed never reached by anything but a meteor had made the world irritable, nervous, querulous, unreasonable, and afraid.*

# SPRINGTIME
## Bohemian Rhapsody

*In those astonishing days of modern industrial shock and awe, some of us were young and joyous and knew no fear.*

*For these the new century was a Bohemian Rhapsody, a Yippie springtime born of magical new music, fabulous literature, transcendent art, great sex, utopian community…and all the poetic yearnings for social democracy and communal joy that come with each newly Awakened wave of Indigenous uproar.*

This one got woke by African-Americans who never took slavery lying down and would not bow to Jim Crow.

High atop the food chain, Booker T. Washington established Alabama's Tuskegee Institute to educate black professionals. He embraced the ruling corporate ethos. But he trained African-Americans to fight on their own terms. Racism, he warned, was a "cancer gnawing at the heart of this republic."

W.E.B. Du Bois became a Communist. Harvard's first black Ph.d. wanted a "talented tenth" to reshape the nation. In 1909, he helped form the multi-racial *(still-fighting!)* National Association for the Advancement of Colored People.

Ida B. Wells demanded the right to vote. So did Mary Church Terrell, who helped form the NAACP while pioneering public education. Marcus Garvey *(the flamboyant Jamaica-born firebrand)* preached black power.

They all danced to a transcendent new music that rolled out of the Big Easy and changed the world: *Jazz.*

Its roots were in the first Great Awakening, when blacks brought their drums to those raucous outdoor revivals. The shocking impact of African rhythms mashed up on European hymns made us dance and shout…gratefully terrifying Calvin's clergy.

Over the next 150 years, America's musical gumbo simmered and stirred, rocked and rolled. Cotton belt slaves invented three-chord blues for the beat-up guitars they strummed on rickety porches after endless hours of unpaid toil. Minstrel shows and sheet music spread reels and Ragtime, a new pop music invented by the black St. Louis-based genius, Scott Joplin.

New Orleans was the jazz root. America's diverse mecca of a quarter-million souls somehow supported three classical orchestras and two opera companies. Its best musicians were often mixed-race "Creoles of Color"---like Homer Plessy of *Plessy v. Ferguson*---whose genetic ancestry defied description.

And in one of history's great fusions, the law of unintended consequences led racist bigots to inadvertently midwife the new century's transcendent soundtrack.

As the Populists lost their bearings in the 1890s, Jim Crow ruled that Creoles were black. In an age of White Supremacy, a single drop of African blood somehow trumped the race card.

83

So the Big Easy's mixed-race musicians were forced to migrate from the opera and concert halls to the bars and dance halls, where their high-blown virtuosity married and mutated the down-home blues.

The blues were slow. Ragtime was scripted. When Jim Crow smashed them up, the happy accident was an epic fusion that blew open that crack *(free form improvisation)* where the light shone in.

African rhythms transformed the Lord's hymnals into "spiritual music," then Gospel. In Congo Square, ancestral drumming, call-and-response, and raucous free-styling burst into a joyous Delta symphony.

NOLA jammed, sang and danced to Cajun, folk, hillbilly, Indigenous, African, Caribbean, military, klezmer, Yiddish, spiritual, slave songs, European folk, arias, tone poems, trios, quartets, quintets, concertos...you name it. Amidst the city's exceptional diversity, a pre-teen *(Louis Armstrong)* picked a trumpet from the trash and wailed on it from the back of a Jewish family's junk wagon.

Through the new century the music merged and morphed in mysterious ways... riding a magical mystery tour through the blues, ragtime, jazz, swing, bebop, folk, country & western, r&b, rock & roll, disco(!), rap, funk, grunge, rave, new wave, hip hop...*whatever comes next.*

To all those beats marched the new matriarchs. Despite their allegedly hallowed perch on the family pedestal, activist women were regularly beaten and abused by random misogynists---often in uniform---calling themselves "Christians."

With its 1848 Seneca Falls *Declaration of Sentiments,* the nascent feminist movement demanded equal rights, including the ballot, property ownership, reproductive freedom, and more.

In 1872, New York's Quaker-raised Susan B. Anthony got busted for trying to vote. But Wyoming had already (in 1869) granted female suffrage. So did other Populist western states like Montana, which sent Jeanette Rankin to Congress in 1917, where she voted against US entry into World War...then did it again in 1941.

Uppity women were at the fiery heart of Populist and Socialist movements that demanded their equal rights and public franchise. Quaker-led demonstrations upped the ante. In 1919, Alice Paul and her suffragette sisters hunger-struck after being jailed for marching at the White House. Their jailers abused them...a BIG mistake.

The lurid headlines tipped the balance. In 1920, women became our voting majority. The Nineteenth Amendment more than doubled the eligible electorate.

Then Alice wrote the Equal Rights Amendment, demanding *(simple enough!)* that women be treated on a legal par with men...

*Equality of rights under the law shall not be denied or abridged by the United States or by any state on account of sex. The Congress shall have the power to enforce, by appropriate legislation, the provisions of this article.*

A century later, it remains unratified.

Out on the prairie, the Populist Mary Ellen Lease wanted her fellow farmers to raise "less corn and more hell." Union organizers like Mother Mary Jones and

Elizabeth Gurley Flynn fought to abolish wage slavery. The radical feminist Emma Goldman pioneered gay rights *(she was deported)*. Margaret Sanger *(with some racial baggage of her own)* founded Planned Parenthood to fight for women's health care, birth control and reproductive freedom. While fighting for legal abortion, Planned Parenthood provided women's health services, sex education and contraception---thus averting far more abortions than those merely demanding they be banned.

The bisexual Mabel Dodge hosted Bohemian love-fests for the new century's first hippies. An *avant-garde* literary maven, Mabel's lower Manhattan mansion was the salon of choice for hot young activists and *artistes* like her sometime lover Jack Reed, journalists Walter Lippman and Lincoln Steffens, and so many more.

They swayed to ragtime, grooved to jazz, lived great poetry, painted crazy pictures, made random love with reckless abandon, danced for joy on the cultural corpse of Puritan prudery. Max Eastman's witty *Masses* merged leftist politics with urbane writing and flip satire…

*In the summer, I'm a nudist.*
*In the winter, I'm a Buddhist.*

The festivities were jointly fueled by *cannabis* and *peyote* that seeped in from a tribal culture and western frontier being driven near extinction.

Dodge later moved to Taos, married a Pueblo man, and dove deep into the slipstream of Indigenous spirituality. Her life story shines with nature-based vision-questing, soon to spark a psychedelic whirlwind.

Chicago's 1893 World Council on Religion stirred Hindu, Buddhist, Muslim, Jain, Christian Scientist, Bahai, Zen, theosophist and more into an early Woodstock of spiritual ferment. It also moved Nikola Tesla, whose genius helped electrify the nearby World Exposition…and then the world.

In 1902, Harvard's William James---Ralph Emerson's godson---compiled *Varieties of Religious Experience,* a *Wholly Divine Catalog* that opened the doors to diverse consciousness and spiritual exploration. Life forbids, he said…

…*a premature closing of our accounts with reality.*

Reborn transcendentalism electrified the arts. Brilliant creatives like Mary Ellen Key, Mark Twain, Charlotte Gilman, Randolph Bourne, Amy Lowell, Carl Sandberg, Louise Bryant, Reed, Lippmann, Steffens remade writing for a radical era.

Upton Sinclair's 1906 *Jungle* aspired---like *Common Sense* and *Uncle Tom's Cabin*---to ignite a new American Revolution. But the nauseating filth it exposed in the meat packing industry spawned a new generation of vegetarians. "I aimed at the public's heart," Upton mourned, "and by accident I hit it in the stomach."

Ida Tarbell's *History of the Standard Oil Company* muckraked John D. Rockefeller for all his hard-knuckle brutality. By questioning the divinity of our Founders, Charles Beard's 1913 *An Economic Interpretation of the Constitution of the United States* joined other progressive heresies then rocking academia.

Jack London's *Call of the Wild* evoked nature at its crystalline peak. His *Iron Heel* warned of a coming American fascism. In 1910, to his racist chagrin, Jack's "Great White Hope," Jim Jeffries, got outboxed by Jack Johnson, the greater black heavyweight.

The stark photo images of Jacob Riis and Lewis Hine opened the public eye to our urban slums. So did Alfred Stieglitz, German-born spouse of the naturalist painter Georgia O'Keefe.

The Ashcan School of Socialist painters like Robert Henri and George Bellows sparked a revolution in oil and canvas. Their feisty 1908 New York Armory exhibit featured a pine tree emblem from the first American Revolution. Teddy denounced them as "degenerate." The *New York Times* called them "cousins to the anarchists." They liked that.

Futuristic fantasies like Edward Bellamy's *Looking Backward*, Ignatius Donnelly's *Caesar's Column*, H.G. Wells's *Modern Utopia* and Frank Baum's satiric *Oz* opened our eyes to the yellow brick road of visionary populism.

Utopian colonies and socialist collectives lit the landscape *(again!)* with Indigenous spiritualism, tribal sharing, polyamorous adventure. Helicon Hall in New Jersey, Georgia's Christian Commonwealth, free-wheeling collectives at Cave Mills, Tennessee and Kaweah River, California...all fed the reborn tides of unbound youth.

As the frontier disappeared, our Indigenous DNA evoked its timeless love for Mother Nature. In 1872, Grant followed Lincoln's preservation of Yosemite with Yellowstone, humankind's first national park. Scotsman John Muir fought to save California's Hetch Hetchy Valley from being dammed *(and damned)*, then founded the Sierra Club, spawning thirteen decades of organized eco-activism.

TR left us an exceptional national park system. He soiled the deed with racist blather against the Indigenous. But he preserved their spirit in millions of acres of land and water---*still* under attack---that are essential to our survival.

The Biltmore Estate of third-generation Baron G.W. Vanderbilt launched western North Carolina's Pisgah National Forest. Gifford Pinchot and George W. Schenk pioneered the green science of sustainable forestry. Preservationist pioneers rose up everywhere to save our Earth from corporate extinction.

At the laboring grassroots, millions marched for workers' rights. An 1886 national strike for the 8-hour day imploded when a bomb killed eight people in Chicago's Haymarket Square. Nobody knows who threw it. But eight anarchists were arrested. Four were hanged.

In 1889, the despicable Steel Baron Henry Frick ordered Pennsylvania's South Fork Dam lowered to accommodate his carriage. When it broke, the infamous Johnstown Flood killed 2,209 people. Three years later, Frick's private thugs murdered some thirty strikers at Carnegie's Homestead steel mills, near Pittsburgh.

Henry was never prosecuted for either mass killing. But an angry anarchist did shoot him. In 1919 he died of syphilis.

Among the working millions, the humanist spirit of Paine's *Common Sense* and Franklin's *Poor Richard* were reborn in mass-circulation newspapers like *The Appeal*

*to Reason* of Girard, Kansas.  In 1905, the Industrial Workers of the World erupted in Chicago as our most radical union.  The one-eyed "Big Bill" Haywood inspired guerrilla *Wobblies* who came in boxcars, slept in hobo camps, wore red and black overalls, aroused all races, genders and creeds, ignited strikes, and then---like the First Revolution's Minutemen --- slipped into the wild to strike again.

Angry legions of American workers raged, organized, marched and struck for equality, freedom, survival, dignity.  Black, white, Asian, Hispanic, Indigenous, female, gay, immigrant, unskilled, homeless, destitute…the IWW embraced us all.

In 1912, we struck the original mills in Lawrence, Massachusetts, still mostly worked by women.  With immigrants who spoke a dozen languages and hailed from everywhere, the *Wobblies* sparked a feminist crusade for life that sang of "Bread and Roses"…decent pay, social justice, a chance to escape poverty and oppression, to love and laugh, sing and play.  Sang the anarchist Emma Goldman…

*…If I can't dance, I don't want to be in your revolution.*

When the mothers of Lawrence sent their kids to stay with union families in other towns, crazed cops attacked them at a local train station, outraging the nation.

From the silk mills of Paterson, immigrant workers joined Bohemian *artistes* in a mystical series of plays and pageants.  Millions marched in unison.  Still more flocked to hear Debs, Haywood and their Awakened unionists proclaim a new humanist dawn.

On April 20, 1914, federal machine guns (*as at Wounded Knee)* raked a strikers' camp at Rockefeller's coal mines in Ludlow, Colorado.  Two dozen died, mostly women and children.

In upstate New York, Cleveland, Columbus, Memphis, Nashville, the Tennessee Valley, Jacksonville, San Antonio, Nebraska, Colorado Springs, Los Angeles, Sacramento, Seattle, and elsewhere, socialist activists seized control of newborn electric utilities.

These public-owned "munies" still produce cheaper, cleaner, safer, more reliable juice than the Baronial "Investor-Owned Utilities" that plague the planet.

From this Awakened eruption of shared sustainability sprang the New Deal, Social Security, Civil Rights, New Frontier, Great Society, Peace & Justice, No Nukes, Solartopia, Occupy, Black Lives Matter, *Sandernista*, #MeToo and so many other movements riding the ever-evolving stream of peace, humanism and eco-Indigenous consciousness forever fighting to bend the arc of justice.

America had thus rocked to its radical creatives in the Awakened 1730s and Transcendentalist 1840s.  It rolled again in this turn-of-the-20th-century Bohemian Rhapsody.  It would arise anew in the radical 1930s upwellings of the Great Depression, the Yippie '60s, the Solartopian '70s and deep into the new millennium of yet another generational uprising…this last with the fate of the Earth riding its young shoulders.

From the volcanic core of these epic upheavals springs an evergreen tribal force, the forever re-rising of our Indigenous DNA.

At its heart, Debs saw that all humans *must* be fed, clothed, housed, educated, medically secure, living with dignity. That the Bill of Rights *must* be respected. That even "too-big-to-fail" monopolies *must* be held accountable to the public, and made to serve people before profit. That poverty *must* be abolished, democracy enhanced, diversity exalted, empire ended, the planet preserved, Her ecological rhythms embraced ...with militarism and war forever banned.

When all that happens, Gene said...

*...We shall have a literature and an art such as the troubled heart and brain of [humankind] never before conceived.*

*...We shall have beautiful thoughts and sentiments, and a divinity in religion, such as [humanity] weighted down by the machine could never have imagined.*

*...The time has come to regenerate society.*

*...We are on the eve of a universal change.*

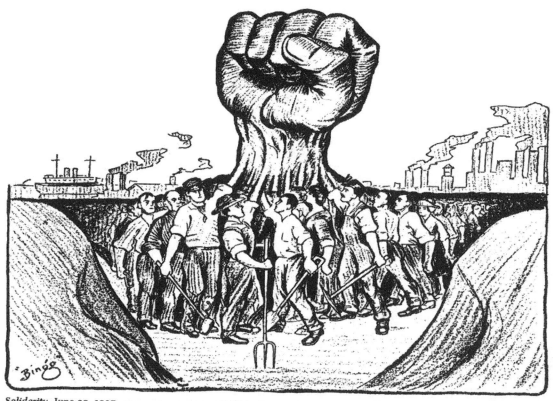

*Solidarity,* June 30, 1917. **The Hand That Will Rule the World—One Big Union.**

# SUMMER
## *Woodrow Wilson's War*

*The Labor/Bohemian demand for a universal transformation thrilled the better angels of our American Century.*

*But their springtime of hope was soon incinerated in the hot summer of a ghastly Pandemic, an imperial war, and the autocratic repression that made it possible.*

*The Barons meant to crush the Socialist Awakening and impose corporate White Supremacy on a global scale. Led by TR and Wilson, the Calvinist Elect's techno-imperial City on the Hill took an anti-human leap to world domination.*

*Under Jack London's* Iron Heel *they executed mass murder and eco-suicide through the new corporate duopoly that STILL rules American party politics.*

In 1914, as American soldiers gunned down striking workers, the madness of war engulfed Europe. Our Populists, Socialists, and Bohemians wanted none of it.

Instead they demanded public control of our major institutions. Preserve our farms. Pay our workers fairly. Provide food, housing, clothing, medical care and education for all rather than squandering our life force on war and empire.

The US never had a security-based imperative to conquer other countries. We were never in danger of being invaded or occupied by anyone. A phalanx of fierce anti-imperialists, led by Mark Twain, demanded we end war and empire....

*...It was impossible to save the Great Republic. She was rotten to the heart. Lust of conquest had long ago done its work; trampling upon the helpless abroad had taught her, by a natural process, to endure with apathy the like at home.*

To serve what TR called the "Young Giant of the West," Indiana Senator Albert Beveridge howled for global conquest. The "March of the Flag" meant the riches of empire...the cheap labor, natural resources, and bottomless markets of Africa, Asia, Eastern Europe, the Caribbean and Pacific Islands, Latin America. We were...

*...on the threshold of our career as the first power of Earth.*

We'd put Persia to shame, become richer than Rome, leave the Brits in the dust.

After crushing the Indigenous, it would begin with Hawaii. "Christian" missionaries came to "save" islanders who'd been pretty *mahalo* for a very long time.

In 1840 a Catholic priest imported beach thorns to end the native joy of going heedlessly barefoot.

Mosquitoes arrived a few years earlier in the water barrels of British and American ships. The ships also brought rats, which had no native natural predators. Neither did mongooses, which some genius brought in to kill the rats (*they ate very few, but did wipe out native bird populations*).

In 1893, Pineapple Baron Sanford Dole conquered the archipelago, then asked President Cleveland for annexation. Grover hesitated.

In 1898 William McKinley "went down on my knees" to get the *aloha* straight from God. The US, He said, had "no choice" but to "civilize" a "backward" nation.

IN FACT!! Hawaii was peaceful, literate, advanced, and *(like the mainland tribes)* far more civilized than her bestial invaders. Following on centuries of sophisticated governance, she embraced a written constitution and a much-loved multi-lingual songwriting Queen Lili`uokalani. Resentment of this imperial conquest still runs deep.

McKinley also anchored the battleship *Maine* in Havana harbor, allegedly to support Cuban rebels fighting to oust a Spanish empire that dated to Columbus.

But in 1898 the *Maine* blew up, killing 266 Americans. The yellow Hearst press ran pornographic drawings of naked white women being molested by swarthy, bearded Spaniards. It was a primal scream for imperial war.

Navy divers later confirmed that the *Maine* blew up from the *inside*, probably from coal dust. Spain did NOT sink that boat.

Nonetheless, Roosevelt's "Rough Riders" rampaged through Cuba, firing their pistols, killing random locals, conquering the island for the new American Colossus.

Next we "liberated" the Philippines. Twain called that jungle war (1898-1903) "a mess, a quagmire." Our soldiers became "uniformed assassins." Some 4,000 died. So did a quarter-million Filipinos in guerrilla resistance, in concentration camps, and in gratuitous mass annihilation that followed from the Barbary Coast, echoed Wounded Knee, portended Vietnam, predicted Afghanistan *(where maybe it'll end)*.

Since the US was born in anti-imperial revolution, we've always denied being an empire. Instead we conquer to "instill democracy" and "teach them a lesson." We let the locals "elect their own leaders." If we dislike their choice *(like the Seminole Osceola and the Filipino Aguinaldo, both of whom we beheaded under white flags of peace)* they can try again "for their own good."

Thus, our taxpayer-funded military has made the world safe for corporate plunder. It's all "a racket," wrote General Smedley Butler, who said his troops pillaged Latin America for "the boys on Wall Street."

In 1900, Britain, France, Germany, and the US kicked in China's "Open Door," creating "spheres of interest" for corporate commerce.

In 1903, TR fomented a "revolution" in Colombia. He concocted Panama, had a "constitution" written in a New York hotel room, stole us a canal with a 99-year lease.

In 1905, Japan became the first non-whites to beat a European power (Russia) since Toussaint's Haitians beat the French and the Seminoles held the Everglades.

In 1907, TR's Great White Fleet waved the American Century's "Big Stick." We soon invaded dozens of non-white nations at least once. In return came untold desperate refugees fleeing the *caudillos* we installed, the poverty we imposed, the death squads and drug wars we funded, the ecological ruin we made inevitable.

In the 1910s, in Europe, Japan, and the US, the upper crust somehow longed for war. It was 40 years since Prussia ran in and out of Paris. Apparently all that peace, progress, and prosperity were more than the bourgeoisie could bear.

It was time to KILL again.

Reading the literature of the day can be mind-bending. Peace had become "stale." Society was "soft." We needed guns, gas and glory. National mass murder would make the white blood red again.

Agrarian democrats, Socialist unionists, anti-imperial intellectuals, Quakers, and otherwise sane humans were aghast. But as Adam Hochschild writes in *To End All Wars*, a hunger for mass death spead like cancer.

In Sarajevo, 1914, a nationalist nut murdered Austria's Archduke Ferdinand and his pregnant wife. Lunacy erupted. For no rational reason, Serbs, Russians, British, French, and Italians lined up to kill Germans, Austrians, and Turks.

Apparently with nothing better to do, Prussia's idiot Kaiser sent his army screaming toward Paris. The French raced out in taxis, on horseback, riding bicycles, by foot. Baguettes in hand, they met *Le Boche* about 70 miles shy of the Eiffel Tower.

Trenches were dug. Poison gas spewed. Machine guns blazed. Bombs fell. Hell erupted.

Over the next four years, at least ten million humans died in battle. Countless more perished in the plagues that followed. To this day it's impossible to make sense of exactly how or why peaceful, prosperous Europe turned itself into an apocalyptic inferno. But it did.

Meanwhile the outrageous *bandido* Pancho Villa lit *El Presidente's* short fuse. With all the panache of a Latin Charlie Chaplin, Villa (*literally!*) made a feature film about himself taunting the gringo colossus along its southern border. More serious revolutionaries like Emiliano Zapata fought for social justice.

Woodrow was not amused. Like Polk before him, Wilson sent our troops screaming into Mexico City, slaughtering the usual innocents. "Our little brown brothers," he sermonized, must be "taught a lesson."

Then war engulfed Europe. Wilson recalled our troops from the Halls of Montezuma. He campaigned as a peace lover who "kept us out of war." He waltzed into a second term.

And then he bared his teeth.

The groundwork was carefully laid. In 1915, the British passenger ship *Lusitania* sailed for London from New York. The Germans said she illegally carried weapons, and

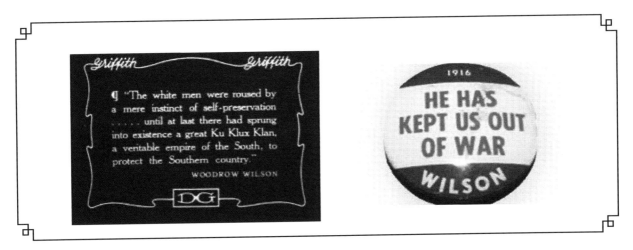

promised to sink her under the rules of war. They bought full-page newspaper ads to warn Americans against taking passage.

Wilson ignored all that. So did 1,959 passengers and crew.

In the frigid Irish sea, two German torpedoes struck the *Lusitania* near those illegal munitions whose existence Wilson denied *(but which---like the Maine---divers later found)*. She sank like a rock, killing 1,198 passengers, including 128 Americans.

Our "horrified" president deployed an army of shills to assault all things Teutonic. Sauerkraut became "Liberty Cabbage." Street names like Beethoven and Mozart turned into numbers. German-Americans became "Barbaric Huns."

Born in Virginia, Woodrow's father was a Confederate chaplain. As a boy he briefly met Robert E. Lee. As President, Wilson pushed Jim Crow segregation. He staged a White House viewing of D.W. Griffith's grotesquely racist *Birth of a Nation,* which exalted the KKK and degraded African-Americans. Woodrow loudly loved it.

Wilson's *faux* progressivism ensnared the American Federation of Labor, led by Samuel Gompers, a cigar-maker who'd come here from England. Most Barons wanted unions obliterated. Woodrow chose to co-opt their leadership. His 1914 Clayton Antitrust Act---he called it labor's *Magna Carta*---gave unions official standing...until the Supreme Court gutted it.

As Wilson's pet union, Gompers' AFL became the "business organization" of the skilled elite. It struck for better wages and working conditions. But it shunned women, blacks, immigrants, the unskilled, the radical. The corporate bulwark of the upper working class, it broke the strikes of other unions, embraced the axioms of the imperial capitalist state, hated Gene Debs.

In trade for White House access *(and for crushing the Socialists)* Gompers cheered the empire...and its World War.

On March 1, 1917, the Brits published a "Zimmermann telegram" allegedly revealing a German plot to help Mexico retake the Southwest J. K. Polk had so profitably liberated. On Hearst's front pages, raping, pillaging, *Lusitania*-sinking Huns made those *Maine*-sinking Spaniards look meek.

Secure in a second term, Wilson ditched that "he kept us out of war" *shtick* and demanded war. He would "make the world safe for democracy." Six Senators and fifty Representatives---including Jeanette Rankin---voted NO.

Millions marched in opposition. The Populist-farm/union-labor/Socialist/ Bohemian majority saw the European slaughter as yet another "rich man's war" and poor man's holocaust. Debs, the Wobblies, the social democrats, the Bohemians, the Quakers shouted that our troops were being sent to kill and die for corporate profits.

As in the Civil War, the draft ravaged America's working families. Quakers went to prison. Farmers and workers chopped off fingers and toes. Thousands deserted their units and fled to Mexico and Canada.

Socialists captured some 1,200 public offices in 340 American cities, including 79 mayors in 24 states. Manhattan's Meyer London, and Milwaukee's Victor Berger, won seats in Congress. Millions signed calls for non-cooperation. "A mighty tide of Socialism," said The Akron *Beacon-Journal,* was about to "inundate" the country.

But the empire struck back.

Rockefeller, Morgan and their fellow Barons had lent the Brits and French far more than they'd lent the Germans. In 1917, Wilson aimed at the media by reviving the 1798 Sedition Act with an updated Espionage Act. Congress purged Berger and barred London. Peace advocates were fired, jailed, beaten, shot.

Dissing Wilson---even in private---became a ten-year felony. So did carrying placards quoting his own books. The US Supreme Court, in *Schenck*, absurdly equated draft resistance with "shouting fire in a crowded theater" *(Yippie activist Abbie Hoffman later clarified that it was actually "shouting THEATER! in a crowded fire.")*

In 1917, Russian workers and peasants overthrew the Tsar. Like Haiti's in 1802, Russia's revolution terrified the corporate elites. For Teddy, Wilson and their ilk, grassroots upheaval posed the ultimate heathen threat to Christian civilization.

But then there was the virus...the *in-flew-enza.*

In January,1918, as Wilson screamed for war, a local doctor reported a flu outbreak ravaging Haskell County, in southeastern Kansas. A quick quarantine would've minimized the death toll.

But like Donald Trump ducking Coronavirus 19, Woodrow Wilson had other priorities. Obsessed with war, his administration ignored the early warnings. Troop transports and mass rallies spread the viral death everywhere.

Unspeakably lethal, what became known as the "Spanish Flu" could strike a squad of healthy 20-somethings in the morning and leave them all hideously dead by nightfall. Turning literally blue from lack of oxygen, bleeding from all orifices, wracked with torturous pain, caused by a virus scientists would not see under a microscope for decades to come, the ailment struck the previously healthy like a satanic curse.

Likely first carried by a single Haskell County pig farmer, it decimated nearby Camp Funston with terrifying velocity. Funston was a vital node in the massive military network Wilson threw together for his much-hated war. Draftees were shuttled from shoddy, filthy, unheated barracks on overcrowded troop trains which became rolling mortuaries.

For reasons still unclear, the virus devastated teens and twenty-somethings, precisely those of prime draft age. Mother Nature Herself could not have designed a more fiendishly efficient way to spread a lethal virus among a vulnerable population.

At Fort Devens, near Boston, a doctor mourned that...

*...We have been averaging about 100 deaths per day...it is only a matter of a few hours until death comes...it is horrible. One can stand it to see one, two or 20 men die, but to see these poor devils dropping like flies...*

Medical and humanitarian experts begged the president to suspend the draft, shut the camps, stop the troop trains. But obsessed with his "war to end all wars." Wilson's martial madness spread the plague with apocalyptic fury.

Diseases resembling this "Spanish Influenza" also surfaced in China and France. But the strain from Kansas ravaged the US with surreal killing power. After surging through our barracks and railway network, the viral madness raged aboard our troop ships, which dropped a steady stream of young bodies into the sea as they sailed

toward the killing fields of France. As it metastasized worldwide, the flu killed as many as 100 million humans within a matter of months.

Without significant federal guidance or resources, American cities and towns went virtually blind. In the spring, San Francisco harshly enforced an early mask ordinance, which kept down the death rate. But it also aroused public outrage. When the city let its guard down in the fall, the returning plague exacted a horrible price.

In Philadelphia, health officials desperately warned against public gatherings. But Wilson demanded a War Bond rally, drawing 200,000 "patriots." Soon 15,000 were dead. Morgues ran out of coffins. Families had to store their loved ones' corpses in their homes as they festered in rot. Bodies were stacked in the streets like cordwood, then ravaged by wild dogs. Heavy construction rigs dug and filled anonymous mass graves. Doctors, nurses and sanitation workers died in droves.

As a nascent public health community desperately sought a cure, terror torched every corner of American life. The unimaginable horror of watching seemingly healthy loved ones die in mere moments traumatized the nation.

But in June 1918, amidst this ghastly plague, Wilson's Feds found time to jail Gene (then 63). Through all forms of repression, *unlike its corporate Democrat/ Republican rivals*, his American Socialist Party honored its commitments to the Bill of Rights and all it represented.

At a rally in Canton, government stenographers *(thankfully!)* recorded Debs's legendary plea for peace. He was charged with a ten-year felony.

In a Stalinesque inquisition, as the Pandemic ravaged the American soul, Gene refused to mount a formal defense. But on September 11---exactly two months before the war ended---he delivered a monumental two-hour oratorio.

The corporate rich, he said, have "always declared the wars; the subject class has always fought the battles...

> *...The master class has had all to gain and nothing to lose, while the subject class has had nothing to gain and all to lose—-especially their lives.*

Resisting capitalism's greedy carnage, said Debs, united humankind with a common bond, a shared spirit, timeless and immutable...

> *Years ago I recognized my kinship with all living beings, and I made up my mind that I was not one bit better than the meanest on Earth.*

> *I said then, and I say now, that while there is a lower class, I am in it, and while there is a criminal element I am of it, and while there is a soul in prison, I am not free.*

For opposing a war that ended 60 days later, Gene was sentenced to ten years in federal prison. As peace settled over the planet, Wilson's gestapo shredded the Constitution and crushed the Socialist Party.

Meanwhile, the "Tin Jesus" took a victory lap.

Along with democracy itself, some 675,000 Americans lay dead from the flu. Wilson's virus had killed more of us in less than a year than had died in the four it took to abolish slavery. Woodrow's avoidable Pandemic piled up corpses like Great Plains buffalo skulls and the frozen dead at Wounded Knee.

In Europe's killing fields, more than 116,000 US soldiers also lay dead.

At the 1919 Versailles peace conference, Wilson proposed an imperial League of Nations…and leniency for the Germans he'd trashed as "Barbarians" and "Huns."

Waving his high hat from an open limo rolling through Paris, frenzied mobs cheered the Great White Supremacist as a prophet of peace.

Thanks to Himself, they prayed, these hellish hot summers of senseless butchery would forever end.

While shredding democracy at home, The Great Man "made the world safe for democracy" and won "the war to end all wars."

It was apocalyptic delusion, a hideous deceit. Soon enough the next mass slaughter would soar beyond all imagining.

## *"I Ain't Marchin' Anymore!!!" ...Phil Ochs*

*In WWI's legendary 1914 Christmas Truce (as Gefreiter Adolph Hitler seethed in his rat hole) some 100,000 warring troops left their trenches for a brave new world of peace and goodwill that included Brit-Boche soccer.*

*Countless grunts have forever refused combat, defied (or even killed) their officers, deserted when possible…including many of our own from the Revolution, Civil, World, Vietnam and other Wars.*

*When enough finally decide to make armies impossible, the door to human survival may definitively open…especially as we convert those military budgets to serve human and ecological needs.*

HELL NO WE WON'T GO!!

# FALL
## *Red Scare/The Palmer Raids*

*The Great War's "Great Migration" brought millions of southern blacks to northern industrial cities to work in the arms industry.*

*Deadly riots over the usual racial flash points (political power, social status, jobs, housing, access to beaches, sexual innuendo, alleged insults) left dozens dead.*

In Houston *(August,1917)* white police assaulted black soldiers assigned to guard a new military base. Sixteen people died. The army indicted 118 black soldiers, convicted 110, sentenced 63 to life, hanged 19. No whites were convicted of anything.

Wilson pumped Jim Crow deep into the federal blood stream. His imperial military thoroughly abused its segregated soldiers *(many fled to French units, winning countless medals for valor).* Meanwhile, his beloved KKK made sure black vets could neither vote nor live in the peace for which they'd allegedly fought.

As usual after a war, the economy collapsed with the Armistice. General strikes paralyzed Seattle, the steel industry, mines, railroads, factories. The fall reaction turned ugly, lethal, fascistic (coined in Italy by Benito Mussolini, the term *fascism* means, simply: *corporate control of the state*).

Nationwide, our diverse working class *(now including thousands of vets)* seethed with rage. Thanks to Wilson, Samuel Gompers' AFL won seats at many bargaining tables, winning better wages, working conditions, the right to organize key industries.

But in the frigid autumn of post-war fascism, corporate Barons crushed the Socialists and Wobblies. With Sam by his side, Woodrow used the Espionage and Sedition Acts to fuel a "Red Scare" *putsch* and shred the Constitution.

From November 1919 to January 1920, even as Wilson's Pandemic ravaged the nation, Attorney-General A. Mitchell Palmer *(a self-proclaimed Quaker)* launched a gestapo-style *blitzkrieg* meant to crush all resistance to corporate capitalism.

Palmer's warrantless thugs smashed into Socialist and IWW offices, union halls, rallies, and the private homes of suspected social democrats and peace advocates.

Mocking due process, Wilson deported activists of Russian descent, including gay rights pioneer Emma Goldman. He used fake "mail fraud" charges to imprison Callie House, who dared demand compensation for ex-slaves like herself.

Grassroots outreach became a life-threatening dare. The homegrown Populist / Socialist / IWW belief in the public owning and operating major industries for the "general welfare" became a "foreign ideology."

For the next hundred years, the American duopoly crushed all independent parties demanding social democracy, ecological protection, an end to empire. Meaningful change now demanded an impossible leap from the rock of the corporate Democrats to the hard place of the Baronial Republicans.

Wilson's *putsch* enthroned imperial monopoly capitalism atop a velvet-covered fortress. It was festooned with illusions of a participatory republic. But its iron heel stomped on social justice with all the rage of a power-crazed imperial beast.

While trashing it here, Wilson descended on Europe to celebrate a post-war wasteland made "safe for democracy."

American intervention had turned a negotiable stalemate into a crushing obliteration. At the Versailles treaty talks, with corpses stacked by the million, Woodrow proposed an explicitly racist, pan-imperial League of Nations. It meant to unite Europe's conquering Caucasians---plus Japan---in the corporate gouging of Africa, Asia, the Balkans, Latin America.

The Allies loved the League. But without a hint of irony, Wilson now begged mercy for all those "Huns" and "Barbarians" he'd been smearing for years.

The Brits and French were incensed. But Wilson held his ground---until he caught the very flu he'd let rip.

Disabled and demented, Wilson dumped his high-minded calls for equitable dealings with the Germans. His horrified staff angrily denounced this incredibly costly betrayal.

But Wilson caved. And in an unspeakable irony, he intimated that if he had been a German confronted with that heartless treaty, he wouldn't have signed it.

In other words, at the end of his "war to end all wars," America's "Tin Jesus" allowed the French and British to strip Germany bare, mock its ravaged soul, and pave a clear path straight to the next holocaust.

Soon enough, the bankrupt, humiliated, infuriated Fatherland puked up Adolf Hitler. Raised as a spoiled, lazy mediocrity, a cataclysmic war-time dose of Mustard Gas morphed Der Fuhrer into a hypnotic monster.

His apocalyptic firestorm of bigotry and hate was the ghastly by-product of a World War that made absolutely no sense---*except* in terms of conceit and greed---from start to anti-climax.

Hitler seized power with the *Big Lie* that Germany had won WW1, but was "backstabbed" by Jews and liberals. A century later, Donald Trump's *Big Lie* said he won the 2020 election...but that, like Germany, he was robbed of a rightful victory. The parallel consequences have been incalculable.

In 1919, Wilson's flu shattered him with a debilitating stroke. Woodrow's second wife---like Nancy Reagan 66 years later---hid her husband's true derangement. Thus Edith Wilson became our first *de facto* female CEO.

Atop a nation gutted by war and Pandemic, she watched the Senate refuse to join League of Nations.

Like the social democracy he crushed, like the Constitution he shredded, like the millions who died for a treaty that failed, Woodrow Wilson's Puritan vision of a Caucasian world order raged through a post-war fire storm of fascist reaction.

Stricken by the fiendish virus he helped spread worldwide, the American Century's techno-messiah ended his apocalyptic presidency in a virtual coma.

He'd perpetrated a fraudulent intervention, trashed the Constitution, enshrined federal Jim Crow segregation, illegally smashed the Socialist Party and radical labor movement, enthroned for a century a two-party autocracy dedicated to imperial conquest and corporate dominion.

"Madness," he mourned, "has entered everything."

# WINTER
## *The Roaring Twenties*

*The Great War ended with the peacemakers who tried to stop it still in prison. A generation's hopes were buried. In Europe's desecrated soil, amidst the mass graves of a horrific Pandemic, the twisted seeds of the next bloodbath took evil root.*

*Among the lost was Quentin Roosevelt. Teddy's youngest of four sons was shot out of French skies at age 20. TR's "blessed rogue" was the family favorite. Just two months after Armistice, our most vigorous imperial fanatic died at 60 of a broken heart...and maybe from the lead bullet still lodged next to it.*

*Roosevelt's transcendent niece Eleanor soon revived his boundless energy and formidable intellect...but with very different values. In the decades to come, this magnificent American matriarch bent the arc of history toward the global peace and social justice her martial uncle had so thoroughly scorned.*

Wilson's intervention lasted 18 months. Some 4,700,000 American men and women were deployed. After Armistice---with no declaration of war---some 7,000 more were sent to crush the Russian Revolution and restore the Tsar. Seventy died.

Woodrow left scores of non-violent activists to rot in prison. For the "crime" of preaching peace---just two months before the Armistice---Debs was condemned to ten years in federal prison. The Indiana-born icon was stripped of his citizenship and denied the right to vote.

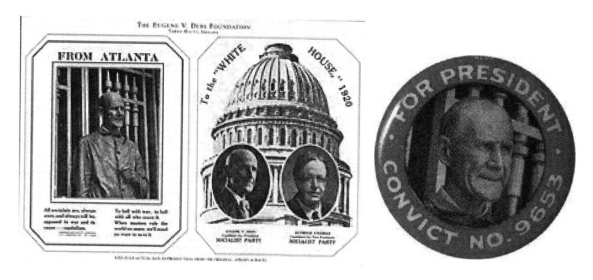

In 1920, Gene ran for president from a federal cell in Atlanta. Mainstream historians usually treat him as a fringe candidate, an electoral footnote.

But Woodrow knew better. When the war ended, he was branded "cruel" and "vindictive" for refusing to free those who'd opposed it. But Wilson had every partisan reason to keep Debs behind bars while illegally obliterating the campaign infrastructure that might've put him in the White House.

With the 1919 passing of Theodore Roosevelt, Gene became by far America's best-loved public figure. His indefatigable decades of spellbinding stump speeches bonded him with millions of ordinary citizens. His huge labor/peace following loved and trusted his integrity, commitment and charisma. His American Socialist Party embodied all the grassroots credence and fervor conjured by Abe Lincoln's 1860 Republicans...and then some.

By contrast, the Democrat/Republicans were hopelessly corporate, corrupt, obsolete, boring. In 1920 they each nominated a dull Ohio stiff. Under their joint maladministration, the nation had just suffered through a useless war, a hugely hated draft, an apocalyptic Pandemic, and a major economic crash...complete with agrarian uproar, massive labor strife, ghastly race riots...*Plus a fixed World Series!!*

Facing a huge rich/poor abyss, Socialism was widely embraced as a reasonable, workable alternative to America's capitalist mess.

Free to barnstorm as only he could, drawing huge adoring crowds, with his deep-rooted union and party apparatus in tact, working from the Congressional seat he rightly won rather than the cell where he was wrongly jailed, there's every reason to believe that---with an even marginally fair vote count---Eugene V. Debs should have been the clear favorite to win the presidency in 1920.

Small wonder Wilson took such pains to keep him locked in a prison cell...and to destroy his surging grassroots infrastructure. With a level playing field and a fair vote count, the US in 1920 might very well have chosen its first Socialist president, trading imperial dominion for social democracy.

*Think, for a moment, how that might've re-shaped all that followed.*

The near-million ballots counted for federal prisoner #9653 in 1920 included many cast by women who were voting for the first time.

Their century-long struggle to get the ballot called down outrageous abuse. In 1918, Alice Paul and her Suffragette sisters were jailed for peaceably marching at the White House...and for carrying signs literally quoting the President.

In jail, Alice hunger-struck. The tube rammed down her throat lit up a major media storm. The 19th Amendment was ratified in time for the 1920 election.

By then, America was exhausted from its third cycle of upheaval, war, and reaction. Warren G. Harding---an amiable, bumbling small-town Ohio newspaper editor---inaugurated another winter's post-Pandemic hibernation. We need "normalcy," he said, "an end to uproar."

Norman Thomas was Harding's hometown delivery boy...and a rising young Socialist. He got the affable Ohioan to free Gene... and a couple dozen more of Wilson's pacifist victims.

So after three years, in a true Heartland moment, the small-town Hoosier-born "American Saint" came straight from his federal prison cell to the Oval Office, where he shook Warren G's small-town Buckeye hand.

In Terre Haute, 25,000 cheering admirers---who'd allegedly given him zero votes for Congress five years before---joyously greeted their prodigal son. But his presidential moment had been sabotaged.

Three years later, Wisconsin Senator Robert LaFollette ran on the Progressive ticket. He'd supported Wilson in 1912, but hated his imperial intervention *(being a US Senator protected him from arrest, as being a Congressman might've protected Debs)*.

In the tradition of America's left third parties, "Fighting Bob" supported universal health care, public ownership of the railroads, fair wages, women's rights, environmental protection and more.

In 1924, he carried 17% of the national vote, along with Wisconsin's Electors.

Fighting Bob passed in 1925, Gene Debs in '26. Their Awakened ideals had directly evolved from egalitarian roots through Franklin, Paine, the transcendental abolitionists and feminists, into agrarian Populism, urban unionism and the rising Bohemian demand for universal harmony.

They married mass movements for social democracy and justice with far deeper commitments to free speech and the Bill of Rights than their Republican or Democrat rivals. They advocated racial, gender and ethnic equality, rights to assembly, press and religion…and an eco-economy geared to serve human needs, not corporate greed. Their cyclical commitments to human dignity, social justice, civil liberties, inalienable freedom and global harmony endowed our historic gyre with exquisite grace.

Though constantly under imperial attack, the intrinsic power of these eternal ideals never left the American Century. Six times their spiritual apprentice, Norman Thomas, ran for president on their unquenchable alchemy. Together they helped transform our DNA into the Awakened '30s and '60s…Solartopian '70s and beyond.

In the early 2020s ---embodied by Bernie Sanders and a rising Millennial/ Zoomer upheaval--- they still serve as an organic beacon for where we must go if our species is to survive.

William Jennings Bryan's oratorical flare also stayed hot. But its direction strayed. His finest hour had come in 1915, when he quit as Secretary of State after Wilson shouted bloody murder over the *Lusitania*.

In his dotage, the evangelical Bryan blamed the World War on "Godlessness." At the 1925 Scopes Monkey Trial in Dayton, Tennessee---in America's first live courtroom radio broadcast--- a schoolteacher was charged with explaining evolution to his students. The legendary labor lawyer Clarence Darrow suggested that explaining *both* evolution *and* the Bible might let students make up their own minds.

The Nebraska Democrat fell too ill for a "Cross of Gold" rebuttal. But in eight minutes the jury banned the "Monkey Heresy" from Tennessee schools.

When Bryan died five days later, his legacy became the ossified Calvinist conservatism of another winter's aftermath.

In the corporatized wake of war and reaction, as our family farms failed in droves, small-town America writhed in anguish. Like the Indigenous shamans of the Lakota Ghost Dance, 1920s Bible thumpers like Billy Sunday preached the Old Time Religion to bewildered congregations losing their way of life.

The Ku Klux Klan ramped up the hate. In November, 1915, their racist terror was reborn at Stone Mountain, Georgia. Wilson's ugly embrace of D.W. Griffith's *Birth of a Nation* fed yet another White Supremacist scourge.

Until the 1882 Chinese Exclusion Act, our doors had been open to the world. In 1908, TR's Gentleman's Agreement stopped immigration from Japan. In 1917, Wilson okayed a literacy test meant to kill the surge from Europe. In the early twenties, a nation-based quota system choked the human flow that had helped shape us for three centuries. A nation made rich by its waves of immigrants now shut the gates.

It was a bigoted mindset that also attacked organized labor.

Despite the new-found status of Gompers' AFL, the feds called no halt to its war on the working class.

In Matewan, WV, ten people died---including the mayor---in a 1920 shoot-out between union miners and Baldwin-Felts corporate thugs. Sheriff Sid Hatfield sided with his hillbilly kin. A jury later cleared him of fake murder charges.

But in 1921, Felts gunmen shot Sid dead in broad daylight as he came unarmed to another courthouse. The shooters did no jail time.

Afflicted with lethal working conditions and grinding poverty, coal country exploded. Some 13,000 underpaid, overworked mine workers wrapped bandanas around their throats. Their "Red Neck Army" marched on the mines at Blair Mountain (since decapitated by mountaintop removal).

Amidst threats from Harding, poison gas bombs fell from the sky. Scores died. Nearly a thousand were indicted. Many rotted in prison for years.

In May 1921, a white mob torched the prosperous "Black Wall Street" section of Tulsa. At least 55 citizens were killed, maybe more than 300. A.C. Jackson, a prominent black surgeon, was murdered while being hauled to jail for no good reason. White police locked up 6,000 of the district's 10,000 black residents. Some 35 blocks of homes, hotels, hospitals, businesses, libraries, newspapers and churches were obliterated. At least 9,000 citizens of color were left homeless and distraught.

Throughout the post-war era, Jim Crow lynchings and violent vote theft fed the Democrats' death grip on Dixie. In Chicago and Detroit, race riots killed dozens. In August, 1922, Irish Republican hero Michael Collins was assassinated. The charismatic guerrilla led the IRA's armed anti-Brit resistance. But after the World War he wanted peace. It got him killed. Seven decades of senseless murder ensued, ending only when Bill Clinton, in his sole moment of greatness, brokered a peace made possible by the pacifist marches of the region's women.

In August 1925, as Bryan's Monkey Trial ended, some 40,000 Klansmen showed their sheets in DC---and were then gutted by internal corruption.

Official bigotry peaked with the 1927 electrocution of Italian-born anarchists Nicola Sacco and Bartolomeo Vanzetti. Their ritual murder sparked global outrage. (Fifty years later, Massachusetts Gov. Michael Dukakis issued an overdue apology).

Meanwhile, Prohibition set rural fundamentalists at war with city slickers. Activist women, says historian Dan Okrent, aimed the booze ban at menfolk who drank their pay and beat them up.

True to the law of unintended consequences, Prohibition actually made alcohol easier for women to get. The old saloons were shut Sundays and banned females.

Now speakeasies ran 24/7.  With a secret knock and some ready cash, liberated feminists---often dressed like flappers---could smoke like chimneys and drink like fish.  The family car's back seat became ground zero for a post-Puritan sex party.

For many Bohemians, the "Tedious Twenties" were as dull and void as the Era of Good Feelings and Gilded Age.  *Artistes* like Gertrude Stein, Ernest Hemingway, Cole Porter, Zelda and F. Scott Fitzgerald, took their "movable feast" to urbane Paris.

But some went to Harlem.  Genius band leaders like Duke Ellington and Count Basie called down divine music.  Langston Hughes, Gwendolyn Bennett, James Weldon Johnson, Jessie Redmon Fauset inspired a "Black Renaissance" that radiated the Roaring Twenties' most brilliant arts and letters.  Amidst a white winter of material mindlessness, the "New Negroes" were alive and well, even if their best and brightest could not eat or lodge where they performed.

Jazz's wild improvisations also spread through Edison's phonograph and Pittsburgh's KDKA, which in 1924 began broadcasting through parlor radios that changed everything.

Telecommunications boomed.  So did the Morgan-Edison-Tesla-Brush electric power business.  Airliners linked the cities.  Autos birthed a new suburban frontier.

Like Grant before him, President Harding's "friends" stole billions.  Then "the Dutchess," his formidable First Lady, went nuts over Warren G's outrageous escapades.  She may or may not have poisoned him...but she *did* bar an autopsy.

Meanwhile, *The President's Daughter*, by First Mistress Nan Britten, became America's best-selling self-published book.  Later DNA tests verified the title.

For a no-longer-so-progressive working/middle class, it was time for another winter's gorge.  A strong residual union movement protected wages.  Millions bought bogus stock certificates on margin while their bankers bet the nation's unregulated, uninsured deposits at the Wall Street casino.

But as the stock market boomed, so did a corporatized mob that cut to the core of American life...all the way up to the White House.

Gambling, prostitution, protection, booze, drugs, influence peddling, labor racketeering, murder-for-hire have always been integral to modern society.

Starting in 1919, Arnold Rothstein put them on a modern footing.  New York's most infamous gambler, Rothstein heard that key players on the pennant-winning Chicago White Sox hated their skinflint owner, Charles Comisky.  So he bribed them to throw the World Series to the underdog Cincinnati Reds.

Spreading bets across the land, Arnold strong-armed Game 8's starting pitcher.  The "Black Sox" lost that one 10-5, and thus the equally dubious series, 5-3.

Nobody was fooled.  But Rothstein beat the rap by buying a Chicago Grand Jury.  Then he used his huge winnings to hire heady upstarts like Charles "Lucky" Luciano, Meyer Lansky and Ben "Bugsy" Siegel.

Street-level gangster capitalism was always part of the American reality.

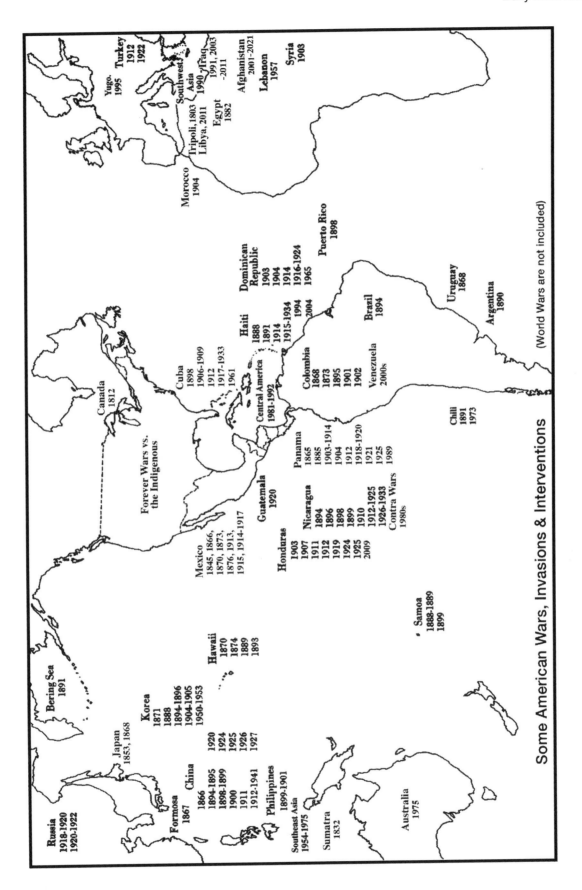

Some American Wars, Invasions & Interventions

(World Wars are not included)

But Rothstein, Luciano and Lansky helped modernize organized crime to a whole other level of corporate reach and power, permeating our social, economic and political fabric...right into the Oval Offices of Nixon and Trump.

Arnold was shot in 1928. Lucky rubbed out two other mob bosses and convened a corporate crime syndicate.

Luciano and Lansky knew enough to keep their heads down. But in Chicago, the flamboyant Al Capone built a high roller empire. On St. Valentine's Day, 1929, he had seven rival mobsters infamously machine-gunned. The feds stuck him in Alcatraz for tax evasion, where he mourned his high profile... and later died of syphilis.

Meanwhile Luciano sent Siegal to run the southern California mob. Morphing into a Hollywood playboy, Bugsy turned a remote desert crossroads, where gambling was legal, into a gangster paradise.

Amidst a freak 1946 rainstorm, way late and over budget, Siegel opened the first Las Vegas casino---called *the Flamingo*, in tribute to his girl friend's long legs.

Like Capone, Bugsy was addicted to fame...and crazy enough to skim Lucky's cash, for which he took a bullet through the eye. But Vegas survived.

So did a newly corporatized mob, whose escalating role in American politics and finance helped lead us right through Meyer Lansky's prime creation, Richard Nixon, to the casino Don...and beyond.

While organized crime ran wild through the Dollar Diplomacy Twenties, so did our imperial legions. Nary a Latin neighbor was left un-invaded. Imperial bases in Hawaii, Guam, and the Philippines made the Pacific our new back shipyard.

But on August 27, 1928, the US, Germany, and France---joined eventually by 59 more nations---signed the Kellogg-Briand Pact pledging never to attack each other.

In the fat winter of our third Gilded Age, humankind seemed ready at last to end all major wars. Our Quaker-raised president, Herbert Hoover, had spent much of the Roaring Twenties doing peace-related good deeds. In early '29, the "Great Engineer" proclaimed a "permanent dawn of peace and prosperity."

But except for a brief "Good Neighbor" respite during the New Deal, the imperial invasions of our Bully Manhood have never really stopped.

Nor has the tragedy of Woodrow Wilson's autocratic assault on our grassroots movements for peace, justice and organized labor...which robbed us of the chance for a far more loving American Century.

# CYCLE 4:
# FULL ADULTHOOD

| Eleanor & Franklin | The '30s<br>New Deal | WORLD WAR II<br>Economic Bill of Rights | Cold War<br>Red Scare 2 | Fat '50s |
|---|---|---|---|---|

# A BURST OF ENERGY
## *Eleanor & Franklin*

*The 1929 Great Crash set the grassroots afire.*

*Countless working/middle class Americans who "played by the rules" went broke, jobless, homeless, destitute. Barons with endless ill-got cash snapped up bankrupt farms, homes, factories, futures....and ignited a bottom-up class hatred that threatened a new Revolution.*

*Our fourth cycle of history (our Full Adulthood) conjured new chieftains to guide this latest burst of energy. Previously they were Good King Billy, Andy Jackson, Bryan/ Debs/Teddy/Wilson...*

*Now they were a (tenuously) married couple.*

*He was in a wheelchair. She was Eleanor.*

As usual, not much of real value anchored all that crazed Roaring Twenties end-of-cycle casino madness. As in 1819, 1837, 1857, 1873 and 1893, first came panic, then the crash. In 1907, while posing as a Trust Buster, TR's "lemon socialism" bailed out the too-big-to-fail banks *(as would happen again a century later)*.

But after 1929, our second Great Depression laid us low.

Germany had pulled itself back up from war and reparations. Now it utterly collapsed, kicking in the door for Adolf Hitler.

Here we were one day fat, happy, nearly fully employed. The next we were cold, hungry, jobless. "Hooverville" tent colonies stretched from sea to sea. We were dazed and confused...desperate for a beer.

Hamilton's corporate aristocracy had conquered America...and left it in ruins.

Progressive regulation was a near-total failure. The 1888 Sherman Anti-Trust Act had been meant to restore market competition. Instead it was used to crush labor unions. The Clayton Act was meant to be labor's "Magna Carta." But it was weak, then killed by the Supremes. By and large, "progressive" regulatory agencies were captured by the Barons and turned into lap dogs.

But now, amidst terrible poverty, the unions fought back. Farm-labor campaigns raged through the upper Midwest. Beginning in 1928, Norman Thomas ran for president six times, sustaining the spirit of social democracy.

In 1932 came the Bonus Army. The vets who'd survived Woodrow Wilson's war were promised a pension, payable in 1945. But they needed it NOW. Thousands marched on the White House, expecting to get bailed like the bankers.

*Fat Chance.*

With some small exceptions, Herbert Hoover---who'd done decent volunteer work through the '20s---would not let the people's government help its desperate citizens. Hobo camps filled with angry families who knew they deserved better.

From 10,000 to 25,000 vets set up in the Anacostia Flats, the very swamp Madison and Jefferson had dickered over with Hamilton at that fancy dinner in 1790.

Now the President refused to meet.  Generals Douglas MacArthur, George Patton, and Dwight Eisenhower torched the Bonus Army's camp...then opened fire.  Two vets died.  The Great Engineer and his smug GOP were political dead meat.

As the grassroots raged, a charismatic New York Democrat came to power alongside the American Century's most powerful matriarch, the better angel of our feminist soul.  Their 1932 landslide said *do something...anything!* to end the Depression.  But except for legalizing booze and singing *Happy Days Are Here Again*, the Roosevelts had scant idea what that would be.

FDR had already been to the mountaintop.  Handsome, clever, and rich, Franklin's domineering mother prepped him for the presidency from birth.  Cousin Teddy gifted him a celebrity name, and---far more marvelous---the "ugly duckling" niece who became his best attribute.

Wilson made FDR Under-Secretary of the Navy.  In 1920 the Dems ran him for VP.  But Franklin may have been exposed to the polio virus during a 1916 outbreak in New York.  In Europe, 1918, as Under-Secretary of the Navy, he survived the flu.

Then, in the summer of 1921, the tall, athletic patrician swam in cold Canadian waters. Chilled to the bone, he awoke the next morning...and never walked again.

Like Lincoln's melancholia, like JFK's war wounds, polio tested the deepest chords of FDR's soul.  Somehow---through depression, war, and worse---he exuded a relentless healing spirit that transcended his well-hidden depths of personal despair.

At Warm Springs, Georgia, Franklin built a pioneering polio treatment center where thousands sought healing.  Had he never been president, Roosevelt would still be justly revered for his boundless compassion and relentless public optimism in the face of terrible personal suffering.

With a seriously pumped upper body, FDR used railings, banisters, and his son's arm to give the illusion of walking.  He sat behind a desk for Oval Office press conferences, spoke from podiums with hidden supports, referred in public to his leg braces only at the very end.

But it was Eleanor who made him.  Working New York's back channels, she engineered Franklin's governorship, then his presidency *(when really it should have been hers)*.

Though not exactly passionate in private, they were the ultimate power couple.  Franklin's radio-broadcast "fireside chats" enhanced Eleanor's daily newspaper column, which ran virtually everywhere.

The "First Lady of the World" was America's second richest (behind Gertrude Berg).  She trekked where her husband could not...to farms, factories, mines, mills, slums and tenements, poorhouses and hospitals...even the California concentration camps where Franklin jailed 120,000 Japanese-Americans for no good reason.

Race, class, religion, ethnicity, sexual orientation – none slowed Eleanor's gritty resolve to touch and inspire her fellow humans.

Alice Paul's Equal Rights Amendment languished through the decades.  Frances Perkins became our first female cabinet secretary (of Labor).  But Eleanor birthed a new sense of matriarchy, of an America that could (*should!*) again be run by women.

Policy-wise, the Roosevelts made another "half-way covenant" between corporate capitalism and American Socialism.

Had Debs's American Socialist Party survived Wilson's *putsch*, public ownership of our key financial and industrial institutions might have driven the national dialogue. Norman Thomas and a small but vocal Communist Party did demand it.

Until war came, the Roosevelts didn't go there. Often branded a Socialist, FDR was *(like Bernie Sanders)* a social democrat. He did not favor public ownership of the means of production. But he did want the corporations to be "carefully restrained creatures of the law and the servants of the people."

Like the greatest Franklin before him, FDR loved to experiment. Tom Paine said all humans deserved the basics of life. Lincoln said we could not survive half slave and half free. Now the Roosevelts would not abide "one-third of a nation ill-housed, ill-clad, ill-nourished."

The New Deal fired off scattershot agencies and executive orders to do what Hoover's GOP would not: make the government tend to the "general welfare" as the *Haudenosaunee* and white Founders *saw* to be the proper role for a people's council.

FDR's key agencies had initials like CCC, PWA, WPA, NRA, AAA. His barrage of band-aids created millions of jobs and saved countless Americans in desperate need.

Social Security, food stamps, child labor laws, the right to organize…all major social programs of the New Deal *(and later the New Frontier and Great Society)* flowed straight from the wellspring of an angry populace. In the spirit of the *Great Law* they made the government act like a tribal council, doing right by the whole human family.

That also meant restraints on corporate greed. The FDIC would guarantee bank deposits. The SEC would regulate the stock market. Glass-Steagall (until the Clintons killed it) would curb bank speculations.

While reining in the Barons, the New Deal created millions of jobs, enhanced our embrace of Mother Earth, breathed life back into our body politic, offered the vision of a nation free from poverty, defused what might have become a violent revolution. As FDR and even his fiercest critics well knew, the New Deal's healing doses of social democracy saved corporate capitalism.

From 1933 when he proclaimed that "Happy Days Are Here Again," until 1937, when Franklin lost his nerve, the Roosevelts' activism was a spectacular success.

It all hinged on an improbable coalition of industrial unions, racial minorities, southern racists, urban intellectuals, angry farmers, populist poets, and millions more with little in common beyond a desperate need to get our tribe back on track.

Franklin's fellow rich hated it *(and him!)*. They were "Economic Royalists," sons of Barons for whom too much money was never enough. When Franklin suggested they might share their wealth, their sociopathic Puritan rage turned murderous.

In 1933, General Smedley Butler told Congress that members of the Rockefeller, Mellon, Morgan, DuPont, and Remington clans had offered him $3 million to arm 500,000 fascists, overthrow the government and kill the president.

Butler spent the "Dollar Diplomacy" 1920s as a "racketeer for Wall Street," using the US military to pillage Latin America for corporate profit. His sensational charges of a "Business Plot" to assassinate FDR were suppressed.

No millionaire was imprisoned for this alleged conspiracy (since questioned by historians).  But European Barons backed fellow fascists Mussolini and Franco in taking Italy and Spain. Joseph P. Kennedy *(father of president #36)*, Prescott Bush *(grand/father of #41 and #43)*, Henry Ford and Charles Lindbergh loudly supported *Der Fuhrer*'s "National Socialism," a term often used by TR.

Now a greed-driven narcissistic madman, Hitler promised to "Make Germany Great Again." Moving first to crush the labor unions, his "silent majority" would hate and fear Jews, Bolsheviks, Slavs, Jehovah's Witnesses, Muslims, heretics, gays, the disabled…the past, the present, the future.

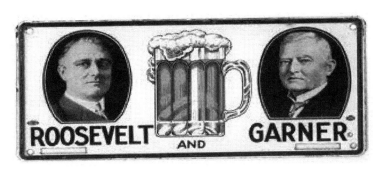

Had the New Deal failed---had the Roosevelts acted like corporate rather than social democrats---an embittered America might well have elected a Hitler of our own in 1936.  But because much of what they did actually worked, Franklin and Eleanor were able to preach a gospel of optimistic good will…

*…The only thing we have to fear is fear itself!*

Their miracle was holding together a uniquely diverse society while, in many cases, actually putting human need above corporate greed.

Overseas, their "Good Neighbor" policy brought a rare stretch of imperial restraint.  Pretty much alone among modern American presidents, FDR mostly refrained from invading smaller countries.

That was liked by Senator Gerald Nye, a North Dakota Republican.  In riveting 1935-36 hearings, Nye confirmed what America already knew: Woodrow Wilson lied us into war, tore up the Constitution, mishandled a Pandemic that killed millions worldwide, let us die to protect Robber Baron loans, let us freeze to save rich Russians from their own people…and jailed those who objected in the name of peace.

America, Nye said, was suckered into insane mass slaughter and a fascist Red Scare aimed at killing social democracy.

Still loyal to Woodrow, corporate Democrats were furious.

But Nye's hearings surprised no one.

Nor did the fierce spring storm of another great grassroots Awakening.

# SPRINGTIME
## "This Land is Your Land"

*As the Roosevelts fiddled with our economic mess, armed agrarian mobs, angry urban workers, and aroused young artistes again awakened our Indigenous spirit.*

New Deal social programs confirmed British economist John Maynard Keynes's theory that government spending at the grassroots would jump-start jobs and recovery.

FDR and Keynes did meet (*not happily*). But the New Deal's alphabet agencies created income for working people and a future for the American economy.

The Roosevelts also kicked in for murals, musicals, books, plays, photos, reportage, and much more. The PWA, WPA, Federal One, and other cultural projects helped another Awakened wave of transcendent creatives survive and thrive.

It all came with a strong strain of desperation. While the New Dealers sang of "Happy Days," Franklin and Eleanor faced a cyclical storm surge of radical resistance that forced them to continually tack left. FDR knew his social programs needed to stay a step ahead of the urban uproar and grassroots prairie fire sweeping the nation. If he didn't succeed as our greatest president, he quipped, he'd be "the last one."

In the Great Plains, armed agrarians replayed Shays's Rebellion by facing down farm foreclosures. A southern Sharecroppers Union rose up among our most downtrodden dirt farmers.

On the rails and highways, mines and mills, docks and slaughterhouses, foundries and factories, militant labor was reborn with a vengeance. Thousands of wildcat strikes raged through the decade. Dozens died confronting troops, cops, company goons, corporate thugs, private armies, hired killers.

Working-class anger shot blacks, women, immigrants, and radical organizers light years past the smug, stuffy AFL. The gruff, tough John L. Lewis and his Congress of Industrial Organizations followed Debs and the Wobblies in organizing whole industries at once, rather than just by craft. As Hitler crammed German unionists into concentration camps, American rank-and-filers won picket line paybacks.

In a "strike heard 'round the world," angry wildcatters led the newborn United Auto Workers in seizing Fisher Body #1 in Flint. From December 1936 through February 1937, some 2,000 occupiers held the factory while 5,000 supporters circled the building. They camped, cooked, staged classes, produced newspapers, and generally turned the world upside down until GM finally signed a contract.

Beyond the union framework, countless wildcat sit-down strikes, occupations, walk-outs, picket lines, insider sabotage, stealth violence, open defiance, and much more spread across the land.

The empire did strike back. In South Chicago, cops shot ten picketing workers in the back at a 1937 Republic Steel Memorial Day rally. But Ford, Republic, and other rubber, steel, automobile, electric power, and meat packing factories were unionized anyway.

Most "Malefactors of Great Wealth" were outraged by the New Deal's willingness to legitimize the labor movement. FDR said he "welcomed their hate." The smarter Barons preferred to deal with union leaders rather than with the wildcat strikers ready to rip them apart without warning.

First Lady Eleanor and Labor Secretary Perkins walked feminism and unionism hand-in-hand. Frances helped make the 1935 Wagner Act a landmark for labor organizing. Unlike Wilson's failed Clayton Act, the New Deal's National Labor Relations Board made a real difference for American workers.

Many were African-Americans. Jim Crow stole their southern ballots. But in 1936, FDR's social programs enticed northern blacks to question the party of Lincoln.

They got little in return. Roosevelt needed racist "good ol' boy" southerners to push the New Deal in Congress, which couldn't even pass an anti-lynching law.

Finally, with war raging in Europe, A. Philip Randolph called FDR's bluff. Head of the Brotherhood of Sleeping Car Porters, our biggest black union, he threatened a mass march. After a tense 1941 Oval Office face-off, Roosevelt signed Executive Order 8802 creating the Fair Employment Practices Committee to monitor federal hiring and curb Jim Crow in the war industry.

Throughout the Depression, black activists got heard through the American Communist Party. Its 100,000 members included artists and intellectuals like Elizabeth Hendrickson, W.E.B. Du Bois, Helen Holman, Paul Robeson, Richard Wright, Langston Hughes. CP lawyers stopped Alabama from executing nine "Scottsboro Boys" falsely accused of rape. They made the case a global symbol of American racism (*at last, none were executed*).

Most American Communists supported the New Deal. They liked the Soviet Union's planned economy, which avoided many of the Depression's worst impacts.

But they found the actual USSR (and the awful Joe Stalin) pretty grim. When idealistic young activists joined the Abraham Lincoln Brigade to save Spain from fascism, Stalin sold them out. His gruesome 1934-35 show trials doomed countless innocents to work camps and death. His 1939 "non-aggression pact" with Hitler let him share in the rape of Poland. But when Adolf turned on him, Stalin became the "Uncle Joe" that *Life Magazine* lovingly portrayed on a 1943 cover.

Beneath the Red veneer, Stalin was an exceptionally brutal Tsar. The only thing more dangerous than being his enemy was thinking you were his friend. Out of dictatorial paranoia, he purged his best generals and shot his brightest intellectuals. He enslaved millions in a ghastly "gulag" exceeded in size only by the Nazi concentration camps (*and then nearly matched by America's Jim Crow/Drug War prison system*).

In Detroit, the Catholic radio preacher Father Charles Coughlin supported the Roosevelts, then degenerated into anti-Semitic hate speech. Coughlin's evangelical fascism stretched through the Fat '50s and Reagan '80s all the way to MAGA Trump.

Sinclair Lewis mocked such small-minded bigotry in *Main Street* and *Babbitt*. Like Jack London's earlier *Iron Heel*, Lewis's *It Can't Happen Here* warned of the fascist coup that on January 6, 2021, damn near came to pass.

Louisiana's frenetic Governor Huey "Kingfish" Long's "Share the Wealth" movement demanded $5,000 grants for all Americans. He rammed "Every Man a King" into the upstart lexicon. Then *(of course)* he was assassinated.

Reborn prairie populism was put to song by the likes of Woody Guthrie, Pete Seeger and the Weavers. *This Land is Your Land, If I Had a Hammer* and other grassroots anthems poured from a banjo that read...

*This machine surrounds hate and forces it to surrender.*

"Okies" sang that way as they fled the Dustbowl eco-disaster for the "left coast," which became an epicenter of upheaval.

In 1934, Socialist Upton Sinclair ran for governor pledging to End Poverty in California. Author of a hundred books, Upton aimed his muckraking magic at corporate greed, making it clear that....

*...It is difficult to get a man to understand something when his salary depends upon his not understanding it.*

FDR betrayed Sinclair, who lost in a huge corporate backlash. But in 1939, Populist Governor Culbert Levy Olson ignited four years of grassroots uproar before losing to Earl Warren, who later became our greatest Chief Justice.

In Long Beach, Frances Townshend's massive network of angry retirees paved the way for Social Security, which *still* saves from poverty millions of elders and the working children who must otherwise support them.

The era's signature ode was John Steinbeck's 1939 *Grapes of Wrath*. As a novel and then a Hollywood classic, the Awakened odyssey of battered class and climate refugees became the era's *Common Sense, Uncle Tom's Cabin, Jungle*. "I'll be everywhere," says our heroic Tom Joad...

*...Wherever you can look – wherever there's a fight, so hungry people can eat, I'll be there. Wherever there's a cop beatin' up a guy, I'll be there. I'll be in the way guys yell when they're mad. I'll be in the way kids laugh when they're hungry and they know supper's ready, and when the people are eatin' the stuff they raise and livin' in the houses they build – I'll be there, too.*

Movies like *Mr. Deeds Goes to Washington* and *Mr. Deeds Goes to Town* became populist classics, as did Frank Baum's not-so-liberally adapted *Wizard of Oz*. Charlie Chaplin's *Modern Times* (1936) trashed corporate greed. His *Great Dictator* mocked Tojo, Mussolini and Hitler *(who stole Charlie's mustache)*.

But our greatest "Marxists" were the madcap brothers Groucho, Harpo, Chico, and Zeppo. Their lunatic anarchy in *Night at the Opera, Day at the Races, Duck Soup* later aroused a stoned generation that *SAW* them as righteous, raucous rebels.

In music, the color line finally broke.

On June 15, 1933, the Chicago Symphony played the African-American Florence Price's gorgeous Symphony #1 in E Minor. In '36, at the Hollywood Bowl, William Grant Still conducted his own A-flat masterpiece for the LA Phil.

Meanwhile Benny Goodman brought the black piano genius Teddy Wilson to play on stage with him and Italian-American drummer Gene Krupa (who was jailed for *cannabis)*. The Jewish clarinet *meister* was warned to expect a riot.

Instead there came a truly magical gathering. The "King of Swing" then added the black vibes master Lionel Hampton, escalating the show biz assault on Jim Crow.

An epic struggle also erupted over energy and the environment.

The electric utility industry was born of Morgan, Edison, Brush, Tesla and Westinghouse in the 1880s. Mostly it was corporate. But dozens of community-owned "munis" reliably shipped "socialist juice" cheaper, cleaner, safer and more reliably than the Barons' aptly named IOUs (Investor Owned Utilities).

In the 1920s, utility stocks soared, then crashed. But electricity demand grew---profitably---throughout the Depression.

FDR's Rural Electrification Administration lit up countless remote farmhouses. But it undercut thousands of legendary Jacobs wind turbines that pumped Great Plains water, crushed grain, and generated clean, fuel-free electricity.

The New Deal's Tennessee Valley Authority and Bonneville Power Administration built massive dams meant to prevent flooding and produce cheap juice. But they morphed into Soviet-style bureaucracies that later built nuke reactors, sparked huge defaults, and treated their customers like serfs.

The New Deal also built a giant aqueduct to bring water to southern California's new megacities.

But the prairies were stripped bare. When the rains stopped, the topsoil baked. Mile-high walls of apocalyptic dust turned fields to deserts, made day into night. Homes and lungs filled with soil. Whole cities darkened.

So FDR became a "tree farmer." His Civilian Conservation Corps planted more than 220 million saplings along the Rockies' front range, slowing dust storms, holding moisture, capturing CO2. New parks, dams, schools, playgrounds, pools, streets, highways, public housing promised hope for ecological survival.

FDR's 1934 Indian Reorganization Act got very mixed reviews. But the hated Bureau of Indian Affairs got a "chief"---John Collier, a friend of the Bohemian Mable Dodge---who restored some tribal sovereignty and spoke to the Indigenous with an official respect unseen since Wounded Knee.

Then FDR stumbled. His National Industrial Recovery Act demanded that corporations cooperate with unions and the public.

The Supreme Court *(of course)* killed it.

Flush from his 1936 landslide re-election, Franklin demanded an age limit for Justices and more seats for him to stuff. It didn't fly. Dictatorships had come to Germany, Russia, Italy, Spain, Japan. The country feared one here.

But as with so much else in his life, FDR got lucky. Two conservative Justices swung left. Seven seats opened. Liberals like William O. Douglas and Hugo Black got robes.

So from the late 1930s to the early '70s (when Nixon dragged it down) the Supreme Court certified some of our greatest leaps for human rights, civil liberties, ecological survival, and more.

Unfortunately, amidst the Court-stuffing debacle, Franklin got cold feet over federal deficits. He slashed key New Deal programs. The economy slumped. Keynesianism was confirmed (in reverse).

But the Depression Era's turbulent spring had revived our Indigenous commitment to the well-being of every member of the human tribe. FDR later certified that part of our DNA with an *Economic Bill of Rights*. Eleanor did it on a global scale with the *Universal Declaration of Human Rights*.

The humanitarian sentiments of both those magnificent documents never became actual law.

But amidst the hot summer of yet another war---facing the Axis Devil Woodrow Wilson helped create---our awakened humanism and Good Neighbor legacy gave us the moral high ground.

It also brought us the essential allies we would so desperately need in the World War that came at the peak of our adulthood.

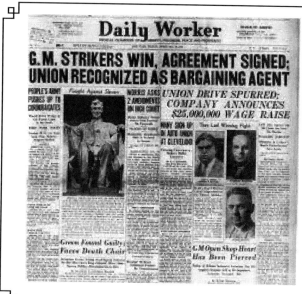

*VICTORY AT FLINT!*
*The successful 1936 worker occupation of General Motors' Fisher Body #1—along with other 1930s triumphs---forever elevated American organized labor.*

# SUMMER
## *World War 2*

*As the Great Crash morphed and surged, it led us straight to global war.*

When Hitler got Stalin's nod to invade Poland on September 1, 1939, America still seethed over Woodrow Wilson's WW1 disaster. We did not want a re-run.

FDR saw the larger danger. He used a "lend-lease" subterfuge to send the British arms and ammunition. He did all he could to get the Germans to attack us.

On December 7, 1941, infamy struck from Japan. Some say he let it happen. Franklin was an notorious dissembler and a shameless gambler.

But he wasn't stupid. A second front in the Pacific with our fleet in ruins was a hell of a stretch, even for him. Had Tokyo nailed our aircraft carriers, the Pacific might still be theirs.

Pearl Harbor was an imperial outpost on a conquered archipelago. But the attack did *(for once in our history)* unite America in war.

The Revolution, 1812, Mexican, Civil, Spanish-American, First World, Korean, Vietnam, Contra, Iraq, and Afghan wars have all deeply divided us.

Against Japan, Americans rallied in near-unison. It was Armageddon Time for the City on the Hill.

In our most critical industries, FDR at last became an outright Socialist. All that wonky blather about the "wonders of the free market" disappeared when it came time to make sure the Arsenal of Democracy delivered the goods.

"Dr. Win-the-War" commandeered much of the auto, airline, mining, milling, manufacturing, agricultural, telecommunications, and other key industries. In the spirit of Gene Debs---but for war rather than peace---America chose a planned economy based on command and control, aimed consciously at a shared goal. In time of crisis, private profit and corporate greed would not save us.

*The Invisible Hand picked up a planner's pen.*

The result was full employment and a booming industrial machine. From 1943-5, with 15 million soldiers overseas, pretty much any American could get a decent job.

At least 2,200,000 women, including Rosie the Riveter, worked the assembly lines. About 400,000 served in the armed forces.

Women were paid half what men got for doing exactly the same work. But polls said they generally loved their independence and "did not miss their husbands."

When the men returned to kick Rosie back into the kitchen and bedroom, a new World War erupted...with the ultimate outcome as yet unresolved.

Meanwhile, Jim Crow still ruled the south...and most key Congressional committees. Blacks were helped by the New Deal. But even during the war, the First Lady couldn't get racist southern Democrats to pass an anti-lynching law.

In 1941, after A. Philip Randolph threatened a national uproar, FDR did desegregate the booming arms industry. But riots erupted anyway. In 1943, six whites and twenty-five blacks died in a single Detroit day.

Overseas, African-Americans again served in segregated units. But they brought home what Martin Luther King, Jr., later called "a marvelous new militancy" that turned the nation upside down.

Navajo code talkers spoke in cyphers that were never broken. They were universally honored until 2017, when Donald Trump insulted them under a White House portrait of the slave-owning Indian killer Andrew Jackson.

Citizens of Japanese descent from California and Hawaii comprised the legendary 442d Infantry which tore through Europe and became one of America's most decorated units.

But FDR's awful Executive Order 9066 unforgivably forced some 120,000 Japanese-Americans into concentration camps. Most were second- and third-generation Californians who lost their homes, businesses, families, health…and lives. Eleanor had the amazing grace to visit one of these horrible hovels. But like the crimes against the Indigenous, this racist outrage still curses us all.

So, too, the *Jewish Question*. Bitter dispute still rages over how many of the millions Hitler incinerated could have been saved *(including Roma, gays, Jehovah's Witnesses, East Europeans, the physically and mentally challenged, social democrats and innocent bystanders)*.

Most glaring are the 937 Jewish refugees who sought asylum in Miami aboard the *USS St. Louis*. Confronted with a national furor (and the Roosevelts' troubling tinge of patrician anti-semitism) they were sent back to Hitler's Europe. Many died in death camps to which they were transported on rail lines our military declined to bomb.

Among so many others, the US denied visas for the family of Dutch diarist Anne Frank, who died *(at age 15)* in Bergen-Belsen. "I believe that all Germany's Jews are looking around the world, but can find nowhere to go," mourned her mother in 1939, six years before her family could've been saved with a single visa stamp.

Yet on a single astonishing night---October 1, 1943---the Danish people evacuated 90% of Denmark's 7,800 Jews (including their non-Jewish spouses) over treacherous waters to Sweden. French villagers saved hundreds of children from Nazi slaughter. Throughout Europe, Catholic nuns "adopted" otherwise doomed Jews *(including my wife's mother)*. "Righteous gentiles" saved countless innocents.

Individual valor, often at great risk, came from countless heroes whose names we don't know. They meant life itself for refugees who became stalwart citizens and raised beautiful families. Their heroism was rarely matched by self-righteous bureaucrats who ducked their duty while loudly claiming the high moral ground.

Until FDR began pulling the plug in 1937, the New Deal's hybrid mix of social democracy with corporate/state capitalism made life inestimably better for our battered working/middle class.

In 1944, amidst a hot summer's sense of social revolution, Franklin proposed an *Economic Bill of Rights*. Mostly read over the radio as part of the annual State of the Union address, Congress approved it as a resolution…but *not* as statute.

In sentiment, this was America's most revolutionary official document since the abolition of slavery and the 15th and 19th Amendments granting black and female suffrage. In principle, it confirmed every human's tribal right to life's essentials.

116

Framed as a logical corollary to the Constitution, it promised to serve "the general welfare." It was the modern humanist embodiment of the *Haudenosaunee Great Law* and Madison's Bill of Rights, guaranteeing our spiritual, intellectual and physical freedoms, expecting the government to act for a benign community.

"Necessitous" people are not free, said FDR. The human community---through a government of, by and for the people---would guarantee ALL citizens a decent living.

Our human family, said the president, had the right to "useful and remunerative" work that would provide "adequate food and clothing and recreation." Farmers and entrepreneurs deserved liberation from monopoly control. Good housing, medical care, education, "protection from the economic fears of old age, sickness, accident and unemployment"…these were universal human rights, to be guaranteed by the community, acting through the Congress, the executive, the courts.

Rooted deep in our Indigenous DNA, this humanist vision is forever carried by diverse activists who time and again Awaken to push the arc of history toward unity and justice.

But unlike the original 113 *Haudenosaunee Codicils,* or Madison's Ten Amendments, the Economic Bill of Rights has yet to become *LAW.* Dominated by all-powerful corporations and bought politicians, we remain hostage to poverty, ignorance, bigotry, narcissism, greed, empire…and *fear*.

In 1945---at the peak of our powers---we *SAW* two unGodly horrors: Nazi Extermination Centers, and the Atomic Bomb.

Marching toward Berlin, the Allies found in Hitler's concentration camps an unspeakable abyss. Its first victims were political opponents: unionists, leftists, dissidents, social democrats, communists.

Then came the scapegoats: Jews, Gypsies, Jehovah Witnesses, slavs, gays, humans with physical or mental challenges. Starved, ill, worked and beaten to death, they died by the millions

Throughout his career, Hitler loudly admired how the US handled its "Indian Problem." In his own "reservations," millions perished. At Bergen-Belsen, Allied troops found some 30,000 corpses (*including Anne Frank*) and hordes of "human skeletons" barely alive.

But six death camps in Poland crossed an unspeakable line. There the Nazis operated industrial-scale factories for the systematic elimination of human multitudes. Auschwitz-Birkenau, Bełżec, Chełmno, Majdanek, Sobibór, and Treblinka embodied a whole other level of murderous insanity for which there is no language or comprehension. These hideous charnel houses say something so deeply disturbing about our own species that we still struggle to make sense of it.

Likewise the atomic bombings of Hiroshima and Nagasaki. Supreme Allied Commander Dwight Eisenhower opposed them…

*…on the basis of my belief that Japan was already defeated and that dropping the bomb was completely unnecessary.*

117

Their use was sold on the idea that they would shorten the war. But to this day the US military calls the Hiroshima/Nagasaki bombings "announced nuclear tests."

At first, we denied the very existence of the radioactive fallout we now know leaps the generations, and assaults our biological essence at its genetic core.

Then came the suicidal madness of exploding some 2,000 nukes in above-ground "tests," filling our ecosphere with deadly radiation, killing millions down through the generations.

From 1946 to 1963---from Siberia to the South Pacific to our own desert southwest---above-ground tests proved one thing: we humans can indeed wipe ourselves off this planet… in an instant…or longer-term by assaulting our ecological support systems…and by irradiating our very genome.

A bang or a whimper….doom either way.

But we have a larger choice.

We can reawaken the vision of our Indigenous origins, embrace a universal union, live in Solartopian harmony with our Mother Earth…and turn our peaceable wealth into a just, sustainable society.

Or…we can proclaim ourselves the Elect of God, wage a doubt-free war on diversity, crusade for global dominion, flaunt ecological extinction as if it's a myth.

Sadly, in the chill autumn that followed our hottest summer peak, we chose the road less loving…or sustainable.

# FALL
## *Cold War/Red Scare 2*

*As the World War ended, FDR died (at 63). Eleanor did not.*

*Wilson's Calvinist League had been an imperial phalanx, fundamentally racist.*
*In her matriarchal humanism, Ms. Roosevelt helped birth the United Nations, meant be a tribal forum, a global rebirth of Indigenous Confederacy, gathering diverse, warring nations into a circle of peace.*

*But could she comb the snakes from the heads of the Masters of War?*

The 1948 *Universal Declaration of Human Rights* exalted humankind's shared soul. Newly independent nations like China, Singapore, Indonesia, Congo, the Philippines and Vietnam now had a place to assert their post-colonial identity.

In India, Mohandas Gandhi's huge non-violent campaigns finally bore fruit. Influenced by Thoreau and the Quakers, the Mahatma's *satyagraha* forced Britain to *Quit India*. It was a towering triumph for the power of peaceful civil action.

But when Muslims and Hindus started killing each other after independence, Gandhi refused all food and water. In an amazing response, the embittered rivals ended their civil war so the Mahatma (*Great Soul*) might live.

Gandhi was soon assassinated, with catastrophic consequences that plague us still. But activists seeking peace, justice and post-imperial independence now had a non-violent beacon to light their way. In 1948, Costa Rica voted to shed its military.

The US also took an apparent leap toward lasting peace. Like Grant at Appomattox offering rations to Lee's defeated rebels, our conciliatory Marshall Plan extended a supportive hand to sixteen war-torn European countries. That included the Germans we had just beaten at such horrendous cost.

Despite the carnage they caused---and rather than repeating the Allies' disastrous reparations demands from WW1---we gave Germany billions of dollars to help rebuild. "Our policy is not directed against any country," said General George Marshall (the plan's architect) "but against hunger, poverty, desperation and chaos."

Stalin didn't see it that way. Most Europeans credit the Soviets with the defeat of the Nazis. At least 20,000,000 of their people died, maybe far more.

Marshall did offer the Soviets help. But the new Truman Doctrine also threatened armed intervention against any nation leaning towards communism. Direct aid soon went to fascist forces in Greece and Turkey, leading to brutal dictatorships.

Stalin's protege Vyacheslav Molotov toyed with taking Marshall's desperately needed dollars. But the ever-paranoid Red Tsar saw too many strings attached.

So their "Molotov Plan" (with chains of its own) dug an eastern European "moat" to prevent any new western assault. Separated by a line of subservient dictatorships, relations between the former US/USSR allies quickly deteriorated.

It was a terrible moment for our species. In suffering the ungodly carnage of a second world war, we'd oblitered perhaps another hundred million of our own. From the deepest depths of human depravity erupted the ghastly realities of Hitler's concentration/death camps. Atomic explosions ripped through our hearts and minds, threatening our very survival on this planet...as would the ensuing disaster of commercial atomic power.

*At war's end we had that brief, precious, most sacred moment where we could come together to heal and revive...to lay the groundwork for a permanent peace...to transcend to a level of human unity that would guarantee a peaceful, prosperous, egalitarian future for our entire species.*

It was right there*!*

Somehow, we missed one of humankind's great evolutionary opportunities. But we just could not seem to grab that Magical Ring of global peace.

Stalin had his own agenda. For all his Red rantings, Joe was a traditional Tsar. His real hero was Ivan the Terrible, not Marx or Lenin. For the "Man of Steel," the Communist Manifesto began and ended with "the dictatorship of the proletariat."

*Meaning HIM.*

A world on fire for social justice and humanist evolution was not Stalin's thing. He backstabbed grassroots revolutionaries in 1930s Spain, where they might've seriously slowed Hitler. He did it again in post-war Greece, then Czechoslovakia. Worldwide, the Soviet presence was marginal, malignant, ineffective, unhinged.

In 1949, Mao took China. On America's schoolroom walls, the Asian landmass turned into a great big blotch of scary Red.

In tandem, the Red Tsar and the Red Emperor were high on the list of history's worst mass killers. Both modernized their countries, advanced industrialization, provided education, health care, and more.

But between their ghastly show trials, failed collectivizations, Orwellian re-education camps, slave labor/prison gulags, assaults on eastern Europe and Tibet...countless millions needlessly died. Overall what passed for modern Communism in and around the Soviet and People's Republics was a very long way from anything resembling a worker's paradise.

Yet neither nation ever posed a tangible physical threat to the continental United States. The Soviet Union beat the Nazis...but lay in ruins. China was still mired in centuries of desperate poverty. Neither was about to march into Manhattan.

In Fulton, Missouri (1947), the ousted forever warrior Winston Churchill---with time on his hands---preached that Stalin's "Iron Curtain" was not merely crushing eastern Europe...it threatened all humankind.

China's Revolution sparked a wave of hysteria reminiscent of Salem 1692-3. Soon enough, the latest claque of crusading Roundheads shrieked with horror at the Red Peril's heathen non-white hordes allegedly poised to overrun the City on the Hill.

Sold with the Big Fear of a Godless commie menace, our own imperial interventions were brutal, savage, inexcusable.

While howling at the Reds, the US unleashed upon the Third World a toxic horde of equally detestable torturers, murderers, drug dealers and thieves. Their corporate/ Calvinist body count was less than Stalin/Mao's only because they raped and pillaged smaller countries.

The slightest whiff of social democracy or anti-imperial nationalism drew a toxic stream of US troops and spooks whose blazing guns and rigged voting machines asked no questions.

As per Smedley Butler, the Cold War globalized Dollar Diplomacy. War was always a racket. Untold trillions poured into the arms dealers' coffers. Under the cover of anti-communism, there were cheap labor and resources to exploit, mass markets to corner, bases to build, kickbacks to collect, drugs to export, upstarts to execute.

The "Military Keynesian" fear that peace would bring another crash was itself the clear and present danger.

And then there was that thing about Christianizing the planet. As with early Boston's Puritan Elect, America's wealthy post-war elite meant to purify the Earth of any heathen alternative to monopoly capitalism. For our corporate magistrate-priests and their Wall Street bean counters to tolerate any financial or belief system other than their own was to doubt their entry into Robber Baron Heaven. The door to social democracy was to be slammed forever shut, no matter where...no matter the body count.

In 1950, Truman and his Doctrine sent some 55,000 Americans---and countless Koreans and Chinese---to awful deaths in a futile war that ended where it began.

Throughout the era, our endless imperial invasions ravaged the Third World. Our real Cold War enemies were never Communist dictators. With them---as among Nixon, Brezhnev and Mao---the corporate elite could always do business.

Instead it was the social democrats and democratizing nationalists we hated... the forever Sukarnos and Allendes...the Godless grassroots Mavericks who always erupt to lead their new nations away from entangling alliances with western theocracies. Among the more shameful coups:

In 1953, TR's CIA grandson Kermit Roosevelt disposed of Iran's duly elected Mohammed Mosaddegh, a social democrat. The ghastly Shah---a heartless torturer--- paid us back in cheap oil, moral filth and Persian rage.

In 1954, Guatemala's Jacobo Arbenz dared propose land reform. The thugs that replaced him oozed up from a bottomless pit of murderous mobsters.

In 1961, Congo/Zaire dared to elect Patrice Lumumba, a leftist postal worker. With just three days left in Ike's second term, the Company enthroned a ghastly hand-picked dictator (Mobutu) who for decades looted the country and terrorized its people.

In 1965, a CIA-led uprising killed perhaps three million Indonesians while enthroning the dictator Suharto, who grifted at least $2 billion from the public treasury.

With all these and so many more Cold War attacks on social democracy came a permanent war economy...and a demand for global hegemony...in a home front defined by totalitarian despair.

Said George Orwell in his 1948 dystopian classic *1984*…

*…The war is not meant to be won, it is meant to be continuous.*

*Hierarchical society is only possible on the basis of poverty and ignorance. This new version is the past and no different past can ever have existed. In principle the war effort is always planned to keep society on the brink of starvation.*

*…The war is waged by the ruling group against its own subjects and its object is not the victory…but to keep the very structure of society intact.*

Soon enough, things got radioactive. In 1949 *(as the Chairman danced)* Stalin exploded his first nuke. Hundreds more followed, filling our lungs and planet with deadly radiation.

Some 700 US "tests" in the South Pacific and Nevada destroyed countless downwind islanders and desert ranchers. A quarter-million of our own "atomic soldiers" were irradiated. Thousands were force-marched through seething Ground Zeros.

They died in droves.

So did John Wayne, Rita Hayworth, and much of the cast of "The Conqueror," filmed downwind in the heavily contaminated St. George, Utah. Tons of radioactive sand were carted back to Hollywood studio sets *(the sand was later donated for use in LA public school play boxes)*.

As with radiation sickness at Hiroshima/Nagasaki *(and again with Agent Orange and Gulf War Syndrome, 9/11 First Responders, the PTSD of our forever wars)* our military denied any health impacts on that film crew, among atomic vets or for the global millions whose lungs and ecosystems were irradiated with test fallout.

Those who opposed the madness paid a price. To protect us from "godless communists" out to "destroy our freedom and liberty," corporate fundamentalists set out to obliterate our freedom and liberty. The 1940 McCarran and 1950 Smith Acts inflamed yet another Lavender/Red Scare.

The latest "army of devils" came from the unionized left. Postwar labor uprisings *(including a powerful general strike in Seattle)* tore through the mines, mills, railroads, city streets. The Baronial Elect shuddered in terror.

So Congress passed the anti-labor Taft-Hartley Act. Truman vetoed it. But it passed anyway…and has yet to be repealed by any number of "pro-union" Democrats with ample opportunity to do so.

Harry also faced black vets returning more militant than ever. Race hate seethed over jobs, housing, rights, power. Riots erupted. Threatened again by A. Philip Randolph, in 1947 Truman desegregated the Army.

In racist response, South Carolina's Dixiecrat Sen. Strom Thurmond ran a 1948 "States' Rights" Klan candidacy. He won Mississippi, Alabama, South Carolina and Georgia, where Jim Crow---now a Trump Republican---*still* fights to keep blacks from voting. *(All the while, Strom secretly supported Essie Mae, his own mixed-race daughter, who kept their secret until he died)*.

Former-VP Henry Wallace also ran in 1948---as a true Progressive. Henry wanted to end the Cold War, abolish nuke weapons, stop the Red Scare, win social democracy. His grassroots fervor surged with Awakened Populist/Socialist ideals.

But his quirky theosophist spiritualism and the usual Red baiting helped kill his campaign. The party's 1948 vote count came in under 3%.

Meanwhile the legendary athlete-singer-actor-activist-attorney Paul Robeson was burnt at the media stake by a new round of witch-hunters. At the House Un-American Activities Committee, when the bigoted Ohio Congressman Gordon Scherer told Paul to go live in the Soviet Union, Robeson replied...

*...My father was a slave, and my people died to build this country, and I'm going to stay right here and have a part of it just like you. And no fascist-minded people like you will drive me from it. Is that clear?*

*...You are the non-patriots, and you are the un-Americans, and you ought to be ashamed of yourselves.*

The committee quickly summoned Jackie Robinson, who called some of Robeson's statements "silly". But he emphasized that of 400 players in the Big Leagues, just seven were black...

*...The white public should start toward real understanding by appreciating that every single Negro who is worth his salt is going to resent any kind of slurs and discrimination because of his race, and he is going to use every bit of intelligence such as he has to stop it. This has got absolutely nothing to do with what Communists may or may not be trying to do. And white people must realize that the more a Negro hates communism because it opposes democracy, the more he is going to hate any other influence that kills off democracy in this country-and that goes for racial discrimination in the Army, and segregation on trains and buses, and job discrimination because of religious beliefs or color or place of birth.*

(Tom Yawkey wouldn't sign Robinson or Willie Mays to his Boston Red Sox, where they could've joined Dom DiMaggio and Ted Williams (*who had Mexican grandparents*) in baseball's greatest batting order and defensive outfield. It took another 57 years before the Dominican David "Big Papi" Ortiz would win the Sox a World Series).

KKK racists attacked a 1949 Robeson concert at Peekskill, NY, killing Paul's stellar stage career. But Robeson still mocked the Cold War and (*at great personal cost*) helped inspire a Civil Rights movement that turned America upside-down.

In 1953, two Jews---Julius and Ethel Rosenberg---were electrocuted for allegedly sending A-bomb secrets to the Soviets. Like Sacco and Vanzetti, their killings still reek of ritual murder.

In Congress, the new Grand Inquisitor was Joseph McCarthy. The drug-addicted Wisconsin Senator lied about everything, including his war record. Like a hysterical Salem adolescent, "Tailgunner Joe" got teachers fired, books banned,

activists jailed, artists driven to suicide. Gays like his mobbed-up lawyer Roy Cohn stayed cautiously in the closet.

Cold War TV was dumbed down, newspapers censored, civil liberties shredded. As president of the Screen Actors Guild, B-lister Ronnie Reagan and his second wife, Nancy, spied for the FBI. Walt Disney, John Wayne, Hedda Hopper and other Hollywood Cold Warriors joined the Reagans in juicing their careers by ruining their rivals.

The Cold War fifties came with strong undertones of anti-semitic and anti-gay witch hunting. The Lavender/Red Scare showed serious strains of Jew-baiting and open contempt for blacks, Asians, Hispanics, Gays. Bigotry and repression hung in the autumn air like an icy pall.

While the Puritan elite chilled free speech, its arms industry strategically stuck at least one factory in every Congressional district. Ike's blue-blood Secretary of State, John Foster Dulles, and his CIA Chief---John's brother Allen---deployed our imperial legions to crush social democracy wherever it reared its heathen head.

This endless global assault on economic justice cost us enough "Military Keynesian" Cold War cash to have fed, housed, clothed, educated, medicated and underwritten a dignified social-democratic life for all of humankind.

Instead, the Puritan Elect demanded we shudder through yet another frigid winter of Gilded excess.

*The material pursuits of the Gilded 1950s were framed by the fear of nuclear annihilation and the rise of the Civil Rights movement, whose demographic outcome is still equated by American conservatives with the image at left.*

# WINTER
## *The Fat Fifties*

*In 1945, we were absolutely the greatest, freest, most powerful, most blessed, most down-home-righteous-tell-everybody-else-how-to-live nation the world ever saw.*

*We spread Nylons, chocolates and condoms all over Europe, dropped the Big Ones on Asia, got fully employed at home.*

*But a lung cancer Pandemic killed millions of GIs addicted to Big Tobacco cigarettes "gifted" during the war. The industry denied that murderous toll as vehemently as the military denied harm from atomic test fallout.*

FDR's GI Bill of Rights got millions of us a free college education, easy home ownership, ardent parenthood. At the peak of our powers, we were richer, more powerful, more secure, better educated, more globally-loved, self-confident, fiscally sound, technologically advanced than any other nation in history.

In 1952-53 Dwight Eisenhower did something truly unique. He ran for president promising to "go to Korea" and end a war...then actually did both! *What a concept!!*

Amidst domestic peace and a robust labor movement, the new American middle class built a great university system, cured polio, bought houses, drove cars, had a boatload of Boomer kids, played golf, went to the ballpark, watched color TV.

Adlai Stevenson---his victim in both 1952 and 1956---quipped that Ike had replaced the New Dealers with car dealers. As under Jefferson, Madison and Monroe; Grant, Hayes and Cleveland; Harding, Coolidge and Hoover...the business of America was once again business.

Elected as a Republican, Eisenhower preserved the New Deal's core social programs and regulatory infrastructure. For Wall Street, the Fat Fifties meant another wild ride for stock speculators. In 1957, the economy slipped into recession.

But thanks to the New Deal's legacy, the capitalist casino did not implode as so often before. Regulatory "socialistic" safeguards made us far more secure than in cycles gone by. Ike was fine with that.

Above all, Eisenhower enforced a 91% marginal tax on the highest incomes, limiting the power of the Baronial elite, which was now expected to pay at least some of their fair share (*imagine that!*). In 1956, as he cancelled elections in Vietnam, the wildly popular Kansan balanced the federal budget. In Old School Republican style, he spent much of his time golfing, napping and reading westerns.

Ike also honored FDR's GI Bill, funding a priceless university system, producing history's best-educated workforce. We were at the global epicenter of modern learning and research. Until Nixon's *dumb-us-all-down* Vietnam miasma, America's public education system was among humankind's most treasured assets.

As in the Era of Good Feelings, Gilded Age and Roaring '20s, prosperity in the Fat '50s was limited by class, race, ethnicity, gender. For farmers, women, citizens of color and the structurally poor, things were neither fair nor just. About a quarter of us

*(the "Other America")* still lived in poverty, a reality studiously ignored by the corporate mainstream …at least until Jack Kennedy came along.

The AFL's very imperial George Meaney helped keep things that way. Part Sam Gompers, part mob boss, Meaney meant to purge labor's social democratic left. But unions still guaranteed some of history's highest wages, drove the decade's prosperity, safeguarded the shards of modern industrial democracy.

For the corporate man in the grey flannel suit, income soared.

When the first credit card---Diner's Club---rolled out in 1950, Middle America entered what seemed to be a consumer's paradise.

Formerly progressive middle managers and bureaucrats toed the corporate line. Rosie the ex-Riveter was told to cook dinner and lay down. Suburban wives sank into boredom, denial, depression… what Betty Friedan called "the problem nobody knows." Soon enough, the ultimate struggle would erupt.

Ike bemoaned nuking Japan, but continued the Bomb tests. Like the anti-slavery abolitionists a century before, No Nukers dug in for the long haul.

In 1956, Stevenson opposed atomic testing. In 1958, American scientist Linus Pauling joined Russian physicist Andrei Sakharov in huge public marches for *ND (Nuclear Disarmament)*. Ike finally stopped the above-ground explosions.

But A-Bombs had a demon twin: commercial atomic power.

In 1952, Truman's Blue Ribbon Paley Commission predicted 15 million solar-heated US homes by 1975. In '53, Bell Labs' first photovoltaic cell converted sunlight to electricity. Alongside a rising wind industry, solar panels birthed a mighty green engine for cheap, clean, job-rich energy production, one that would work in harmony with our Mother Earth, rather than at war with Her.

But that December, Eisenhower pitched the "Peaceful Atom" to the U.N. Scientists guilt-ridden by the Bomb's mega-carnage promised nuke-powered electricity "too cheap to meter." For the Atomic Energy Commission, it was a happy face pasted onto on an apocalyptic technology…and a whole new line of business.

Commercial reactors proved expensive, dangerous and eco-disastrous. By 1985, *Forbes* branded them "the largest managerial disaster in US history." Accidents at Santa Susana, Fermi, Three Mile Island, Chernobyl and Fukushima made atomic energy history's most expensive techno-failure. In the 2020s a fleet of 93 disintegrating geezer US nukes portended even worse. There were more than 400 worldwide, scorching the planet, just waiting to blow.

Meanwhile, Ike's interstate highway system---with 41,000 miles of pavement---became the worlds biggest public works project.

In the 1920s, just one American in ten owned a car. To hype sales, GM Chair Alfred Sloan perpetrated a "Great Streetcar Conspiracy" that sabotaged at least 80 urban mass transit systems. GM was later found guilty of this evil deed…and fined $5,000. Sloan went on to fight the UAW at Flint and sell sedans to Hitler.

More Americans have since died in cars than in all our wars combined.

The toll on our planet and health *(especially before the ban on leaded gasoline)* has been incalculable.

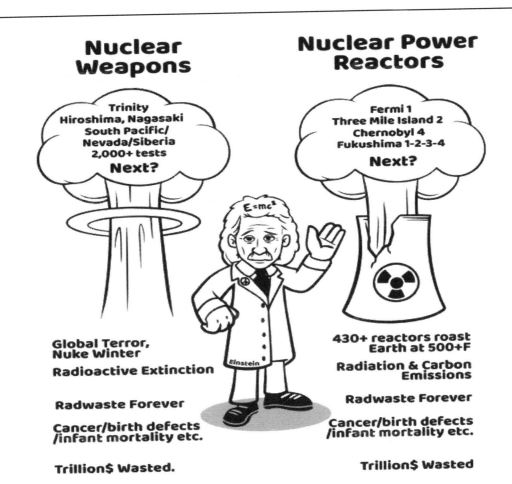

## Nuclear Weapons

Trinity
Hiroshima, Nagasaki
South Pacific/
Nevada/Siberia
2,000+ tests
**Next?**

Global Terror,
Nuke Winter

Radioactive Extinction

Radwaste Forever

Cancer/birth defects
/infant mortality etc.

Trillion$ Wasted.

## Nuclear Power Reactors

Fermi 1
Three Mile Island 2
Chernobyl 4
Fukushima 1-2-3-4
**Next?**

430+ reactors roast
Earth at 500+F

Radiation & Carbon
Emissions

Radwaste Forever

Cancer/birth defects
/infant mortality etc.

Trillion$ Wasted

## "Maybe I should have been a plumber"

Artwork by Iulian Thomas.

Humankind's most horrific weapon was fathered by a devout pacifist. Its "Peaceful Atom" reactor offshoots threaten us with extinction.

In 1939, while at Princeton, Albert Einstein warned President Roosevelt that the Nazis might be working on a super-bomb based on his atomic discoveries.

They were. But Werner Heisenberg may have sabotaged his own program, becoming one of history's greatest heroes. On the other hand, the US DID make the Bomb. "Had I known that the Germans would not succeed in developing an atomic bomb," said Einstein after Hiroshima, "I would have done nothing."

More than 2,000 atmospheric tests have since contaminated our Earth's atmosphere. We have enough Nukes to destroy human life many times over. Some 430 commercial atomic power reactors scorch the ecosphere at 300 degrees Centigrade each. Five (so far) have exploded. Their wastes remain unmanageable.

Einstein once mourned that the world might've been better off if he'd been a plumber. Maybe he was right.

But the interstates *(which would've done well with rail lines down their center strips)* moved millions to the suburbs...and then to the ballparks, where we worshipped the national religion: baseball. When Don Larson pitched a perfect game in the 1956 World Series, countless school principals like mine played it over the intercom. When Roger Maris hit 61 home runs, the Earth wobbled.

Jackie Robinson's 1947 Rookie-of-the-Year season with the Brooklyn Dodgers broke America's most visible color line. Pro basketball and football integrated. In tennis, the African-American Althea Gibson won eleven Grand Slams.

In 1954, the Supreme Court's 9-0 *Brown* decision told Jim Crow to go. On December 1, 1955, Rosa Parks refused to give up her seat on a segregated Montgomery bus. Martin Luther King *(a rookie preacher)* helped win a year-long boycott that changed everything.

Reviving U.S. Grant's Reconstruction, Ike reluctantly sent federal troops to integrate schools in places like Little Rock, Arkansas.

On CBS-TV, former war correspondent Edward R. Murrow televised McCarthy's deranged rantings. The country tuned out his commie/gay witch hunt.

In Chicago, 1953, Hugh Hefner *(with a $1k loan from his uptight mother)* birthed *Playboy Magazine.* His lusty first cover featured the naked Marilyn Monroe celebrating sex as good, clean fun.

This wild new sensuality came with beat poetry, steamy novels, radical art, hot jazz. Little Richard, Chuck Berry, Fats Domino, Ray Charles, and other black artists gave us Rhythm & Blues. Then the very white Elvis came on with a black sound. The TV networks blacked out his gyrating hips. But Rock & Roll was here to stay.

The GNP grew through the '50s by 30%-plus. When Recession hit in '57, New Deal safeguards prevented a Crash. At decade's end, Ike was as loved as when he went to Korea to end that war.

In 1960, Jack Kennedy defied a right-wing picket line to see *Spartacus,* which deified a rebel Roman slave. It was written by Howard Fast---a fan of Tom Paine--- and adapted by the blacklisted leftie Dalton Trumbo. Both flirted with Communism.

Spartacus himself was played by Kirk Douglas, who demanded Trumbo get a screen credit. When the president-elect gave the film a thumbs-up, the hard right went haywire. *Red Scare2 was done.*

As a nation in 1960, our Indigenous/Puritan DNA was twisted as ever. We were amazingly prosperous, but tainted by poverty. Democratic in spirit, but cursed by sexism, racism and inequality. Endowed with cultural freedom, but haunted by Puritan intolerance. Vastly loved, but rulers of a cruel corporate empire. Shaped by a magnificent *Great Law of Peace* and Bill of Rights, but addicted to autocracy and dominion.

Bounced around by so many killer contradictions *(amidst the dramatic rise of the huge new Boomer generation)* America's aging organism blew out of balance...and blasted toward a whole new way of being.

# CYCLE 5:
# *MID-LIFE CRISIS*

| JFK | The '60s<br>New Frontier/Great Society | VIETNAM<br>*Watergate* | Drug War<br>Cointelpro | Me '70s |
|---|---|---|---|---|

# A BURST OF ENERGY
## *JFK*

*Jack Kennedy was America's first rock star president.*
*Our telegenic Irish prince took the White House with a blinding smile and a brilliant young wife.*
*He was born to wealth and power, preternaturally intelligent, reeking of sex.*

In 1960, JFK was the reincarnation of King Billy and Old Hickory, Teddy and Wilson, Franklin and Eleanor, all rolled into a transcendent burst of electric vigor.

He came on as a conservative Cold Warrior, full of caution and contradiction, corporate dominion and imperial arrogance.

But for a giant new generation, he hyper-evolved, taking a thrilling leap toward a brilliant new paradigm. Then he left us mourning what might have been….

Black votes put John F. Kennedy in the White House. Amidst the 1960 campaign, Martin Luther King was jailed in Georgia. His family asked Vice President Nixon to help him out. Dick was a friend of Martin's father, who was a staunch Republican. But the White House wouldn't free him. Nixon never called the family.

But Jack did. On the spur of a moment, prodded by an aide (Harris Wofford) the Senator phoned King's worried wife Coretta. The Kennedy record on civil rights was pretty thin. But younger brother Bobby---Jack's campaign manager---knew an opportunity when he saw one.

He called a judge. Martin went free. MLK's public gratitude mutated our national DNA.

After Emancipation, African-Americans embraced the Party of Lincoln. That began to change in 1936. Jim Crow was a southern Democrat. But many blacks who migrated north liked the New Deal, and voted for FDR.

In 1960, with the King family's blessing, black votes probably swung Illinois, New Jersey and Texas. Many Chicago ballots may also have been bought by Jack's uber-rich dad, whose underworld ties ran deep.

JFK carried the Electoral College 303-219. Without Illinois's dubious 27 votes, he would have won 276 to 246. But those mob favors still came with a steep price.

As the young president-elect waited in the wings, Ike's *Farewell* bent history's arc toward justice. Eisenhower had regretted the Hiroshima/Nagasaki atomic bombings. In 1953, he warned that military spending could drain our economy. In 1958, he joined the Soviets in a *de facto* ban on atmospheric nuclear testing.

As president, Eisenhower maintained the atomic arsenal, backed military spending, and revived Dollar Diplomacy with the usual imperial invasions. His foreign policy was shaped by the blue-blood Dulles brothers, two of our fiercest Cold Warriors.

But in 1953, as he ended the carnage in Korea, the avuncular general set the stage for a new way of thinking. In war, Ike said…

*...every gun that is made. every warship launched, every rocket fired signifies, in the final sense, a theft from those who hunger and are not fed, those who are cold and not clothed. This world in arms is not spending money alone. It is spending the sweat of its laborers, the genius of its scientists, the hopes of its children.*

The amiable plainsman's 1961 *Farewell Address* echoed Washington's 1797 warning against "Entangling Alliances." Ike cautioned against a "military-industrial complex" that had metastasized during his years in office. It was "new in the American experience." Its...

*...total influence – economic, political, even spiritual – is felt in every city, every Statehouse, every office of the Federal government...*

*...The potential for the disastrous rise of misplaced power exists and will persist.*

The Commander in Chief's misgivings resonated worldwide, from our European allies to rising Third World nations to American blacks as well as women, the young, the beats, the poor, the powerless, the peaceniks.

So too, JFK. In his 1961 Inaugural address, Kennedy warned that...

*...If a free society cannot help the many who are poor, it cannot save the few who are rich.*

In March, at the University of Michigan, JFK introduced the Peace Corps. An idealistic new generation of young Americans would become the better angels of our global soul. Thousands were changed forever.

The Awakening carried into outer space. The Soviets shot Sputnik into orbit in 1957. Now Kennedy promised to put a human on the moon by 1970 *(Neil Armstrong landed July 20, 1969)*.

So too the arts. The First Lady's breathless televised White House tours exuded glamour and grace. A new Jeffersonian elite (*the "best and the brightest"*) exalted education, athletics, the outdoors, literacy, humor and the arts in a burst of Enlightened exuberance. The Kennedy seduction was a golden *Camelot* of post-Puritan ease, a rising electronic wave to be joyously surfed by awakened creatives.

"Those who make peaceful revolution impossible," JFK warned at the White House in 1962, "make violent revolution inevitable."

Below the glow lurked dark secrets, hidden from the public like Lincoln's melancholia and FDR's wheelchair. Jack was seriously wounded in WW2. Constant back pain and Addison's Disease---a rare endocrine disorder---filled him with a steady stream of major drugs, prescription and otherwise.

So did a serial sex drive, implanted in the Kennedy DNA by Joe, Sr., the clan's randy patriarch. Among the many, Jack apparently bedded actresses Marilyn Monroe and Marlena Dietrich *(who may also have done his dad)*. The President, said legendary stripper Tempest Storm, "was a great man in everything he did."

Less whimsical was Jack's choice of Judith Exner, whose mobster lover Sam Giancana may have helped rub out both him and his brother.

The early Kennedys were Cold Warriors. In 1960 Jack faulted Nixon for a (non-existent) missile-gap, and rattled sabers over two tiny islands off China. At Ike's insistence, Jack sent troops and counterinsurgent Green Berets into Vietnam.

Imperial Priority #1 was Cuba. Fidel Castro overthrew the mobbed-up dictator Fulgencio Batista in 1959. Ike *(what was he thinking!?!)* tapped VP Nixon to check him out. But Tricky Dick owed his soul to Meyer Lansky and the mobsters whose casinos Castro confiscated, costing them millions. It was not a happy talk.

Soon Fidel turned toward Communism. Candidate Kennedy demanded an invasion. Regrettably, Ike and the CIA had one all set to go.

Just after launching the Peace Corps, the new president approved an attack at the Bay of Pigs. The CIA assured him the Cuban people would rise up *en masse*.

But Cuba rose up no further than did Iraq and Afghanistan when it was their turn to be invaded. Kennedy got cold feet, and withheld air cover.

Most of the Cuban counter-revolutionaries were killed or captured. The enraged young president fired Allen Dulles and vowed to scatter his Agency to the winds. Neither "the Company" nor its patrician godfather were likely to forget.

Nikita Khrushchev then tested Kennedy at a hostile June summit in Vienna. The Soviet premier had divided Berlin with a toxic wall. An insane spasm of radioactive chest thumping ensued as both sides resumed blowing up A-bombs in the atmosphere, pouring lethal fallout into the bodies of all living things.

Amidst the chaos, Khrushchev gave Castro nuke-tipped missiles to protect Cuba from another invasion. American spy planes spotted them. Kennedy set a quarantine.

For thirteen days---in October 1962---humankind shuddered at the abyss of Armageddon. Fixin' for us all to die, America's Joint Chiefs voted unanimously for total annihilation of both the Soviets and the planet.

But the Kennedys kept their cool. Jack promised not to invade Cuba. Nikita pulled his missiles. We later *(quietly)* took ours out of Turkey.

The Bay of Pigs, Berlin and Cuban missile debacles shook the young president's Cold Warrior mindset. While sliding into Vietnam's quagmire, he rebooted. On June 10, 1963, at American University, he called for an end to suicidal confrontation.

Jack honored the Soviets' immense WW2 losses. He embraced our common humanity. He re-designed, modernized and began to pacify our City on the Hill.

Like Lincoln's Second Inaugural and FDR's Economic Bill of Rights, JFK's American University speech took an evolutionary leap. In 29 minutes, he linked to the Kremlin with a hot line, pledged to abolish atomic weapons...and to stop exploding them in the air...saving millions of lives *(maybe even YOURS)*. Above all, Jack called for "general and complete disarmament," an end to war, a communal embrace.

Peace and freedom, he said, must walk together...

*...No government or social system is so evil that its people must be considered as lacking in virtue....*

132

*...If we cannot end now our differences, at least we can help make the world safe for diversity.*

*...For, in the final analysis, our most basic common link is that we all inhabit this small planet. We all breathe the same air. We all cherish our children's future. And we are all mortal.*

Jack's Awakened plea for peace filled the front pages in Europe and Asia...but not here. Later rumblings weren't quite so pacific.

But in October, 1963, Kennedy and Khrushchev ended all above-ground blasts *(tragically, they continued underground until 1991).* Kennedy's October 11 National Security Action Memorandum #263 said all US troops would leave Vietnam by 1965.

JFK also quietly reached out to Fidel. He revived FDR's Good Neighbor Policy and sent cash to Latin America's Alliance for Progress *(much of which was grifted by the corrupt dictatorships our CIA supported).*

By November 21, 1963, what began as a militant Cold War presidency seemed to have shape-shifted toward a transcendent quest for permanent peace.

Meanwhile, the Civil Rights movement bent the Kennedys toward social justice. Born poor, Lincoln had been a fabulous storyteller. Born rich, JFK was a voracious speed reader...and an exceptional listener. Intellectually, he embraced *The Other America,* Socialist Michael Harrington's Debsian exposé of our multi-racial plague of poverty and desperation.

But like Abe's, Jack's tangible record on civil rights remains forever incomplete. The Kennedys viewed the movement with caution. They were anchored in Congress by the same Jim Crow southern bloc as FDR. They offered little in return for the black votes that won them the White House. They cut taxes for corporations and the elite. Said Martin Luther King...

*...This country has socialism for the rich, rugged individualism for the poor.*

But rallies, marches, sit-ins, boycotts, voter registration campaigns, Freedom Rides, civil disobedience and much more forced Jim Crow to the brink at restaurants, hotels, public buses, ballyards, housing, and schools throughout the south.

Thousands of arrests in scores of US cities took on the aspect of a Gandhian Salt March. An enraged KKK lashed back with shootings, lynchings, cross burnings, arson, bombings of black homes and churches.

Much focused on Birmingham, where Dr. King again went to jail. Attack dogs, fire hoses, and beaten schoolchildren were Police Chief "Bull" Connor's calling cards. The televised images went global...and into the Oval Office.

On June 11, 1963---the day after his American University speech---Kennedy faced down racist Governor George Wallace and got the first blacks safely into the University of Alabama. That night, NAACP organizer Medgar Evers, a WW2 vet, was shot in Jackson, Mississippi. Covered in blood, he crawled into his living room and his family's arms...then died.

Racial turmoil peaked at Dr. King's transcendent "I Have a Dream" March for Jobs and Justice on August 28 at the Lincoln Memorial.

It was organized largely by A. Philip Randolph, who'd already stared down FDR and Truman. His deputy was the openly gay Bayard Rustin, who'd spent three years in prison for his Quaker opposition to WW2. A quarter-million marchers---about 60,000 were white---demanded a transformed America.

Two weeks later, a bomb killed four young black women at Birmingham's 16th Street Baptist Church. A massive new multi-racial abolitionism demanded that an awakening president bury both Jim Crow and the Cold War.

On November 2, Kennedy was told the CIA had assassinated Ngo Dinh Diem, our puppet dictator in South Vietnam. Twenty days later, he too was dead.

America has never fully recovered from the public execution of John F. Kennedy. As with Lincoln, debate still rages about who these two men really were, and what they might have done had they lived.

*But we sure did see what happened after they died.*

The bullets that ripped through Jack Kennedy's throat and brain still afflict us with a form of generational Post-Traumatic Stress Disorder. Like those of Lincoln being shot from behind, the endlessly re-run images of that smiling young man's head being blown apart are deeply embedded in our national DNA. For millions, that morning marked "the last moment America was truly happy."

That each man sat with his wife *(in a moment of tranquility)* is hard to bear. That the political impacts of their passing have been so intense has magnified the trauma in ways for which we can never quite account.

The Kennedy psychosis still wonders who really killed him.

Countless Americans---including First Lady Jacqueline---never bought the official story that Lee Oswald was a sole shooter. After calling himself a "patsy," Oswald's police interview transcripts somehow "disappeared." Then he was shot.

"Conspiracy theorists" believe many things about the JFK assassination. Common is the idea that LBJ green-lighted the murder…likely enlisting Allen Dulles, the CIA and the underworld. Mobsters Santo Trafficante and Carlos Marcello later claimed "credit" for killing Kennedy. Agency godfather Dulles never stopped raging over JFK's "betrayals" at the Bay of Pigs, Vietnam and his own firing. Richard Nixon and George H.W. Bush were both in Dallas that day.

The Warren Commission---to which LBJ appointed Dulles--- produced an "official story" at least as widely scorned *(for good reason)* as any of the countless less lofty conspiracy theories it spawned.

Whoever killed his predecessor, Lyndon Johnson did follow with a resounding triumph…and then the schizoid Vietnam tragedy that trashed our soul.

On civil rights and social justice, LBJ's Great Society was a reborn New Deal. It aided the needy *and thus ALL of us*. Its War on Poverty expanded Social Security for the elderly, disabled, veterans, students, poor, homeless. Medicare and Medicaid brought health care to millions. Head Start served our toddlers with early education and improved nutrition.

New Departments of Transportation, and Housing & Urban Development, echoed the New Deal's creation of the Department of Labor. An expanded Food Stamps program, the Job Corps, VISTA, the Office of Economic Opportunity…all revived the spirit of FDR's alphabet agencies. So did the National Endowment for the Arts, National Public Radio and the Public Broadcasting Service. Federal money poured into public education and infrastructure.

The long-term effects were tangible and just. We didn't get close to defeating poverty. But millions benefited. Incomes rose at the grassroots. The gap between rich and poor shrank. So did the prison system *(until Nixon's Drug War)*.

As historian Eric Foner has shown, unlike the New Deal, the Great Society arose amidst widespread prosperity. And unlike FDR or JFK, LBJ attacked Jim Crow head-on. Born dirt-poor in the populist east Texas hill country, Lyndon embraced social justice, and knew the value of a black constituency.

In the late 1950s, just one in five African-Americans voted…far fewer in the south. As Senate Majority Leader (1953-61) Johnson played a mixed role in passing Eisenhower's 1957 and 1960 civil rights acts.

JFK did call for an end to public segregation. But his social justice agenda was tepid and stalled.

As the Civil Rights movement raged *(and we mourned Jack's murder)* LBJ won a landslide 1964 election. While being pushed hard by the Civil Rights movement---and to the horror of his fellow southern Democrats---he helped win a Voting Rights Act meant to guarantee "one man, one vote."

Gone were the literacy test and racist hypocrisies barring blacks from the ballot box. In came a reborn Reconstruction. The 24th Amendment---ratified in '64---ended the poll tax. Transcending a century of Klan terror, black voter registration soared.

That year, Mississippi Freedom Summer brought to the south thousands of students to organize for voting rights. Black/white activists marched arm-in-arm. Racial barriers dating to the dawn of chattel slavery began to bend.

The 1965 Civil Rights Act banned public discrimination and let the races mix in ways unseen since the 1670s. The flow of newcomers shifted from Europe to Latin America and then Asia. America's demographic destiny was being remade.

A heartbroken nation rode JFK's vibrant life and tragic death toward a new Emancipation. His successor was a Shakespearean diva *(reeking of hubris)* with a Texas drawl and blood on his hands.

But LBJ also helped restart the reconciliation that John Wilkes Booth and Andrew Johnson had so cruelly ruptured. As Jack Kennedy moldered in his freshly dug grave, Lyndon Johnson shot us toward a transcendent ride up the arc of justice.

Then he blew it in Vietnam. And he *knew* better!

# SPRINGTIME
## The Greatest Awakening

*Back in the Bohemian '10s, Mabel Dodge called free sex "like splitting the atom."*
*In the 1960s, it was R&B, rock & roll, Motown, pot, LSD... civil, women's and LGBTQ rights...black, student and green power...and the explosive vision of a whole new post-Puritan Indigenous-inspired Solartopian Way of Being.*

With the coming of Jack Kennedy, a rising Baby Boom generation entered its wild, unruly teens.  We demanded a cultural revolution, and an end to empire.
*So far, we're one-for-two.*

In the arts, academia, muckraking, music, fashion, food, race, gender, sexual adventurism, ethnicity, mass media, the New Left, hippies, yippies, the environment, lifestyle, spirituality, *cannabis*, psychedelics...and then with the personal computer and world wide web...the Awakened 1960s counterculture changed *EVERYTHING.*

Its upstart spirit had surged again and again through the springtime Awakenings of our historic cycles.  Its indigenous roots fed the eternally evolving demands for peace, justice, freedom, joy, beauty, liberation, love....and for youthful, naked, defiant, exploratory, irresponsible, unrestrained, down-home, *make-those-uptight-Puritans-have-a-heart-attack* SEX...be it straight, gay, group whatever.

Love-making has *(of course)* always been integral to American life.  It's not clear Sixties rebels *did it* any more frequently than any other generation.

But Hippies tickled the Goddess.  Absurdly *shouting-theater-in-a-crowded-fire* open about it, they loudly flaunted once-taboo sensuality in all its after-Calvin glory.

Like the rest of the Sixties' counterculture, the so-called Sexual Revolution had been spiraling up toward critical mass through all the previous cycles of our history.  Each round escalated its own assault on the sensual repression so deeply rooted in the autocratic, uptight misogyny of our Puritan DNA.

But this latest, greatest explosion came with all the insane twists, unintended consequences and unfathomable fallout one might expect from a thermo-nuclear explosion at the core of humankind's second-most powerful biological imperative.

*If the Good Lord did not intend us to have sex*
*She would not have made it so damn much fun!*

Whatever remnant tongue clucking the 1950s Puritan Anti-Sex League *(George Orwell's term)* could muster sank with a whimper beneath a hormone-fueled youth culture demanding freedom in sacred realms that mere words could not penetrate.

But psychotropics could...and did.  *Cannabis, peyote,* hallucinogenic mushrooms, psychedelic chemicals *(LSD, DMT, MDMA)*...all linked an emerging youth culture to the ancient vision-questing of Indigenous America.

Right from the start, white Europeans had tried to stamp that stuff OUT.  Christian crusaders just HAD to ban tribal *peyote*.  Likewise the ancient herb *cannabis*,

embraced for millennia as a miracle healer among pagans, mediums, hucksters and shamans from China to Arabia, India to Indiana.

Both pot and peyote surfaced among urban white Bohemians in the raucous 1910s. The stylish salons of the libertine Mabel Dodge sailed into the mind-altered slipstream of herbal exploration, which she soon rode to Taos, New Mexico, and a whole new life among the Indigenous.

*The Puritan Elect were not pleased.*

With apparently nothing better to do, an unemployed post-prohibition career cop named Harry J. Anslinger---Woodrow Wilson's son-in-law---spewed out a global counter-attack. Calling pot *marijuana ("Mary Jane")* for its Hispanic vibe, Anslinger's crusade exempted his morphine-addicted fellow witch-hunter Joe McCarthy, but sought to imprison millions of Others.

Despite Anslinger's attacks, the 1950s Beat underground rode *weed* like a magic carpet. Countless rebels with good causes used pot as a healing alternative to demon alcohol, killer cancer sticks, addictive anti-depressants, lethal meth *(Hitler's drug of choice)*.

Zen-bred 1950s poets like Allan Ginsberg and Gary Snyder regularly imbibed. So did the freewheeling Jack Kerouac *(who preferred booze)*. Beat writers, artists, and musicians stayed stoned throughout the Eisenhower/Kennedy eras. They made clear that---for some---*cannabis* could both heal and liberate.

Dr. Lester Grinspoon disagreed….but then changed his mind. Amidst chaotic campus upheavals, the prestigious Harvard medical professor feared pot's impact on an innocent young generation. But after a sabbatical devoted to intense medical research, Grinspoon wrote *Marihuana Reconsidered* proclaiming the powers of *cannabis* as a miracle drug.

Grinspoon's Harvard colleagues Richard Alpert and Timothy Leary took on the more serious psychedelics---especially LSD---which the CIA somehow seized upon as a potential weapon for Cold War mind control. The Agency ran some extremely disturbing secret tests, often not telling its victims what was happening to them, causing at least one suicide.

But history has a way of conjuring up marvelous unintended consequences … like, say, having an Agency of imperial espionage helping to midwife humankind's most transformational cultural upheaval.

At Stanford, a young writer named Ken Kesey answered a notice on a bulletin board. Promised a few easy bucks, he took the CIA's LSD. A transcendent carpet ride ensued. Counter to everything the Agency imagined, he LOVED it.

So then *(of course)* he just HAD to tell a few million of his closest friends.

Kesey's awakened screeds included *One Flew Over the Cuckoo's Nest* and *Sometimes a Great Notion*. His magic bus *Further* took a guerrilla band of *Merry Pranksters* tripping across the continent, spreading the psychedelic gospel like tie-dyed Paul Reveres *(inspiring Tom Wolfe's iconic Electric Kool-Aid Acid Test)*.

Kesey surfed a long left-breaking hallucinogenic curl. Mabel Dodge's southwestern journeys with Indigenous *peyote* had been followed by Albert Hoffmann's discovery of LSD at Sandoz in 1943. Gordon Wasson, a New York banker and amateur mushroom hound, began eating *teonanacatl (Aztec for "flesh of the gods")*. A very

stoned Aldous Huxley birthed his still-in-print *Brave New World.* Actor Cary Grant tripped early and often, then loudly proclaimed LSD to be a cure for fear of death and other obsessions. Conservative publishers Henry and Claire Booth Luce warmly featured Wasson and other psychedelic explorers in *Time* and *Life* Magazines.

At Stanford *(again!!)* a very grateful Robert Hunter imbibed the CIA's LSD, psilocybin and mescaline. Then he lyricized *Uncle John's Band (and more)* for the Grateful Dead. As he told his best bud Jerry Garcia...

> *Sometimes the light's all shining on me*
> *Other times I can barely see*
> *Lately it occurs to me*
> *What a long strange trip it's been.*

Michael Pollan's epic 2018 *How to Change Your Mind* says health researchers, universities and official agencies openly ran some seventy serious (often well-funded) expeditions into the ancient Indigenous-based "country of the mind." They tested LSD on alcoholism, drug addiction, anxiety, depression and more. They inspired *(among Others)* Bill Wilson's founding of Alcoholics Anonymous.

But at Harvard, Professors Alpert and Leary were fired for allegedly breaching protocol by giving acid to an undergrad *(sexual innuendo was also involved)*. The fiery, charismatic Timothy then summoned an Irish whirlwind, urging the media millions to *"Turn On, Tune In, Drop Out."*

LSD is a uniquely powerful substance that for most people should *never* be taken without an understanding presence nearby. Its potential damage to the unwary and unready should *never* be underestimated.

Likewise its ability to dissolve both inner psychological barriers and the *verboten* boundaries of the Puritan culture. "Psychedelics," wrote Pollan...

> *...introduced something deeply subversive to the West that the various establishments had little choice but to repulse.*

> *...LSD truly was an acid dissolving almost everything with which it came into contact, beginning with the hierarchies of the mind...and going on from there to society's various structures of authority.*

Amidst a massive public uproar, Leary and Kesey terrified the Calvinist corporate-imperial elite which banned LSD and defunded the research on it. Dick Nixon, then pillaging Southeast Asia, branded Leary (along with Dan Ellsberg) "the most dangerous man in America."

Tim somehow maintained his *Leprechaun* grin through countless acid trips and escapades with *very* hostile cops. A half-century would pass before above-ground science could resume exploring Albert Hoffmann's promise of a healing future....

> *...If people would learn to use LSD's vision-inducing capability more wisely, under suitable conditions, in medical practice and in conjunction with*

*meditation, then in the future this problem child could become a wonder child.*

Meanwhile, Leary's Harvard buddy Alpert became *Baba Ram Dass* and took an Awakened path to India. His *Be Here Now* rebirthed the excursions into Oriental spiritualism pioneered by Emerson and Thoreau, William James and Nikola Tesla....

*...We're talking about metamorphosis*
*We're talking about going from a caterpillar to a butterfly*
*We're talking about how to become a butterfly.*

The Beatles' brief fling with Maharishi Mahesh Yogi *(guru of Transcendental Meditation)* linked a chord with Ravi Shankar, Ali Akbar Khan, and the musical *Hindu Kush* of the Indian raga.

Through the '60s and beyond, the ancient Oriental quest for inner peace penetrated deep into the American mindset. Buddhist meditation, tai chi, shiatsu, yoga and the Tao spread like magic mushrooms in a rainy cow pasture...

*...Turn off your mind relax and float downstream...*

The doors of perception blew open for Theosophist, Taoist, Celtic, Druid, Norse, Sufi, Essene, Cabalistic, Huna, Runic and other mystic teachings. It was the quintessential Calvinist nightmare...which is partly why so many Boomers and their Millennial/Zoomer progeny still love it.

LSD's Awakened advocates hoped it would help humankind emerge "as if newly created." The Solartopian movement, digital revolution, world wide web and much more were birthed in the process.

That brave new vision moved to the musical beat of another springtime symphony. The Awakening rhythmic seeds planted in the first cycle of our history by newcomer African drummers gushed up through exhausted slaves who extemporized on their rickety front porches and onto the screaming stages of ten thousand rock revivals. Three-chord blues resonated through countless old beat-up guitars, forming the "underground aquifer" of all our pop music.

In the Jim Crow 1890s, the blues fused with Ragtime and tribal drumming. In the Big Easy's Congo Square, *JAZZ* was born.

Awakened to the pounding freedom of its visceral power, the beat rode up the Mississippi and into the new century, morphing into swing, bebop, rhythm and blues, then rock, punk, grunge, hip hop *(let's not discuss disco).*

In the 1950s, the music crossed the racial membrane into the gyrating pelvis of the very white Elvis. King Presley became the latest Euro dude---after Benny Goodman, before the Stones and Eminem---who could really sell black music. Whole stadia packed with screaming teens exploded with the pubescent force of a hormonal Armageddon. Once they swooned for *Sinners in the Hands of an Angry God.* Now they fainted for *Jumpin' Jack Flash* and *A Hard Day's Night.*

Babatunde Olatunji's *Drums of Passion* sold 5 million albums and gave the '60s a pounding Nigerian backbeat. As documented in *Rumble*, rock's deep roots also flowed through the Indigenous artistry of Link Wray, Buffy St. Marie, Robbie Robertson, Crazy Horse, Taboo.

It all rode the electric guitar. Maybe invented in the 1930s by a black bluesman named Charlie Christian, the very white Les Paul *(with his melodious partner Mary Ford)* brought it to a new level of mostly country genius.

Blacks like Chuck Berry, Little Richard, Muddy Waters, Son House, Fats Domino, Mississippi Fred *("I do not play no rock and roll")* MacDowell fused the sound with country/western whites like Buddy Holly, The Big Bopper, the Everly Brothers. The Hispanic Ritchie Valens ushered in Carlos Santana, whose guitar genius STILL rocks our world.

Ray Charles's damn-near-lewd *What'd I Say?* hit #1. R&B and gospel crossed into rock and pop with Motown's Aretha Franklin, Diana Ross & the Supremes, Smokey Robinson & the Miracles, Marvin Gaye, Otis Redding, the Temptations, Gladys Knight, Etta James, James Brown, Ruth Brown, Charles Brown.

Folk singers Woody Guthrie, Joan Baez, Pete Seeger & the Weavers, Phil Ochs, Peter, Paul, & Mary, and The Byrds gave pop political content. So did Bob Dylan, who bridged folk to rock, got the Beatles stoned...and later got a Nobel Prize, which he couldn't be bothered to pick up in person.

But for millions, it started with Elvis. Bruce, in his *Springsteen on Broadway*, says he *(the eventual Boss)* at age seven saw The King "in a blinding flash of sanctified light" on *The Ed Sullivan Show* when...

*...suddenly a new world existed...the joyful life-affirming hip-shaking ass-quaking guitar-playing mind-and-heart-changing race-challenging soul-lifting bliss of a freer existence...exploded into unsuspecting homes all across America.*

When the Beatles played *Sullivan* in '64, the Earth wobbled. Clean-cut mop-tops that night, the Fab Four were totally transformed by '67 *(compare the photographs!)* when they stopped touring...but continued doing psychedelics.

With them came the transcendent Jimi Hendrix, who kissed the sky. Before he died at *27 (like Brian Jones, Janis Joplin, Jim Morrison, Amy Winehouse, Kurt Cobain...all addicted to demon alcohol)* Jimi at Woodstock shot our national anthem wordlessly into space, where it needed to go. Initially attacked as "unpatriotic," today his transcendent version lights up July 4 celebrations all over America.

*Sergeant Pepper* and the Summer of Love, bra burnings and Be-ins, perennial pot parties and rural hippie communes, anti-imperial civil disobedience, *back-to-the-land* eco-activism, Bohemian Buddhist mysticism all rolled into the *up-yours* Yippie anarchism of the IWW / anti-imperial / eco-Socialist / pot-loving New Left.

On campus, "people's historians" and humanist academics like Frances Fox Piven and Howard Zinn, Frances Fitzgerald and Jesse Lemisch, Marlene Dixon and Staughton Lynd, Elise Boulding and William Appleman Williams helped shatter the scholarly, constipated ivory tower of the Puritan mystique.

The totality of the 1960s uprising wrapped the Great Awakening, Transcendentalist, Bohemian, and New Deal upheavals into an electronic shock wave that blew Calvin's cultural death grip clean out of the American mainstream. The arc of creative history bent loud and clear toward a whole new way of Being.

"God," reported *Time* Magazine on its front cover, "Is Dead."

Embracing Jesus's peaceable preachings, Thoreau's call for civil disobedience, Debs's demands for social justice, Gandhi's genius for mass organizing...Rev. M.L. King, Jr., channeled the rage against racial bigotry into a nonviolent crusade for jobs, justice, peace and freedom.

His arms-length cohort was Malcolm X, the charismatic ex-con turned radical Muslim who at first preached an angry separatist creed. But a pilgrimage to Mecca softened Malcolm's heart. He embraced Martin personally and turned toward a broader multi-racial activism. In '65 he was *(of course)* gunned down.

In 1966, James Meredith, the first black enrolled at Ole Miss, got shot-gunned as he marched alone toward Jackson for voter rights. Dr. King rushed down to a tiny black church in Grenada *(where I shook his hand)* surrounded by the FBI and Klan. A night later, the young Stokely Carmichael---later "Kwame Ture"--- shouted "BLACK POWER!!" at a rally in Greenwood.

Carmichael and other leaders had a special talent for insulting America's re-emerging matriarchs. Movement men forever infuriated activist women...with the usual unintended consequences. In 1840, they insulted Lucretia Mott and Elizabeth Stanton at a London abolitionist conference. The new-born feminists fought back with their landmark 1848 Women's Rights Gathering in Seneca Falls, New York. In the Populist-Socialist-Bohemian 1910s---as in the radical unionist '30s---women ceaselessly fought male domination. Increasingly, they won

After WW2, men pushed more than 2.2 million "Rosie the Riveters" out of the factories and into the 'burbs to raise their 2.5 Boomer kids. Mostly the women were bored out of their minds.

At their feminist core was the demand for reproductive rights, the power of a female to control her own body. Abortion was an herbally-induced assumption of the Indigenous matriarchy.

Now Margaret Sanger's Planned Parenthood became the fountainhead of a transformed post-Puritan sexual landscape. Motivated by her mother's death during childbirth, Sanger *(who had race issues of her own)* was persecuted for her pioneer work in women's reproductive health.

At Sanger's first clinic---in Brooklyn---the Feds seized on her pioneer work in sex education and birth control to prosecute her for "pornography."

But Sanger (who died in 1966), enshrined a woman's right to enjoy sex while controlling her own body. In 1960, the child-free orgasm's "split atom" made the birth control pill what *Time* called "the most important scientific advance of the 20th Century."

The late sixties publication of *Our Bodies, Ourselves* by the Boston Women's Health Book Collective also fed a feminist tsunami that remade America's sexual calculus. In 1973 came *Roe v. Wade*, guaranteeing a woman's right to choose.

# Back to the Land (Again)
## *Our Organic Hippie Communes*

Montague Farm ~1972,  Photo by peter simon

*Following the "back-to-the-land" footsteps of the Indigenous, Transcendentalists, Bohemians and 1930s radicals, thousands of young 1960s seekers poured into "hippie farms" around the US.  Deep in the woods (trading toilets for outhouses) we conjoined the peace, civil rights, feminist, LGBTQ and environmental movements.*

*In concert, we shifted the Earth's axis.*

*After FBI infiltrators shattered our New Left Liberation News Service, the "Bloom Faction" (that's me behind the tree) decamped to an old dairy farm in Montague, Massachusetts, 90 miles west of Boston.  Farming without chemicals, such communes birthed an organic vegetarian/vegan food movement that's remade much of the American diet.*

*This one also escalated a global grassroots No Nukes movement by stopping two proposed reactors (the site is now a nature preserve).  On Washington's birthday, 1974, Sam Lovejoy---far left, arm outstretched---toppled a 500-foot weather tower in protest.  Historian Howard Zinn and Dr. John Gofman, first Health/Safety Chair of the Atomic Energy Commission, testified at Sam's legendary civil disobedience trial (he was acquitted).  In 1975 the Toward Tomorrow Fair at nearby UMass helped visualize a Solartopian future based entirely on green energy, a global industry now stretching into the trillions, bearing the key to human survival.*

*While fleeing in disgrace, Nixon promised 1000 US nukes by the year 2000. There were 104.  The fleet still shrinks (but not fast enough) as renewables skyrocket.*

*In 2018 we Montague Farmers joyously celebrated our 50th reunion.*

Anti-choice fundamentalists and corporate evangelicals chose to simultaneously fight sex education, contraception and abortion. That perverse 1-2-3 punch *STILL* causes countless abortions---botched and otherwise---as Calvin's misogynist crusade rages against its matriarchal demise.

In 1962, Betty Friedan's *Feminine Mystique* explored the "problem nobody knows"...the demand of American women for meaningful work and personal freedom.

In '68 the National Organization for Women joined protests against the Miss America Pageant. Their reborn radical feminism turned the world upside down. By decade's end, half the nation's college students were female---soon to become nearly two-thirds, along with half the law students.

With them came a revived campaign for the Equal Rights Amendment, first drafted in 1923 by Alice Paul, who lived until '77. Women poured into the House, Senate, state legislatures, and governors' mansions...onto the bench, into police, fire, and university academic departments, running tracks, ballfields, basketball/tennis courts...and much more.

Our reborn surge toward a restored matriarchy came with demands for legalized homosexuality *(Puritanism's deepest secret)*. Punishable by death in 1600s Boston, being gay was still illegal in much of the US three centuries later. Only the Bohemian anarchist Emma Goldman had dared to speak of it in public. The tiny Mattachine Society finally came out after WW2.

The counterculture promised an evolving embrace. But even in the Sixties, to be gay in America was to be shunned, jobless, jailed, beaten, abused, outcast.

Then came the uprising at Stonewall, a gay hangout---now a national monument---in Lower Manhattan. With nothing better to do, NYPD cops routinely beat up the clientele. It was, said one victim, "their whim to make our lives miserable."

For three hot June/July nights in 1969 (as the cameras rolled) the LGBTQ community fought back...and came out forever.

Stonewall Unions rose up on campuses everywhere. LGBTQ rights joined the social justice agenda. Queer sexual and political power flowed deep into the cultural mainstream in ways that still amaze even its most optimistic advocates.

From June through August came the Harlem Cultural Festival, an iconic long-hidden "Summer of Soul." Thousands of black New Yorkers flocked to Mount Morris Park to hear the 5th Dimension, Stevie Wonder, Gladys Knight, the Staples Singers, Nina Simone, BB King, Sly and many more in an astonishing *Coming of Age* for a rising new *Black is Beautiful* Renaissance that still resonates after a half-century of turmoil.

In August came Woodstock. At an upstate New York farm, more than 300,000 music fans converged for a torrential interlude of joy and song. For three days they sustained the world's biggest intentional community, nonviolent in practice, pure in spirit, iconic in celebration. For you who claim to remember being there, it was a commencement, an exclamatory howl for a decade that proclaimed a giant new generation's transformative way of Being.

On October 15, 1969, millions marched worldwide for a Vietnam moratorium. More than 100,000 gathered in Boston, followed by another 100,000 a month later in DC.

In November, 89 heavily armed Indians of All Nations---most of them women---seized Alcatraz Island. The abandoned former federal prison was ripe for an Indigenous cultural center. Various treaties certified their right to possession. The activists sent $24 in junk jewelry to San Francisco's mayor to seal the deal.

With them came a reborn awareness of our Mother Earth. As in the Transcendental and Bohemian Eras, young artists and activists fled the cities. We formed communal farms, went organic, embraced our Indigenous DNA. New to the land, seasoned civil rights/antiwar activists came raging at corporate polluters right in our new rural backyards. It was an Awakened synthesis with epic impact.

Rachel Carson drafted the Solartopian movement's green rebirth certificate. In the conservationist spirit of Henry Thoreau and John Muir, Brook Farm and the *Haudenosaunee*, her *Silent Spring* warned that DDT was decimating the bird population and unbalancing our global eco-system.

Cancer killed Carson far too early. But the pesticide ban she inspired rebooted our mindset on managing human life in harmony with our only planet.

In 1965, muckraker Ralph Nader published *Unsafe at Any Speed*, warning against the lethal Corvair. For a half-century, Ralph inspired, educated, and employed countless muckrakers, activists, organizers. His "Nader's Raiders" fought for justice and sanity on issues ranging from consumer price gouging and Congressional corruption, to auto safety and atomic energy.

"Ralph's children" soon joined the tens of millions who marched for the Earth. They became the vital white blood cells of our species' survival.

Said Rachel...

*...Those who contemplate the beauty of the Earth find reserves of strength that will endure as long as life lasts.*

As another hot summer of war boiled over, we would need every juhl of that energy.

# SUMMER
## *Vietnam*

*America's assault on Southeast Asia was the deathly darkness at the end of the corporate-Puritan-imperial tunnel, the terminal burst of what Arkansas Senator J. William Fulbright famously branded our "Arrogance of Power".*

*It was also the ultimate proof that no nation (not even the "exceptional" US) can exist half-empire and half-democracy. And that ALL empires eventually fall.*

As Martin Luther King warned on April 4, 1967, exactly one year before he was assassinated...

*...If America's soul becomes totally poisoned,*
*part of the autopsy must read:* **Vietnam.**

The Calvinist imperative---ingrained in our double helix since Boston, 1630---said we had the *duty* to dominate the globe and cleanse it of the "unfitt."

Such Luciferian Others (*geopolitical heathens!*) are nearly always non-white. Their very existence poses a Godless threat to the City on the Hill, no matter how far from our shores, or how absurd the idea that they might militarily threaten us.

*NEVER* has it been about physical security.

After WW2, "Communists" became an amorphous swarm of satanic anti-capitalists who may or may not have read Karl Marx or signed on with the Soviets or Chinese. Most have been iconoclastic social democrats and defiant Indigenous, refusing to bow before the Elect of God and His Calvinist minions.

In the Puritan lexicon, to allow such heretics to even exist was to embrace Luciferian complicity. *GOD FORBID* the world should witness a lack of spotless Divinity, or a refusal to do America's bidding by even a tiny, distant dissident nation. Such defiance might topple that single domino to bring down Calvin's entire edifice.

As God's Elect we claimed the right *(in the names of "civilization," "Christianity," "democracy" and "freedom")* to invade and conquer anyone, anywhere.

Ignoring the Seminoles' victory in the Everglades *(and the muddles of 1812 and Korea)* defeat was unthinkable. For a macho BOSS like Lyndon Johnson, being "the first president to ever lose a war" was an unbearable cross.

Jack Kennedy got beyond that. Vietnam was an un-winnable fight with no clear purpose in a jungle nation 8,000 miles distant. Secure in his intellectual and personal identity, getting out made sense (see *NSAM 263, October, 1963*).

Those who bothered to study Vietnamese history knew its legendary chess-master---Ho Chi Minh---had washed dishes in New York, studied history in Paris and Moscow, mastered Indigenous warfare. He was nobody's puppet, least of all Moscow's or Peking's. But the Puritan/corporate/Imperial/Dulles/CIA Elect hated Ho's defiance...and the fact that he existed at all.

After the Bay of Pigs, Berlin and Cuban missile crises, JFK had other ideas. In a post-imperial world, diversity might finally be seen as the true eco/geo-political state of nature. He (*quietly*) moved to bring the troops home.

Then somebody murdered him. And Lyndon broke bad.

Three days after JFK's assassination, LBJ leapt into the quagmire. The body bags, the lies, the angst, the war at home, the madness, the horror, the defeat made him seem above all a man with a primary body part clamped in a steel vice...

> *... I knew from the start that I was bound to be crucified either way— in order to get involved with that bitch of a war on the other side of the world, then I would lose everything at home. All my programs. All my hopes to feed the hungry and shelter the homeless. All my dreams to provide education and medical care to the browns and the blacks and the lame and the poor.*

> *...[But] if I left that war and let the Communists take over South Vietnam, then I would be seen as a coward and my nation would be seen as an appeaser and we would find it impossible to accomplish anything for anybody anywhere on the entire globe.*

By 1967, he had 550,000 troops over there. More than 300 a WEEK were coming home in body bags.

By '68 LBJ was a broken man. His presidency was a shambles, his legacy a graveyard, his party in ruins. The *light at the end of the tunnel* was an on-coming payback train.

Why'd he do it? Take your pick...

X The military brass said the Vietnamese were weak, and that victory was in sight;

X There was the perpetual Big Muddy of corporate lucre that forever flows from an imperial military (war was still a racket);

X There was immediate crony cash to be had, like that $2 billion for Brown & Root (later Halliburton) to build the mega-base at Cam Ranh Bay;

X There was race, as LBJ explained in 1948: "Without superior air power America is a bound and throttled giant, impotent and easy prey to any yellow dwarf with a pocket knife";

X There was macho pride, like when he grabbed an advisor (David Comey) by the lapels, lifted him off the ground, and spat...

> *... Son, Ho Chi Minh is over there saying f**k you to Lyndon Johnson. And NOBODY says f**k you to Lyndon Johnson;*

X There was the *Big Lie* that we were "saving them from Communism"... protecting the Vietnamese from the Soviets and/or Chinese... all "for their own good"... while we destroyed their villages to "bring them democracy";

146

X There was geo-politics, as Gen. William Westmoreland explained to me after our 1984 debate at the University of Florida. "Harv," he said, standing ramrod straight, staring me down with his hands firmly joined behind his back…

*…We didn't lose the war in Vietnam. We were there to buy time for the ASEAN nations, and we did it.*

SO… by **The Man's** own decree…to preserve the regimes of corporate capital's pet dictators Suharto (Indonesia), Marcos (Philippines), and Lee Kuan Yew (Singapore)…58,000 Americans and countless Southeast Asians had to die. It was the Divinely ordained Manifest Destiny of Calvinist America's corporate global dominion… infallible, unbeatable, inevitable, exceptional, insatiable, insane.

In the end, America's magistrate-priests---LBJ, then Nixon---could let no nation *(no matter how tiny or distant)* soil God's pure and spotless corporate-capitalist Earth. We *STILL* pay the price.

In August 1964, Lyndon pitched a fake fit over an alleged North Vietnamese attack on two US ships in the Gulf of Tonkin.

Then-Secretary of War Robert McNamara later admitted it never actually happened. Like the Indigenous who were here first; Mexicans who Polk said attacked us but didn't; the *Maine* the Spaniards did not sink; the Filipino masses that did not want us there; the *Lusitania* that did carry munitions; the Vietnamese, Afghan and Contra "allies" who ran heroin, opioids and cocaine deep into our Heartland; Iraq's non-existent WMDs; the Osama bin Laden who was not in Afghanistan…and so many others…we again got lied into the fog bank of Puritan/corporate America's endless imperial war.

This imaginary "Tonkin attack" by non-existent gunboats from a tiny navy against our gargantuan Armada somehow became a dire threat to US security. Next thing you know, warned Lyndon, they'll be marching into Malibu.

When he asked a hundred Senators to grant him special war powers, just two--- Wayne Morse and Ernest Gruening---said NO.

Like Wilson in 1916 and FDR in 1940, LBJ ran for re-election in 1964 pledging to keep us out of the war he'd just stolen the power to wage.

The double-cross came in March '65. Wearied by centuries of death, the beleaguered Vietnamese were ready to settle. LBJ replied with the biggest bombing campaign in human history.

Amidst the madness---in a classic Dollar Diplomacy escapade--- Johnson invaded Santo Domingo to replace yet another duly-elected social democrat with the usual corporate-imperial dictator.

In Indonesia, the CIA killed millions to install the kleptocrat Suharto, who personally stole at least $2 billion from the public trust. Marcos in the Philippines, Lee in Singapore, Diem/Thieu/Ky in Vietnam all did much the same.

Then we drenched Southeast Asia with the herbicide Agent Orange. Meant to strip the jungle of guerrilla-friendly foliage, it poisoned countless innocents …including our own soldiers…who upon return home were denied treatment for themselves…and their birth-defected children.

By then there was the war at home that rages to this day.

At the dawn of the decade, Al Haber, former U. of Michigan *Daily* editor Tom Hayden and a band of youthful activists gathered at Port Huron to demand "participatory democracy." Their Students for a Democratic Society *(SDS)* echoed the Intercollegiate Socialist Society that Wilson crushed in WW1.

In March 1965---a hundred yards from the Peace Corps' birthplace---Ann Arbor's first Vietnam teach-in set the syllabus for dozens more like it. As LBJ escalated the madness, the Great Sixties Awakening became another abolitionist crusade. Its tie-dyed transcendence re-birthed organized upheavals for peace and civil rights that rolled down through the nation like a mighty stream.

On October 21,1967, 100,000 of us rallied at the Lincoln Memorial, then crossed the Potomac. We overran the Pentagon for a night and day. Hundreds of marches--- some led by Jeanette Rankin--- raged across our body politic.

In January '68, guerrilla fighters poured through Vietnam's countryside and into Saigon. Their Tet Offensive prompted CBS News's Walter Cronkite---our Voice of Reason---to say "LEAVE!"

Amidst the chaos, Commander Westmoreland tried to add nuke weapons to the US arsenal in Vietnam. Johnson (*thankfully!*) said NO. The insane request stayed secret for fifty years.

On March 12, Minnesota Senator Gene McCarthy primaried LBJ in conservative New Hampshire.  His peace candidacy claimed 42% of the vote.  Our depressed former hero of the Great Society now (*wherever he went*) heard...

*...Hey! Hey! LBJ!  How many kids you kill today?*

Promising peace, New York Senator Bobby Kennedy jumped into the primaries.  On March 31, a broken LBJ dropped out.

On April 4, Dr. King was murdered.  He was tireless, charismatic, incorruptible... an operatic virtuoso who seemed to channel transcendent lyrics straight from a loving God.  He has never been fully replaced.

At a landmark Manhattan speech exactly a year before he died, Martin linked the issues of poverty, race, and empire.  King's master stroke joined the black/white/brown/Indigenous/urban/rural/middle/working-class movements for jobs, civil rights, social democracy, an end to empire.

*MLK's transcendent Alliance drew down Death from a shooter still unknown.*

Riots engulfed a shattered nation.  Cities burned.  Tanks rolled through our streets.  Whole neighborhoods collapsed.  In our urban heartland, three centuries of imperial bigotry came home to roost.  Said the immortal James Baldwin...

*...All of the institutions of this nation, from the schools to the courts to the unions to the prisons, and not forgetting the police, are in the hands of that white majority which has been promising for generations to ameliorate the black condition...*

*...Slaveholders do not allow their slaves to compare notes: American slavery, until this hour, prevents any meaningful dialogue between the poor white and the black, in order to prevent the poor white from recognizing that he, too, is a slave.*

In Indianapolis, Bobby Kennedy made a heartbroken plea.  He compared Martin's murder with his brother Jack's.  He begged for calm.  Nearly alone, the Indiana capital escaped chaos.

A month later---as he won the California primary---RFK was executed (mafia style) with a bullet through the back of his head.  Yet again, say his son and at least one of the nearby wounded, we really don't know who did it.

A guttural gasp of betrayal, rage, psychosis, and despair tore through our collective soul.  The killings of Medgar, Malcolm, Jack, Martin, Bobby, Fred Hampton, Mark Clark (*and later John Lennon*) sent a clear message.  Said Baldwin...

*...The American republic has always done everything in its power to destroy our children's heroes, with the clear (and sometimes clearly stated) intention of destroying our children's hope.  This endeavor has doomed the American nation: mark my words.*

149

Seething with rage, torn by the birth pains of a new way of Being, draft-age Boomers blew the summer of '68 into total bedlam, a tragic maelstrom of terrible torment.

Its unintended handmaiden was Chicago Mayor Richard J. Daley.

Like LBJ, Hizzoner just HAD to show the world who was BOSS. For reasons known only to him, the master of the Windy City machine provoked an absurdly avoidable confrontation that shocked the world, shattered his party, and rammed the Vietnam dagger even deeper into the American soul.

Some 15,000 *Yippies* came to Chicago to protest the Democrats' August gathering. Coined by Paul Krassner, the term fused left activism with hippie theatrics. We were young, headstrong, draft eligible, enraged. The Constitution guaranteed our right to peaceably assemble in the city's streets, and to petition the Democratic Party for a redress of grievances.

But Boss Dick---ILLEGALLY!--- denied us permits to march and camp.
*What the HELL did he think would happen next?*

Daley hated the Vietnam war and loved the Democrats. But his loyalties did not extend to the First Amendment. Televised images of furious Chicago police beating unarmed demonstrators went global. My friend Lissa and I were among those clubbed for no good reason at the corner of Michigan and Balboa.

The uproar rocked Europe, where young Czech, French and Irish rebels defied their own political bosses.

Here, something snapped. Behind in the polls, Vice President Hubert Humphrey limped out of Chicago looking like a loser.

But his GOP opponent was widely loathed. The images from Chicago were awful. But contempt for Tricky Dick ran deep. Hubert promised peace. A weary, wary nation wept with shame, rage and confusion.

At Mexico's October Olympics, hundreds of young protestors were slaughtered in the streets. Inside the stadium, medalists Tommy Smith and John Carlos immortalized their anger with raised clenched fists and shoeless feet.

Meanwhile LBJ desperately sought a Vietnam ceasefire. But as he agreed to stop the bombing, an insider mole---Henry Kissinger---secretly briefed Nixon.

Released in 2014, FBI/CIA wiretaps confirm that Tricky Dick ordered his liaison, Anne Chennault, to tell the South Vietnamese to trash the truce. "Keep the war going," she said. Nixon would take the White House and give them "a better deal."

The Agencies told LBJ, who howled (correctly) at Senator Everett Dirksen...

*THIS IS TREASON!!!*

Nixon denied it all. They both knew he was lying. But Lyndon said nothing... then...or for the rest of his tortured days.

With this traitorous betrayal, the mobbed-up sociopath Richard Nixon took the White House. He promised a "secret plan" to end the war.

Instead he let it rage for seven more psychotic years.

Countless Vietnamese and some 20,000 more Americans died for no good reason. Southeast Asia's human and natural ecology were ravaged. So was the American soul. Two consecutive presidents lied to us all, day after day, about the prosecution and purpose of a useless war that would kill 58,000 Americans and perhaps 2,000,000 Vietnamese.

For a dozen years, imperial cynicism, cruelty and contempt for Truth ravaged our body politic. The mindless, uncivil anger that so hopelessly polarizes us today festered and spread from November 1963 through April 1975, as our presidents lied daily about a hideous, needless war that embittered the generations, split our economy, poisoned our soul. A vile virus of twisted cruelty, cynicism and Randian contempt for Truth, democracy, and human compassion ravaged our body politic. Anyone seeking the origins of the angry, uncivil polarization that has poisoned American discourse through the 1970s and beyond need look no further than this dystopian bloodbath.

Metastasized through the decades, the Vietnam disease morphed into the implacable virus of late imperial dementia.

At the American grassroots, public outrage soared to levels unseen since Wilson's war. Resistance went viral. Draft cards, draft boards, personnel files and banks went up in flames.

Military desertion rates echoed those of poor whites fleeing the Confederate Army. Racial violence ripped through the ranks. Rampant alienation, bitter despair, deadly drug addiction, widespread suicide, cohort murder shredded our legions.

Draftee grunts began shooting their brass and "fragging" them with grenades. Year after year our military reported scores of officers offed by our own enlisted men.

At My Lai, while more than 500 innocent civilians were being murdered, heroic helicopter pilot Hugh Thompson turned his guns on his fellow soldiers. He threatened to open fire unless they stopped killing innocent men, women and children. Later observers estimated that (*without enough Hugh Thompsons to stop them*) at least one such mass murder happened every month of the war.

With our military in shambles, Nixon was set to nuke Southeast Asia and invite a global holocaust. In public, he swore those "damn peace marches" had "no impact" on his decisions.

But privately he told military analyst Daniel Ellsberg he couldn't face the public uproar his longed-for atomic attack would ignite.

*Thus those of you who marched for peace helped stop an insane act of apocalyptic terror whose fallout might have been final. BE PROUD!!*

As the 1972 elections approached, the Cold War took a back seat to political expediency. Nixon and Kissinger kissed the ring of Mao Zedong, China's Red Emperor. They shipped wheat to Leonid Brezhnev, Russia's hardline Tsar. After a lifetime of fevered rantings against the "international communist conspiracy," Nixon made it his prime trading partner.

In fact Dick's *real* enemies were *never* the Red tyrants. They were autocrats, just like him. In the long run, the Brezhnevs and Maos could always do business with the Nixons and Kissingers.

It was, instead, the Populist upstarts they hated...the maddening mavericks, unruly rebels, Indigenous guerrillas, multiracial radicals, social democrats, wildcat strikers, heathen matriarchs.

To buy us off, Nixon abolished the draft and brought our unhinged army mostly home. Then he rained down crater and cluster bombs, Agent Orange and napalm... *Hell itself*... on a tiny, distant nation that never did us harm.

Vietnam's real "crimes" were favoring a social system other than corporate capitalism...and refusing to bow to the City on the Hill.

By 1975, our drug-dealing South Vietnamese "allies" went running for cover. On April 30, the North Vietnamese rolled into Saigon. Terrified advisors scrambled off our embassy rooftop. Overloaded helicopters fled in terminal panic---to then be pitched empty into the ocean, like so much disposable trash.

Years of senseless slaughter, generational warfare and official deceit mutilated our American soul. Toxic poisoning, rampant unemployment, homelessness, racial division, drug addiction, bad medical care, traumatic despair, bitter polarization, shattered families, lingering psychosis, official betrayal, heartbroken suicide, societal PTSD and too much more *STILL* leave our people haunted, unresolved, out of balance.

As always, nobody abused our veterans worse than the government that drafted them. Ordered to fight for "democracy," they killed and died for a corporate-imperial elite meaning to stamp it out forever.

The autocracy that spread Wilson's virus, that lied about radiation sickness at Hiroshima/Nagasaki and our other atomic tests...also hid the horrors of Agent Orange. It denied PTSD, starved human services, busted addicted vets for drugs sold by our "allies," trashed their desperate pleas for help, dignity and respect.

In health, human services, education, infrastructure, social justice, economic well-being, ecological sustainability, mental instability, spiritual turmoil, and so much more...our national organism has never recovered from that useless, worthless, bankrupt, illegal, unconscionable war.

Vietnam also cost us our most vital global asset—-whatever moral high ground our original Revolution and WW2 valor had won us.

In the 1500s, the Spaniards and Portuguese had the temerity to divide up the world. Madrid lost its edge when the Armada fell. The Brits lost theirs with our Revolution...and then with Gandhi's.

Our own corporate globalism claimed a crusader's high purpose. We beat the Axis devil. Between our nylons and chocolates, foreign aid and Hollywood fantasies, we built a devoted planetary fan base.

But in the scorching summer of our late middle age, we lost our economic foundation, our moral mantle, our spiritual compass.

Vietnam should have taught us that our imperial "destiny" was never manifest, that for our species to survive, the very concept of empire must be dumped to decompose in the compost heap of history.

*The lesson did not seem to sink in.*

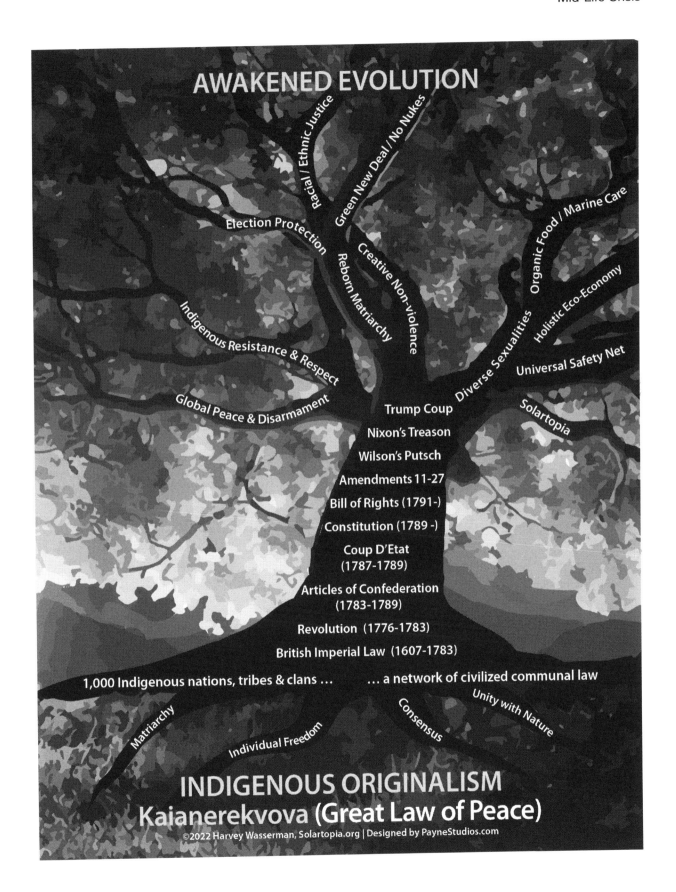

AWAKENED EVOLUTION

Racial / Ethnic Justice

Green New Deal / No Nukes

Election Protection

Creative Non-violence

Reborn Matriarchy

Organic Food / Marine Care

Holistic Eco-Economy

Indigenous Resistance & Respect

Diverse Sexualities

Universal Safety Net

Global Peace & Disarmament

Trump Coup

Solartopia

Nixon's Treason

Wilson's Putsch

Amendments 11-27

Bill of Rights (1791-)

Constitution (1789 -)

Coup D'Etat
(1787-1789)

Articles of Confederation
(1783-1789)

Revolution (1776-1783)

British Imperial Law (1607-1783)

1,000 Indigenous nations, tribes & clans ...          ... a network of civilized communal law

Unity with Nature

Matriarchy

Consensus

Individual Freedom

INDIGENOUS ORIGINALISM
Kaianerekvova (Great Law of Peace)

©2022 Harvey Wasserman, Solartopia.org | Designed by PayneStudios.com

# FALL
## *COINTELPRO & the Jim Crow Drug War*

*J. Edgar Hoover was the Federal Bureau of Investigation's imperial autocrat, America's top character assassin.*

*His arsenal of intimate dirt helped him drag the nation into a vicious fall of fear and repression...and a Lavender/Red Scare of anti-communist homophobia.*

Hoover got his start busting peaceniks and Socialists, feminists and gays, during Wilson's 1918-20 Red Scare. He grew the FBI through Prohibition, the Depression, WW2, the McCarthy '50s. In the Vietnam reaction, he attacked hippies, activists, citizens of color, dissent itself. Among those he spooked and libeled were Albert Einstein, Jack Kennedy, Martin Luther King, Jean Seberg, John Lennon.

In 1965, an FBI agent rode in a car with Alabama Klansmen as they murdered Viola Liuzzo, an activist mother of five from Detroit. Hoover then implied---with baseless sexual slander--that she deserved the execution his agent let happen.

The Grand Inquisitor wiretapped Dr. King, then urged him to commit suicide. Countless Black Panthers and white activists were libeled, bankrupted, jailed, maimed and murdered by Hoover's minions. Far from serving as a legitimate intelligence operation, the Bureau became a tax-funded hit man for the corporate right.

Under Nixon and Hoover, undercover agents actively sabotaged public meetings, turned peaceful demonstrations toward violence, published hateful misinformation, subverted the peace and civil rights movements. When that wasn't enough, the FBI became a Third World death squad, outright murdering Black Panthers Fred Hampton, Mark Clark and too many others.

It was all illegal. The unintended consequences were epic.

In the summer of 1968, Hoover's infiltrators secretly disrupted our hippie/radical Liberation News Service, turning routine meetings into rancorous hell. To escape the madness (*which included gay baiting*) LNS founder Marshall Bloom concocted a *coup*.

With $5,000 in advance ticket sales from a showing of the Beatles' "home movie" *Magical Mystery Tour*, Marshall led a thrilling decamp to a distant dairy farm. With a rented U-Haul, our "virtuous caucus" cleaned out the Manhattan LNS office and set up shop in an old garage in rural Massachusetts.

Bloom's shocking pirouette inspired national headlines...and some astounding countercultural leaps.

Back-to-the-land hippie transcendentalism rebirthed a natural food movement that went global. Rooted in unspoiled farmland, we made the *Silent Spring* decision to garden without chemicals. Long-time organic advocates like the legendary Rodale Family taught us healthy, holistic ways to manage pests, weeds and ... *Weed!*

In 1973, the local utility announced a giant reactor complex four miles from our organic garden. Fellow farmer Sam Lovejoy used a crow bar to topple a 500-foot weather tower in protest. The grassroots *No Nukes* resistance stopped those insane reactors ...and hundreds more worldwide.

In 1975 a *Toward Tomorrow Fair* at UMass featured green visionaries Amory Lovins and William Heronemus, who sketched out a Solartopian future free of fossil/ nuclear fuels. Inspired in part by our Agency-induced leap to the land, photovoltaic cells and wind turbines, batteries and LED efficiency would power a transcendent vision of a green-powered Earth that would remake—*and save!*-- our future.

In 1969, Nixon commissioned his *Huston Plan* to bury American democracy once and for all. From electronic surveillance to warrantless searches, from busting peace groups to mass incarceration, Tricky Dick meant to make America Puritan again.

When he illegally bombed Cambodia in 1970, huge protests ripped through some 200 campuses. So Gov. James A. Rhodes, a Nixon crony *(and mobster bag man)* gave the Ohio National Guard live ammunition to "take care of the situation" at Kent State. On May 4, they were ordered to open fire. Four unarmed students died, another was crippled for life. Two more were soon killed at Jackson State, Mississippi.

On May 3, 1971, Nixon locked 15,000 demonstrators into DC's RFK stadium for America's biggest single mass incarceration. Dick's "Enemies List" threatened the regime's leading opponents, somehow including NY Jets Quarterback Joe Namath.

A place on Nixon's List was widely welcomed as a badge of honor. VP Spiro Agnew assaulted the "nattering nabobs of negativism" and all who dared question *junta* policy. Like A. Mitchell Palmer, Spiro was a fearsome fascist. Aspiring dirty tricksters like Karl Rove, Dick Cheney and Roger Stone attacked American democracy in a guttural rampage that would soon puke up Donald Trump.

In the 1970 mid-term elections, Nixon wanted the "Silent Majority" (a term used by Hitler) to give him full control of Congress. He barely missed.

In '71, the *Pentagon Papers*---a secret Defense Department study---showed the Vietnam War to be illegal and un-winnable. Released by Dan Ellsberg and Tony Russo, Nixon tried to kill publication. But the Supreme Court, nearing the end of its liberal run, ruled that the First Amendment did abide. The purloined Papers became mega-news.

So Nixon ordered deep-cover spooks to break into Ellsberg's psychiatrist's office. Then five of his "plumbers" got caught pilfering the Democratic National Headquarters at DC's Watergate Hotel. Two of them---Frank Sturgis and E. Howard Hunt--later proudly claimed insider knowledge about killing JFK, eagerly implicating LBJ. Some still believe they were Grassy Knoll shooters.

In 1972, Nixon ended the draft, began pulling troops out of Vietnam and established *détente* with China and the Soviets. Re-elected everywhere except Massachusetts and DC, Dick's path to absolute power seemed perfectly paved.

But as FDR found after 1936, LBJ after '64, Reagan after '84, and Clinton after '96, a re-election landslide can turn into a terminal avalanche.

Against his wife's advice, Nixon recorded his Oval Office conversations. The tapes nailed his paranoid, racist, anti-Semitic inner self...and his ties to Watergate.

Admitting to tax evasion, Agnew resigned as VP on October 10, 1973. Ducking impeachment, Nixon resigned on August 9, 1974. Gerry Ford later pardoned him. But lesser flunkies like Bob Haldeman and John Ehrlichman went to prison.

Along with the pall it cast on our spirit, Nixon's odious legacy included two body blows against American democracy. He launched the Drug War. And he gutted the Supreme Court.

The War on Drugs was Nixon's answer to the Civil Rights and anti-war movements...four decades of reborn KKK lynchings and Red Scare Palmer Raids...with pot as pretext.

In 1972, to Nixon's chagrin, the high-profile *National Commission on Marihuana and Drug Abuse*---led by Pennsylvania's GOP Governor Raymond Shafer---opposed *cannabis* prohibition. It accurately assessed pot's mixed health issues. It strongly advised counseling and treatment over arrest and incarceration.

Dick briefly genuflected toward a network of healing centers. But while our country drowned in war, racism, poverty, despair and ecological disaster, Nixon said "drugs" were "America's #1 problem".

Much of America's hard substance supply came from the heroin dealers Nixon sent us to fight and die for in Vietnam. But it was really about his "Southern Strategy."

The math was simple. LBJ's Civil and Voting Rights Acts infuriated Jim Crow Democrats. In 1968 and '72, Alabama Governor George Wallace picked up where Dixiecrat Strom Thurmond left off and ran for president as an outright racist.

Wallace vowed to never be "out-n******d." Yelling "Segregation Now. Segregation Tomorrow. Segregation Forever," he barred blacks from the U. of Alabama. His hateful Trumpian attacks drew big white crowds.

But in 1972 he was shot. He won Michigan's Democratic primary the next day. But trapped in a wheelchair, his campaign faltered. He later apologized to the black community, embraced integration and won a fourth term as Alabama's governor.

Such redemption was not for Nixon. Dick wanted a safe southern base, with blacks disenfranchised and Wallace's Klan constituency for himself.

Said strategist Lee Atwater...

*...You start out in 1954 by saying, 'N****r, n****r, n****r'. By 1968 you can't say 'n****r.' That hurts you. Backfires. So you say stuff like forced busing, states' rights and all that stuff.*

But racist whites were not enough. Some Deep South states were 25-40% black. Nixon needed to void their votes. That's where the Drug War came in. Said White House aide John Ehrlichman...

*...We knew we couldn't make it illegal to be either against the war or black, but by getting the public to associate the hippies with marijuana and blacks with heroin, and then criminalizing both heavily, we could disrupt those communities.*

*...We could arrest their leaders, raid their homes, break up their meetings, and vilify them night after night on the evening news. Did we know we were lying about the drugs? Of course we did.*

156

Nixon's pot busts turned communities of youth and color into virtual police states. More than 41,000,000 (*that's NOT a typo*) US citizens have since been jailed. At a cost of more than $1 trillion, the race-based prison culture *STILL* poisons every corner of American life. The disenfranchisement has escalated.

Princeton Professor Bruce Western has estimated that in 1980 there were 143,000 African-Americans in prison versus 463,700 in college; in 2000 the ratio was 791,600 in prison versus 603,032 in college.

*Imagine the impact on our society---and our political balance of power---had all those in prison gone to college instead.*

Today's calculus is still satanic. For a half-century, *cannabis* has been regularly consumed by at least 10% of the US population. That's 30 million-plus Americans at any given time. With so many using it, cops had license to assault virtually anyone---especially anyone black---whenever they wanted. Our "democracy" bled into a prison population far bigger than those held by dictatorships in China and Russia.

In her 2010 *The New Jim Crow*, Ohio State Professor Michelle Alexander showed how the Drug War gutted an entire generation of young black and Hispanic men, decimated their communities, crammed them into an American gulag run largely for corporate profit, and stripped their right to vote. That victim base has been exceeded in raw size only by the work and death camps of Hitler and Stalin.

As Nixon wanted, the Drug War tipped our electoral balance far to the racist right. It filled our political and cultural landscape with systemic repression that still breeds sickness, paranoia and division. The alienating poisons of a profoundly sick prison system were jammed deep into our communal veins.

Likewise the Supremes. From FDR to LBJ, the Court was a vital haven for liberty and justice. Packed with New Deal/New Frontier stalwarts, it was long led by the surprising Chief Justice Earl Warren. Ike had assumed the California governor would be a conservative. He later called Warren's appointment "the biggest damn fool mistake I ever made!" LBJ then added civil rights legend Thurgood Marshall as our first African-American Supreme.

Beginning with a string of pro-civil rights decisions in the late '40s, carrying through *Brown* (1954) and beyond, the Court fashioned a humanist legal foundation for our greatest cultural Awakening. *Baker v. Carr* (1962) confirmed the principle of "one person, one vote" in state representation; *Engel v. Vitale* (1962) established separation of church and state by limiting school prayer; *Gideon v. Wainwright* (1963) affirmed the right to a lawyer; *New York Times v. Sullivan* (1964) firmed up freedom of the press; *Griswold v. Connecticut* (1965) protected the right to birth control; *Loving v. Virginia* (1965) legalized interracial marriage; *Miranda v. Arizona* (1966) expanded the rights of arrestees.

Warren retired in 1969. His humanist momentum carried into the '70s with key decisions on the Pentagon Papers, *Roe v. Wade* and others.

# Indigenous Originalism
## *What's the REAL Root of American Law?*

*Since 1789, the American populace has lived under a legal system based on a Constitution written (in secret) in Philadelphia, 1787, then dubiously ratified.*

*But for millennia before, North American law derived from the oral constitutions that flowed from perhaps a thousand Indigenous tribes, clans, nations and confederacies like the Haudenosaunee, which influenced Franklin and Washington.*

*Much is mysterious about how the many tribes really ran. But the fabric of Indigenous civilization was generally bound up in matriarchy, consensus, security for all members of the tribe, individual freedom, and a sense of indivisibility with nature. Critical decisions accounted for long-term impact—-seven generations, maybe more.*

*European imperial law was imposed in the 15-1600s. The Revolution brought the Articles of Confederation (1783-9).*

*Then came the Constitution. Our mainstream historians lend this document an air of divinity. But it came in reaction to a grassroots uprising (Shays's Rebellion) by farmers trying to protect their rights. The rich white men who staged this coup got themselves an imperial military, strong executive, unfairly high taxes for working people, an Electoral College and more. They exalted slavery, trashed women and people of color, assaulted the environment, enshrined a rule of money over people/planet.*

*This Constitution has ruled us for 23 decades. Its gratefully appended Bill of Rights is one of humankind's greatest documents, our legal system's saving grace.*

*But the Constitution's failures include extreme mal-distribution of wealth, a bloated imperial military, a dictatorial/demented executive, a dysfunctional Congress, a corrupt court system, a ruling institution—-the corporation—-accountable to no one, hell-bent on ecological extinction.*

*Today's "conservative" judges seem to intimate that their "Originalist" decisions must come straight through some sort of seance or trance with the Founders themselves. But their decisions clearly derive from Morgan and Rockefeller, not Franklin and Madison. The homophobic "Originalist" Antonin Scalia apparently missed hearing from the far more tolerant George Washington.*

*As our nation spins out of control and our species flirts with extinction, we might consider the REAL American originalism—-the tribal wisdom rooted here for millennia before the coming of this rich man's Constitution. Making decisions based on long-term impact rather than the next quarterly report is critical to our survival.*

*Likewise acknowledging our inseparability from nature, the need for social justice, individual security, real freedom.*

Given misogyny's epic failure, restoring matriarchy has great appeal.

*A rule of law is only good until it fails. Given what's going on around us, it's time to re-consider our original network of custom and order…to re-examine the wisdom, traditions and legal strictures of the First Peoples who survived and thrived here so long before the coming of a Constitution that now so thoroughly fails us.*

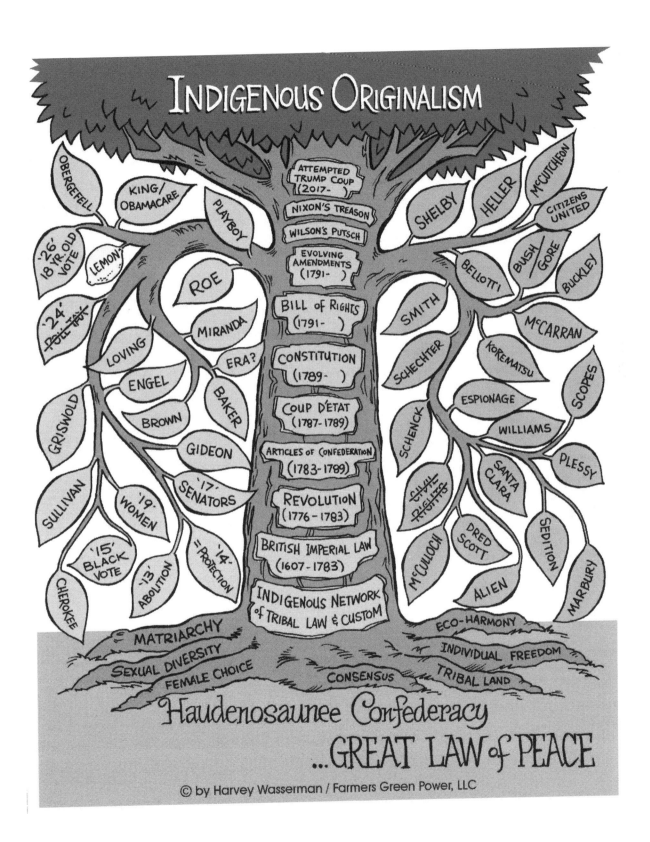

Thus a rebel generation saw our Constitutional liberties protected by an enlightened Court that honored the "general welfare" it was meant to enshrine.

But then came the Nixonites.

Warren Burger was Chief Justice for 17 years.

William Rehnquist made his early mark denying citizens of color their right to vote…. then sat on the Court until 2005 *(when John Roberts followed in his anti-democracy footsteps)* Among other things, Rehnquist pronounced from the bench his firm belief that the First Amendment does not apply to the Indigenous.

Harry Blackmun and John Paul Stevens both swung to the left.

But Lewis Powell changed everything. The genteel Virginian enshrined Alexander Hamilton's 1791 *Report on Manufactures*, advocating that taxpayer money should fund our industrial infrastructure, and that corporations had human rights. Public dollars would enrich private investors and spawn a new entitled autocracy.

For Powell---like Hamilton---that was the American Dream.

His infamous 1971 "Powell Memorandum"---written for the US Chamber of Commerce---deified corporate control. It defined his pivotal 1972-87 Court tenure.

In *Buckley (1976)*, and with his 1978 *Bellotti* majority opinion, Powell helped gut public attempts to regulate money in politics. He paved the way for *Citizens United* (2010) and *McCutcheon* (2014), which enshrined corporate personhood and put our elections, and thus our government, completely up for sale.

In the reactionary autumn aftermath of the Vietnam catastrophe, corporate-imperial cash overwhelmed what was left of American democracy as originally conceived.

Even worse was yet to come.

# Stop the Wars!!!
## ~~Korea~~
## ~~Vietnam~~
## ~~Central America~~
## ~~Grenada~~
## ~~Iraq~~
## ~~Libya~~
## ~~Afghanistan,~~ etc...
# *NEVER AGAIN!!*

# WINTER
## The "Me Decade"
## & Ayn Rand's Cult of Contempt

In January-February, 1969, gushers of oil fouled Santa Barbara's pristine beaches. In June, Cleveland's Cuyahoga River caught fire.

In July, Jack Kennedy's dream of putting a man on the moon came partly true. JFK had envisioned a shared effort, meant to bring humankind together. Instead, Nixon had the lunar dust littered with an American flag and discarded golf stuff.

On August 9---just before Woodstock---followers of Charles Manson murdered actress Sharon Tate and five others in Los Angeles. Manson was the mutant spawn of a festering gulag, a predatory prison-raised bottom feeder trolling the hippie fringe.

On November 1, Liberation News Service founder Marshall Bloom (*age 25*) died near our communal farm in western Massachusetts. His suicide followed a vicious personal attack (*called "And Who Got the Cookie Jar?"*) faked by Hoover's FBI as a "leftist" critique. Deftly circulated throughout the underground, it was an every-day COINTELPRO assault on a non-violent peace/civil rights/eco-activist whose life had been devoted to serving the general welfare.

On December 6, the Rolling Stones tried to recapture Woodstock's magic with a concert at California's Altamont Speedway. But the Hells Angels they hired for security (*what were they thinking?!*) stabbed a young fan to death. It was a tragic mess.

On March 6, 1970, three young "Weather Underground" radicals were killed by bombs they made in a Manhattan townhouse. By July of '71, rock stars Janis Joplin, Jimi Hendrix, and Jim Morrison were all dead. The corporate media blamed "drugs." But the X factor in their deaths was alcohol.

The next month prison activist George Jackson---author of *Soledad Brother*---was shot in the back at San Quentin. A four-day confrontation at New York's Attica prison left 43 dead after Gov. Nelson Rockefeller refused to negotiate a settlement.

At Wounded Knee, 1973, Indigenous activists confronted corporate goons who'd taken over the tribal government. Despite mountains of evidence, AIM co-founder Leonard Peltier was accused of killing two FBI agents. He was imprisoned indefinitely without a meaningful trial.

In Southeast Asia, saturation bombings that outstripped all of WW2 poisoned the era. America's trust in government and faith in our future sank with a "libertarian" gospel of hyper-individualism and narcissistic greed. Rightist cults like Young Americans for Freedom, the John Birch Society, the Tea Party and, later, Trump's MAGA all worshipped at the altar of the Russian immigrant Ayn Rand.

Nasty, brutish, and curt, Ayn's *Fountainhead* (1943) and *Atlas Shrugged* (1957) glorified Social Darwinism (*but not Darwin himself, who would have been horrified*). Ayn's sociopathic screeds for "rugged individualism" and oligarchic contempt fed a greed-fueled war on civility, community, truth and compassion.

A flamboyantly voracious atheist, Rand appeared three times in 1967 with top-rated TV talk host Johnny Carson. She opened by advocating nonviolence. Except

in self-defense, Ayn said, "no man has the right to initiate physical force, violence, compulsion against another man." Before she died in 1982, Rand signed up for the Social Security and Medicare she'd snidely scorned.

But altruism, kindness, empathy and love were Ayn's ultimate enemies. A crass contempt for civic virtue and human oneness became the mean-spirited credo of modern conservatism. Greed was great, cruelty was strength, facts were fake.

Nixon's Tricksters worshipped wealth and power. Henry Kissinger's "realpolitik" stripped foreign policy of all morality. Milton Friedman's "free market" gospel made money all that mattered. Alan Greenspan's Federal Reserve impoverished millions. Wisconsin's Paul Ryan and Scott Walker assaulted Social Security, Medicare, social justice, grassroots democracy, common decency, human dignity.

At the Randian core was the American Legislative Exchange Council. Founded in 1973 by Paul Weyrich and billionaires Charles and David Koch, ALEC's Dark Money fought all taxes, ecological regulations and lending heathen aid or comfort to "unfitt" non-millionaires who might be hungry, impoverished, unhoused.

The Kochs opposed the wars on poverty, Vietnam and drugs...plus any restrictions on their filthy, global-warmed fossil fuel empire's apparently limitless gushers of cash. Their hugely funded, highly effective campaigns drove the nation as far from the havens of human compassion and eco-sanity as money could buy.

But in this down-bound rerun of our Gilded Ages, no lowly hovel was as mired in moral filth as the Nixon White House.

Starting with his high-roller 1969 inaugural, Dick wallowed in morbid wealth. His all-white, all-male cabinet reeked of kleptocracy. Everything public was for private sale to crony insiders. The business of America was again pure greed. Oligarchic contempt and church-state theocracy were coins of the realm.

Nixon's 1970s ultra-rich brought what Eric Foner calls "The End of the Golden Age." Dick reveled in the Vietnam slaughter. Public billions poured into his crony coffers. Our mid-life crisis sank into depressive psychosis.

That included child abuse. The WW2 Lanham Act provided care for kids up to age twelve. While parents fought overseas or worked the home front, their youngsters---and a new generation of teachers---were fed, nurtured and taught in child care centers serving what Eleanor Roosevelt called "a need that was constantly with us."

The centers went down during the Cold War reaction. But in 1971, a liberal Congress embraced the Comprehensive Child Development Act, meant to provide meals, medical screening and day care for millions of American kids. Based on a family's ability to pay, an annual $2 billion would provide safe haven for our working parents' progeny.

Dick's heartless veto tore a bloody gash in the lives of tens of millions of American families who STILL struggle to find and fund decent day care.

Meanwhile war profiteers like Brown & Root (cronies of LBJ, later known as Halliburton, cronies of Dick Cheney) did just fine. But in 1971---for the first time since the 1890s---the US balance of trade went into the red. Nixon took the dollar off gold, and briefly tried wage and price controls.

Unemployment, the national debt and college tuitions all soared. The rich/poor gap---which had been closing since the New Deal---blew into an abyss.

162

Nixon designed White House security uniforms to look like the royal guards of Austria's Prince Metternich, a Kissinger favorite. Said the president...

*...Ask not what your country can do for you, ask what you can do for yourself.*

Dick's 1972 Campaign to Re-Elect the President (CREEP) became a mobbed-up numbers racket. Dwayne Andreas---of Archer, Daniels, Midland---brought him a paper bag stuffed mob-style with $100,000 in greenbacks. The President used a forged document covering public-funded "security" renovations at his California home to avoid paying taxes on them. Ford's pardon protected Nixon from fraud charges. But his tax accountant went to prison.

Until Nixon---and then Trump---no other president *(except perhaps Jackson and Polk)* so thoroughly fused official bigotry with petty theft. A new Great Barbecue let Dick's corporate/mafia cronies gorge on public assets. Meanwhile our working/middle class drowned in industrial decline and imperial overreach.

Nixon fled on Nagasaki Day, 1974. But for all the focus on Watergate, his treasonous 1968 sabotage of Vietnam peace talks and his illegal 1970 bombing of Cambodia went unpunished.

Instead Tricky Dick enshrined the dictatorial notion that...

*...If the President does it, it's legal.*

When that proved not to be the case, the absurd epithet of being "the first American president to lose a war" fell to Gerald Ford, our first president who'd never run for national office.

Nixon made Ford VP when Spiro Agnew fled in disgrace. When Nixon himself fled in disgrace, Gerry---to let the nation "heal"---pardoned Nixon for all crimes he "might have committed."

But like Woodrow Wilson, Ford never pardoned the peace activists, conscientious objectors, draft resisters and deserters who still rotted in jail long after the end of the illegal atrocity they'd fought to prevent.

Through the post-Watergate '70s, an awakened Congress tried to limit the Barons' ability to buy our elections. But led by Lewis Powell, the newly Nixonized Supreme Court gutted public demands for campaign finance controls. It carved in stone the oligarchic capture of our corrupted body politic.

After one more cycle---in our national senility---the dying corpus would cry out for a healing, transcendent rebirth...but....

# CYCLE 6
# IMPERIAL SENILITY

| Carter | Solartopia<br>Rainbow Awakening | ATOMIC TERROR<br>Nuke Freeze | Corporate<br>Fundamentalism | Greedy '80s |
|---|---|---|---|---|

# A Puff of Energy
## *Jimmy Carter*

*From the wreckage of Vietnam and Watergate our battered nation picked itself up (barely) for a final cycle of decline.*

A youthful, leftist surge made the pacifistic South Dakota Senator George McGovern the Democrats' 1972 nominee. He stood no real chance against the mob operation run out of a corrupt White House drowning in corporate cash. *(Watergate was too good for these guys).*

George's campaign crumbled when his VP nominee Thomas Eagleton, a Missouri Senator, was found---like Lincoln---to suffer from depression. McGovern inexcusably dumped him, shattering his campaign.

This agonized public vetting did open a long-overdue national dialogue on mental health. But it paved the way for a Nixon landslide…which buried Dick himself.

In 1974, Watergate sent a young progressive wave surging into the Congress.

Two years later, Jimmy Carter and Gerry Ford ran the last of our relatively unbought elections. At the bicentennial of our birth, the low-key, reasonably civilized campaign featured two uniquely uncharismatic candidates.

Both agreed to limit spending to $20 million each. They apparently kept their word. It was---to date---our last presidential election not to drown in cash.

A former U. of Michigan All American football center, Ford spiced things up by tumbling down various stairways. His pratfalls lit up TV's merciless *Saturday Night Live* and helped cost him the election.

Jimmy (*as he asked us all to call him*) was an amiable one-term Georgia governor and an evangelical Sunday school teacher. His surprisingly media-savvy campaign jazzed a folksy image by admitting to "lust in my heart". The urge was amply embraced by the Allman Brothers and other rockers who supported him.

Above all, Jimmy Carter was not Richard Nixon, and had not pardoned him.

For his Jacksonian inauguration, the new "Common Man" walked up Pennsylvania Ave. as a country/rock horde of 350,000 danced in the streets. Many were Vietnam draft resisters, of whom Carter pardoned some 15,000.

Jimmy sold the White House yacht and dumped Nixon's imperial image. He carried his own bags onto airplanes and actually smiled at working people.

Carter also supported a Constitutional Amendment to end the Electoral College, which author James Michener called a "time bomb lodged near the heart of the nation." But open racists like South Carolina's Strom Thurmond protected it as a bastion of white privilege. The unelected disasters of George W. Bush and Donald Trump were their reward.

An affirmative action advocate, Carter made civil rights icon Andrew Young (*later forced to resign*) his ambassador to the United Nations. He appointed Patricia Roberts Harris to be the first African-American Secretary of Housing and Urban Development.

But overall his record on civil rights was mixed. He slashed vital social programs, infuriating his left supporters while weakening his re-election campaign.

Jimmy at first tried to cut the imperial military. He killed the useless B-1 Bomber. He cancelled the proposed Clinch River Breeder reactor for fear of an expanded black market in bomb-worthy radioactive materials...and because it wouldn't work. He pursued a new détente with the Soviets...and openings to Cuba, Vietnam, China, and North Korea. He revived FDR's Good Neighbor policy and slashed aid to Guatemala's brutal military dictatorship, which had been installed in the Dollar Diplomacy '50s by United Fruit and the Dulles Brothers.

In 1977, he returned the Panama Canal to the Panamanians well before its 99-year lease was set to expire (in 2003).

Amidst an Arab embargo, Carter deregulated oil. His windfall profits tax netted more than $100 billion...which he blew on synthetic fuels (*investing it in green power would've made the world a much cooler place*).

Carter's popularity peaked with Camp David Accords signed by Egypt's Anwar Sadat and Israel's Menachem Begin on March 26, 1979. Peace seemed to have come to the Middle East. And Jimmy seemed set to cruise to a second term.

But within 36 hours, his future melted at Three Mile Island.

In April 1970, millions of us rallied nationwide to celebrate our first Earth Day. It was a vital upwelling of Indigenous DNA, a species-wide homage to our only home.

Guided by the surprisingly green John Ehrlichman, Nixon had followed Lincoln, Grant, and the Roosevelts' eco-footsteps by approving the National Environmental Policy Act and inaugurating the Environmental Protection Agency.

Jimmy openly courted the Solartopian groundswell. In an FDR-style fireside chat, wearing a homey cardigan, he declared energy conservation "the moral equivalent of war," urging us to lower our winter thermostats to 65F and our freeway speeds to 55 mph. He put a solar water heater on the White House roof. In Golden, Colorado, he launched the Solar Energy Research Institute---later the National Renewable Energy Lab---to push a cooling surge toward a green-powered Earth.

Carter also made "green cowboy" S. David Freeman head of the Tennessee Valley Authority. Dave pioneered Solartopian technologies from Nixon's EPA to the LA Department of Water & Power, Sacramento Municipal Utility District and more. He cancelled nine TVA nukes, saving several likely melt-downs and billions in cash.

Candidate Carter promised strict reactor safeguards. But as president he OK'd Three Mile Island Unit 2 and New Hampshire's Seabrook1, which met none of them.

On March 28, 1979 just hours after signing the Begin-Sadat Rose Garden treaty, TMI-2 spewed deadly radiation deep into the central Pennsylvania heartland. The plant's owner (*of course*) lied about all of it.

Carter had been a Navy nuclear engineer. Wearing protective booties, he rushed to TMI's control room and downplayed a disaster that threatened to blanket the entire northeast with deadly radioactive fallout.

With eerie synchronicity, Hollywood mega-stars Jane Fonda, Michael Douglas and Jack Lemon released the *China Syndrome*. The tense drama bore haunting

parallels to the reactor accident in progress as the film was released. Atomic energy fell into a PR pit from which it never escaped.

Meanwhile, Jimmy seemed to lose his mind. As he leapt into deregulation, much-hated gas lines made him look impotent. Fuel prices soared while he slashed social programs. The Federal Reserve shot interest rates toward 20%. Tight money devastated families, small businesses, home construction.

In December '79, the USSR stupidly stumbled into the "graveyard of Empires." The Afghan quagmire had already consumed a dozen imperial invaders, stretching back 2,300 years to Alexander the Great. When the Soviets lamely escalated their own long-standing military presence, Jimmy pitched a fit, absurdly calling this epic error…

*…the most dangerous geopolitical betrayal since World War 2.*

He broke off disarmament talks. He stopped grain shipments to Russia, ruining countless US farmers. He made our best athletes boycott the 1980 Moscow Olympics, which should have been a bridge to ending the Cold War (in '84 the Soviets skipped the Games in Los Angeles).

Jimmy's new "Carter Doctrine" claimed rights to "our" oil anywhere. He pushed an insane MX mobile missile system, and sent the imperial military budget soaring.

When Amnesty International won the 1977 Nobel Prize for working to free political prisoners, Carter duly preached the gospel of human rights.

But then he courted Iran's awful oil-rich Pahlavi dictatorship, which the CIA installed in 1953 by overthrowing the popular social democrat Mossadegh. The Shah's SAVAK secret police indulged in terrible repression and torture. Yet Carter backed a lunatic French proposal to sell him 36 bomb-ready nuke reactors.

In 1979, a complex social upheaval dumped the Shah. When Carter let him into the US for cancer treatments, outraged students held 52 US diplomatic personnel hostage in Tehran.

Amidst a global media frenzy, Jimmy sent a helicopter rescue mission that crashed in the desert. Eight Americans died. Secretary of State Cyrus Vance quit *(replaying W.J. Bryan's 1915 protest against Wilson's march toward WWI).*

Just before the 1980 balloting, Carter proudly announced a deal to bring the hostages home. The dramatic "October Surprise" guaranteed his re-election.

Then, like the 1968 Vietnam peace deal sabotaged by Richard Nixon, it didn't. The hostages stayed in Tehran until the exact moment Reagan took power.

Carter's pale green puff of energy had opened the sixth cycle of our historic spiral on a promising note… then went off-key in a dubious end-of-empire mess.

By 1981, Jimmy was one and done. The latest Awakening was not.

# SPRINGTIME
## A Rainbow Solartopian PV/PC Revolution

*Throughout the 1970s, Puritan pundits penned gleeful obituaries for the Hippie/ Yippie/New Left.*

*They crowed over Altamont, Manson, the Beatles' break-up, the deaths of Jimi Hendrix, Janis Joplin, and Jim Morrison. Tired of being invaded by tourists and hard drug dealers, Haight-Ashbury staged an elaborate funeral for "Hippie".*

*But last rites for the Awakened counterculture were seriously premature.*

Throughout the 1970s, Black, Hispanic, Asian-American, Indigenous, feminist, LGBTQ and other upstarts accelerated their relentless march toward the restoration of matriarchy and the birth of a rainbow society free from bigotry, misogyny, homophobia.

Gloria Steinem, Letty Pogrebin, and other activists turned "a movement into a magazine" called *Ms.* which finally gave women a legal title of their own choosing.

In 1972, Brooklyn Congresswoman Shirley Chisholm became the first African-American woman to run for the White House (*she said she got way more push-back as a female than as a person of color*). The Supremes' 1973 *Roe v. Wade* affirmed a woman's right to reproductive choice.

A national campaign to finally ratify Alice Paul's Equal Rights Amendment fell three states short. But women poured into the workplace, demanding equal pay and fair treatment. They became the majority of college students, evenly divided the law schools, and began winning elections

Carter's initial acceptance of civil rights leader Andrew Young as a major advisor symbolized the black community's rise in politics, business, the media, learning, the arts. Following Althea Gibson, African-American Arthur Ashe won tennis slams at Wimbledon, Australia, and the US Open.

In 1972, Cape Cod's Gerry Studds (*descended from Elbridge Gerry, father of gerrymandering*) became the first openly gay member of the US House. Six years later, San Francisco elected Harvey Milk as a Supervisor, making him the symbol of a surging LGBTQ movement.

The Beatles' trek to India opened the door to world music. Paul Simon introduced Ladysmith Black Mambazo from Africa, and a powerful Hispanic dimension in *Graceland*. Gil Scott Heron's anti-nuke *We Almost Lost Detroit* birthed rap.

Bruce Springsteen electrified the working-class angst of his native New Jersey. Michael Jackson still defies description.

Another child star---Stevie Wonder---came of age with a string of masterpieces including *Songs in the Key of Life* and *Innervisions*. He made an immense political contribution by winning a national holiday for Dr. King, first celebrated in 1986.

Meanwhile a Goddess choir of not-to-be denied women shattered popular music's patriarchal monoculture. In the '80s, center stage belonged at last to history's transcendent chorus of musical matriarchs....

Thus the healing, liberating, exalted power of female virtuosity rose then, now and through the ages from the likes of Bonnie Raitt, Sippie Wallace, Sister Rosetta Tharp, Memphis Minnie, Sarah Chang, Shakira, Lady Bo, Marian Anderson, Brandi Carlile, Mahalia Jackson, Ma Rainey, Big Mama Thornton, Billie Holliday, Ruth Brown, Clara Schumann, Amy Beach, Amy Grant, Fannie Mendelssohn, Marin Alsop, Beverly Sills, Mary Ford, Loretta Lynn, Kiri Te Kanawa, Queen Liliuokalani, Kathleen Battle, Florence Price, Margaret Bonds, Julie Andrews, Shirley Jones, Eartha Kitt, Ethel Merman, Rita Moreno, Lena Horne, Dorothy Dandridge, Doris Day, Ani deFranco, Ronnie Gilbert, Patti Page, Connie Francis, Giselle MacKenzie, Leslie Gore, Mama Cass, Michelle Philips, Michelle Williams, Celine Dion, Barbra Streisand, Bette Midler, Cher, Janis Joplin, Joan Baez, Mimi Farina, Donna Summer, Gladys Knight, Tina Turner, Deborah Harry, Madonna, Annie Lennox, Aretha Franklin, Diana Ross, Whitney Houston, Carly Simon, Eva Cassidy, Chaka Khan, Stevie Nicks, Christine McVie, Grace Slick, Mary Travers, Norah Jones, Joni Mitchell, Martha Reeves, Judy Collins, Cyndi Lauper, Nico, Edith Piaf, Yoko Ono, Mary Black, Carole King, Dar Williams, the Liverbirds, Toni Morrison, Rihanna, Adele, Lady Gaga, Christina Aguilera, Sheryl Crowe, Suzanne Vega, Marie Osmond, Neshama Carlebach, Martha Argerich, Yuja Wang, Lynette, Melissa Ethridge, Snataum Kaur, Jennifer Hudson, Diva Primal, Mariah Carey, Yofiyah, Queen Latifah, Celia Cruz, Laura Nyro, Holly Near, Karen Carpenter, Patty Carpenter, Patti Carpenter, Patti LaBelle, Patti Smith, Tracy Chapman, Joan Armatrading, Sarah McLaughlin, Sarah Vaughn, Nina Simone, Britney Spears, Alicia Keys, Anne-Sophie Mutter, Katy Perry, Ms. Julie, Taylor Swift, Sade, Sarah Caldwell, Susan Tedeschi, Amy Winehouse, Anoushka Shankar, Loreena McKennitt, Selena Gomez, Miley Cyrus, Jennifer Lopez, Janet Jackson, Dolly Parton, Etta James, Nikki Minaj, Buffy Sainte-Marie, Beyonce and way too many more to list here/now *(please forgive the many obvious omissions, and send to Solartopia.org your passionately loved favorites for this evolving list).*

The "vast wasteland" of network television also caught fire.

Norman Lear's *All in the Family* embraced a gay guy…while the absurdly bigoted Archie Bunker got kissed by Sammy Davis, Jr.

*Mary Tyler Moore* honored a powerful woman navigating a tough career. Ed Asner's lovably gruff *Lou Grant* never compromised. *M\*A\*S\*H* turned war into satire. The 16-hour *Roots* exposed chattel slavery's raw realities *(put in transformative context by Howard Zinn's 1979 People's History of the United States).*

*Mork & Mindy* launched the transcendent genius of Robin Williams. *Saturday Night Live* began skewering every president from Ford to Biden while wielding humankind's greatest non-violent weapon against dictatorship—*ridicule!*

Beyond the tribal issues of race, gender, sexual orientation, and the arts, the core awakening of our sixth and final cycle embraced yoga, meditation, veganism. The esoteric philosophies of the East moved our DNA toward a global consciousness. The transcendent explorations of Thoreau and Emerson, Mabel Dodge and Emma Goldman, wandered into the mystic teachings of Joanna Macy and Frances Lappe, Alan Watts and Gary Snyder, Margaret Mead and Bucky Fuller.

With them all came a desperate plea for our beleaguered Mother Earth. The Puritan view of a disposable planet was at last deemed obscene. Sustainable

agriculture and vegan/vegetarianism moved our one-ness with animals and the planet softly toward the mainstream. Judi Bari, Aldo Leopold, Greenpeace's Annie Leonard, the Sierra Club's David Brower, Vendana Shiva, Ansel Adams, all revived the spirit of Thoreau and the *Haudenosaunee*. An ecological mantra *(ascribed to the legendary Chief Seattle)* permeated a counterculture that says we are all connected...

*Whatever we do to the web of life, we do to ourselves.*

Starting in 1973, the phase-out of leaded gasoline saved countless lives and may have fed a drop in crime. The grassroots energy of the peace, civil rights and environmental movements moved to ban nuke weapons, slash industrial emissions, end offshore oil drilling, recycle waste, reduce consumer excess, fight climate chaos.

In 1976, Quaker elders Elizabeth Boardman and Suki Rice trained hundreds of *No Nukes* activists to occupy New Hampshire's Seabrook reactor site. A year later some 550 occupied National Guard armories for two weeks, lifting the debate over atomic energy deep into the mainstream. In June, 1978, more than 20,000 Solartopian souls camped on the coastal nuke site to hear Pete Seeger, Jackson Browne and John Hall serenade a green-powered Earth.

After Three Mile Island, some 200,000 No Nukers swarmed over lower Manhattan's Battery Park City for the decade's Woodstockian peaceful finale. Some 90,000 more joined Musicians United for Safe Energy for five nights in Madison Square Garden. The triple album went platinum.

The MUSE concerts fed the Solartopian vision of a green-powered Earth in desperate need of cooling. Roof-top photovoltaic cells fused Indigenous naturalism with high-technology to produce clean organic energy free from corporate control.

Atop the world's sixth-largest economy, California Governor Jerry Brown's tax breaks drew thousands of wind turbines. Geothermal, wave, tidal, ocean thermal, batteries and increased efficiency deepened the sustainable mix.

Meanwhile, fueled by *cannabis* and psychedelics, an inspired band of California geeks cracked the digital cloud. Working from a Silicon Valley garage, Steve Wozniak and Steve Jobs busted into the futuristic universe of the personal computer.

On April 1, 1976, they ripped their company's name from the Beatles' music label and launched Apple Inc. Said Jobs...

*...We started out to get a computer in the hands of everyday people. We succeeded beyond our wildest dreams.*

The personal computer and world wide web made tangible the transcendent fantasy that the human mind could someday communicate instantly (*as One*) throughout the globe, like a unified, universal brain, with endless possibilities.

From the late '70s through the turn of the millennium, digital utopians saw the PC/internet explosion as the informational fusion of Calvinist techno-genius with Indigenous visioning, offering an almost mystical means of bringing us all together.

As Edward Snowden put it…

*…for one brief and beautiful stretch of time…the Internet was mostly made of, by, and for the people. Its purpose was to enlighten, not to monetize, and it was administered more by a provisional cluster of perpetually shifting collective norms than by exploitative, globally enforceable terms of service agreement.*

It was a place, Ed said, "where the virtual and the actual had not yet merged," where "the freedom to imagine something entirely new" could originate locally but flourish globally.

Cyberspace would soon enough be toxified by government and business, commerce and conquest, incompetence and greed, monopoly and mega-scams, saturation spying and algorithmic manipulation.

With social media and cyber-war would come the gargantuan power of X/O mega-corps like Apple, Google, Facebook, Microsoft, Twitter, Netflix, Amazon, Disney, Pixel, Cambridge Analytica…and worse.

*By 2020, the global market value of information would exceed that of oil.*

So would the power of movements to reverse global warming and prevent the next reactor disaster. With the rise of 1970s campaigns against fossil/nuclear fuels came the transcendent growth of industries based on wind and solar, batteries and LED/efficiency.

They rose in tandem with newly networked grassroots awakenings aimed at linking modern green technology with the needs of our Mother Earth.

But then came Ronald Reagan.

# SUMMER
## *Ron Reagan's Reign of Retro-Terror*

*At the bicentennial of our birth, in the wake of the Vietnam catastrophe, some celebrated the End of Empire. The obituary was premature.*

The early Jimmy Carter pardoned draft resisters, cut the military, loved human rights, pursued détente, supported Solartopia, toyed with legal pot, returned the Panama Canal.

Then came the Shah, the hostage crisis, Afghanistan, more Cold War, Olympic/wheat embargoes, the anti-ballistic missile system, endless gas lines, soaring interest rates, boring speed limits, lowered thermostats, a killer rabbit, the October Surprise.

Having pitched the country into chaos, Carter whined about our "malaise."

That was all Ronald Reagan needed to hear. The B-movie maven proclaimed "Morning in America" and blew Carter away.

Born in Illinois, Ronnie renounced the New Deal, endorsed McCarthy's Red Scare, loved the Blacklist, spied for the FBI, sold out his fellow actors, shilled for General Electric. As California's hard-right *Jefe*, he assaulted higher education, defamed blacks and hippies, escalated the Drug War, proliferated prisons, drilled for oil everywhere, stuffed Sacramento with the super-rich.

As the 1980 election approached, the incumbent Carter held a heavy lead. He proclaimed a done deal to bring the hostages back from Tehran.

Then there was no deal.

It seemed a foul replay of the time Nixon sabotaged LBJ's 1968 Vietnam peace talks. Likeliest suspects this time were future and past CIA Chiefs William Casey and George H.W. Bush, Reagan's running mate. The hostages went free just as Ronnie was inaugurated. Then the arms flowed (illegally) to Iran.

Our then-oldest CEO fired up a radioactive summer of atomic bombast, threatening all-out nuke war on the Soviet "Evil Empire"…and Earth Herself.

Carter had already jacked up the imperial military. Now Reagan's "Star Wars" would weaponize space, waste trillions, shower the ecosphere with terminal radiation, threaten all living things. As explained by pop scientist Carl Sagan in terrifying detail, the nuclear winter alone would end us all.

In 1982, Reagan's daughter, Patti Davis, met the Australian anti-nuclear physician Dr. Helen Caldicott at *(of course)* Hugh Hefner's Playboy Mansion. Helen had called Reagan "the Pied Piper of Armageddon." On December 6, 1982, after a 90-minute chat in the Oval Office, she emerged "terrified."

On March 8, 1983, Reagan paraphrased for evangelicals a speech by singer Pat Boone, who apparently said he would rather have his daughters…

*…die now believing in God than live to grow up under communism and die one day no longer believing in God.*

With his fanatic finger on the *blow-us-all-up* button, the president endorsed an utterly terrifying Revelations-style Apocalypse---and unwittingly just missed one.

On September 26, 1983, as Reagan ranted at the Russians for causing "all evil in the world," computers at a Soviet missile base said the US had launched a nuke attack. Military protocol demanded an immediate world-ending response.

But Stanislav Petrov, the officer on duty, bravely refused. Under unimaginable personal pressure, he held out for direct radar confirmation that Reagan's missiles were actually in the air.

Thankfully, they weren't. ONE BRAVE HUMAN had averted a catastrophe that could have killed us all (*the digital glitch is still a mystery*).

About three weeks later, more than 100,000,000 Americans watched ABC's *The Day After*, a searing dramatization of our world being destroyed in a nuclear holocaust. Virtually no one knew how close we'd just come to the real thing.

As we danced at the atomic brink, Carter and then Reagan armed and trained Islamic fundamentalist Mujahideen guerrillas in Afghanistan, among them Osama bin Laden. They decimated the Soviets...as Afghans have done to imperial invaders since before Alexander *(we came next)*.

Our imperial/CIA warlords crowed with smug satisfaction as our very own Islamic guerrillas helped topple the USSR.

But then we infuriated these "Frankenstein" allies. We failed to aid the impoverished Afghans. We left troops in Saudi Arabia. We blithely greased the slippery slope toward epic blowback.

In an insane Iran-Iraq War that killed at least a million people---many of them teenagers---Reagan cynically armed both sides. In Baghdad, Defense Secretary Donald Rumsfeld gave our CIA-made dictator Saddam Hussein---bin Laden's worst enemy---a very public hug.

In 1983, a suicide bomber killed 241 Americans at a barracks in Lebanon. Reagan quickly pulled out.

To allegedly protect some US medical students, Ronnie two days later sent 8,000 face-saving warriors screeching into the tiny Caribbean Island of Grenada. A score of Americans died along with a hundred Cubans and Grenadians.

Then came *Iran-Contra*. This utterly surreal *you-can't-make-this-stuff-up* scandal married mass slaughter in southwest Asia with drug-dealing terrorism in central America and a devastating crack cocaine epidemic here at home.

Simply put: Reagan's White House illegally sold weapons to our alleged blood enemies in Iran. It may have been done to win the release of three hostages... something Ronnie said he'd never do. Or it may have been payback for the 1980 "October Surprise" hostage release delay that put Reagan in the White House.

Whatever the case, proceeds from those illegal arms sales went illegally to *Contra* rebels who illegally ran tons of cocaine into the US while illegally aiming to destroy Nicaragua's duly elected social democrat Sandinista government.

Nixon had compared Vietnam's drug-smuggling Thieu-Ky *junta* to Washington, Jefferson and our American Founders. Now Reagan did the same for these coke dealing *Contra* street thugs.

In 1985, in the White House, Reagan also referred to our Taliban "allies" in Afghanistan as "the moral equivalents of our Founding Fathers."

The "crack and smack" epidemic fed by these "heroic" criminals decimated our inner cities. But it gave Ron and Nancy a public excuse to take Nixon's Jim Crow "War on Drugs" to a whole new level. While primly telling us all to "Just Say No," their pet Contras poured cheap crack into our cities, while heroin poured in from our pet Afghan poppy growers---giving the Reagans *carte blanche* to fill our prisons.

When the story broke, *El Presidente* duly proclaimed his ignorance.

By then Ronnie's state of mind was indeed dubious. He'd been shot in 1981 by John Hinckley, a Bush family friend proving his love for lesbian actress Jodie Foster (*what was he thinking?!?*).

Taking a bullet in the side, The Gipper barely missed becoming Tecumseh's eighth presidential fatality.

But advanced age and PTSD may have shattered his frail faculties. Both Ron, Jr. and Reaganite Bill O'Reilly say the president suffered from Alzheimer-related dementia that destroyed his ability to function.

With his shaky hand on the nuclear button, Reagan became the second president to outright terrify our entire species with the immediate prospect of a radioactive demise. He was also the second president to give way to his wife.

We may never know how much Ronnie understood about Iran-Contra or the apocalypse he courted. It's still unclear whether he knew (or cared) that millions of desperate humans were marching worldwide, demanding he freeze nuke weapons and NOT blowup the planet.

But (*thankfully!*) an unlikely matriarch did take heed.

*This hugely hyped anti-drug advice from First Lady Nancy came as the Reagans embraced central American Contras whose cocaine ravaged our cities and fueled the Drug War that imprisoned, disenfranchised and debilitated millions of Americans of youth and color, pushing the nation ever further to the authoritarian right (see "American Made" with Tom Cruise, and "Narcos" on Netflix).*

# FALL
## *New Right Corporate Fundamentalism*

*On November 18, 1978, some 900 followers of the Reverend Jim Jones died in the jungles of Guyana. It was the unhinged symbol of a dying age.*

The San Francisco-based "People's Temple" had become a hellish cult. Hundreds drank cyanide from a vat of Kool-Aid. Others were outright executed, including US Rep. Leo Ryan, who'd flown to Guyana to investigate.

Just nine days later, a deranged conservative murdered San Francisco's brilliant, urbane Mayor George Moscone, and the charismatic, proudly gay Supervisor Harvey Milk. In his infamous "Twinkie" defense, the killer claimed that eating sugar made him insane. He later committed suicide.

In 1980, Ronald Reagan opened his presidential campaign in Philadelphia, Mississippi, where three civil rights workers had been brutally murdered. His dubious presence conjured up the racist rantings of Strom Thurmond and George Wallace, meant to lure KKK Democrats to the Republican Party.

On December 8, 1980, a month after Reagan's victory, a crazy person senselessly shot John Lennon. The beloved Beatle and his widow Yoko Ono remain treasured icons of peace, social justice, and a counterculture come of age.

On May 11, 1981, Bob Marley died of cancer. Like Lennon, the Rastafarian reggae master was transcendent and irreplaceable…wholly given to a global vision of organic unity. Marley's *One Love* lives with Lennon/Ono's *Give Peace a Chance* and *Imagine* high atop our Awakened playlist.

Meanwhile, Reagan declared war on organized labor…and mostly won.

The Professional Air Traffic Controllers Organization was one of the few trade unions to back him for president. The candidate vowed never to endanger the flying public over labor issues. Then he did exactly that.

The everyday safety of millions of airborne Americans depended on PATCO. Decent wages, secure working conditions and a 32-hour week were essential to the precision performance of these vital professionals.

But when they struck for all that, President Reagan loudly fired and blacklisted 11,325 of them from federal service. Sinking safety standards endangered millions of travelers. Some (*like Libby Gregory*) died in a completely avoidable crash at LAX.

Ronnie's corporate cronies gleefully slashed wages, busted strikes, assaulted collective bargaining, shipped jobs overseas. In an anti-labor age, permanent well-paid work went away. Reagan also gutted federal support for affordable housing, turning a solvable homelessness problem into a debilitating forty-year national tragedy.

The rich/poor gap exploded. Our aging industrial democracy bled to the bone.

Nixon/Reagan's thinly veiled bigotry attracted Jim Crow southern whites like moths to a cross-burning. The GOP moved to the authoritarian far right while Contra coke and Reagan's Drug War decimated our communities of youth and color.

As the Powell Court killed campaign finance laws, Baronial cash gushed into our elections through ALEC and "think tanks" like the Cato Institute and Heritage Foundation. The Koch Brothers flooded our universities and media with Randian devotees to sanctimony and greed.

A "Christian" corporate/fundamentalist crusade spewed from megachurch televangelists awash in cash. Contempt for women, gays, non-millionaires, people of color and the Earth itself fattened the new Calvinist Elect and its imperial "exceptionalism." Divine displeasure rained down on organized labor and a declining working/middle class born to "fight wars, work hard, get sick, die early."

Fervent Puritan preachers *(many of them in the closet)* welcomed the deadly plague of Acquired Immune Deficiency Syndrome as God's righteous revenge on those who dared to be gay. Ronnie sneered at the LGBTQ community. Even as AIDS killed his actor friend Rock Hudson, he never fully funded research or treatment.

But the Reagans were odd Messiahs. Grudging Hollywood churchgoers, Nancy was with child at their wedding; apparently, they'd "dined before grace."

The First Lady was pro-choice. Obsessed with pagan astrology, she set Ronnie's gubernatorial inauguration for a magical astrological moment somewhere after midnight. Daughter Patti posed nude for *Playboy*. Ron, Jr., pranced around *Saturday Night Live* in his undies. As George W. Bush would later say of Donald Trump's Inaugural Address, *"that was some weird sh*t."*

With the Gipper as our magistrate-priest, hippies and heathens inflamed the Puritans' medieval Dark Side. The New Right's Randian witch-hunts were anti-labor, anti-integration, anti-feminist, anti-sex, anti-education, anti-choice, anti-contraception, anti-gay, anti-pot, anti-tax, anti-poor, anti-health care, anti-regulation, anti-environment, anti-empathy, anti-compassion, anti-immigrant, anti-semitic…racist, misogynist, xenophobic…pro-death penalty, pro-gun, pro-Drug War, pro-surveillance, pro-corporate, pro-lemon socialism, pro-war, pro-empire and utterly autocratic.

How this awful ethos deemed itself Christian, Libertarian or even traditionally American remains a scriptural mystery *(except when Ronnie laundered holy boatloads of taxpayer cash to evangelical schools)*. Ayn Rand disciple Rep. Ron Paul (R-Texas) was anti-federal and anti-union, but also anti-empire and pro-pot. His fierce attacks on the Vietnam and Drug Wars still abide. In 2019 the fossil-fueled Koch Brothers joined liberal icon George Soros to fund a global campaign to end war.

But most corporate-fundamentalist CEOs just hated paying taxes. Scorning public accountability and human compassion, their truest love was for exploiting the planet…and the rest of us.

One such profound thinker was Donald J. Trump, son of an anti-semitic Klan-loving slumlord deeply tied to NY's top mobsters. Biographer David Cay Johnston and researcher Craig Unger say that in 1983 Russian gangsters began laundering cash through Trump's hotels and casinos. Thanks to his many bankruptcies and billions in debt, the Russkie mob early on bought The Donald at a deep discount.

While Trump ran his rouble laundromat, Televangelists like Jerry Falwell and Pat Robertson reaped from their flocks an unholy stream of tax-free cash. As Robin Williams explained in his deathless satire of a fake fundamentalist…

*...The word* AUDIT *does not appear in the Bible.*

The '80s "Christian Crusade" rolled racism, homophobia, misogyny and greed into a City on the Hill defined by high-stakes Puritan hate. Poverty was a sin, race mixing a mark of the Devil, loving thy diverse neighbor a bunch of hippie hype.

So too rights for women, sexual diversity, racial justice, ecological preservation, smaller nations that might deny our divine/imperial right to rape and pillage.

Joining the Hallelujah Chorus, a new breed of corporate "blue dog" Democrats abandoned social justice in all but image. As Trump funneled the Russian mob's roubles, Bill and Hillary Clinton used the Democratic Leadership Council to launder the party into Wall Street's cash accounts. Their mid-eighties clique of ambitious, amoral, triangulating centrists was led by Robert Rubin of Goldman-Sachs.

Scorning New Left, social democrat, Civil Rights, green and peace activists, the "New Democrats" turned the party hard right. The New Deal, New Frontier, and Great Society were stale discards for *Clintonista* opportunists who hid their Reaganism while preaching the mantras of a booming counterculture.

Reaganite America's swift corporate sword was the electronic media. The Fairness Doctrine had required that any partisan opinion endorsed on federally licensed airwaves by a radio/TV magnate be balanced with equal time for an opposing point of view.

Reagan dumped that in 1987. His billionaire battalions flooded the media with endless bigotry...and to Hell with fairness, balance or facts. Corporatizing our public frequencies, the New Right relentlessly replayed the Randian creed.

Top shock jock Rush Limbaugh fed the endless hate-mongering procession of Ann Coulter, Bill O'Reilly, Laura Ingraham, Glenn Beck, Seth Hannity, Tucker Carlson, Ben Shapiro (*the King of Loshan Hora*) and too many more to sanely list. The Evangelical Elect peddled imperial arrogance as God's exceptional gospel.

In the hard autumn of the Reagan Reaction, the drug war raged, the monopolized media blared, the Russians bought Trump, the Democrats went corporate, the empire hit over-reach, the planet heated, the latest crew of billionaire Barons saddled up for another Gilded gala.

Democracy struggled in the darkness.

As Ronnie put it before the lights went dim...

*You ain't seen nothin' yet.*

# WINTER
## *The Greedy Eighties*

*The Reagans' 1981 inauguration proudly exceeded all previous Gilded orgies of aftermath excess...and then some.*

*The First Lady made the White House an American Versailles.*

*Ronnie's all-male, all-white, all million/billionaire GOP cabinet proclaimed that (as in the 1890s, 1920s, '50s and Nixon '70s) the Greedy '80s were all about imperial arrogance, autocracy, heartlessness, opulence and excess.*

"Reaganomics" deregulated everything Jimmy Carter had missed. The private looting of public assets sank to new depths. Reagan left the working/middle class and natural planet to the tender mercies of the latest band of super-rich barbarians *(whose Russian mobster cousins did the same to the dying USSR).*

Top tier taxes had been 91% at the margin under Ike. Reagan slashed them from 70% in 1981 to 28% by 1988. He raised interest rates for those with money in the banks – and for the Barons who owned them.

The decade began in a deep chasm, then briefly recovered. In 1987, the stock market suffered its worst crash since '29. Savings & Loan corruption cost taxpayers billions. Ronnie had promised to slash the bureaucracy and balance the budget. Instead he left a record federal payroll with a record deficit.

The Gipper also stuck us with a bloated military, a brain-dead bureaucracy, a ravaged industrial landscape, a declining foreign trade balance, a soaring gap between rich and poor, rampant poverty, a nascent homeless crisis, imperial arrogance, technological obsolescence, indifference (even hostility) to our warming Mother Earth, and a corporate culture built on "me-first" cynicism, contempt for civic virtue and zero Social Darwinian tolerance for human empathy or compassion.

As the planet heated up, wages, schools, national parks, and our global ecosystem were all in deadly decline. America's core job market shifted from unionized industrial work to menial burger flipping. Encouraged by Reaganesque incentives, factory production poured overseas. So did our lead in the green Solartopian technologies soon to remake the world.

Poverty, tuitions, homelessness, and hunger soared. The working/middle class rode a down-bound express through indifference, alienation, anger.

America's richest 20% owned 80% of our assets. It would get much worse. The races were deliberately polarized. Upward mobility disappeared except for the tiniest few. The Drug War raged, AIDS ran rampant, the gulag was packed.

The shared Alexander Hamilton/Lewis Powell vision of a nation run by King Cash was upon us. TV's *LifeStyles of the Rich and Famous* metastasized into a worship-the-wealthy dump of gilded garbage stretching from *Dallas* to *Dynasty* to *Knots Landing* to *Falcon Crest* and below. The billionaire Barons dug an open grave for our dying republic under a tawdry tombstone that read: *Corporate Autocracy*.

Pious New Rightists ravaged our regulatory agencies...and our Mother Earth.  Interior Secretary James Watt said not to worry because Jesus "would soon come."

While pillaging parks established by the Republicans Lincoln, Grant and Roosevelt, Reagan ripped Carter's perfectly functional solar panels off the White House roof.  He assaulted renewable energy and conservation while pushing--- unsuccessfully---for an atomic reactor renaissance.

In California, GOP Governor George Deukmejian roadblocked---but couldn't kill- --Jerry Brown's Solartopian baby steps.  In 1983 the Washington Public Power Supply System ("Whoops") defaulted on more than $2 billion in municipal bonds fused to five nuke reactors, only one of which fired up.

In 1965, a chemist at G.D. Searle---home of the Pill---assaulted our food with aspartame.  Congressional hearings exposed the artificial sweetener as a deadly neuro-toxin linked to Parkinson's, Alzheimer's, lupus, dementia and more.

But in the Reagan '80s, Searle gave GOP insider Donald Rumsfeld a $15 million bonus to ram it through the Food & Drug Administration...and into more than 6,000 widely consumed "edible" products.

On January 28, 1986, the space shuttle Challenger blew up.  Schoolteacher Christa McAuliffe was an honored passenger.  Millions of children watched the lift-off.

But frantic engineers like Allan McDonald warned that unseasonable cold might shrink critical O-rings.  NASA ignored them.  A horrified world then watched seven humans needlessly die from obscene politicized negligence.

Reagan had planned that night to highlight his State of the Union address by exalting the Challenger crew.  Instead he delivered a Hollywood travesty of hypocrisy and deceit.  He praised the dead astronauts but took no responsibility for the avoidable horror that engulfed them.  Ignoring the regime's role in the disaster, the corporate media gushed all over Ronnie's hollow eulogy.

The Challenger epitomized the Reagan Aftermath.  Humankind's leading empire had invited the whole world to watch the City on the Hill shoot seven people into space...and then, out of criminal negligence, it killed them all, traumatizing an entire generation of school children...and the rest of us.

With his mental state likewise in decline, the Gipper's Teflon shield deflected all criticism...even as his policies devastated the working/middle class...and the planet.

Amidst the Great '80s Barbecue, the New Right Media mythologized a gargantuan military budget that allegedly drove the Soviet Union into bankruptcy.  They STILL credit Ronnie for ending the Cold War.

But according to its last Prime Minister, Mikhail Gorbachev, what killed the Soviet Union was Chernobyl.

And when it came to setting the table for peace, they have the wrong President...and the wrong Reagan.

In 1987 Nancy fired White House Chief of Staff Donald Regan.  Word spread that in her husband's mental decline, the First Lady---like Edith Wilson in 1920---was run- ning the show.

But Nancy Reagan was no Edith Wilson. Even her most hostile biographers, including Kitty Kelley and Barbara Ehrenreich, confirm Nancy's desire to leave a legacy of peace. Amidst a global grassroots upheaval, she found a willing partner.

Mikhail Gorbachev came to Soviet power in 1985. Endowed with the soul of a New Deal Democrat, he was the first Russian Tsar to embrace a semblance of constitutional democracy since Alexander2 got shot in 1881.

Gorby's *perestroika* restructured the rotted Communist bureaucracy. *Glasnost* opened public dialog. They worked.

In the Moscow '80s, a pair of western blue jeans could fetch $200. Young Russians loved the rock they heard on black market radios. If any single outside agent helped blow open the stodgy, obsolete, out-of-touch USSR, it was the Beatles.

*And then came Chernobyl.*

On April 26, 1986---three months after the Challenger disaster---Unit #4 at the nuke site 80 kilometers from Kiev melted and exploded. Lethal radioactive fallout spewed high into the atmosphere. It carpeted the Ukraine, Belarus, and much of western Europe. It gutted a USSR already in decline.

Some 600,000 *(that's NOT a typo)* drafted "liquidators" were forced to clean up the ruined nuke. They were each given 90 seconds to run in and then out of the core dead zone. Many were fatally irradiated. Compiling some 5,000 studies, scientist Alexey Yablakov in 2007 put Chernobyl's still-rising human death toll at 985,000. The dollar costs have soared beyond a trillion.

It's not clear how much Gorbachev initially understood about the scope of the Chernobyl disaster. But as ALL governments lie about reactor accidents, so did his. Soviet Boomers and the half-million doomed liquidators vehemently hated the perpetrators from the depths of their Russian souls. Gorby later emphasized that it was Chernobyl and its many coverups that finished his government.

But his angry public also hated "Russia's Vietnam." As the Soviets stupidly plunged into the Afghan quagmire, the CIA gleefully gave stinger missiles to Mujahideen fundamentalists. True to two millennia of desert resistance, the Afghans shot 269 helicopters into flames. The Soviet empire went down with them.

Pakistan's soon-to-be-assassinated Premier Benazir Bhutto warned that in arming Osama bin Laden and his Al Qaeda fanatics, the US had created a "Frankenstein." The Afghan Monster included the Taliban, a medieval claque of fundamentalist fanatics vehemently opposed to women's rights.

Our tribal anti-Taliban allies ran *(of course)* a complex opium exporting network that worked parallel to the Contras' cocaine trade.

Thus the Reaganites' surreal "Just Say No" Drug War came with a soul-killing "crack and smack" assault on American urban life, perpetrated with central American coca pouring in alongside heroin from Southwest Asia, all paid for with taxpayer dollars and the blood of our young.

The Trumpian payback would soon come.

On December 8, 1987, as Gorby's home front disintegrated, the First Lady hosted the ultimate Gilded Russo-American repast. For weeks she obsessed over the tiniest details. Most likely the time and date were set by her astrologer, Joan Quigley.

Texas pianist Harvey "Van" Cliburn played "Moscow Nights" by the immortal Sergei Rachmaninoff *(who finished up in Hollywood, writing movie themes)*.

Ms. Reagan's astrologically ordained fete became ground zero for a global species desperately seeking peace. In a complex set of tense negotiations, Gorby wanted all nukes abolished. Ronnie told him to tear down the Berlin Wall.

Somehow, a treaty emerged. Forty years of insane Cold War ended with a well-fed whimper. So did the Soviet Empire, as a magnificent wave of non-violent---except for Romania--- revolutions rolled through eastern Europe.

By 1989, the Iron Curtain was a scrap heap.

*For two obsolete global rivals, the end time had arrived.*

The Cold War impoverished us all. But the US was now Earth's sole super-power. From their gilded imperial perch, our Hollywood Queen and CIA Spook-in-Chief presided over the spiral passing of US governance as originally conceived.

In 1988, George H. W. Bush introduced electronic election theft to New Hampshire's spring primaries. Polls showed him losing handily to Bob Dole. But Poppy *somehow* pulled off a virtual statistical impossibility, perpetrating a fake vote count right out of the CIA's third world playbook.

That stolen primary set the stage for America's 21st century electoral quagmire.

In the 1988 general election, VP Bush smeared Massachusetts Governor Michael Dukakis with the crimes of a pardoned black prisoner named Willie Horton. The Connecticut blue blood then re-infected the White House with malignant Nixonian tricksters like Lee Atwater, Dick Cheney, Karl Rove.

Bush1 was our farewell WW2 president… the last country club Republican, a dying breed of ultra-rich oligarchs whose old WASP veneer of honor and decency thinly veiled their iron fist of corporate autocracy and imperial over-reach.

President George H.W. Bush pushed the Americans with Disabilities Act. He won upgrades to the Clean Air Act and some fiscal regulations.

And he pardoned core perpetrators of Iran-Contra, obscuring his own role in it.

He escalated the Drug War. Then he waffled on taxes, his final downfall.

Bush1's signature moment came with the retirement of civil rights icon Thurgood Marshall from the Supreme Court. In replacing him with a black man, Bush might've honored the epic triumphs of Marshall's hallowed career.

But Clarence Thomas was a bitter, narrow-minded reactionary…everything Marshall was not. His ghastly confirmation hearings centered on defaming a strong woman---Anita Hill---who dared come forward with charges of sexual predation.

Predictably, Thomas's long tenure has provided the corporate right with decades of pro-greed, anti-human, democracy-killing contempt.

In the interim, Bush1's presidency became an imperial showcase…with brutal payback that would spread deep into the new millennium.

In 1989, eastern Europe fled the Soviet empire.

Premier Gorbachev did NOT send in troops. He, Nancy and Bush1 together buried the worst of the Cold War. Our 24/7 hair-trigger nuke-armed Strategic Air

Command B-52 global overflights ended. So *(thankfully)* did the underground Bomb tests that lingered since the Kennedy/Khrushchev 1963 atmospheric ban.

Humankind breathed a sigh of relief. As did our Mother Earth.

The sixth and final martial summer of our organic spiral ended with a global-warmed whimper rather than an Apocalyptic bang. Reagan's dance at the brink had scorched our souls with fear, our media with loathing, our treasury with debt, our planet with toxic heat.

In 1991, Gorby was battered by dinosaur generals, gulag mobsters, CIA spooks, a public still reeling from Chernobyl and Afghanistan...and an ocean of outrage over his foolish desire to tax vodka.

Soon the Agency bragged openly about replacing yet another social democrat with a standard-issue mobster stooge--in this case the forever drunk Boris Yeltsin. Russian hit men poured out of the gulag and into control of the Former Soviet Union's massive untouched resources, which they began laundering through Donald Trump's mobbed-up real estate. In 1999, Vladimir Putin became the Company's favorite former KGB agent, hand-picked to seize the FSU's underworld assets...including The Donald.

In the middle east, another Agency asset--- Saddam Hussein---rolled his tanks into Kuwait's oil fields. That was fine with the Company...until he made the fatal mistake of hinting that he might dump the petrodollar and embrace the Euro.

THAT was NOT going to happen. Equating Hussein with Hitler, Poppy launched Operation Desert Storm, a 100-hour *blitzkrieg* that vaporized Saddam's army, urban shelters, vital infrastructure and countless thousands of innocent Iraqis.

About 100 Americans died in the fighting. Thousands more returned with a Gulf War Syndrome that's STILL never been fully explained. After the four-day slaughter, a quarter-million vets were disabled, victims of the usual post-war denial, neglect, broken families, homelessness, PTSD, drug addiction, suicide...and political invisibility.

Poppy also brought down his drug-dealing CIA-installed dictator Manuel Noriega. In a Dollar Diplomacy re-run, innocent Panamanians died in droves in barrios we bombed to clarify *("read my lips!")* that not even our puppets dare defy us.

Now America's conquering imperial hero, Bush1 sailed toward re-election with a 91% approval rating. But the spiral of our history had peaked. Our 1992 baronial income structure put America as far from social democracy as was Russia from Marxist communism. The Guardian described them both as...

*...the intertwining of government and big business, the creation of an oligarchy and a huge widening of income differentials in favour of the rich...*

The Boomer generation had fought for peace and civil rights while shattering the mainstream Puritan culture. Now we demanded one of our own in the White House, a reliable public servant who'd gracefully and fairly usher out the Empire.

Instead we got a tragic, infuriating era of triangulation and deceit...ending in domestic terror.

# PURITAN DEATH RATTLE

## The Era of Boomer Triangulation

# *The Clinton Catastrophe*

*From 1993 to 2017, three consecutive two-term Baby Boom presidents ran the White House. It was the first such succession since the 1801-25 Era of Good Feelings.*

*Jefferson, Madison and Monroe were neighboring Virginia slaveowners, sons of a Revolutionary generation with very similar worldviews. Together they stabilized a rising young nation before it fell (after the single shattered term of JQ Adams) into the grifting hands of the vile, violent Andrew Jackson.*

*The echo trifecta of Bill Clinton, George W. Bush and Barack Obama was a devastating failure. Through the quarter-century of their 8-year presidencies, they betrayed the trust and hopes of their own Baby Boom generation as deeply as Jefferson-Madison-Monroe had pleased theirs of the Revolution.*

*Their tainted legacy then collapsed into the mobbed-up hands of another Jacksonian grifter, Donald Trump.*

William Jefferson Clinton was the Baby Boom's penultimate Peter Pan, its hill country hound dog. Born poor, raised by a single mother, the charismatic pragmatist clawed his way to a Rhodes Scholarship, a law degree, Arkansas' youngest governorship.

He married the equally bright Hillary Rodham, a Chicago-born product of Wellesley College and Yale Law. Raised a staunch Methodist, she was an early Goldwater girl, and a campus Republican.

Boomer spawn of the '60s counterculture, the first couple spoke with passion for our working/middle class, for feminism, the environment, diversity, peace.

They occupied the epicenter of a global cultural revolution. With Awakened attitudes toward sex, drugs, the arts, diversity, religion, attire, women's and minority rights, environmentalism, and more, they advanced the evolutionary leap beyond traditional Puritanism that had exploded in the 1960s, from whence they came.

They also inherited two of history's greatest economic windfalls: the Cold War's "Peace Dividend," and the immense wealth generated by the computer revolution.

*By rights*, those resources should have realized at last a just, sustainable society.

Instead the *Clintonistas* triangulated. They took the Senate in 1986, but ruled in the repressive tradition of Woodrow Wilson and the corporate Duopoly that's run America since the Pandemic Palmer Raids of 1918-20.

Posing as Progressives, they ruled as Reaganites. Their showy, shallow trickle-down prosperity did little for a working/middle class that soon enough retaliated with Donald Trump's end-of-empire Hate Cult.

For Bill and Hillary, Big Money was the new Woodstock. As Governor, Bill blinked while the CIA ran huge quantities of *Contra* cocaine through the Arkansas town of Mena.

Then they sold the party to Wall Street. The ultra-elite Democratic Leadership Council trashed our *democratic wing*, as Paul Wellstone had called it, and swooned for America's mega-bankers, led by Goldman-Sachs's Robert Rubin.

As GHW Bush sailed toward apparent 1992 re-election, Ross Perot became Bill's key to the kingdom. The quirky Texas billionaire hated the federal debt and the North American Free Trade Agreement. He rightly warned that NAFTA's "giant sucking sound" would swallow millions of heartland jobs and wreck the Rust Belt.

Perot turned the 1992 televised debates into a three-ring circus. The obviously bored Blue Blood Bush made it clear he had better places to be....and he did!

Boomer Bill countered with a prime time set on the saxophone. Hipster shades and endless verve matched his long history of apparent sexual predation---including at least one alleged rape---and illusory nods to social change.

Despite ample opportunity to do so, the Clintons did little to strengthen the unions that had been the bulwark of the Democratic party....and of our democracy. Nor did they seriously pursue statehood for the District of Columbia, which would've enfranchised more than a half-million Americans, and made a huge difference in democratizing the US Senate.

To look "tough on crime," the "progressive" Arkansas Governor rushed home to execute Ricky Ray Rector, a destitute black man so addled he asked that his last dessert be saved for him to eat after being killed.

Perot's disruption and Wall Street's cash won Bill the White House. The Clintons' 1992 inauguration---like Jimmy's in '76---was a hip Jacksonian fiesta. The last WW2 relic was gone. The Boomers came hot for sex, rock, and legal weed...plus diversity, freedom, prosperity, social justice and a chance to remake the world.

Our "first black president" appointed the first female Attorney General (Janet Reno) and Secretary of State (Madeleine Albright). He made Norman Mineta our first Asian-American cabinet member (at Transportation). He chose the magnificent Ruth Bader Ginsberg to grace the Supreme Court.

He followed with a genuine global triumph. With Gaelic roots of his own, Bill dared embrace the Irish Republican Army's Gerry Adams. The masterful George Mitchell used the president's Celtic charisma to calm the Emerald Isle's awful 350-year civil war. Irish women sealed the deal with a brilliant barrage of in-the-streets activism.

It was a miracle *(hopefully)* for the ages.

Above all, to their everlasting credit, the Clintons did NOT start a major new war.

Under Bush1, with the end of the Cold War, the published military budget dropped from around $530 billion to around $435 billion. The Clinton's took it down to $412 billion.

The era's long post-Cold War economic expansion brought drops in poverty and unemployment alongside rises in homeownership and college opportunities. But the noxious abyss between the very rich and the rest of us actually escalated, an avoidable injustice that led straight to Trumpian disaster.

The Clintons connected much of the public school system to the internet, won the Family and Medical Leave Act, the Earned Income Tax Credit, and got new protections for voter registration. They dismantled some 1,700 old Soviet nuke warheads. They protected five new national parks along with 60 million acres of roadless regions. In 1998 they did the Perot thing and balanced the federal budget for the first time since Ike did it in 1956 (the very day he canceled Vietnam's elections).

The Clintons reversed the lethal Reagan/Bush contempt for an HIV/AIDS epidemic ravaging the LGBTQ community. They saved countless lives and restored dignity to many of the stricken.

At the grassroots, freewheeling eco-warriors like Greenpeace, Sierra, Friends of the Earth and the Rainforest Action Network helped 1989's Montreal Protocol Agreements cut ozone-destroying CFC emissions. They persuaded Bill and Hillary to NOT resume nuke weapons testing, even underground.

But the "liberal" southern Democrats also slashed welfare's safety net, ravaging millions of families. The "Faircloth Limit" trashed public housing construction, surging straight from Reagan's cuts to today's national homeless crisis.

Bill gratuitously attacked the black rapper Sister Souljah. He helped kill the Black Caucus's Racial Justice Act, meant to end the biased use of the death penalty. In 1996 Hillary dog-whistled young African-Americans as "super predators."

The *Clintonista* centerpiece was the $30 billion 1994 Violent Crime Control and Law Enforcement Act. Written largely by Delaware Senator Joe Biden, the omnibus law brought with it the Violence Against Women Act, which helped fight domestic abuse. A 5-4 Rehnquist Court struck at its core, but its long-term effects were still substantial.

So were Community Oriented Policing Services, meant to put law enforcement in close touch with local neighborhoods. A landmark Assault Weapons Ban stopped domestic production of some automatic weapons---until Bush2 killed it in 2004.

But in selling himself as "tough on crime," Bill barred one-time pot smokers *(like himself)* from public housing *(in which he lived)*. He escalated a "three strikes and you're out" policy dooming thousands to life in prison after a third felony conviction. Some $12 billion went to build state prisons, which the Crime Bill quickly over-filled.

Biden lauded "60 new death penalties...70 enhanced penalties...100,000 cops ...125,000 new state prison cells." America's prison population leapt from 1.3 million to nearly 2 million, the biggest jump in mass incarceration for any single US regime.

Overseas, in ousting Yugoslavia's awful dictator Slobodan Milosevic, Bill ignored local non-violent activists who begged him NOT to bomb their country. Showering them with deadly depleted uranium, he also ignored global pleas to intervene in Rwanda, where at least 800,000 died in avoidable ethnic slaughter.

"Hipster" Clinton waffled on gays in the military with a senseless "Don't Ask, Don't Tell" meander. His bigoted Defense of Marriage Act degraded LGBTQ vows. He failed to protect crucial northwestern forests that were too soon ravaged.

Overall the Clintons traded the Democratic Party's ancestral, excited grassroots Boomer base for the big corporate money that would soon make them multi-millionaires. They betrayed the social democrats who elected them, shafting a working/middle class that needed real help and would soon take Trumpist revenge.

The Clintons head faked toward health reform, but trashed single-payer Medicare-for-All...and got nothing. They frowned at polluters but wimped out on plastics, mass transit, fracking and forests...even failing to restore Jimmy's solar panels to the White House roof. NAFTA helped (as Perot predicted) shatter the Rust Belt, wreck Mexican agriculture, and set the stage for Trump's fascist fake populism.

*Printed by David Weiss, this button (with a photo by Brooke Shear) appeared in major media throughout the US. It was used as an official VIP pass at the 1993 Clinton inaugural. The photo was taken when Bill was a Rhodes Scholar at Oxford, where he may or may not have inhaled.*

*In eight full White House years (punctuated by the first formal presidential impeachment since 1868) the "progressive" Clintons, while starting no new major wars....sold the Democratic Party to Wall Street, made no major structural advances with unprecedented Peace Dividend/Internet windfalls, failed to win national health care, abolished the New Deal's Glass-Steagall Act (paving the way to the Big Short crash of 2007-9), trashed the welfare system that had supported millions of low-income families, delivered NAFTA to Robber Baron manufacturers who fled to low-wage factories in Mexico and elsewhere, perpetrated the 1996 Telecommunications Act allowing monopolization of the media while preventing community health challenges to microwave transmission towers, bombed Yugoslavia against the wishes of her peace movements, escalated the Drug War while imposing a draconian crime bill that added 600,000 inmates to our Jim Crow prison gulag, attacked the rapper Sister Souljah while labelling young black men "super predators," wasted the progressive movement's moment of opportunity with a cringe-worthy sex scandal and absurd impeachment farce, turned the Oval Office over to George W. Bush, and soon emerged with tens of millions in personal wealth..*

Bill did indulge a showy yell or two at the Big Banks.  But he took their money, followed orders, and gutted FDR's Glass-Steagall Act…leading directly to the *Big Short* crash of 2007-9.  "I don't know about you," wrote the Austin pundit Molly Ivins…

> *…but I've had it with the D.C. Democrats, had it with every calculating, equivocating, triangulating, straddling, hair-splitting son of bitch up there.*

With Wall Street's Rubin running the show, the Peace Dividend and worldwide web windfall disappeared into what Matt Taibbi famously called "The Great American Bubble Machine."  Goldman-Sachs, he wrote, became…

> *…the world's most powerful investment bank…a great vampire squid wrapped around the face of humanity, relentlessly jamming its blood funnel into anything that smells like money.*

While the Clintons betrayed our working/middle class, a Republican tsunami swept both houses of Congress, enshrining a hate-filled band of reactionary banshees.  Newt Gingrich's hard-right 1994 "Contract on America" converted the Democrats' class/race betrayals to a GOP juggernaut of mean-spirited arrogance and contempt.  Boorish hate-speak polarized what little there was of American political dialogue.

The mood was matched in Israel.  At Clinton's urging, Prime minister Yitzhak Rabin had signed the 1992 Oslo accords with Palestinian leader Yasser Arafat.  The agreement seemed to promise peace between two terribly alienated peoples.

But in 1995 Rabin was murdered at a public rally.  Like the killings of Lincoln, Alexander2, Michael Collins, Gandhi, Medgar, Malcolm, King, the Kennedys, Lennon, Pakistan's Benazir Bhutto, Egypt's Sadat and too many more, the *shande* loss of this peacemaking *zaide* was utterly devastating.

The world, the region, the state of Israel, the Jewish people have yet to recover.

In 1996, House Speaker Gingrich stupidly shut the government. The GOP ran the dull-as-paint Bob Dole.  Lucky Bill got another open door to real change.

It swung asunder amidst a heyday for geeky utopians who joyously surfed the booming worldwide web.  John Perry Barlow coined its *Declaration of the Independence of Cyberspace*. "We are creating a world," he exulted…

> *…that all may enter without privilege or prejudice accorded by race, economic power, military force or station of birth.  We are creating a world where anyone, anywhere may express his or her beliefs, no matter how singular, without fear of being coerced into silence or conformity.*

But cyberspace sucked us in to some horrific black holes.

Early warnings came with Clinton/Gore's neo-liberal 1996 Télécommunications Act, which virtually de-regulated major media ownership.

Reagan had killed the Fairness Doctrine.  Now the corporate Democrats let Baronial radio-TV-print monopolies choke our nation's above-ground information flow.

In a toxic shriek of cynical hate-mongering, truth and civility fled the airwaves. FOX "News" spawned an air-head horde of nasty shock jocks and shameless, mind-bending, heart-gouging Orwellian disinformation.

Clinton's Telecommunications Act also banned local communities from raising health issues to stop cell tower construction. A huge electromagnetic infrastructure erupted with no real scientific understanding of what they might be doing to us, or how our species must protect its delicate cortex...especially that of our children. As 5G becomes omnipresent, we wander in a VERY dangerous biomedical wilderness.

Bill's signature moment came with some oral sex from a 20-something intern in the Oval Office, as he gave phone to a Florida sugar Baron widely accused of poisoning the Everglades. For endless months he chanted his fake mantra...

*...I did not have sexual relations with that woman.*

Unwilling to step aside for a full-time working CEO, Clinton indulged the GOP in a useless impeachment farce. The legal pretexts were thin. For the Republicans, it was just another power play. For Bill, it was all about him.

Clinton apparently presumed that his being president was so much better than having Al Gore that we just *had* to endure his batty, soul-killing psycho-drama.

For the millions who'd worked in good faith for a presidency committed to real social change, it was a tortuous tragedy, a colossal breach of faith, an unforgivable waste of time and opportunity.... the Boomers' lost weekend, the stillbirth of what should have been another transcendent Awakening.

*By 1999 our body politic was hatefully polarized into warring corporate brands.*

"I believe we have lost the culture war," mourned the conservative king-maker Paul Weyrich in a landmark open letter. "That doesn't mean that the war is not going to continue...But in terms of society in general, we have lost."

Riding that demographic reality, the terminally hip *Clintonista* Boomer Democrats triangulated away any hard commitments to social, economic or ecological progress that might threaten their corporate cash flow or elite lifestyle.

Across the abyss, the medieval New Right GOP---soon to become the Trump Cult---trashed its Eisenhower/Bush country-club aristocracy, shrieking in evangelical tongues as it morphed into a KKK/Ayn Rand/Willie Horton Confederate lynch mob.

Clinton/Gore handed them their very own Foxist bullhorn, through which they puked a lethal stream of mean-spirited blather deep into our shafted Heartland.

With no fair or balanced voice for the common good---with lines blurred between ordinary facts and *Big Lies*---we flatlined into a schizoid end-of-empire dystopian nightmare.

# Bush the Lesser & His Revelations: 9/11

*George W. Bush's 2000 presidential usurpation hung on stripped Florida voting rolls, flipped electronic machines, a terrorized vote count, a deranged Supreme Court edict, and America's fifth Electoral College trashing of the popular will.  He escaped Tecumseh's Curse, surviving his full eight years in office and beyond, perhaps because he was not legitimately elected.*

*But having lost overall by a half-million votes, Bush2 hosted Biblical 9/11 attacks, the "Patriot Act" gutting of the Constitution, the crony/Enron bankrupting of California,  the Rove-inspired fiendishly lethal $8 trillion end-of-empire Iraq-Afghan atrocities, the horrific images of shameless torture at Guantanamo and Abu Ghraib, Hurricane Katrina's climate chaos devastation of the Big Easy, the Big Short housing bubble that birthed America's worst bust since 1929.*

*W's start-to-finish fiasco guaranteed a 21st Century that would be anything but an American one…and that the dogs of a dying empire would shred the City on the Hill's last illusions of exceptional White Supremacy.*

Unlike his polished, urbane CIA dad, George W. Bush was a not-so-bright good ol' boy likely to get you drunk (or stoned) at an upscale barbecue.  Dubbed "Shrub" by Austin's Molly Ivins, he executed 152 humans as Governor of Texas.  One was Karla Fay Tucker, a Christian convert whose pleas for mercy he openly mocked.

Campaigning for his oxymoronic "Compassionate Conservatism," the boyish blue blood emitted a signature, cringe-worthy gush onto an exhausted single mother…

*"You work three jobs?  Uniquely American, isn't it?  I mean, that's fantastic!"*

As documented by Greg Palast, younger brother Jeb, Governor of Florida, set up W's infamous 537-vote "victory" by using a complex computer code to strip voter rolls of more than 90,000 mostly black and Hispanic citizens.  Bev Harris uncovered some 20,000 electronic votes bouncing around on machines in Volusia County.

But when a "Brooks Brothers mob" of Hitlerian Brown Shirts (*disguised as Yuppies*) terrorized volunteer vote counters, five Supremes traded their final shreds of credibility for a Bush presidency.  Warning that its absurd *Bush v. Gore* ruling did not meet the bar of legal precedent, the Court stopped Florida's vote count and certified its devolution into a sub-judicial abyss.

The Electoral College sealed the deal by seating America's fifth losing president (Donald Trump would come next). John Roberts, Brett Kavanaugh and Amy Coney Barrett soon transitioned from the Bush GOP to its Supreme appendage.

Bush2 did step beyond Reagan and his Dad to campaign against AIDS/HIV in Africa. He also joined liberal Senator Edward Kennedy in a "No Child Left Behind" education campaign that Kennedy later regretted. Mused the new President...

*Rarely is the question asked...'Is our children learning?'*

Running Team Bush were two Nixonian dirty tricksters whose careers were defined by desecrating democracy. Vice President Dick Cheney opened his reign of oil with a secret gathering of his closest petro-pals aiming to slash the Clean Air Act and make our energy supply forever fossil/nuke.

In the tradition of the LBJ-Nixon Vietnam deceit, and of Ronald Reagan's Hollywood dementia, Karl Rove assaulted Truth itself...later denying he told reporter Ron Susskind that the "reality-based" world was beneath him, and that....

*...We're an empire now, and when we act, we create our own reality. And while you're studying that reality---judiciously, as you will---we'll act again, creating other new realities which you can study too, and that's how things will sort out. We're history's actors...and you, all of you, will be left to just study what we do.*

Though W (like Bill) had puffed pot, the regime continued using the Drug War as a way to fill the prisons, strip the voter rolls, trash the inner cities. Team Bush also killed Clinton's ban on assault weapons, with horrific results.

In early 2001, Texas crony "Kenny-boy" Lay's Enron power brokers decimated the California economy, purposely blacking out entire regions while bankrupting America's biggest utility and state. Enron's brazen piracy gouged ratepayer billions while Team Bush watched with apparent satisfaction.

With no real explanation, Shrub fired nine federal prosecutors and perpetrated massive tax cuts for his fellow Barons, pitching what was left of the Peace Dividend into their pockets. True to his petro-roots, W denied climate chaos and trashed the 100-nation Kyoto Protocol along with other measures meant to cool the planet. Lost in a rudderless haze, the economy slumped...along with his ratings.

Like Ike, Reagan, and later Trump, Bush2 perfected the traditional GOP art of not working real hard. He pumped iron daily, took off one day in five...and maybe scored the presidency's longest single vacation (five weeks).

He did solarize the White House pool. But unable to speak a full, coherent sentence, the ever-amiable George, Jr., just seemed comfortably numb.

Then...9/11 changed everything.

The image of loaded airliners flying into skyscrapers had been cinematically introduced in 1977's awful *Medusa Touch*, starring a satanic Richard Burton. But September11's surreal nightmare remains humanly incomprehensible.

The initial Bush response seemed masterful. He called for unity. He dampened anti-Muslim hysteria. He appealed to the sympathies of the world, which were with us.

He also lauded our incredibly brave First Responders. Working without respirators or protective gear, they gave up everything to save their fellow beings.

But a fiendishly toxic cloud of pulverized asbestos, glass, concrete, mercury, lead and too much more blanketed Ground Zero and much of the surrounding region. Basic sanity demanded providing every First Responder with proper protective equipment while evacuating the region. Bush did neither. Government agencies later denied benefits for those whose selfless bravery enshrined that awful day. Like Atomic Vets and the victims of Agent Orange and Gulf War Syndrome…First Responders died in droves from inexcusable official neglect.

An appropriate evacuation of the surrounding region would've meant shutting the Stock Exchange and more. The Environmental Protection Agency's Christine Todd Whitman later regretted the obscene inaction that cost countless lives.

Shedding its early "uniter not a divider" image, Team Bush declared a forever "War on Terror," a classic Calvinistic crusade against heathen "evil doers" and unseen apostasy. With a nameless, faceless, ubiquitous enemy that was impossible to confront, the Bush/Cheney/Rove Puritan upgrade conjured yet another Orwellian pretext for forever war. As W put it…

*…Our enemies are innovative and resourceful, and so are we. They never stop thinking about new ways to harm our country, and neither do we.*

To help hunt down that *Army of Devils*, the regime rammed through Congress a *Patriot Act*, obliterating much of the Bill of Rights, especially the Fourth Amendment. In the heat of the moment, only Wisconsin Senator Russ Feingold voted NO.

As chief CIA information officer Ira Hunt later explained to Edward Snowden…

*…we fundamentally try to collect everything and hang onto it forever…It is nearly within our grasp to compute on ALL human-generated information.*

Snowden and whistleblowers Chelsea Manning, Jeffrey Sterling, John Kiriakou, Reality Winner, Julian Assange, Daniel Hale and others were prosecuted for reporting such realties. The actual perpetrators were not.

Meanwhile doubts linger over who REALLY brought down those towers. Like the *Maine* and *Lusitania*… through the King and Kennedy assassinations…to the 1968, 1980 and 2000 elections…much about the 9/11/2001 official story doesn't add up… and probably never will.

To say we'll agonize over the origins of this horrific mass murder for decades to come is an epic understatement.

But Osama bin Laden took "credit." His CIA-trained Mujahidin guerillas had used our stinger missiles to take down the Soviet Union. When it collapsed, the US military enshrined him as a hero.

But when we failed to rebuild or leave his homeland, Bin Laden's fundamentalists became (as Benazir Bhutto warned) "a Frankenstein." Bush sent troops to find him…then lost interest and wandered off to Iraq, triangulating the horror of 9/11 into another oil-driven imperial war, this time against Saddam Hussein.

Iraq's dictatorial CIA monstrosity was very publicly hugged by Defense Secretary Donald Rumsfeld amidst a 1980s Iran-Iraq war that left a million dead. Saddam then

angered his Godfather by attacking Kuwait's oil fields, prompting Bush1's four-day Gulf War that crushed Saddam militarily...but left him in power.

As with LBJ in Vietnam, there are innumerable possible reasons why George the Lesser decided to finish the job....

X.  He wanted to prove that he could do what his Daddy didn't;

X.  It was all about oil;

X.  Having failed to protect us from the 9/11 attacks, he had to compensate with a diversion equally loud and bloody;

X.  As in Haiti and the Russo-Japanese War, people of color had humbled the Great White Colossus...and something had to be done about it;

X.  Having seen Reagan attack Granada after losing 241 soldiers in the 1983 Beirut barracks bombing, Team Bush attacked Iraq as a similar distraction;

X.  Saddam was a convenient scapegoat for 9/11, even though he hated fundamentalists like bin Laden, and had nothing to do with it;

X.  Karl Rove saw Bush2's popularity plummet, knew he'd have a better shot at re-election if he was a "war president," and therefore started one;

X.  Saddam threatened to undermine the petro-dollar by shifting to the Euro;

X.  War being a racket, there were billions to be made in another quagmire;

X.  Saddam had Weapons of Mass Destruction, threatening all of humankind.

*It's unlikely anybody on Team Bush believed that last one.*

Nor did Minnesota's hugely popular progressive Senator Paul Wellstone.  In the fall of 2002, as war clouds gathered, Paul's re-election was a virtual certainty.  But he reported that Cheney personally threatened him with "severe ramifications" for his Iraq war opposition.  On October 25, Wellstone, his wife and daughter were killed in a mysterious private plane crash.  Paul's Senate seat fell to a pro-war Cheney ally.  His death burned a still-painful hole in the "democratic wing" of the Democratic Party.

On February 3, 2003, Defense Secretary Colin Powell lied to the United Nations about WMD's that didn't exist.  More than 15 million people marched worldwide for peace.  But Cheney's petro-warriors promised that as we bombed their country, the Iraqi people would shower our soldiers with flowers.

In Congress, reprising the role of Jeanette Rankin, only California's Barbara Lee voted NO.  "Let's step back for a moment," she urged...

*...let's just pause, just for a minute, and think through the implications of our actions today, so that this does not spiral out of control.*

No such luck.  For her monumental wisdom and courage, Rep. Lee was inundated with death threats...but repeatedly re-elected.

On March 19, 2003, Team Bush bombed Baghdad.  Their "shock and awe" failed to kill Saddam...but opened the barbaric rape of an ancient land.  Countless innocents were impoverished, starved, slaughtered.  Iraq's cities were obliterated, its countryside ravaged, its priceless historic treasures scattered to the wind.

In the cancerous world of petro-realism, this was a "mow-the-lawn" atrocity in a tortured region where all that mattered was "our" oil.

On May 1, 2003, as countless thousands lay dead and dying, and as Bin Laden still ran free, W declared "Mission Accomplished." Southwest Asia's 20-year, $8 trillion quagmire mirrored the one in the Southeast.

In August, an Ohio nuclear utility blacked out the entire northeast and much of Canada, plunging 50 million people into darkness, escalating public demands for a remade power system.

In the summer, 2004, as the oil-war raged, the global media ran ghastly images of smiling US soldiers perpetrating sub-human atrocities at Iraq's Abu Ghraib prison.

Loudly embraced by Cheney and Rumsfeld there and at Guantanamo Bay, "enhanced interrogation" included water boarding, sleep deprivation, beatings, partial electrocutions, prolonged nudity, sexual abuse, excessive heat and cold. Intelligence experts denounced them all as useless in gathering reliable information.

But at Abu Ghraib, hideous, excruciating visuals showed laughing Americans forcing helpless prisoners into sodomy and masturbation, piling them up naked, firing electrodes into their genitals, desecrating their holy books.

In the April 30, 2004 *New Yorker*, Seymour Hersh (who'd broken Vietnam's My Lai story) documented the horror with detailed military reports.

Team Bush blamed a few "bad apples," triangulated back to 9/11, defended torture, scoffed at this shameful, excruciating public desecration.

Team Bush's top priority in 2004 was to excite evangelical voters in swing state Ohio with a referendum aiming to ban gay marriage.

GOP Secretary of State Ken Blackwell made the Buckeye state a test market for dirty tricks. While running Ohio's election as an allegedly neutral public official, he co-chaired the Bush-Cheney campaign. To count the votes, he slipped a no-bid contract to Michael Connell, the Bush family's personal computer geek.

The 2002 Help America Vote Act had designated $2 billion for hackable electronic touchscreens. HAVA's primary author, Ohio Congressman Bob Ney, went to prison. The *Texas Observer's* Ronnie Dugger said the new machines were "perfectly designed to steal elections."

Ohio 2004's catalog of "irregularities" included stripped voter rolls, flipped machines, official deception, eliminated precincts, forever lines, "lost" ballots.

At 12:20am election night, John Kerry was carrying the state (and thus the Electoral College) by 200,000 votes. But a "glitch" shut down the count. By 2am, Connell-managed computers flipped Ohio---and the presidency---to Bush.

When Kerry meekly conceded, furious Election Protection activists birthed a national movement for paper-based voting. In 2020 they became a decisive force in a Pandemic election otherwise poised to make Donald Trump President for Life.

In the interim came Katrina...a 2005 category 5 hurricane whose 175-mph winds poured over a global-warmed Gulf and ripped into New Orleans. Some 1800 deaths and $100 billion in damages might've been avoided by maintaining---at a cost of some

$5 billion---nearby barrier wetlands. Instead, bloated corpses floated through the Big Easy's flooded black wards. Those who fled to the Saints' Superdome endured deadly, degrading filth for days on end.

The Bush Family's response was classic Cavalier. Without bothering to come in person (he finally made it in 2007), the President "inspected" the ruined city from Air Force One, surmising that FEMA's Director did "a heckuva job." First Mother Barbara welcomed to her beloved Texas "fortunate" NOLA refugees who'd lost everything.

George, Jr., cut taxes for the rich while vetoing Congressional attempts to extend health care coverage for children. His tanked popularity fueled a 2007 Democratic takeover of Congress and the rise of Nancy Pelosi, our first matriarchal House Speaker. A grassroots uproar involving musicians Bonnie Raitt, Jackson Browne, Graham Nash and John Hall helped kill a $50 billion nuke bailout scam, paving the way for a Green New Deal.

Meanwhile Wall Street ran wild. With Glass-Steagall and other fiscal restraints long gone, financial mega-scams made the market a mess again (see *The Big Short, Heist, Smartest Guys in the Room, Inside Job*). Shrub's ugly "Too Big to Fail" exit ruined millions of American families deemed "too small to matter."

Thus our second lousy Boomer president took power with a violent assault on democracy, certified by shamelessly partisan Supremes. His *9/11 Revelations* shattered any illusion that our dying empire could protect us, even at home. Abu Ghraib/Guantanamo's unspeakable atrocities lynched our last pretense of spiritual superiority. Bush 2 slaughtered Saddam in 2006, but let Bin Laden run free as the region devolved into catastrophic chaos. Forever oil wars incinerated the image of an affordable, moral or immortal empire. Katrina confirmed an escalating climate apocalypse. The Big Short ignited our worst Crash since 1929.

Overall, Bush2's serial two-term dysfunction obliterated the Puritan myth of our white magistrate-priests' Divine superiority.

So our first African-American CEO was brought in to clean up the mess.

# Obama's "Too Big to Fail"
# Ratf**ked Coup

*Reagan-Bush1-Clinton-Bush2 wrote a blank check to America's "too-big-to-fail" modern day Robber Barons. Obama sealed the deal with a stylish but hollow and ultimately disastrous presidency that failed to stop our forever wars, stood mute as the GOP lethally injected US democracy, saw us careen toward a hellish dystopian pit.*

*As imperial decay deepened, climate, air, water, food, industrial, medical, housing, transportation, educational, social justice and other critical components slid toward soul-killing rubble...with key indicators of a dictatorial coup falling ominously into place.*

The financial collapse of 2007-9 was rooted in the escalating gap between rich and poor. Average overall wages rose steadily from Jefferson to Nixon. But the post-Vietnam era saw zero major legislation to benefit the working/middle class. Says Yale Prof. Timothy Snyder in *The Road to Unfreedom*...

*...In 1978, the top 0.1% of the population, about 160,000 families, controlled 7% of American wealth...*

*...A family in the top 0.01%, about 16,000 families...was about 222 times as rich as the average American family...*

Since 1980, wrote Snyder...

*...90% of the American population had gained essentially nothing, either in wealth or income. All gains have gone to the top 10%—-and within the top 10%, most to the top 1%; and within the top 1%, most to the top 0.1%, and within the top 0.1% most to the top 0.01%.*

By Bush2, the New Deal/Great Society's fiscal controls and human safety nets were in shambles. Wall Street's toxic sludge oozed from the mortgage fraud tar pit into the threadbare Heartland homes of a devastated working/middle class. Mainstream despair and lethal opioid addiction ran rampant.

Through the summer/fall of 2008, as the presidential campaign raged, the Feds put the giant Fannie May and Freddie Mac mortgage agencies into conservatorship. Lehman vaporized. Merrill Lynch was fire-saled to Bank of America for $50 billion. The Fed loaned $85 billion to the insurance giant AIG.

A century prior, "Trust Buster" Teddy Roosevelt bailed out a parallel crash by printing millions in greenbacks for too big to fail Robber Barons. The 1913 formation of the Federal Reserve and income tax (1916) soon followed....as did WW1, the apocalyptic flu pandemic, and Woodrow Wilson's Red Scare *putsch*.

On October 3, 2008, Congress responded with a parallel Troubled Asset Relief Program and untold billions for the latest tranche of Bully Boy Barons. As for the forever-trashed working/middle class, they lost their savings, jobs, homes, cars, medical

insurance, futures.  With Wall Street trickling down on them, America's "99%" was desperate...and ready send Bush2 back to Texas.

A month later, Barack Obama won the presidency. He was born in Hawaii, August 4, 1961. His mother was from Kansas, his father from Kenya.

Exceptionally charismatic, a brilliant speaker and a consummate showman, Barack was not descended from slaves. But his wife Michelle was...and suitably proud of it. Their telegenic aplomb lit up our ever-evolving, permanently Awakened core.

When Obama nailed an *in-your-face* three-point shot at a live 2008 event in Kuwait, his destiny seemed manifest.

Barack ran against Arizona's aging corporate war horse, John McCain, who postured as a "maverick" Republican. His choice of Alaska Governor Sarah Palin for a running mate was patently insane.

A female GOP VP should've been a stroke of genius.  But to even many Republicans, Sarah seemed an incompetent, mean-spirited airhead, a shaky backup for the no-spring-chicken senior Senator (*what was he thinking?!*).

She did, however, ignite an edgy, hateful militia base that loved her know-nothingness. For the likes of Donald Trump, Sarah was a radioactive ice-breaker.

On the left, Obama's diverse *"Hope and Change"* demographics inspired an Awakened army of grassroots activists, old and new. His social media mastery drew millions in small donations. Young believers brought souls to the polls, fought stripped voter rolls, challenged rigged electronic tallies, blocked re-runs of the bitter heists that had defined Florida 2000 and Ohio 2004.

When Barack claimed victory in Chicago's Grant Park (*where Dick Daley beat the hell out of us forty years before*) Boomer tears flowed like a healing rain.

Obama's election seemed like a giant leap for American diversity. Trumpster bigots endlessly obsessed over Barack's birth certificate, confirming the symbolic punch of a black man----with his wife, two kids and mother-in-law---running the White House.

*And run it they did.*

Dating to George and Martha, Barack and Michelle managed as tight and clean an executive ship as any in US history. They beautifully raised their two daughters at the edge of the public eye. Their internal operation was uniquely scandal-free.

With charm, grace and wit, "no drama Obama" was calm and cool enough to pass for a hologram. Michelle's boundless energy recalled Eleanor and Franklin's *Happy Days*. Barack sailed in with a 257 to 178 margin in the House. The Democrats held 60 Senate seats for four months, and were over 55 for two full years.

In anticipation, the media filled with obituaries for a GOP they said was dead (*which it was, but not in ways they fully understood, as Donald Trump would soon prove*).

The door was open. Statehood for the District of Columbia was there for the taking, and would have made a world of difference.  Repealing Taft-Hartley and other anti-union barriers could have empowered labor.  Winding down the empire and moving those huge resources from the military to social/infrastructure needs would have changed everything. Electoral reforms---especially on gerrymandering---would have

helped to protect a thread-bare democracy already under deadly assault, now facing collapse.

Obama did none of the above.

He did open with the Lilly Ledbetter Fair Pay Act, overturning a Supreme Court decision that had limited the clock for employees to challenge pay discrimination.

The Administration moved forcefully against the homelessness so cruelly seeded by Reagan's public housing cuts and the Clinton-era Faircloth Limit. The FHA's Hardest Hit Fund helped end the Bush2 wave of evictions. Barack fought segregation in public housing and saved countless vets from being forced into the streets.

Obama and Secretary of State Hillary Clinton helped salvage Paris Climate Accords that China might have derailed. Their EPA pushed a Clean Power Plan to reduce $CO_2$ emissions--primarily from coal. With little fanfare, the Obamas advanced the White House solarization begun by Carter and Bush2.

Obama also introduced the Stimulus Package, the undersold embryo of an epic groundswell that morphed toward a Green New Deal. Envisioning a sane, survivable 21st century, Obama took serious leaps in renewable energy, infrastructure, education, help for vets, ecological restoration, high tech breakthroughs, computerized medicine, tax breaks for the working/middle class.

The Stimulus could have been three, four, five times bigger, with lasting structural changes for social justice and ecological stability demanded by our surging youthful progressive core. But they never came.

Obamacare and Medicaid expansion were huge advances that saved countless lives and untold billions. For the increasingly unhinged GOP, these were socialist apparitions. For the grassroots left, they fell far shy of the universal health care neither he nor the Clintons were willing to seriously discuss.

Overall, the economy avoided both total collapse and a serious restructuring. The Troubled Asset Relief Program was the pinnacle of American "lemon socialism." As usual, the working/ middle class paid for the "free market" larceny of the obscenely rich. Said Noam Chomsky...

*...A basic principle of modern state capitalism is that costs and risks are socialized to the extent possible, while profit is privatized.*

While they gorged on the public ransom, Wall Street's billionaires feared a "populist" president's "New New Deal" that might demand justice for the desperate millions footing the bill. But, said Thomas Frank of Barack's March, 2009 meeting with the Big Boys...

*...After warning them about the 'pitchforks' of an angry public, Obama reassured the frightened bankers that they could count on him to protect them; that he had no intention of restructuring their industry or changing the economic direction of the nation.*

It was then, said Frank, that "the hope drained out of the Obama movement." Minor limits were put on some executive salaries. But the Administration was

stuffed with insiders like Robert Rubin, Tim Geithner, Larry Summers. Except for one obscure number cruncher carted off for ritual sacrifice, no Wall Streeters went to jail. Trillions vanished, billions were grifted, millions of over-stretched families lost their jobs, homes, and any residual faith in government...or the Democratic Party.

It didn't help that Rahm Emmanuel, Barack's Chief of Staff and Congressional enforcer, came with a Dick Cheney sneer and endless contempt for working/middle class Americans and their activist advocates. Obama's elite demeanor was wrapped in deplorable condescension toward "bitter" citizens who "cling" to guns and religion in times of need...as they would soon enough cling to Donald Trump.

There were no exciting alphabet agencies, no high-profile public arts projects, no grassroots embrace or "feel-your-pain" angst...and nowhere near enough resources put into rebuilding the grassroots foundation of an American future.

Much TARP money did eventually return to the Treasury. The car companies survived to stonewall the next techno-revolution (see *Who Killed the Electric Car?*).

The million/billionaire elite/Elect who profited from their own shipwreck sailed away in public-funded lifeboats. The rest of us swam or sank. Those lost Big Short trillions became ever more socialism for the rich.

*The Heartland fury would soon turn deadly.*

Likewise the Drug War.

Early Barack glibly chuckled about inhaling both cannabis and cocaine. "That was the point," he quipped. But he openly mocked legalizers who'd ardently supported him.

His federal drug warriors did ease up (see the "Cole Memo"). Many gulag victims went free. Some two dozen states did approve medical cannabis. Colorado very successfully legalized it outright (*40% went into edibles!*). But the arrests continued.

So did the REAL drug crisis---opioids. Big Pharma made billions pouring trillions of lethal little pills through corporate pharmacies into despairing Heartland veins. Millions had been jailed for pot ---which killed virtually no one. But fentanyl ravaged the working/middle class, killing countless kids, with no meaningful official response. (*Unlike pot dealers, no Big Pharma pushers were ever arrested*).

Until Indigenous activism forced his hand, Obama also ignored the Earth-killing Keystone and Dakota Pipeline projects, fracking, and the un-labelled spread of Monsanto's Genetically Modified Organisms, which he'd promised to stop. His *all-the-above* energy strategy slipped $8.5 billion in interest-free loans to twin Georgia reactors that sank into a $30 billion quagmire and - if they ever go critical - will never compete with renewables.

In 2011 the GOP killed a pair of Barack's landmark American Jobs Acts. In late 2012 his proposed Social Security cuts (via a complex ruse called the "chained CPI") were thankfully stopped by grassroots outrage, Sen. Bernie Sanders, and Joel Segal, a staffer for Rep. John Conyers who helped author Obamacare.

**(Bill Clinton & George W. Bush Not Shown)**

A Constitutional lawyer, Obama's iron grip on state secrets dwarfed that of Reagan, Clinton and the Bushes. He prosecuted a record number of whistle-blowers like Edward Snowden, whose "crime" was to reveal our intelligence agencies' worst excesses. He denied a fair trial or pardon for Indigenous activist Leonard Peltier, left to rot in federal prisons for nearly a half-century. His DREAMER plan offered citizenship to thousands of young immigrants while he otherwise deported millions.

As Obama failed to deliver the lasting grassroots gains that might've solidified a decisive progressive coalition, the right leaped toward outright fascism.

In February, 2009, Chicago TV face Rick Santelli used the *Too-Big-To-Fail* Bail-out to smear low-income Americans (*read: "blacks and Hispanics"*) trapped in scam mortgages. The astro-turf "Taxed Enough Already" TEA Party used corporate cash to fund a nasty, increasingly violent Jim Crow lynch mob that metastasized into four years of Donald Trump…and threatens far worse.

In 2010, the GOP's RedMap Coup gutted our electoral system. While the Democrats slept, Karl (*"we're an empire now"*) Rove and fellow Nixonian dirty tricksters used fossil-fueled Koch Brothers cash to buy an iron grip on the Heartland/Old Confederacy's gerrymandered legislatures, seizing control of the ten-year redistricting cycle and setting the stage for a fascist putsch.

The opposite was happening in California.

Despite hot opposition from Nancy Pelosi and the corporate Democrats, grassroots progressives won state-wide 2008-2010 referenda for transparent, multi-partisan districting commissions meant to abolish gerrymandering. GOP actor/governor Arnold Schwarzenegger reportedly contributed $3 million of his own cash.

Popular, fair-minded and efficient, the new process later took root in Michigan (*Arnold's son was a student in Ann Arbor*). Democrat elites fought the trend.

But as described in David Daley's infuriating *Ratf**ked*, the 2010 Democrats lost six US Senate seats, 63 in the House, many state capitals. Certified by *Citizens United (2010)*, *McCutcheon (2014)* and other Supreme Court *"One Dollar, One Vote"* decisions that killed campaign finance restrictions, the GOP bought America's political core while the Dems slept. They won 2010's Congressional races nationwide by some 1.4 million popular votes…and watched the GOP emerge with a 33-seat House majority…plus a decade's-long death grip on America's swing state legislatures.

They did it, said Daley, with a "wholesale political resegregation along both sides of the Mason-Dixon line."

The GOP, added Rev. William J. Barber, II, of the Poor People's Campaign, "cracked, stacked, packed, and bleached Black voters."

Obama blithely called the 2010 coup a "shellacking," calmly surveying the wreckage without visible upset or the stirring counter- campaign needed to undo the damage. But the GOP had buried a fascist hatchet deep into our democracy. As the Tea Party and its evangelical wing shaped their "facts" to fit their Truth, the Republicans now customized their districts to fit their voters.

In 2013 the Supremes trashed the 1965 Voting Rights Act. The lethal *Shelby* decision was penned by Chief John Roberts, former legal aide to the Brooks Brothers

mob that assaulted the Florida 2000 vote count.

A Civil Rights centerpiece, the VRA guaranteed the franchise to millions of black voters. But with gerrymandered districts, stripped registration rolls, rigged vote counts, ousted election officials and a reshaped paradigm, the Obama era Republicans seized a thousand seats.

In 2015, with full support of the Obama Administration, a 5-4 Court did approve gay marriage. Obama-appointed Justices Sonya Sotomayor and Elena Kagan joined Ruth Bader Ginsburg and Stephen Breyer with the decisive swing voter, San Francisco's Anthony Kennedy...who soon retired.

*Obergefell* brought boundless joy to millions of loving Americans. But when Obama tried to put the very moderate Merrick Garland in Kennedy's seat, he was stonewalled by Mitch McConnell, the brutal Majority leader of a now extreme right-wing Senate.

The Court was set to go the way of the RedMap Coup. And far worse would follow.

Overseas, Obama broke far more than just our hearts.

Barack's Senatorial vote against the Iraq War helped win him the Democratic nomination from Hillary Clinton....then the presidency...and then a VERY premature Nobel Prize.

That Nobel remains a mystery. In perhaps the Peace Award's most inappropriate acceptance speech, Obama argued for the "necessity" of war. He later told Stephen Colbert he didn't know why he'd gotten it. Nobel Secretary Geir Lundestad termed the choice a "mistake" and a "disappointment" that didn't achieve "what the Committee had hoped for."

For many, that Prize seemed a roll of the dice, a desperate bribe to move the new American president toward ending the war in Iraq (which he mostly did)...plus pulling out of Afghanistan, winding down the empire, shutting Guantanamo and abolishing nuclear weapons (of which he did none of the above).

Barack did negotiate a critical non-proliferation treaty with Iran. He became the first sitting president since Calvin Coolidge to visit Cuba. But despite a campaign promise, Guantanamo's hellish torture chamber stayed open.

To the horror of his grassroots backers, Obama also extended Shrub's refusal to sign a global ban on landmines, which annually kill countless innocent children.

Said fellow Laureate Jody Williams...

*...This decision is a slap in the face to landmine survivors, their families and affected communities everywhere.*

Candidate Obama loudly pledged to abolish nuclear weapons. But as president he advanced a trillion-dollar program to "upgrade" the atomic arsenal.

And when he leapt into the bottomless Afghan sinkhole, he took with him the chance to definitively wind down the American empire...opening the door to Donald Trump.

Historian Thomas E. Gouttierre lists previous losers in the "Graveyard of Empires" as Persia (500BC), Alexander the Great (330BC), Kushans (96BC), Sasanians

(200AD), Huns (400), Persians again (900), Mongols (1200), India and Persia again (1550), Great Britain (1839), Russia (1850), Great Britain again (1878), the Soviet Union (1978).

In 2009, while withdrawing troops from Iraq, Obama made a public pageant of his decision to send thousands more Americans to kill and die in the Afghan desert. Exulting in high-profile consultations, he ignored the peace movement. When he executed Osama bin Laden, it was in Pakistan.

With zero due process, Obama continued to fling extra-legal drones at "suspected terrorists," including at least one US citizen and his child. Wedding parties, family gatherings, innocent civilians, small children, random villages fell like three-point shots.

The sandy corridor stretching across Southwest Asia, the Middle East and north Africa devolved into a festering Hades. Ancient Arab/Israel/Palestinian conflicts deepened and metastasized. Mass slaughter ravaged Syria, Yemen, Jordan and beyond. "Arab Spring" uprisings morphed into tyrannies even worse than those they overthrew.

With Secretary of State Hillary Clinton beating the war drums, Libya's Gaddafi was erased. Along the Shores of Tripoli---site of Thomas Jefferson's first overseas intervention two centuries prior---America's imperial overreach came full circle.

Like Saddam, Gaddafi's suicidal sin was to threaten the petro-dollar. His gold reserves---maybe 130 tons---could back his All-African currency, the *dinar*.

A brutal dictator, Gaddafi was also a secular stop on Islamic terror...

*...Now listen you people of Nato. You're bombing a wall, which stood in the way of African migration to Europe and in the way of al Qaeda terrorists. This wall was Libya. You're breaking it. You're idiots, and you will burn in Hell for thousands of migrants from Africa.*

Sure enough, Libya devolved into a barbaric Iraq-like failed state. Thousands died. Still more fled to an unready Europe. Their ragged desperation conjured the specter of another fascist reaction.

In Honduras, not far from the Halls of Montezuma, Obama and Clinton sabotaged the duly elected Manuel Zelaya. They backed the usual grifter thugs in another deadly round of Dollar Diplomacy's forever war on social democracy.

As in so many other imperial fiefdoms, Honduras sank into the murderous morass of corporate dictatorship, feeding a flow of desperate refugees for Donald Trump to use as pretext for autocracy.

With our states gerrymandered, our elections undermined, the Supremes on the brink, another round of Dem triangulators had delivered plenty of Hope but scant Change.

*The Donald was waiting.*

# TRUMPOCALYPSE

## *Our Imperial Vulture*
## *Comes Home to Roost*

*"We're going to take over the election apparatus. [Trump cultists with military and police training] are now going to volunteer to become a precinct committeeman, they're going to volunteer to become an election official, they're going to come and run for county clerk and overthrow these county clerks and they're going to take over the secretaries of state…And we're going to be relentless and we're not going to give up…And we're going to take over elections."*

*…Steve Bannon*

*In The Donald's toxic swamp, our imperial karma came due.*

*The balloon payment on the American Empire, Trump was living proof that the Universe has a sense of both payback and the absurd.*

*Born to organized crime, Trump stamped his mobster profile all over our Republic's death certificate. Around him the corporate-fascist right built a toxic wall, meant to dam democracy and stem the tide of demographic destiny.*

*Whether it holds will tell the future of our democracy and our planet.*

Donald Trump's German immigrant grandfather was a human trafficker who ran a house of prostitution. His father, Fred, was a proud KKK bigot.

According to investigations by then federal prosecutor Rudy Giuliani, New York's mobster Five Families poured concrete for Trump's tenements and towers. Michael Chertoff, Bush2's Homeland Security chief, characterized one of the Trumps' suppliers as "the largest and most vicious criminal business in the United States."

"Usually, I build buildings," explained the young apprentice. "I have to deal with the unions, the Mob, some of the roughest men you've ever seen in your life."

Daddy Fred's high-rise slums were continuously cited for blatant discrimination. "Old man Trump," wrote one of his tenants (the legendary folk singer Woody Guthrie) "knows/Just how much/Racial Hate/He stirred up/In the bloodpot of human hearts."

The Donald's early mentor was Roy Cohn, the twisted mob shill who anchored Joe McCarthy's Lavender/Red Scare. Cohn's exceptionally vicious personal attacks and complete lack of empathy or grace defined his disciple's persona. At the end, ravaged by AIDS, Cohn's life-long acolyte cut him off. The young Trump, said Roy (*perhaps with Falstaffian pride*) "pisses icewater."

As his dad lay dying, The Donald tried to strip all the old boy's money, then sank into multiple bankruptcies and massive debt. British commentator Nate White cited the narcissistic bully for having...

*...no class, no charm, no coolness, no credibility, no compassion, no wit, no warmth, no wisdom, no subtlety, no sensitivity, no self-awareness, no humility, no honor and no grace.*

Raised to rant without remorse or consequence, The Donald bragged to an Evangelical audience that he could...

*...stand in the middle of Fifth Avenue and shoot someone, okay, and I wouldn't lose any voters, okay?"*

As the Soviet Union fell, its emerging wise guy billionaires laundered their roubles through Trump's toxic rat's nest of failing properties and serial bankruptcies. By

1999, when Vladimir Putin became Russia's don, Trump Tower (725 Fifth Avenue) became a *Rossiyskaya Mafiya*...a mob safe house.

In 2004 Trump stumbled into reality TV, forever disconnecting from any actual facts. With some 20 million weekly viewers on a ten-year run, the *Apprentice* made him another financial fortune...which he quickly blew.

But it led to his bigliest scam---running for president.

Candidate Donald Trump never spoke of an ideology or vision beyond his celebrity persona, dubious wealth and racial hate. His 2016 presidential jaunt began as a money grubbing publicity stunt that he expected to end upon losing election night.

When he won, his primary goals quickly clarified: to become President for Life, to trash the tattered democracy that stood in his way, and to grift all he could grab for his personal profit.

Trump had already absorbed the political currency of public bigotry from his Klan dad and mobster godfather. In a dying empire drowning in ill-got imperial tribute, where cash was political currency and elections buyable, organized crime's destiny as a driving force in American public life was abundantly manifest.

In 2009 the "colored caste" newly in the White House shattered the "race bribe" born of chattel slavery in 1600s Virginia...and mutated America's Puritan DNA.

Hillary Clinton deepened the trauma with sneering contempt for laboring "deplorables" now churning with rage at the bottom of the heap...minus both a social safety net and the former slave caste beneath.

Trump had been training for just this moment. According to his first wife, Hitler's writings lived on a night stand next to his bed. For endless hours the Donald mimicked *der Fuhrer* in front of a mirror.

At the *Apprentice*, he perfected his skills as a master media manipulator, twittering non-stop a shameless, unhinged stream of *Big* Lies perfectly designed to dominate the 24/7 news cycle. As the ultimate Bad Boy, he hypnotized even those who hated him...especially the ones he made rich.

Armed with his Klan daddy's divide-and-conquer racist anti-semitism, he screamed that Obama (*of course*) was born in Africa. His boorish opulence seduced the "fake media"...even as he attacked them. Said CBS's disgraced Les Moonves...

*...the money is rolling in and this is fun...I've never seen anything like this, and this is going to be a very good year for us. Sorry. It's a terrible thing to say, but bring it on, Donald. Keep going.*

Calvin's Heartland/Confederacy rallied for its Lost Cause last stand against the pagan masses. "Make America Great Again" ballcaps buried the *Clintonista* elite's Ozian miasma, which deplored Bernie's young Sandernistas and Trump's Cult of Embitterment, but couldn't stoop to actual grassroots campaigning.

Long before election day, MAGA mobs screamed that "*Jews will not replace us!*" At Hitlerian rallies saturated with violent, racist rants, Trump howled to his death cult that *ONLY MY VICTORY WILL BE ALLOWED!*

With white misogynist evangelical supremacy fueling his panzers, Herr Trump drove a masterful web/media blitzkrieg into the Capitol. Coordinated by his uber-authoritarian *consigliere*, Steve Bannon, the London-based Cambridge Analytica used hyper-advanced algorithms to manipulate the masses.

Facilitating all forms of human communication, the WorldWideWeb embodied an epic tectonic shift, an instant globalized mind meld powering a clear evolutionary leap. But from its many black holes, manipulative mega-corporations and random bad actors picked apart the political process and warped the human condition beyond any rational reckoning. Says analyst Jaron Lanier...

> *...our attention can be mined.. We're seeing corporations using powerful artificial intelligence to outsmart us and figure out how to pull our attention toward the things they want us to look at, rather than the things that are most consistent with our goals and our values and our lives....*

> *...We've created an entire global population of people who were raised... within the contexts where the very meaning of communication, the meaning of culture, is manipulation. We've put deceit... at the very center of everything we do.*

In 2016, as the *Clintonistas* slept, Bannon turned countless Facebook profiles into dark, calculated chaos. Hired electronic guns fired a carefully calibrated, intensely polarizing stream of bilious lies, generic hatred, mistrust, cultural bias, racial bigotry, misogyny, homophobia, credulity, nihilism...pure ugliness and lethal insanity...dark, depressing, demonizing, debilitating...portending dictatorial doom.

Computing capabilities a trillion times more powerful than the first digital devices turned our culture into a toxic swamp of division and despair. With devastating precision, Bannon's pixelated death squads made Truth itself an "enemy of the people."

Bannon/Analytica's polarizing poisons fed an ethnic/gender/race-based crusade for a reborn Calvinist Order. Capped by Trump's insane tweets, unhinged lies, Nuremberg-style public rallies and endless hate-streaming, the hideous impact on America's moral fiber and civil dialogue metastasized into a cancer festering most critically among white "Christian" men who above all feared uppity women (especially of color).

With some two dozen charges of sexual imposition and rape, *El Jefe* made himself America's Titan of Testosterone...

> *...You know, I'm automatically attracted to beautiful...*
> *I just start kissing them. It's like a magnet. Just kiss. I don't even wait. And when you're a star, they let you do it. You can do anything.*
> *Grab 'em by the p\*ssy. You can do anything.*

Or so he thought.

As Trump took power in 2017, he made clear his intent to never leave, and to impose an autocratic rule based on a single premise: "I alone can fix it."

The new *Caudillo* surrounded himself with immediate *famiglia*, handing the nation's business to a demented clown car of daughter, sons, son-in-law...and assorted other utterly incompetent ring-kissers.

Entranced by the huge tax breaks Trump arranged for their preachers, millions of Evangelicals proclaimed him the new Messiah, somehow equating Jesus of Nazareth with an unchurched con artist. Lending the regime an aura of divinity, The Donald's fanatic followers never hesitated to threaten Godly violence against any who might oppose him. Under Trump's GOP, the death threat became common currency.

The hateful wall Trump said Mexico would fund became a tawdry scam for cronies like Steve Bannon, who pocketed a fortune, then got Trump to pardon him. In our formerly Mexican southwest, the regime revived My Lai and Abu Ghraib, locking countless political and climate refugees into wire cages, separating families, abusing children, denying them food, medical care, access to any and all legal or human rights.

Playing endless rounds of golf, Trump squandered some $100 million in public money paid to his own failing resorts. *Forbes Magazine* puts his four-year grift at $2.4 billion...not counting hush money for paramours and prostitutes...or millions funneled to friends and family like son-in-law Jared Kushner, whose public position may have helped him erase a half-billion in personal debt on a single Manhattan property.

To satisfy his own corporate backers and fellow Russo-American mobsters, Trump trashed national parks, mined and burned fossil fuels, voided environmental protections, poured irradiated cash into the reactor rat hole, denied the climate crisis, toxified our air, water and food.

Globally, Donald played the insufferable stumblebum, embracing dictators, taunting China, bloating the military, breaking alliances, trashing treaties, groping heads of state like Germany's Angela Merkel, who was running Europe at the time.

Having promised to end the Afghan disaster, Trump let it fester until he cut a lousy deal with the Taliban. He was the empire's vampire come home to roost, an obscene guttersnipe delivering the karmic payback for Frankenstein monsters like Pinochet (Chile), Castelo Branco/Bolsonaro (Brazil), Somoza (Nicaragua), Batista (Cuba), the Duvaliers (Haiti), Mobutu (Congo/Zaire), the Greek Junta, the Shah (Iran), the Saudis, Saddam Hussein (Iraq), Yeltsin/Putin (Russia), Shinzo Abe (Japan), Rhee (Korea), Suharto (Indonesia), Marcos/Duterte (the Philippines), Pol Pot (Cambodia), Lee Kuan Yew (Singapore), Diem/Thieu/Ky (Vietnam), Noriega (Panama), Alvarado (Honduras).

*And then there was the Pandemic.*

In 1918-20, Woodrow Wilson helped spread a Spanish Flu virus that killed 675,000 humans here and 100,000,000 worldwide. Ignoring pleas to end the draft, troop movements and pro-war rallies, he caught the Flu himself and suffered a debilitating stroke. FDR's case may have fed the polio that crippled him in 1921.

Trump's primary COVID obsession was protecting the stock market. He first dismissed the virus's killing power, costing valuable time and countless lives. He advocated shining magical lights inside the body while ingesting bleach and unproven pharmaceuticals in which he may have had personal investments. His team supported a cruel, mindless "herd immunity" theory meant to infect the whole country.

Once infected himself, he refused--- for a full week--- to tell White House staff and visitors, heedlessly exposing small children and vulnerable elders. He debated Joe Biden while secretly carrying (and spreading) the virus.

As the end neared, he slaughtered 13 federal prisoners…trashing due process, burying their appeals, pouring blood all over his hands and our hearts.

On January 6, 2021, it all exploded. Trump became our first incumbent to launch a violent assault against the presidential succession. He howled for weeks (starting well prior to the actual balloting) that the election was being stolen. Like Hitler's *Dolchstoßlegend*, America was being "stabbed in the back" by Jews and Others. The White House was his to seize. His Vice President could trash both the popular and Electoral College vote. Violent "patriots" were *duty-bound* to terrorize Congress and shred the Constitution.

After 24 decades of American presidents, Trump alone pressured the military to make him Leader for Life.

At least five Americans died…along with our exceptional sense that while we'd perpetrated coups in countless smaller nations, here we were immune.

The real delusion is that this is all about Trump…that once he be gone, the authoritarian threat will disappear with him.

In fact the Donald is just a tiny dancer atop the far broader dictatorial streak running through the spiral of our history…from the first trickle of whites to the diverse demographic tsunami now flinging us all toward the ultimate face-off.

## The Puritan Death Rattle's Fascist Wall

Dating to slaveowner Jamestown and Puritan Boston, European newcomers and their entitled progeny have forever assumed a brave "New World" rigidly ruled by straight rich white "Christian" men.

Overrunning the Indigenous, enslaving Africans, exploiting immigrants…America's Calvinist/capitalist/corporate/imperial elite never dreamed of a majority non-white nation run by women, embracing diverse worldviews, openly enjoying taboo sexualities….or of an Earth dominated by China.

Through the cycles of our history, successive social, political and cultural Awakenings have raged against Calvin's machine …only to be battered back toward submission (never quite getting all the way there) by an entrenched establishment.

But in the new millennium, a transformational demographic destiny has become manifest. By virtue mostly of rising immigration and diverging birth rates, whites have devolved toward minority status. California, Texas, Florida and many more stand on or over the line. By 2045, the nation as a whole will be majority non-white.

Repeatedly uhinged by our cyclical transcendent Awakenings, the straight white "Christian" male has grown desperate. In his catechismic culture war surrender notice, far-right Catholic activist Paul Weyrich threw in the rosary, mourning …

> …a cultural collapse of historic proportions, a collapse so great that it simply overwhelms politics... the United States is very close to becoming a state totally dominated by an alien ideology, an ideology bitterly hostile to Western culture.

In instinctive terror, the authoritarian fringe began to goose step. Led by Barry Goldwater in 1964, our modern Visible Saints seized the Republican Party. Convening a mean-spirited Crusade of nasty former Dixiecrats, alienated northern whites and off-beat evangelicals, Richard Nixon used the Drug War to fill an Orwellian gulag. Ronald Reagan's macho contempt sanctified greed. Bush2's utter incompetence confirmed that as a global empire, our "City on the Hill" ---certainly after 9/11---was dead meat.

With the rise of the Millennial/Zoomers has come an Evangelical eruption. In 2006 the movement claimed a 23% share of the American populace as calculated by the Public Religion Research Institute. Calling itself "Generation Joshua," the gay-hating Calvinist cult envisioned a purified future, vowing to "outbreed" the left. Their Messiah in the White House promised an untaxed tyranny for their Megachurches.

*"Jesus is my Savior...Trump is My President."*

But the movement hit a generational stonewall, dropping by 2020 to less than 15%, becoming our most elderly cult (median age: 56), being transcended among the young by "Nones" who avoid church-going like a Biblical plague.

Robert P. Jones's *The End of White Christian America* sees an Evangelical fury inflicted with "a real visceral sense of loss of cultural dominance." Facing spiritual and demographic doom, with satanic direction from the likes of Rudy Giuliani and Steve Bannon, Trump's autocratic rump has gone full fascist. Says Reagan/Bush advisor Bruce Bartlett in the NY Times...

> ....*The Republican Party today is basically a coalition of grievances united by one thing: hatred. Hatred of immigrants, hatred of minorities, hatred of intellectuals, hatred of gays, feminists and many other groups too numerous to mention. What binds them together is hatred of Democrats because they are welcoming to every group that Republicans reject.*

But an autocratic Ghost Dance does not depend on a mere Donald. For decades the radical right has been building its dictatorial citadel.

Piled onto 14 pillars, it goes something like this...

X. THE SUPREME COURT: Already stacked with rightists Roberts, Thomas and Alito...Trump and Mitch McConnell further stuffed the Court with Gorsuch, Kavanaugh and Barrett, producing a 6-3 *death-to-democracy* consensus set to enshrine outright autocracy. Ruling that state legislatures can choose their own Electoral College delegations, that corporate money can rule our elections, that voting rights need not be protected, that women must not control their own bodies...the Supremes mean to drive the final stakes through American democracy's barely beating heart.

X. THE ELECTORAL COLLEGE: First meant to protect small states and slave holders, this medieval relic tilts our presidential elections far right. It's buried the popular vote to enthrone Bush2 and Trump. In 2020 The Donald used *Bush v. Gore* to demand that gerrymandered state legislatures trash their popular vote counts and install Electoral College delegates to make him President for Life. There's no reason to doubt that a future Court would do whatever he—or someone like him—wants.

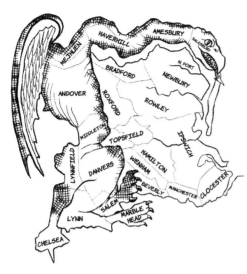

X. GERRYMANDERING: In 1812 Massachusetts Governor Elbridge Gerry disenfranchised his rivals with legislative districts that looked like salamanders. In 2010, as the Democrats slept through the Koch-funded REDMAP COUP, the GOP made them into pythons.

X. THE US SENATE: From birth the Upper House has been a Lordly bastion. In 2021 its 50 Democrats represented 42 million more Americans than the 50 Republicans. In 2018 it took Diane Feinstein of California more than six million votes to get re-elected. Kentucky went to Mitch McConnell with 1.23 million, Kyrsten Sinema won Arizona with 1.19 million. West Virginia's Joe Manchin came with just 290,000. Meanwhile, thanks to the negligence of Clinton and Obama, the 700k citizens of the Douglass Commonwealth have zero Senators.

X. THE FILIBUSTER: Derived from a Dutch word for "pirate," the term (like "corporation" and "Jesus") appears nowhere in the Constitution. Originally a simple majority could bring a vote to the Senate or House floor. But an Aaron Burr speech led to an 1805 change that's mutated into today's 60-vote death trap. Southern white racists have used it to kill our civil and voting rights. Now it's a lockstep GOP's weapon of choice against all that hints of empathy, democracy or eco-survival.

X. SYSTEMATIC DISENFRANCHISEMENT: Since at least 2000 the Rove/Bannon GOP's dirty tricks have denied the vote to non-millionaire citizens of youth and color. Impossible ID requirements, disappearing precincts, stripped registration rolls, de facto poll taxes, malfunctioning electronics, missing and unmailed paper ballots… all facilitate the Republican mega-purge. Gerrymandered Heartland/Confederate state legislatures have enshrined a new Jim Crow reversible only with federal legislation and fair-minded Supremes. Good luck on those.

X. SABOTAGED ELECTIONS: Trump's attack squads have infiltrated our local election boards. From once-obscure secretaries of state to the ground-level functionaries that run our elections, partisan corruption is rampant. Expect future Election Day intimidation, theft and chaos, from start to finish.

X. RIGGED AUDITS AND RECOUNTS—-Legitimate audits and recounts are essential to credible elections. But in Arizona 2020, Team Trump staged a clown car fiasco meant to obscure an obvious loss. Dubious recounts and audits are now a virtual certainty. Election Protection advocates have pushed back hard and successfully. Standardized regulations and procedures must come soon.

X. THE DRUG WAR—-Pot arrests have aimed to disenfranchise some 40 million mostly young, non-white, non-millionaires.  When Florida voted in 2019 to restore the ballot to ex-felons, the Gerrymandered legislature just said no.  This won't stop soon.

X. MONEY—-American elections have always been for sale.  The Supremes' awful enshrinements of legalized bribery include *Buckley* (1976), *Bellotti* (1978), *Citizens United* (2010), *McCutcheon* (2012).  Howard Dean, Barack Obama and Bernie Sanders have ridden alternative waves of internet based donations (Bernie's averaged $27).  But corporate cash is as deadly as ever.

X. FASCIST VIOLENCE—-White Supremacists have lynched at least 4,000 likely voters of color since 1865. In 2000 the natty "Brooks Brothers Mob" terrorized Florida vote counters to put Bush2 in the White House.  Armed militias have threatened to kidnap and kill the Governor of Michigan, overrun the Wisconsin statehouse and toted automatics to rallies in Texas and Arizona.  Random slaughter daily debilitates our schools, workplaces, public commons.  Nazi-style death threats---even against moderate Republicans---today define the American right.  Should Jesus reappear to preach his *Sermon on the Mount* at an evangelical Trump rally, The Donald would denounce his altruistic nonviolence as the ravings of "a commie, a hippie, a sucker, a loser," and the cult would rip him to shreds.

X. THE MEDIA—-When radio arose in the 1920s, a Republican Congress demanded it provide fair and balanced opinions.  Later came laws against monopolization.  But Reagan-Clinton roll-overs let cash cow corporations and their fascist bloviators make much of the major media into a *Big Lie* bullhorn for organized hate.  Internet-based rightist social media like Facebook have deepened the disaster.

X MILITARY—In the ultimate symptom of a dying empire, our bloated, obsolete armed forces drain the gargantuan resources we could otherwise use to spread prosperity, fund human needs, protect the planet.  In 2021, the military refused Trump's demand for martial law.  Next time we may not be so lucky.

X. THE WEIMAR DEMOCRATS—-As in pre-Nazi Germany, modern fascism's ultimate enabler has been its feeble "opposition"--- the boring, corrupt, corporate Democratic Party.  To all the above the Democrats have mounted no effective resistance.  They slept as massive irregularities flipped critical elections, laughed off the RedMap Coup that gerrymandered the GOP's iron grip, failed to bring statehood to DC, forever trash progressive pleas for a pro-democracy shift to grassroots organizing.

As The Donald howled that he'd won an election he bigly lost, he purged the GOP cult of all but his most psychotic zealots.  Their fascist wall looms like a tombstone over American democracy's open grave. Never in our historic spiral has the Republic's demise appeared more imminent.

*Yet the Republicans still have one major problem: the American public---especially its women and its rainbow youth--- is not with them.*

# Getting to Solartopia

*"To change something, build a new model that makes the existing one obsolete..."*
—-Bucky Fuller

*"The Happy Ending is Our National Belief"*
—-Mary McCarthy

# A Generational Green-Powered Revolution

The matriarchal Haudenosaunee confederacy birthed us individual rights, consensual decisions, communal compassion, natural unity.

Euro-Founders like Ben Franklin and Tom Paine, embraced that vision, and shot it through our evolutionary cycles.

Amidst an epic demographic upheaval, at the peak of of our spiral, our surging diversity demands social democracy, racial justice, human rights, global eco-harmony.

Donald Trump got beat in 2020 by seven million votes. It was US history's third-worst incumbent drubbing, trailing only Hoover in 1932 and Carter in '80. His defeat exalted America's grassroots Election Protection movement, on which our future as a democracy now depends.

It was born amidst Florida 2000's stripped voter rolls, flipped electronics, an alleged 537-vote margin, and a violent *blitzkrieg* on volunteer ballot counters. Three legal aides to the"Brooks Brothers Mob" that terrorized that process—-John Roberts, Brett Kavanaugh, Amy Barrett—- themselves became Supremes.

The *Bush v. Gore* edict that handed Shrub the White House mirrored the post Civil War decisions that crushed Reconstruction. It also laid the foundation for the Trump/Bannon fascist wall.

Gore could have become president by carrying his home state of Tennessee…or an Electoral College begging for abolition. Florida's Greens gave some 90,000 votes to consumer activist Ralph Nader…which were easily overshadowed by black/brown citizens purged from the voter rolls by W's brother, Governor Jeb. A blatantly mis-drawn ballot gave heavily Jewish neighborhoods to the far-right Pat Buchanan.

But rather than fight to reform our broken democracy, the Democrats wasted the next two decades howling at Ralph and the progressive movement.

In Ohio, 2004, an astonishing wave of dirty tricks from Karl Rove shamed even Florida 2000. Election Protectionists who exposed it were relentlessly slimed by both parties.

In California, 2008-10, Pelosi Democrats opposed citizen gerrymander reforms won with help from Arnold Schwarzenegger. Nationwide, they did nothing as Rove—-flush with Koch cash—-perpetrated the 2010 RedMap coup that turned a thousand blue seats red, gerrymandered the Dems to virtual oblivion in the US House and Heartland/Confederate statehouses…and opened the door for a Trump coup.

The Dems simultaneously purged popular progressives like Cleveland's Dennis Kucinich. Despite a firm early grip on Congress, Obama also did nothing to win DC statehood and the two US Senate seats that could've spared us the Manchin-Sinema debacle of 2021-3.

In 2016, Hillary shafted Bernie in the primaries, won the popular vote, was robbed herself in the Electoral College, then trashed the Election Protectionists who dared expose the dirty tricks that beat her. But throughout the new millennium, those pro-democracy Solartopians have held firm against both the corp Dems and the GOP cult. On them depends the Fate of the Earth.

# solartopia!

## DUMP KING
## Coal
## Oil
## Nukes
## Gas

## DON'T NUKE

*Visit Solartopia.org*

## 8 STEPS TO SOLARTOPIA

**Ban Fossil/Nuclear Fuels**

**Convert to Renewables**

**Achieve Total Efficiency/ Revive Mass Transit**

**Raise Sustainable/ Organic Food**

*Empower Women*

*Transform the Corporation*

*End War*

*Win Social Justice/ True Democracy*

## THE CLIMATE!

HarveyWasserman.com

In 2018, that surging young groundswell demanded paper mail-in ballots and much more, feeding an epic sweep of the US House with the most diverse matriarchal delegation of our spiral history.

In 2020, another Sandernista campaign fell to another set of dubious primaries. But unlike Hillary, Joe Biden refrained from dismissing Bernie's Millennial/Zoomers or Trump's MAGA Heartland supporters as "deplorables."

As per so many other epic mass movements that start from nothing, Election Protection did hit critical mass, making all the difference. Amidst the COVID Pandemic, grassroots activists won the right to mailed, hand-marked, digitally-scanned paper ballots, secure audit/re-count procedures, and more. Trump's 2016 coup had come on easily hacked computerized voting machines; unique in the spiral of our history, 2020 was overwhelmingly fair and accurate (what a concept!).

For Team Trump, the satanic horror of non-millionaire citizens of youth and color receiving ballots in the mail, marking them by hand and mailing them back to be accurately counted was beyond comprehension. In such a heathen democracy, warned The Donald, the GOP would "never win another election."

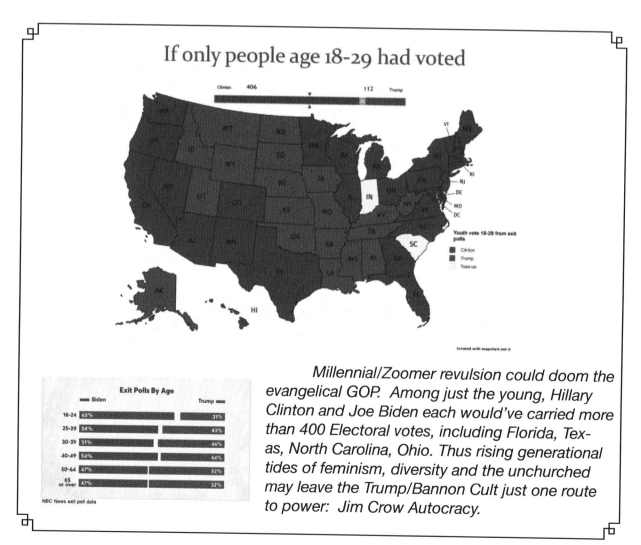

## If only people age 18-29 had voted

*Millennial/Zoomer revulsion could doom the evangelical GOP. Among just the young, Hillary Clinton and Joe Biden each would've carried more than 400 Electoral votes, including Florida, Texas, North Carolina, Ohio. Thus rising generational tides of feminism, diversity and the unchurched may leave the Trump/Bannon Cult just one route to power: Jim Crow Autocracy.*

So on January 6, 2021, demanding a military coup, he sent his Jim Crow minions to lynch Mike Pence and trash the vote counts.

The day before (January 5, 2021) a "Georgia Miracle" had improbably delivered to the Democrats two progressive US Senate victories... and thus control of the Upper House.

The unusual run-offs featured a black and a Jewish candidate running against centuries of bigotry. But Andrea Miller of the Center for Common Ground, Ray McClendon of the Atlanta NAACP, and other independent activists turned small donations and on-the-ground organizing into a monumental victory for down-home democracy. Candidates Ralph Warnock and Jon Ossof won their "miracle" races with unwavering commitments to social justice and ecological protection. It was a shining model for remaking democracy.

That fall, the Clintonistas sadly reverted to form. Virginia seemed at the brink of becoming a blue bastion. But insider Terry McCauliffe blew millions on a lame campaign, stiffed his canvassers, stood for nothing. Losing Richmond, the Dems howled at Nader, denounced progressives, stood firm against anything meant to inspire anyone of youth or color to organize or vote.

And thus democracy's dilemma: Will the entrenched Dems forever squander endless cash on their delusion search for a non-existent center? Or can the rising millennial/zoomers break on through to real progressive change and a sustainable future?

Put it this way: Women in 2020 voted 58-42 to fire our demented p*ssy-grabbing snake-haired chief. Voters under thirty gave Joe Biden a 24% margin, pitching The Donald toward history's compost heap. Can they now do the same to the corporate Democrats...and then to that fascist wall?

At 10:10 am, Friday, November 19, 2021, Kamela Harris became the first female President of the United States.

Edith Wilson and Nancy Reagan each unofficially ran the country when their husbands were unable. But now (with the latest old boy out for a colonoscopy) Kamela was the Boss, our first legally constituted female Chief Executive, connecting the line of American matriarchy straight back to Jigonsaseh.

So it seems the time to ask two questions:

Will we Americans save our democracy?

Will our species choose to survive on this planet?

Dwight Eisenhower had an answer. In 1952-3, he became America's first candidate to promise to end a war (Korea) then actually do it as president. His Inaugural and Farewell Addresses warned that between the bang of apocalypse and the whimper of eco-extinction, militarism and empire tower over all the evils we must transcend.

In August, 2021, Joe Biden wound down American's inexcusable war in Afghanistan. Clumsy, expensive, incomplete, bloody, cruel...the withdrawal evoked Saigon, 1975. It asked again: will this be the Empire's last war of conquest? Will it bookend Jefferson's 1801 imperial fiasco in Tripoli?

As our people hunger and our ecology collapses, we still squander trillions on distant outposts and an epic death machine perfectly designed to defeat the Soviet Union in 1989...or an "Army of Devils" in 1630.

America's empire has never really been about "national security." It's always been an obscene profit-driven delusion, the "City on the Hill" telling the rest of humankind how to live...and gaining from their pain.

Outnumbered everywhere, Trump and his mob boss exalted autocracy's genocidal hatred for social democracy. Putin's $2 billion mansion and matching yacht were hard-wired to Trump's rouble laundromat. The Donald adored Vlady's "genius." His "savvy" Ukrainian slaughter confirmed that on an Earth ruled by King CONG (Coal, Oil, Nukes, Gas), mined with reactors, blinded by arrogance, empire and greed...any Master of War can conjure Armageddon.

Transcending militarism, nationalism, empire and eco-madness, looms in their Medusa shadow as the evolutionary leap our species must make...alchemizing these ridiculous weapons, imperial armies, industrial polluters and fossil/nuke planetary arson—-all that carbon, radiation and fire—-into usable resources.

Social justice, quality education, universal health care, ending poverty, hunger, homelessness...all are within our technological reach. They await that Awakened moment when humankind's internet-connected hearts and minds at last embrace our rainbow diversities of skin colors, ethnicities, nationalities, sexualities, worldviews, spiritualities.

*"You may say I'm a dreamer,"* sang Yoko and John, *"but I'm not the only one."*

After all these shortening cycles, our glorious Awakenings must at last evolve to a state of grassroots democracy, permanent peace, global harmony, renewable energies, organic ways of being...or our overheated, overstressed, seriously pissed Mother Earth will surely find superior offspring to sustain.

*Getting to Solartopia has become a matter of survival.*

And she knows full well that while the spiral of our history sings of varied siren songs, there's one annoying howl that tops the charts (as hammered home by the macho likes of Trump and Putin)...

*...the colossal failure of male domination.*

At the dawn of America's historic spiral, the male spirits Deganawidah and Hiawentha spread the gospel of our original democracy, the Hodenosaunee Confederacy. But it was the matriarch Jigonsaseh who combed the snakes from the war chief Tadodaho's hair...and made peace possible.

*Guys, it's time we step aside.*

Calvin's macho-Jim Crow-Robber Baron cult still clings to caste and empire. Armed and autocratic (oozing from our very worst instincts) its "Western values" hate

# Survival of the Greenest

*Dead nuke cooling towers at Rancho Seco, CA, surrounded by live solar panels.*

--------------

As Russia in 2022 threatened Ukraine's 15 reactors with Chernobyl re-runs, Finland cancelled a joint reactor project, accelerating the global burial procession. After Fukushima, 2011, Germany began shutting its 19 nukes. When Sacramento voted in 1989 to unplug Rancho Seco, nearby cancer rates dropped. Photovoltaics installed in 1984 still generate safe, clean, cheap power.

On a burning planet, the rapid rise of solar, wind, battery and LED/efficiencies makes viable the leap to 100% green energy. Advancing rooftop PV and off-shore mega-turbines could soon bury fossil/nukes while we sanely electrify Earth.

Diverse holistic organics could transcend monocultural chemical-based industrial agribiz, sustaining an ample global food supply and slashing/stashing carbon. Fungal composting of oil-based wastes and natural substitutes for plastics could help redeem our bio-sphere. Accelerating leaps in artificial intelligence, computing and communications could spiral ever upward. Holistic advances in wellness, medicine and micro-dosing could remake how—and how long—we live.

But none of it's inevitable. No matter how smart we think we are, we can't clear the needle's eye without shedding the curses of bigotry, injustice, greed, war.

Our imperial techno-powers—-however green they might seem—-get us nothing without the compassion, heart and Earthly one-ness of our Indigenous Mother.

So can we walk and chew gum at the same time?

social democracy and the *Sermon on the Mount*. Its corporate/imperial misogynist madness threatens to burn us off a dying planet.

But through the Spiral of US History—-with its ever-evolving Indigenous core—-our People's DNA has (in part) ousted an empire, birthed a democratic republic, abolished formal chattel slavery, enfranchised women and citizens of youth and color, won unionization, legalized being LGBTQ and marrying that way, embraced myriad spiritualities, pioneered post-fossil/nuke organic green ways to sustain us all, staged a credible national election that ousted a tyrant.

*We must bend at last the arc of the moral universe.*

"In the time of the 7th fire," says Anishnaabe matriarch Winona LaDuke, "we are given a choice between two paths, one well worn and scorched...and one green."

"Whether it is to be Utopia or Oblivion," adds Bucky Fuller, "will be a touch-and-go relay race right up to the final moment..."

Which gives us all until November 5, 2024, to finally win that more perfect union.

# *Mitakuye Oyasin...*

# ***May the Force be with us!***

 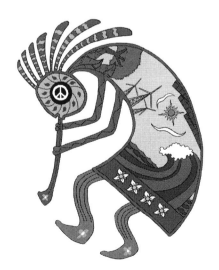

# "You Can't Be Neutral on a Moving Train"...Howard Zinn

*We study history to know how to make it.*

*At the end time of a definitive human transformation, the arc of the moral universe lands here and now.*

*Our survival depends on a bottom-up movement to transform the US into a just democracy thriving in harmony with our Mother Earth.*

*Everything matters.*

*In 1952 the great William Appleman Williams was purged from Ohio State by coach Woody Hayes for refusing to change the grade of a star football player (Go Blue!). Williams later published* Contours of American History, *exalting the power of cycles, and* The Tragedy of American Diplomacy, *mourning empire.*

*In 1970 the great Howard Zinn's single yellow sheet (below) prompted Harper & Row to publish* Harvey Wasserman's History of the United States. *An early title was* The People's History of the US, 1860-1920 *(what—at age 24--- was I thinking?!?).*

*In 1979 Harper published Howard's REAL* People's History of the United States, *which changed everything.*

*History can endlessly entertain us with great stories (you can't make this up!!!). But it also inspires and guides us.*

*At the peak of our spiral, facing the abyss of injustice and extinction, we need a powerful engine for real social change. Our monumental task will be to transform the Democrat Party into a broad-based grassroots coalition that includes the Green and other left parties (stop yelling at each other!!!) and the universe of sympatico campaigns to win the interconnected issues on which our survival depends.*

*The stakes couldn't be higher.*

*Nor could the work be more rewarding. We see through history that activism is the key to everything. "The pay's no good," quipped the non-violent legend A.J. Muste, "but the work is steady."*

*In fact the pay is great: you arise to a day with meaning, you work with wonderful people, you sleep knowing you made a difference...*

*...and that now, more than ever, we have no choice but to get active...and to WIN!!...*

*See you in the streets, suites, jail cells, election boards, voting centers, zooms, public meetings, solar rooftops, wind farms, organic gardens...&* www.solartopia.org.

# Harvey "Sluggo" Wasserman...

..marched in 1962 to de-segregate a central Ohio roller rink (we won!); with Martin Luther King in Grenada, Mississippi (1966); at the Pentagon (1967); the Chicago Democratic Convention (1968); the Seabrook, Diablo Canyon and other nukes with the Clamshell, Abalone and sibling Alliances; with Ben Spock, Mary Morgan, Dan Ellsberg, Dan Berrigan, Susanna Styron at the Pentagon (1980); with Greenpeace (still a Voting Member!) at the Nevada Test Site (1991); for DC Statehood, Election Protection, Green Jobs & Justice (see www.electionprotection2024.org). Join us!!

Hampshire College (1973-5); Capital University and Columbus State Community College (2004-17) kindly let me teach based on my U. of Chicago MA (1974) and U. of Michigan BA (1967). Dan Keller and I co-wrote Lovejoy's Nuclear War & The Last Resort (1975 & '8) for GMPFilms. *Sluggo Wasserman Explains All of US History in 54 Minutes* (on YouTube) debuted at the 2018 Left Coast Forum.

*Time* and the UPI (which globalized my 1967 Michigan Daily edit for legal pot) let me string from Ann Arbor. Great spirits conspired at Liberation News Service, the Montague (MA) organic farm, the global grassroots No Nukes, NukeFree.org, Solartopian & Election Protection movements, 1979/2011 MUSE Concerts, Great Blue Heron Alliance, CWA, AREDay, Starwood. I vaguely recall speaking for Greenpeace to 350,000 semiconscious music fans at Woodstock2 (1994), and co-writing the *Solartopia Song* (2010) with Pete Seeger, Dar Williams & David Bernz (the *Rocky Top* version is with Dana Lyons). Media/internet articles/appearances include shows at prn & Pacifica/90.7fm, LA. Our Grassroots Emergency Election Protection zooms air Monday, 5pm ET via www.electionprotection2024.org.

## This book flows from the love and support

of our extended Wasserman/Shapiro/Saks families...our wonderful parents, siblings, children/grandchildren, nieces/nephews...from Susan, who works so lovingly hard for all of us....and from countless co-conspirators (*you know who you are; thanks!*).

Photo by *abbiesophia.com.*

## "You Could Look it Up!"

If nothing in this book infuriated or inspired you, please read it again & write me: 12439 Magnolia #18, Valley Village, CA 91607, or @ www.solartopia. org, where sources, audiobooks, e-books & posters reside with: *Harvey Wasserman's History of the US* (intro by Howard Zinn); *Solartopia! Our Green-Powered Earth* (intro by RFK, Jr.); *The Strip & Flip Disaster of America's Stolen Elections* (w Bob Fitrakis); A Glimpse of the Big Light: Losing Parents, Finding Spirit (Intro by Marianne Williamson); *Our Gay Potsmoking Founders & their Fantastic Psychedelic Adventures* (w "Thomas Paine").

**See you in Solartopia!!!**